The Palace Museum's Essential Collections

CHINESE JADE WARE

The Commercial Press

Chinese Jade Ware

Chief Editor	Zhang Guangwen 張廣文
Deputy Chief Editors	Zhang Linjie 張林傑, Zhao Guiling 趙桂玲, Xu Lin 徐琳
Editorial Board	Huang Ying 黃鶯
Photographers	Hu Chui 胡錘, Liu Zhigang 劉志崗, Zhao Shan 趙山, Feng Hui 馮輝, Yu Ningchuan 余寧川, Sun Zhiyuan 孫志遠
Translator	Chan Sin-wai 陳善偉
Editorial Assistant	Florence Li 李穎儀
Editorial Consultant	Hang Kan 杭侃
Project Editors	Xu Xinyu 徐昕宇, Wang Yuechen 王悅晨, Qiu Yinqing 仇茵晴
Cover Design	Zhang Yi 張毅
Published by	The Commercial Press (Hong Kong) Ltd. 8/F., Eastern Central Plaza, 3 Yiu Hing Rd, Shau Kei Wan, Hong Kong http://www.commercialpress.com.hk
Printed by	C & C Offset Printing Co., Ltd. C & C Building, 36 Ting Lai Road, Tai Po, N.T., Hong Kong
Edition	First Edition in January 2017

© 2017 The Commercial Press (Hong Kong) Ltd.

ISBN 978 962 07 5679 5

Printed in Hong Kong

Introducing the Palace Museum to the World

SHAN JIXIANG

Built in 1925, the Palace Museum is a comprehensive collection of treasures from the Ming and Qing dynasties and the world's largest treasury of ancient Chinese art. To illustrate ancient Chinese art for people home and abroad, the Palace Museum and The Commercial Press (Hong Kong) Ltd. jointly published *The Complete Collection of Treasures of the Palace Museum*. The series contains 60 books, covering the rarest treasures of the Museum's collection. Having taken 14 years to complete, the series has been under the limelight among Sinologists. It has also been cherished by museum and art experts.

After publishing *The Complete Collection of Treasures of the Palace Museum*, it is understood that westerners, when learning about Chinese traditional art and culture, are particularly fond of calligraphy, paintings, ceramics, bronze ware, jade ware, furniture, and handicrafts. That is why The Commercial Press (Hong Kong) Ltd. has discussed with the Palace Museum to further co-operate and publish a new series, *The Palace Museum's Essential Collections*, in English, hoping to overcome language barriers and help more readers to know about traditional Chinese culture. Both parties regard the publishing of the series as an indispensable mission for Chinese history with significance in the following aspects:

First, with more than 3,000 pictures, the series has become the largest picture books ever in the publishing industry in China. The explanations show the very best knowledge from four generations of scholars spanning 90 years since the construction of the Museum.

Second, the English version helps overcome language and cultural barriers between the east and the west, facilitating the general public's knowledge of Chinese culture. By doing so, traditional Chinese art will be given a fresher image, becoming more approachable among international art circles.

Third, the series is going to further people's knowledge about the Palace Museum. According to the latest statistics, the Palace Museum holds more than 1.8 million pieces of artefacts (among which 228,771 pieces have been donated by the general public and purchased or transferred by the government since 1949). The series selects nearly 3,000 pieces of the rare treasures, together with more than 12,000 pieces from *The Complete Collection of Treasures of the Palace Museum*. It is believed that the series will give readers a more comprehensive view of the Palace Museum.

Just as *The Palace Museum's Essential Collections* is going to be published, I cannot help but think of Professor Qi Gong from Beijing Normal University; famous scholars and researchers of the Palace Museum Mr. Xu Bangda, Mr. Zhu Jiajin, and Mr. Liu Jiu'an; and well-known intellectuals Mr. Wu Kong (Deputy Director of Central Research Institute of Culture and History) and Mr. Xu Qixian (Director of Research Office of the Palace Museum). Their knowledge and relentless efforts are much appreciated for showing the treasures of the Palace Museum to the world.

Looking at History through Art

YANG XIN

The Palace Museum boasts a comprehensive collection of the treasures of the Ming and Qing dynasties. It is also the largest museum of traditional art and culture in China. Located in the urban centre of Beijing, this treasury of ancient Chinese culture covers 720,000 square metres and holds nearly 2 million pieces of artefacts.

In the fourth year of the reign of Yongle (1406 A.D.), Emperor Chengzu of Ming, named Zhu Di, ordered to upgrade the city of Beiping to Beijing. His move led to the relocation of the capital of the country. In the following year, a grand new palace started to be built at the site of the old palace in Dadu of the Yuan Dynasty. In the 18th year of Yongle (1420 A.D.), the palace was completed and named as the Forbidden City. Since then the capital of the Ming Dynasty moved from Nanjing to Beijing. In 1644 A.D., the Qing Dynasty superceded the Ming empire and continued using Beijing as the capital and the Forbidden City as the palace.

In accordance with the traditional ritual system, the Forbidden City is divided into the front part and the rear part. The front consists of three main halls, namely Hall of Supreme Harmony, Hall of Central Harmony, and Hall of Preserving Harmony, with two auxiliary halls, Hall of Literary Flourishing and Hall of Martial Valour. The rear part comprises three main halls, namely Hall of Heavenly Purity, Hall of Union, Hall of Earthly Tranquillity, and a cluster of six halls divided into the Eastern and Western Palaces, collectively called the Inner Court. From Emperor Chengzu of Ming to Emperor Puyi, the last emperor of Qing, 24 emperors together with their queens and concubines lived in the palace. The Xinhai Revolution in 1911 overthrew the Qing Dynasty and more than 2,000 years of feudal governance came to an end. However, members of the court such as Emperor Puyi were allowed to stay in the rear part of the Forbidden City. In 1914, Beiyang government of the Republic of China transferred some of the objects from the Imperial Palace in Shenyang and the Summer Palace in Chengde to form the Institute for Exhibiting Antiquities, located in the front part of the Forbidden City. In 1924, Puyi was expelled from the Inner Court. In 1925, the rear part of the Forbidden City was transformed into the Palace Museum.

Emperors across dynasties called themselves "sons of heaven", thinking that "all under the heaven are the emperor's land; all within the border of the seashore are the emperor's servants" ("Decade of Northern Hills, Minor Elegance", *Book of Poetry*). From an emperor's point of view, he owned all people and land within the empire. Therefore, delicate creations of historic and artistic value and bizarre treasures were offered to the palace from all over the country. The palace also gathered the best artists and craftsmen to create novel art pieces exclusively for the court. Although changing of rulers and years of wars caused damage to the country and unimaginable loss of the court collection, art objects to the palace were soon gathered again, thanks to the vastness and long history of the country, and the innovativeness of the people. During the reign of Emperor Qianlong of the Qing Dynasty (1736 A.D. – 1796 A.D.), the scale of court collection reached its peak. In the final years of the Qing Dynasty, however, the invasion of Anglo-French Alliance and the Eight-Nation Alliance into Beijing led to the loss and damage of many art objects. When Puyi abdicated from his throne, he took away plenty of the objects from the palace under the name of giving them out as presents or entitling them to others. His servants followed suit. Up till 1923, the keepers of treasures of Palace of Established Happiness in the Inner Court actually stole the objects, set fire on them, and caused serious dam-

age to the Qing Court collection. Numerous art objects were lost within a little more than 60 years. In spite of all these losses, there was still a handsome amount of collection in the Qing Court. During the preparation of construction of the Palace Museum, the "Qing Rehabilitation Committee" checked that there were around 1.17 million items and the Committee published the results in the *Palace Items Auditing Report*, comprising 28 volumes in 6 editions.

During the Sino-Japanese War, there were 13,427 boxes and 64 packages of treasures, including calligraphy and paintings, picture books, and files, transferred to Shanghai and Nanjing in five batches for fear of damage and loot. Some of them were scattered to other provinces such as Sichuan and Guizhou. The art objects were returned to Nanjing after the Sino-Japanese War. Owing to the changing political situation, 2,972 pieces of treasures temporarily stored in Nanjing were transferred to Taiwan from 1948 to 1949. In the 1950s, most of the antiques were returned to Beijing, leaving only 2,211 boxes of them still in the storage room in Nanjing built by the Palace Museum.

Since the establishment of the People's Republic of China, the organization of the Palace Museum has been changed. In line with the requirement of the top management, part of the Qing Court books were transferred to the National Library of China in Beijing. As to files and essays in the Palace Museum, they were gathered and preserved in another unit called "The First Historical Archives of China".

In the 1950s and 1960s, the Palace Museum made a new inventory list for objects kept in the museum in Beijing. Under the new categorization system, objects which were previously labelled as "vessels", such as calligraphy and paintings, were grouped under the name of "*gu* treasures". Among them, 711,388 pieces which belonged to old Qing collection were labelled as "old", of wh2ich more than 1,200 pieces were discovered from artefacts labelled as "objects" which were not registered before. As China's largest national museum, the Palace Museum has taken the responsibility of protecting and collecting scattered treasures in the society. Since 1949, the Museum has been enriching its collection through such methods as purchase, transfer, and acceptance of donation. New objects were given the label "new". At the end of 1994, there were 222,920 pieces of new items. After 2000, the Museum re-organized its collection. This time ancient books were also included in the category of calligraphy. In August 2014, there were a total of 1,823,981 pieces of objects in the museum's collection. Among them, 890,729 pieces were "old", 228,771 pieces were "new", 563,990 were "books", and 140,491 pieces were ordinary objects and specimens.

The collection of nearly two million pieces of objects is an important historical resource of traditional Chinese art, spanning 5,000 years of history from the primeval period to the dynasties of Shang, Zhou, Qin, Han, Wei, and Jin, Northern and Southern Dynasties, dynasties of Sui, Tang, Northern Song, Southern Song, Yuan, Ming, Qing, and the contemporary period. The best art ware of each of the periods has been included in the collection without disconnection. The collection covers a comprehensive set of categories, including bronze ware, jade ware, ceramics, inscribed tablets and sculptures, calligraphy and famous paintings, seals, lacquer ware, enamel ware, embroidery, carvings on bamboo, wood, ivory and horn, golden and silvery vessels, tools of the study, clocks and watches, pearl and jadeite jewellery, and furniture among others. Each of these categories has developed into its own system. It can be said that the collection itself is a huge treasury of oriental art and culture. It illustrates the development path of Chinese culture, strengthens the spirit of the Chinese people as a whole, and forms an indispensable part of human civilization.

The Palace Museum's Essential Collections series features around 3,000 pieces of the most anticipated artefacts with nearly 4,000 pictures covering eight categories, namely ceramics, jade ware, bronze ware, furniture, embroidery, calligraphy, paintings, and rare treasures. The Commercial Press (Hong Kong) Ltd. has invited the most qualified translators and academics to translate the series, striving for the ultimate goal of achieving faithfulness, expressiveness, and elegance in the translation.

We hope that our efforts can help the development of the culture industry in China, the spread of the sparkling culture of the Chinese people, and the facilitation of the cultural interchange between China and the world.

Again, we are grateful to The Commercial Press (Hong Kong) Ltd. for the sincerity and faithfulness in their co-

operation. We appreciate everyone who has given us support and encouragement within the culture industry. Thanks also go to all Chinese culture lovers home and abroad.

Yang Xin former Deputy Director of the Palace Museum, Research Fellow of the Palace Museum, Connoisseur of ancient calligraphy and paintings.

ontents

List of Jade Ware

E ASTERN ZHOU TO THE SOUTHERN AND NORTHERN DYNASTIES

SUI AND TANG TO MING DYNASTIES

QING DYNASTY

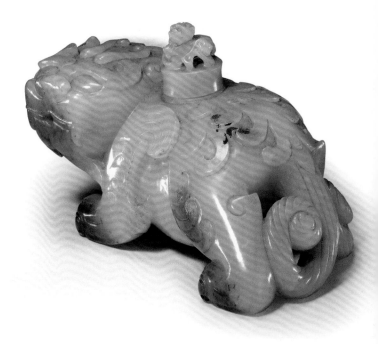

Introduction to Chinese Ancient Jade in the Collection of the Palace Museum

ZHANG GUANGWEN

In *An Explanatory Dictionary of Chinese Characters* written by Xu Shen of the Eastern Han Dynasty, "jade" is defined as "a beautiful stone" with "five virtues". Looking at it from the present perspective, jade, in short, is a kind of mineral that is fine in substance, strong, glossy, and slightly translucent. The mineral that is generally called jade is mainly of two types: hard jade (also known as jadeite) and soft jade (such as amphibole and actinolite). Soft jade is the traditional jade material in China, and it is from soft jade that we have the designation of "jade" . The texture of both soft jade and hard jade is extremely strong, which explains why jade has gained the good reputation of being "the king of stones". The various objects carved in jade are known as jade ware which has formed, with the passage of time, the jade culture.

The use of jade ware has a long history in China. Unearthed from the Xinglongwa Site of the Aohan Banner in the eastern part of Inner Mongolia were jade ware of the Xinglongwa Culture of around eight thousand years ago. These are the earliest jade objects that we know, and heralded the use of jade in prehistoric China. The jade material used in the jade ware of the Xinglong Depression Culture was mainly the tremolite. A large amount of ring-shaped objects were found, which show that in the early period of the Neolithic Age, the Chinese people not only started to use jade ware, but also had clear criteria in the selection of jade material and mature jade processing techniques. By the middle period of the Neolithic Age about five to six thousand years ago, a large quantity of jade ware began to emerge, as shown in the sites of Hongshan Culture, Liangzhu Culture, Lingjiatan Culture, and it formed a number of categories, such as witchery ware, ceremonial ware, pendant ornaments, vessels, and funerals and burials. Jade ware greatly affected social life at that time and in later ages, and a variety of it had been used until the Qing Dynasty.

The Palace Museum has a collection of around thirty thousand pieces of jade ware and precious stones in ancient China. A large part of it was inherited from the Qing court, and it is known as the "Qing court collection". Of these, jade ware forms the majority, covering basically all varieties of jade ware from the Neolithic Age to the Ming and Qing periods. These items are characterized by a large temporal span, a clear sequence of development, a comprehensive coverage of variety, and their individual features. They include jade ware preceding the Yuan Dynasty, some of which are exquisite pieces from archaeological excavations, others, precious pieces inherited from the past, and still others, valuable pieces kept in the Qing court. The Palace Museum is formerly the palaces of the Ming and Qing courts. This exceptional advantage is manifested in its collection of jade ware from the Ming and Qing courts as a large number of jade items of Qing in the collection of the Palace Museum were those left in the Ming court or stored in the Qing court, and these pieces are the most important materials for studying jade from the Ming Dynasty. The quantity of Qing jade ware in the collection of the Palace Museum is

numerous, comprising that in the Qing court and the fondling pieces given as tributes by officials of different positions, and thus covering the various aspects of Qing jade ware and reflecting in a comprehensive way its making, use, and cultural connotations.

This volume has selected 260 pieces out of thousands in the collection of the Palace Museum, and will show them in chronological order, hoping that it can help readers to have a basic understanding of the jade collection in the Palace Museum and the development of jade ware in China. This article introduces the jade collection in the Palace Museum by showing the objects and their two major aspects: "usage" and "history".

The Major Uses of Jade Ware in the Ancient Period

Jade ware in ancient China was, broadly speaking, used as witchery ware, ceremonial ware, pendant ornaments, and utensils.

Jade witchery ware can be traced back to remote ancient times. Witchery was an important part of ancient culture. The so-called "witch" referred generally to the clergy. People from the earliest period believed that there existed gods for heaven, earth, and nature. They also believed that when one died, one's soul would not disappear and one could become a god. However, only a small number of people could communicate with gods, and these people were the "witches". *An Explanatory Dictionary of Chinese Characters* explains the character *wu* 巫 as follows: "One who prays to the gods. *Wu* refers to women who are capable of serving the formless and mysterious and dancing with charm to attract gods and spirits to descend on the scene". Witches of the early period used jade ware during the ceremonies in order to communicate with the gods. In *An Explanatory Dictionary of Chinese Characters*, the explanation of the character *ling* (soul) is: "Witches communicate with gods with jade". In other words, the witchery jade ware was a kind of religious tool. The ivory disk on the human chest unearthed from the Dawenkao Culture Site and the jade pig-dragons unearthed from the human skeletons at the Niuheliang Site of the Hongshan Culture, for example, were probably the tools for communicating with the gods during the witch praying ceremonies. The Jade Standing Figure, unearthed from the Lingjiatan of Mount Han in Anhui (Figure 12), wears a hat, has his arms close to his chest and his ten fingers stretched out, which shows clearly that the witch is performing some sort of ceremony.

Jade ceremonial ware was used for offering sacrifices to the sun, moon, heaven, and earth, as well as other ceremonial activities. This sort of jade ware appeared relatively early. Jade ceremonial disk, jade tubes, and jade pendants had already appeared in the Neolithic Age. They matured in the Xia, Shang, and Zhou periods, and their use was continued into the Qing Dynasty. The systematic use of jade ceremonial ware was first seen in the book *Rites of Zhou*. In this book, which was completed two thousand and three hundred years ago, the chapter "Officer in Charge of Ceremonial Jades" records that: "Jade is made into six objects to pay homage to heaven, earth, and the four directions. The grey jade disk is to pay homage to heaven; the yellow jade tube is to pay homage to the earth; the blue jade tablet is to pay homage to the east; the red jade tablet is to pay homage to the south; the white tiger-shaped jade is to pay homage to the west; and the black semi-annular jade pendant is to pay homage to the north". People, therefore, regarded the jade disk, tube, sceptre, tablet, semi-annular pendant, and tiger-shaped piece as the major types of jade ceremonial ware, known as "six ceremonial jade" or just "ceremonial jade". Of these, the tiger-shaped piece was the only type that lacked the real object for true verification, and its real physical shape had yet to be discovered from archeological sites and further studied. The other five types of jade ware have unearthed or extant objects.

Of the six types of ceremonial jade ware, the jade sceptre was the most widely used. The "Officer in Charge of Ceremonial Jade" section of the "Spring Minister" chapter of the *Rites of Zhou* records the names and applications of the jade ware used in five ceremonies: "The four jade sceptres, which have bases, are to offer sacrifices to heaven and God; the two jade

sceptres, which have bases, are to offer sacrifices to the earth and the four directions; the libation jade sceptres have ladles to offer sacrifices to ancient emperors and pour out a libation to guests; the sceptre disks are to offer sacrifices to the sun, moon, stars, and celestial bodies; the jade tablet, which has a base and a pointed part, is to offer sacrifices to mountains and rivers, and to be given as gifts to guests; the jade timepiece is to express the four seasons, days and months, and give land to feudal states; the imperial envoy's jade seal is for expeditions and defence and relieve famines; the teeth tablet is to arouse the troops and manage military defence; and the long jade disk is for measurement. The large sceptre, tablet, disk, tube, tiger-shaped jade and semi-annular jade pendant have concave and convex patterns, and the disk and the tube are carved for burials. The grain sceptre is for settling grievances and wedding. The round-shaped sceptre is for the cultivation of virtues and making friends. The pointed jade is to change misbehaviour and remove evil. For sacrifices and offerings, and for matters relating to guests, they are served with jade ware". The above citation mentions a series of designations of ancient jade ware, including jade sceptres, and also describes the applications of these jade ware. This shows that the application of ceremonial jade ware was extensive, and the ware was strictly regulated by a system. What is regrettable is that many designations of jade ware mentioned in the text did not have unearthed or inherited items due to the passage of time, it is not yet possible to ascertain their shapes, the ways they were used, and those which had continued their use to later ages were very small in number. In the archeological excavations of the sites of the Xia, Shang, and Zhou dynasties, discoveries of jade disks, tubes, sceptres, tablets, semi-annular jade pendants, dagger-axes, and battle axes were abundant. Jade ceremonial ware after the Han Dynasty included mostly disks and sceptres. These jade ware were mostly round with curved lines or square with vertical lines. These were the two basic systems of geometrical jade ceremonial ware.

Wearing was an important function of jade ware. The jade pieces one wore had extremely complicated implications. They could show one's status or display one's ability. They could serve as ornaments or show off one's wealth. In the primitive society, eight thousand years ago, some jade ware that people used could be worn, such as the jade slit rings found in archeological discoveries, which were usually placed on the ear part of the head of the skeleton, as ear ornaments. With the development of society, jade pendants formed their own system, carrying complicated social meanings. The collection of the Palace Museum includes the "Jade Pendant Carved in the Shape of a Bird" of the Shang Dynasty engraved with the characters of "*Mu*" (farmer) and "*Hou*" (marquis), and jade handle carved with the characters of "*Mu*" (wood) and "Hou" (*marquis*). These pieces, whose characters clearly show the statuses of the wearers, are representative works of jade pendants in the early period. In the tombs of the Eastern and Western Zhou periods, a large number of jade pendant sets was unearthed, illustrating that they reflected the status of the person in the tomb.

At the same time, jade pendants could also show the abilities of people. The jade bodkin, for example, was originally a practical tool that could be used for unknotting. It later evolved into an ornament, which transmitted that the wearer had the ability to solve problems. The jade slit ring showed one's "power of making decisions". Further examples of this kind are too numerous to be enumerated.

The ancient people related the use of jade ware with a person's virtues and character. The idea of "comparing jade to virtue" is seen in many schools of thoughts and literature of the ancient period. The Confucian school, in particular, was most representative. In the chapter "The Significance of the Rite of Friendly Visits between the Feudal Princes" in the Confucian classic *The Book of Rites*, there is a detailed elaboration of the virtues inherent to jade: "Confucius says, 'In the days of old, men of moral excellence always likened man's virtues to jade. Jade is temperate, smooth, and glossy: this is benevolence. It is fine and solid: this is wisdom. It has edges but never hurts people: this is righteousness. It droops like a weight: this is courteousness. Its sound is crisp and melodious when struck and stops abruptly at the end: this is music. Its flaws never obscure its splendour, while its splendour never hides its flaws:

this is faithfulness. It is glittering, translucent, and glorious: this is trustworthiness. Its vitality is like a fogbow: this is heaven. Its spirit is seen in mountains and rivers: this is the earth. The jade sceptre and the jade tablet are unparalleled: this is morality. Jade is valued by everyone: this is the Way". Here, Confucius combined people's convention of wearing jade pendants with moral cultivation and proposed the eleven virtues that jade had. To Confucian scholars, jade is a symbol of the ideal situation in which things develop. It is said in "Wanzhang Part Two" in the *Mencius*: "The assembling may be likened to the linking up of the golden sound of a metallic bell to the silvery sound of a musical jade stone. The metallic bell begins the rhythmic order and the musical jade stone winds it up".

Confucianists also emphasized the use of jade pendants in the cultivation of virtues and the regulation of people's behaviour, relating jade pendants to the cultivation of the person and one's moral character, the good habit of self-reflection, and the proper control of one's behaviour. It is said in the chapter "Jade-bead Pendants" of *The Book of Rites*, "All should wear the jade pendant at the girdle, except when they observe the mourning rites, and *chongya* was a kind of jade pendant. A gentleman will never be without a jade pendant unless with a good reason. He compares jade to virtues which he should cultivate". "All gentlemen in the ancient time wore jade without exception... When they hurried along, they followed the tempo of *Caiqi*; when they walked, they followed the tempo of *Sixia*; when they turned round, they made a complete circle; and when they turned to another direction, they did so at a right angle... and in all these movements, jade emitted their tinkling." *Chongya* is a kind of jade pendant, and "*Caiqi*" and "*Sixia*" are the tempos of the music. What is emphasized here is that, when a gentleman wears jade, he does so on his own accord and this is a kind of self-control. Walking or lying, a gentleman has to follow certain movements and rhythm and should not cause the jade pendant to tinkle in a disorderly manner. *The Book of Poetry*, the first anthology of poems in China, collected 305 poems from the early years of the Western Zhou Dynasty to the middle of the Spring and Autumn

Period, a period of over five hundred years. Many poems in this anthology reflect the social life three thousand years ago and have a large number of lines that use jade pendants to describe people's virtues and cultivation, and moderation of their speech and behaviour. In the poem entitled "Homesick Woman" of the Chapter "Songs Collected in Wei" in *The Book of Poetry*, it is said that "The Qi River is on the right and the spring of the fountain is on the left. My sweet smiles are lustrous (*chai*), and my jade pendants, moderate (*nuo*)". The annotation of this line is: "*Chai* means a smiling face, and *nuo*, moderation in one's behaviour". *Chai* can also be interpreted as exposing one's teeth when smiling. This is to say that jade pendants show that one's behaviour is regulated and that one has the power of self-control. The ancient people, when choosing jade pendants, paid attention to the warmth and moisture of the jade material, which was regarded as representing the mildness and gentleness of their character. In the poem "A Lord on Expedition" in the "Songs Collected in Qin" in *The Book of Poetry*, it says: "The reins thread through the live rings to control the horse, and the silver rings lock up the leather straps of the carriage; a tiger skin is placed on my chariot, I ride on a horse with dark and green spots. I think of my lord, who is as gentle as jade". "As gentle as jade" is an external form of the cultivation of the character.

Burying the dead with jade pendants has been popular for a very long time throughout the history of China. People believed that jade was the essence of mountains and rivers and that it could communicate with gods, bridging this world with the other world. Thus, jade was the best object that the dead could benefit. The practice of burying the dead with jade emerged in the Neolithic Age. This was practised in the tombs of those dead people with higher status and position. In the excavations of the Wujing Temple Site in Jiangsu, which took place in 1982, over one hundred pieces of jade ornaments and ceremonial ware, such as disks and tubes, were unearthed from the Tomb No.3, characterized by the number of ceremonial jade ware pieces that were buried with the dead, totalling 57. Out of the 24 pieces of jade disks, the most exquisite and largest were placed on

the chests of the dead. A piece of bracelet-shaped jade tube was placed on the upper right side of the head, and 32 pieces of square-shaped jade tubes were placed on the four sides of the human skeleton, apart from one piece that was placed at the fore of the head and four pieces that were placed behind the legs, After 1990, some important cultural relics, such as jade tubes and disks, were discovered in this site. This huge tomb from the late Neolithic Age had jade ware for lavish burials with strict rituals, illustrating that the custom of burying the dead with jade was gradually becoming systemized.

In the Qin and Han dynasties, the use of jade ware in burials reached a new height. At that time, the trend was to serve the dead as if they were living beings, and lavish burials were popular. There was a complete variety of burial jade in different forms. Apart from the ware for display, wearing, and daily use, there were also jade items specially for the nine orifices of the dead: eye covers, nose plugs, ear plugs, and plugs for the anus and genitals. Other burial jade ware included jade grips which were held by the hands of the dead. The most common grips were the jade pigs. There were also jade mouthpieces placed in the mouth of the dead upon burial, and jade garments. The most outstanding feature of burial jade in the Han Dynasty was the use of jade disks in combination with jade garments, whose use was extensive. Emperors, feudatory princes, adjunct marquis, newly-conferred worthy ladies, and imperial princesses all had jade garments. Jade garments were made by joining togther jade chips. There were differences among garments made with gold wires, silver wires, brass wires, or silk.

Apart from the kinds of applications mentioned above, there were many other purposes for jade in ancient times. People, for example, used jade to offer sacrifices to mountains, rivers, and gods, as well as practising divination. Moreover, there was also jade ware for display, practical use, fondling, and use in a study, among other functions.

The Stages of Development of Jade in Ancient Times and Their Periodic Characteristics

The development of jade ware in ancient times can be generally divided into five stages: the Neolithic Age, the period from Shang to Western Zhou, the period from Eastern Zhou to the Southern and Northern dynasties, the period from Sui and Tang to Ming, and the Qing Dynasty.

Jade in the Neolithic Age

For a very long period, people believed that the early peak in the appearance of jade ware was the period of Xia, Shang, and Zhou, less than four thousand years from now. The so-called "three-dynasty" jade ware was the early jade ware. The late Qing scholar Wu Dacheng, in his work *A Study of Ancient Chinese Jade with Illustrations*, misplaced some jade ware that belonged to the Neolithic Age as works of the Zhou Dynasty. However, with the development and deep examination of the archeological study of the Neolithic Age, and the discovery of jade ware from sites of the Neolithic Culture, the hypothesis that the traditional "three-dynasty" jade ware was proven unscientific. The first peak of jade ware in China occurred in the Neolithic Age.

Jade ware of the Neolithic Age was closely related to the social activities of the time. The majority showed totem worship, clan gatherings, military warfare, leadership status, and witchery activities. The relationship between jade and gods was patent. Ancient people used jade to communicate with gods as they believed that even gods used jade. When wizards wore a jade worship implement, they could have dialogues with gods. The Jade Combiner of Turtle Back Shell and Belly Shell, unearthed from the Lingjiatan Site of Mount Han in Anhui (Figure 11) had a Rectangular Jade Chip with a Map (Figure 10). On the chip, there are drawings of the shapes of a ring and radiation with lines in intaglio. Scholars have different interpretations of the contents shown

in the drawings of this work. One interpretation is that this set of jade ware should be related to the "Eight Diagrams", tools used by wizards to make divinations or conduct religious ceremonies.

In terms of shape and structure, jade ware of the Neolithic Age can be divided into two major types: geometrical shaped and animal-shaped. Geometrical jade originated from weapons and production tools. Square columns, spades, rings, and arches were the most popular shapes and later constituted the system of ceremonial jade ware. The animal-shaped jade ware comprised mostly jade pendants.

During this period, most works of jade ware had few decorative patterns on their surface, those that had were extremely simple in their design. The jade ware of the Liangchu Culture, however, had exaggerated beast masks, human heads, and bird patterns, which drew people's attention.

Jade ware processing in the Neolithic Age involved line and chip cutting, cutting with an emerald wheel, milling, carving, and drilling. Therefore a relatively systematic jade ware processing technique was created, industrializing the production of jade ware.

Jade in the Xia, Shang, and Western Zhou Period

As abovementioned, the jade ware in the Neolithic Age was constrained by the level of social development at the time and by different regional cultures and thus showed relatively distinctive regional characteristics. However, the making of jade ware in the Xia, Shang, and Western Zhou periods had overcome this regional limitation. It had its unique style, a larger scope of application, and it established the system for ceremonial jade and basic system for jade pendants.

As far as the material is concerned, the kind of jade used in the jade ware of Xia, Shang, and Western Zhou can be divided into tremolites, taxoites, and other materials. There was a more precise selection standard for the materials of jade and the regional characteristics in the use of jade material were no longer distinctive. Regarding decoration, jade ware of this period was mostly decorated with long lines. Two types of long-line patterns were most commonly

seen: one was the group straight-line patterns on the tabular ceremonial jade ware, and the other was the curved line patterns on jade pendants.

The ceremonial ware system and the jade pendant system were the focuses of the jade ware of this period. First, the ceremonial jade ware of this period was at its height, with the appearance of many large pieces. What is "ceremony"? Ancient people interpreted it as "practice" and "norm", carrying the meanings of methods and systems. The so-called "ceremonial jade ware" simply referred to jade ware used in religious sacrifices and grand occasions of the state. As previously cited, it was recorded in the Section "Officer in Charge of Ceremonial Jade" of the Chapter "Spring Minister" of the *Rites of Zhou* that the six jade ware of jade disks, tubes, sceptres, tablets, semi-annular pendants, and tiger-shaped items are collectively known as ceremonial ware. Besides, there were numerous knives, dagger-axes, large axes, battle axes, and spades, which should be jade ware used in combination with the six jade ware, and should belong to ceremonial ware. From archeological excavations, it was found that though it is difficult to see group ceremonial jade ware that exactly matched documentary records, the ceremonial ware occupied a high proportion in the jade ware of this period, which clearly indicated its important position. This characteristic way of using jade has a far-reaching impact on later generations, and many dynasties since Qin and Han used ceremonial jade ware in sacrificial activities.

These ceremonial jade ware were mostly decorated with sets of lines. This was because for ceremonial ware, the ancient people focused on the appreciation of the jade quality and did not pay much attention to decorative patterns. As said in the "Countryside Sacrifices" in *The Book of Rites*: "Large sceptres are not carved so as to appreciate their plainness".

Second, apart from ceremonial jade ware, jade pendants of this period also occupied a large proportion. The major works were semi-annular pendants, rings, slit rings, bodkins, thumb rings, hairpins, animals, beasts, birds, fish, insects, and figures. Jade pendants mostly adopted long lines

in intaglio as decorations. Jade ware of the Shang Dynasty used mainly the pattern of broken lines, jade ware of the Western Zhou Dynasty mostly used the pattern of curved lines, with a small number of jade ware decorated with line drawings in relief. Since the Shang Dynasty, more animal drawings were used on jade ware. The animal drawings of the Shang Dynasty were consistent with the shapes of jade ware, whereas independent drawings that had nothing to do with the shapes of objects appeared on the jade ware of the Western Zhou Dynasty, which included mainly patterns of birds, beasts, dragons, and figures, and the drawings were of a more unified type.

During this period, exquisite jade pendants were usually used to show the nobility status of the wearers. Jade used by emperors was the core of jade ware. On specific occasions, the wearing and holding of jade had to conform to one's status. It is said in the chapter "Jade-bead Pendants" of *The Book of Rites* that: "The Son of Heaven wears a jade pendant with white beads hung on dark strings; a duke or marquis wears a jade pendant with hilly dark beads hung on red strings; a Grand Master wears a jade pendant with aqua-greyish beads hung on white strings; an heir-son wears a jade pendant with lustrous beads hung on bluish-black strings; and an ordinary officer wears a pendant with inferior beads hung on orange strings". This was to request people of different statuses to wear and hold different jade as a way to control and regulate to some extent the ceremonial system. Some scholars are of the view that based on this record, it could be inferred that during this period, people below the level of an ordinary officer did not wear jade.

Jade Ware in the Period from the Eastern Zhou to the Southern and Northern Dynasties

From the Eastern Zhou (Spring and Autumn Period and the Warring States Period) to the Southern and Northern Dynasties, the variety, shapes, and decoration patterns of jade ware underwent drastic changes due to the use of utensils made of iron and advances in the technique of carving jade. There was an increase not only in the variety and beauty of the decoration of the surface of jade objects, but also in the shape, which was mainly based on exaggerated animal patterns and geometrical forms. Besides, the materials used for jade ware during this period comprised for the most part tremolites and taxoites due to their elegance, and the selection of materials was more stringent than in the previous dynasties.

During this period, the proportion of ceremonial jade ware fell sharply, while the amount of jade pendants rose drastically, and the system of pendant sets was at the height of its development. Jade pendants consisted of four major components: the pendant set system hung on the front part of the body, jade pieces on both sides of the body, belt ornaments, and head ornaments. *The Book of Poetry* and other ancient writings called the jade pendants worn on the front part of the body "jade pendant set", which in turn comprised the top gem of a dragon-shaped or semicircular girdle-pendant for hanging other pieces. There were also tabular rings, jade-like stones, pendants, teeth-crashers, and pendants with human figures and beasts. The dragon-shaped jade pendants comprised mainly double-dragon pendants, S-shaped dragons, and double dragon-head semi-annular pendants. These had endured from the Spring and Autumn Period to the Han Dynasty, becoming the most typical and brilliant works of jade pendants of this period. The "Semi-annular Jade Pendant with Dragons Carved in Openwork" (Figure 68), for instance, presents both sides carved with four dragons in openwork. The carving skill is superb and this object is a gem of the jade ware of that time. Jade worn on both sides of the human body principally included bodkins and thumb rings, which were originally a finger tool when shooting a bow and later evolved into decorative jade thumb rings. Since the Warring States period, there emerged varieties of jade pendants, such as jade swords, seals, and belt hooks. The so-called "jade swords" involved inlaying jade ornaments in components of the sword, such as the end of the blade, the guard, or the sheath. Jade swords had been used for a long time and the regions of their distribution were extensive. However, their designation in different periods and different places is not consistent. In fact, still today, people cannot come to any consensus on their designations. Jade belt hooks

were the most popular jade ware from the Warring States Period to the Han Dynasty. They could have two forms: a long hook, which was used horizontally, and a short hook, which was used facing downward for hanging other objects. These two types of belt hooks continued to be used until the periods of Ming and Qing. After the Han Dynasty, some new species of jade ware emerged, including double talismans, weights, stationery, and garments.

The jade ware of this stage had full and dense decorations, putting a single-unit drawing into a two-side or four-side arrangement, thus forming drawing combinations. The most common patterns included grains, cattails, lying silkworms, hook-shaped clouds, coiling hornless dragons, and beast masks, which instituted the classical style of Chinese ancient jade. This style continued for several hundred years, from the Spring and Autumn Period to the Southern and Northern Dynasties, and still nowadays has a great significance.

In the Spring and Autumn Period, the separations of the warlords undermined the authority of the Zhou emperors and diminished the control of the patriarch and ceremonial systems, resulting in the collapse of the rite system and the degeneration of the music of the entire society. Against this background, ceremonial jade ware took a back seat, and the scope of jade pendants was enlarged. In particular, jade pendants with simplified beast masks and coiling snakes as main decorations rose in large numbers. Archeological discoveries of jade ware from the Spring and Autumn Period from Mount Ping in Xu County in Jiangsu, River Yi in Shandong, and Xinyang in Henan included tiger-shaped pendants, rectangular pendants, bird-head arched pendants, and rings, disks, semi-annular pendants, bodkins, and pipes. The above shows clearly the major trends in the development of jade pendants.

Jade ware in the Warring States Period was built on the foundation of the Spring and Autumn Period ware. They were mainly tablet-shaped jade pendant ornaments, slight thicker those of the previous period. Geometric and animal shapes were still the majority. On the other hand, the major decorative patterns were clouds, linked hooks, cattails, grains, whirlpools, twisted silk, and beast masks. They had clear characteristics and strong periodic features.

The aforementioned "grain patterns" and "cattail patterns" were extensively used on the jade ware of the Warring States Period, and they were indeed the most characteristic patterns. Their designations are seen in the "Officer in Charge of Ceremonial Jade" section of the "Spring Minister" chapter of the *Rites of Zhou*: "Jade is used as six tallies to indicate statuses and rank the states. The king holds a *zhen* sceptre, a duke holds a *heng* sceptre, a marquis holds a *xin* sceptre, an earl holds a *gong* sceptre, a viscount holds a grain disk, and a baron holds a cattail disk". As there were no pictures to compare with the texts, people had made various guesses about these two patterns for several thousand years. Nie Chongyi, in his work *Recollected Illustrations to the Three Versions of the Book of Rites*, drew them in the shape of a grain seed. *An Atlas of Chinese Ancient Jade*, which appeared in the Qing Dynasty but whose date of completion is uncertain (it was believed that this work was written by a person in the Song Dynasty, or a fake work by somebody in the Qing Dynasty), painted a grain about to sprout, and a cattail with criss-crossing diagonal lines. Most people, therefore, called them "grain patterns" and "cattail patterns".

The curved little flower pattern on the jade ware in the Warring States Period was named "hooked-cloud patterns". This pattern, which was particularly popular in the Warring States Period and the Han Dynasty, was mainly used in jade ware decoration. It showed hooks between the grain patterns, or in a "T" shape arranged both horizontally and vertically. Literature after the Yuan Dynasty called this pattern the "lying silkworms" pattern, because the shape of this pattern resembled a small silkworm which had learned how to move.

The beast mask had been an important pattern throughout the previous several thousand years. It became popular in the Neolithic Age, and its patterns changed with the passage of time. During the Spring and Autumn and the Warring States periods, the beast mask pattern changed from the mask of the

Xia and Shang periods, which was characterized by an exaggerated mouth and an image of ugliness and ferocity, to a mask which was generally rectangular, with flat brows, squared eyes, and no horns, making it more mighty and majestic. The latter type of beast mask pattern was used extensively in jade ware, extending into the period after the Han Dynasty.

Jade ware of the Han Dynasty inherited the trend of development of the jade ware of the Spring and Autumn Period and the Warring States Period. Of the ceremonial objects, jade disks were most common. Jade pendants carried on the style of the jade ware of the Warring States Period, with swords sheaths, belt hooks, seals, and mortises being the most commonly used. Regarding the burial jade objects, the jade garment was the most luxuriant of this period.

The most notable achievement of the Han Dynasty jade ware was the use of jade vessels and the production of jade animals. On the whole, the making of the jade vessels of the Han Dynasty was exquisite, with a moderate thickness, flat and neat rims and beautiful surface patterns. Some vessels had lids, whose designs were skilful, with excellent craftsmanship. It was recorded in the literature that the ancient people highly praised the use of jade vessels. However, jade vessels before the Warring States Period were scanty. The vessels unearthed and inherited from the Han Dynasty, nevertheless, had many varieties, among which, jade cups, boxes, and inkstone water-dripping pots were most noticeable. For jade cups, there were horn-shaped cups unearthed from the Nanyue King Mausoleum in Guangzhou, three-legged jade bottles with lids and wine cups unearthed from a Han Tomb at Mount Lion in Xuzhou, and small high-legged cone-shaped cups unearthed from Luopo Bay at the Gui County in Guangxi. There were also different shapes of jade boxes, such as round flared-mouth boxes and round straight-mouth boxes. Concerning inkstone water-dripping pots, some flying-bear-style inkstone dripping-water pots were unearthed from the Han Tomb at the Tiger Mound in Yangzhou. This type of inkstone dripping pots inherited from the past is commonplace. The styles included in the collection of the Palace Museum are the goat, turtle dove, and *pixie* (an exorcising mythical animal) styles. The "*Pixie*-shaped Jade Inkstone Water-dripping Pot" (Figure 106), for example, has a couching *pixie* carved in accordance to the shape of the jade material. On the body of this animal are three little *pixie* carved in different postures. They are lively and vivid, comparable to the *pixie* unearthed from the Han Tomb at the Tiger Mound.

The production of jade animals was an important component of jade ware in the ancient period. Works before the Warring States Period followed the trend of transforming and flattening the sides of the body. The making of jade animals in the Han Dynasty was clearly a great improvement in comparison with the previous dynasties and achieved remarkable results. The shape and image of the animals were accurate and the proportion of the parts of the body was appropriate. Jade animals can be divided into large, medium, and small sizes. The large indoor jade ware that can be seen nowadays include the stone leopard unearthed from the Han Tomb at Mount Lion and the jade *pixie* unearthed from the Northern Territories of Baoji. Extant works of medium and small sizes include jade weights, jade grips, and jade inkstone water-dripping pots. "The Lady of the River Xiang" in the "Nine Songs" chapter of *The Odes of Chu* contains a sentence which says: "The white jade is used as a weight", followed by an annotation which reads: "The white jade is used as a weight to press down the seating mat". In the "Heavenly Abode" of the "Spring Minister" chapter of *The Rites of Zhou*, it is said that "the Heavenly Abode is in charge of the keeping, storage and prohibition regulations of the ancestral temples. The jade weights of all states are stored in a great treasure container". The ancient people, when sitting on mats, used to place weights on the four corners of the mat, with the purpose of keeping the corners of the mat from curling up. "Jade weights" were "weights" of a higher level. Of the jade weights that survive today, some had animal shapes, such as horses, oxen, goats, and bears, and other imaginary animals shapes, such as the *pixie*, *tian lu*, and *xiezhi*. A jade grip was a piece of burial jade, a typical example is the "Jade Pigs" (Figure 112). It was put into the hands of the dead or under its arm,

symbolizing the possession of wealth. Besides, there were some three-dimensional small beasts in the Han Dynasty, which also belonged to jade pieces of a small size.

The jade ware of the Wei and Jin and the Southern and Northern Dynasties mainly inherited the style of the jade ware of the Han Dynasty, while at the same time it merged with the style of the art of the northern people. Works with cattail and grain patterns were almost absent, and their decorations were for the most part strange animals, clouds and water, or plain surfaces. The "Semi-annular Jade Pendant with Cloud and Tiger Motifs" (Figure 119), for example, had one side carved with a tiger, and the other side a floating cloud pattern in the shape of the character "ten" (十) carved in lines in intaglio, with spaces joined by lines in intaglio, and this was the pattern that was popular in this period.

Jade Ware from the Sui and Tang Dynasties to the Ming Dynasty

The Sui Dynasty was short-lived, and the jade ware found in archeological discoveries were few. At that time, the trend of concentrating on white jade and bluish-white jade in the selection of jade material and changing the styles of works began to emerge.

Compared to the past, drastic changes occurred in the making of jade ware in the periods of Tang, Song, Jin, Yuan, and Ming. In the selection of jade material, white jade and blue jade were dominant, phasing out the idea of grey jade. The objects shown in jade pieces were gradually dominated by figures, animals, and plants, which increased significantly. For forms of expression, the method of copying from life was introduced, and nature and drawing from reality became the dominant style of jade ware. Imaginary animals, mysterious clouds and thunder, coiling dragons, and *qiequ* were drastically reduced in decoration patterns. The use of jade ware was varied, involving the various aspects of vessels of daily use in social life. There was a change in the phenomenon of "large tombs have more jade" that had been observed in past archeological discoveries. The fact that the kings used jade while people ranked below ordinary officers did not use became a thing of the past, just

like a line in a poem that runs: "Swallows that used to rest at the halls of the big families such as those of Wang and Xie now fly into the houses of the ordinary people". Jade ware was no longer mysterious and no longer symbolized ceremonial system, morality, and mysticism. It gradually became more common and ordinary, yet still full of vitality for development. All sorts of natural phenomena appeared in the drawings of jade ware. Birds, beasts, flowers, grass, forests, trees, mountains, and rivers all became objects of expression. Faithfulness, liveliness, and accuracy of shape became the standards to assess the artistic level of jade ware. This huge change and advancement heralded the style of a new generation of jade ware and injected new life and vitality into an ancient art, and is clearly shown in different types of objects that will be listed below.

Vessels: Since the Tang Dynasty, jade vessels had emerged in large numbers, such as pots, cups, bowls, and imitation antique bronze ware. The majority of jade vessels of the Tang Dynasty that can be found today are jade cups. There were various shapes of cups, but most of them had oval or multi-sectional mouths, shallow inner cavities, and single handles. In the jade vessels of the Song, Jin, Yuan, and Ming dynasties, cups in the shapes of flowers and fruit with two handles appeared more frequently. The shapes of the two handles were varied, including beast-swallowing, two kui-dragons, and flower petal styles. The "Jade Cup with a Sunflower Carved in Openwork", for instance, has its body in the shape of a sunflower. Its inner and outer walls are carved with petals and its inner base is carved with relief pistils and web patterns. The outside of the cup is carved in openwork with plucked branches of chrysanthemums, peach blossoms, lotus flowers, and plum flowers curling round the wall of the cup, and their branches and leaves become as the handles of the cup and its base foot. The shape of the cup was novel and unique and could be called the best work of the age. At that time, there were more imitation antique works. Works of considerable height, such as bottles and wine vessels, were mostly for display purposes. Works with lower gravity, such as imitation bronze tripods and food containers could be used for

burning incense and were called censers. The "Jade Censer with a Beast Mask and Two Beast Handles" (Figure 176), for example, is an imitation bronze ware that is fully decorated with beast masks and kui-dragons, generating a kind of classic favour.

Stationery and Fondling Pieces: At this stage, jade stationery had a great development, and some treasures were produced. The most common ones comprised jade inkstones for grinding ink, inkstone screens for blockage, ink holders for placing ink slabs, brush holders for resting brushes, brush basins for holding water to wash the writing brush, paperweights for pressing down books and sheets, armrests for supporting the arm in writing, water bowls and inkstone dripping pots, which were small water-storage utensils, for storing water to grind ink, brush pots and scroll pots for holding things, brush dippers for straightening out the tips of writing brushes, seal boxes for keeping seals, and inkpads for storing ink paste. Apart from these, there were jade pieces in stationery for appreciation, known as jade fondling pieces.

Belt Ornaments and Pendant Accessories: After the Tang Dynasty, the trend turned to making body ornaments more casual and varied. However, jade pendant accessories remained the same. Some jade pieces had a fixed use format, such as the ornaments of leather belts, ceremonial robe scarves, and hairpin leads. The common jade belt ornaments included plates, buckles, and hooks. Belt plates were made by sewing jade chips, which may be carved with flowers or not, on a relatively broad jade belt. The belt buckles, on the other hand, consisted of two jade pieces on both ends of the waist girdles, which could be buckled up. Finally, belt hooks could be used for silk belts. The "Jade Belt with Dragons Carved in Openwork" (Figure 187), selected and collected in this volume, is formed by belt plates and leather belts. There are altogether twenty belt plates, which corresponded with their shape and structure, as recorded in *A History of Ming* and *A Concise History of Ming*.

During this period, more jade articles were worn in a casual way. Gu Qiyuan of the Ming Dynasty, in his book *Superflous Words from a Guest*, talked about the scarves and shoes of the intellectuals living in the area of Nanjing during the late Ming period and said that: "In recent years, the shape of jade was strange and its making, mysterious. The scarf is either decorated with a jade knot or a jade vase, and both sides are decorated with two large jade rings". The so-called "jade knots" and "jade vases" are jade ornaments in the shape of a tablet. It seemed that people in ancient times first wore their scarves, then decorated the front part with jade knots or jade vases, and the both sides of the head with jade rings. In the same book, Gu also mentioned that women wore jade ornaments of all forms and shapes on their heads and bodies: "They used to put together gold, jewels, jade, making shapes of a hundred things. Above, they had a part resembling mountains and clouds, and flowers. Below, they had a long string joining various articles together. They also made jade pendants and tied them to their body. When they walked, the pendants generated a tinkling sound. It was called "prohibition to walk". All these was known in the past as pendant sets". The so-called "mountains and clouds head" is also named "mountain head" in historical books. It was a part of head ornament set in the shape of a tablet and made of metal. One side of it was a small and long pin to be inserted into a hairpin. The other side could either be inlaid with jade ornament or have a string "joining articles together". It drooped down to the side of the body, swaying with the movement of the body.

Jade of the Qing Dynasty

During the Qing Dynasty, which lasted 268 years, the development of Chinese economy and culture went through great changes. In this period, the northern ethic culture was merging with the traditional culture of the Central Plains, along with the clash between Oriental and Occidental cultures, and new explorations in the cultural domain. All the above had a huge impact on the development of art and craftsmanship, including the making, use, and storage of jade ware.

Generally, jade in the Qing Dynasty can be divided into three stages: the early Qing period, the period of Qianlong and Jiaqing, and the late Qing period. And there were two different paths of

development: the court and the populace. In early Qing, once the war was over and thousands of matters needed to be revitalized, jade ware production was also affected, and for a time, it fell sharply. The recovery and development of social economy during the reigns of Shunzhi and Kangxi created the conditions for the recovery of court jade ware. By the time of Qianlong, the power of the country was strong, and with the support of the emperor, court jade ware had a prosperous growth and reached its height. The majority of the ancient jade and vessel jade collected in the Qing court was collected or made during this period. This trend continued to the Jiaqing period. The court jade ware of the Jiaqing period also became the peak of the development of Chinese ancient jade. During the late Qing period, the focus shifted from the court to the populace, and court jade ware gradually declined.

According to the features of the collected items in the Palace Museum, this volume focuses on introducing the representative works of four major types of court jade ware: large-scale jade ware, jade vessels, jade pictures, and jade pendant ornaments.

Large-scale Jade Ware

Before the Qing Dynasty, large-scale jade ware was rare. Some large-scale jade animals appeared in the early periods. Song literature recorded the Jade Roller Flower Vase, and those inherited from the past icluded the jade vat of the Yuan Dynasty and the jade Buddha in Tuancheng at the Beihai of Beijing. These are, nevertheless, few in number. By the Qing Dynasty and especially during the reign of Qianlong, due to the strength of the national power and under the auspices and promotion of the court, large-scale jade ware increased considerably both in variety and volume, producing a large number of large-scale jade ware, including jade chimes, mountains, jars, bottles, and screens, amongst other objects. Jade mountains are the most representative items of large-scale jade ware. There are four pieces of large-scale jade ware in the collection of the Palace Museum: "Jade Mountain with the Painting of Great Yu Curbing the Flood" (Figure 202), "Travelling in the Autumn Mountains", "Jade Mountain with the Painting of

Nine Old Men at Huichang" (Figure 203), and "The Sourthern Mountains Accumulate Greenness". All these pieces were made during the Qianlong period. Of these, the jade mountain in the "Jade Mountain with the Painting of Great Yu Curbing the Flood" weighed more than ten thousand catties, and it took three years to move it from Mount Mileta in Xinjiang to Beijing. Later, the jade materials were transported to Yangzhou for carving and production, and it took another six years to complete the task. Other than jade mountains, there are records in the documents of the Qing court about the making of large jade vats. The Palace Museum also has a few jade vats in its collection, the largest of which is the "Large Jade Vat with Nine Dragons" (Figure 205), displayed at the Leshou Hall. This piece weighs about five thousand catties, and it took four years to be carved.

Jade Vessels

The major part of the most representative works of jade vessels in the Qing court were made during the Qianlong period and were called "Qianlong artefacts". They are mostly imitation antiques, such as pots, food containers, square-mouthed wine vessels, wine goblets, small-mouthed wine vessels, washbasins; fashions of the time, such as bottles, incense containers, censers, perfume vessels, and flower holders; and vessels for food and drinks, such as ewers, cups, bowls, plates, and vases. The main characteristics of these court jade ware are shown in the use of the jade material, shaping, pattern design, and processing skills.

At that time, the shaping of jade material was changed from following the shape of the jade material to shape jade ware, which was practised in Ming and Qing, to the adherence to the view that the shape of the jade material could not affect or could only slightly affect the shape of jade ware. In making jade ware, more removals would be made on the jade material. Attention was also paid to the pursuit of the colour and lustre of the material, and it was considered more favourable to have bright and glossy colours.

More reference to ancient bronze ware and contemporary artefacts (especially ceramics) was made when designing jade ware shapes, closing the

distance between them. At the same time, there was a pursuit for simplicity and neatness in shape. Works could be broken down into the main body and small parts such as lids, knobs, legs, and handles. The main body part was usually thicker. In the case of bottle vessels, there were flat bottles, but their body was also relatively thick. Their surfaces curved up in relief, and their shapes were mainly vertical, round curves, or S-shaped edge lines. The lid followed the shape of the vessel, and was usually smaller than its body, unifying the shape with the body. Its main shape was in relief, and it was rare to find tablet-shaped flat lids. Generally, the knob was smaller than the lid. And there was a linked pole between them. Regarding the shapes of the knobs, there were still geometric shapes, such as the squares, ovals, and rings, but also other shapes, such as flowers, butterflies, birds, beasts, and melon shapes. The legs of the vessels included closed straight wall, closed sloped wall, column, as-you-wish, hanging-cloud, figure-shaped, and beast-shaped legs. Except for some high-legged artefacts, the leg of the vessel was not longer than its body. Besides, there were no decorative patterns on the legs and when there were, they would match the patterns on the lids, and join with the decorations on the body of the vessel. Usually, on both sides of the vessel, there were decorative handles, whose major decorations were geometric, such as pierced, lion-head-shaped, plain coiling dragon, and folded bands handles; beast-head, such as elephant, goat, *pixie*, dragon, and beast-swallow-dragon handles; and flower-butterfly shape handles, such as chrysanthemum, peony, and butterfly handles. Most of the vessels had columns under their handles, with live rings. Some vessels had four or six handles. In addition, some vessel lids also had handles and live rings, forming double handles and double rings. Vessels with more than three handles and rings, however, were rare.

The decorative patterns of the jade vessels at that time can be divided into drawings and designs. The great majority display lines and their patterns are exquisite and artistic. Usually, the court painter designed the draft of the drawing that was to be produced by the Workshop or sent to places such as Suzhou and Yangzhou for jade crafters to complete the work.

The processing skill development is patent in the even thickness of the body of the jade ware, the smoothness and accuracy of the line edges, the consistency in the breadth of the design lines, the accuracy of the squares and arcs, and the flatness and lack of undulation in the plain and arch surfaces.

Jade Pictures

The so-called "jade pictures", also known as "jade mountains", refer to round carved objects for display with the mountain rocks as their background. The jade ware from the Song and Ming dynasties already presented mountains, but its structure was simple, and its processing, coarse. What was shown was a part of a scene, a figure, or a beast, which could be appreciated with a mere glance, and there was no need to study them closely. The jade mountains in the Qing court were often based on well-known paintings, putting the paintings in three dimensions, Thus, jade mountains were elevated to a new artistic level as exhibits or artworks and their artistry was enhanced. These jade mountains were termed by Emperor Qianlong as "jade pictures". The three-dimensional pictures carved in jade showed in full natural scenery, lively scenes of human activities, and stories of allusions, with small figures and large scenes. This not only had the effect of a sand model, but also strived for liveliness, naturalness, and accuracy in the layout, spirit, and details. The batch of works, included the large-scale jade mountain of the painting of "The Great Yu Curbing the Flood" and the "Jade Mountain with the Painting of Nine Old Men of Huichang" mentioned above, achieved great recognition in art. Some medium- to small-scale jade pictures produced at that time were equally skilled in craftsmanship, and had a relatively high level of artistic achievement. "Jade Miniature Landscapes with Ladies under the Shade of a Chinese Parasol" (Figure 214), for example, is elaborate in its carving. The concept of the painting is the same as the "Ladies under the Shade of a Chinese Parasol" screen in the collection of the Palace Museum, but the images of the figures and the layout are more lively than those of the screen, and it deserves the claim of a unique

piece in the history of jade carving.

In the Qing court jade, there was the category of jade table screens. A table screen is a screen placed on a base for display purposes. In the poems inscribed by Emperor Qianlong, they were all known as "jade…picture", being, therefore, a kind of jade pictures. Jade screens have different sizes. The large ones are screens, and the small ones, tablets. Carved on the jade screen are drawings and characters. The contents of the drawings include live sketches of moving or static objects, scenes, stories of people, calligraphy, and lines of poems, amongst other topics. The "Jade Table Screen with Pine, Pavilion, and Figure" (Figure 233), for instance, has the allusion of the chrysanthemum lover Tao Yuanming on one side and a hundred characters of "*fu*" (Fortune) and "*shou*" (Longevity) cast in regular script on the other side. A jade table screen could be a stationery in a study or placed on a desk as a display object.

Jade Pendant Ornaments

Jade pendants of the Qing court can be divided into three categories. The first category generally inherited the tradition of the ancient period of China, such as the imitation chicken-heart pendants and jade disks. The "Jade Pendant with Kui-phoenixes Carved in Openwork and Characters "Changyi Zisun" (Prosperity for Descendants) (Figure 227), for example, is made as an imitation of the pendant for the prosperity for descendants of the Han Dynasty. Its size is smaller than the jade pendant of the Han Dynasty, and its contents are more substantial. The second category of works included the adoption of fashionable designs and striving for changes through innovation, such as the pendant for the twelve two-hour periods of the day and the "Jade Pendant Set with Climate and Phenology" (Figure 255). The third category involved works that have the characteristics of the Qing imperial court, including the morning beads, feather tubes, and thumb rings for men, and flat boxes and hairpins for women. The thumb rings, to give but an example, were originally used to protect one's hand when pulling the bow to shoot the arrows. Before the Manchus entered China, they made their living by hunting with bows and arrows

and that explains why thumb rings were so popular in the Qing Dynasty and why they became pendant decorations. This volume selected and collected a set of three pieces of jade thumb rings (Figure 228), i.e., the "Jade Thumb Ring with a Hunting Scene", "Jade Thumb Ring with Towers and Pavilions", and "Jade Thumb Ring with Figures", which were coupled with poems inscribed by Emperor Qianlong. The decorative patterns of the painting and craftsmanship are exquisite and elaborate, and they are the best pieces of the similar objects.

The jade materials of objects of the Qing court mentioned above was mostly produced from the Heitian and Yeerjiang regions in Xinjiang. Based on the methods of mining and extracting, they can be classified into jade materials produced from rivers or from mountains. Jade ware produced from rivers, also known as "seed materials", were extracted from the river and their quality were better. However, their volumes were smaller, and most of them were in an oval shape. Mountain jade materials were mined from the mountain. They were larger in size but most of them featured cracks. In the middle of the Qianlong period, the Qing government suppressed the rebellion in the Xinjiang region, guaranteed the supply of jade materials, which effectively promoted the development of court jade ware. At the same time, the Hindustan jade ware suddenly emerged as a new force entering the Qing court in the Qianlong period. "Hindustan" was actually a transliteration. It was located, as known in history, in the northern part of India, comprising the areas of Kashmir and Pakistan. The Qing court, in fact, collectively called the jade ware that came from India, Turkey, and parts of the Middle Asian districts as "Hindustan jade". Emperor Qianlong took a strong liking of "Hindustan jade". Not only he collected, used and wrote poems and inscriptions about Hindustan jade, but also produced a large number of imitations. Nonetheless, with the ending of the Qianlong period, the passion of the Qing court towards "Hindustan jade" faded.

Taking a holistic view of the history of making jade in the Qing Dynasty, which lasted for several hundred years, court jade ware occupied a dominant position for a very long period of time, and promoted

the development of the jade-making industry in the Qing Dynasty. By late Qing, the power of the Qing court was weak and the scope of production of court jade ware and the level of art were not as good as before. Due to this, coupled with the fact that some works merely presented a false appearance of peace and prosperity, the status of jade declined. The main trend of jade production was thus shifted gradually to the populace.

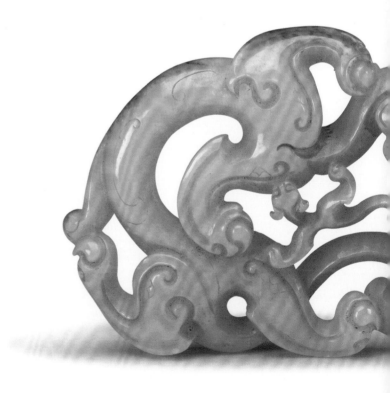

Neolithic Age

1

Jade Dragon

Hongshan Culture

Curved Length 60 cm
Diameter 2.2 – 2.4 cm

This figure is made of yellowish-green jade. The shape of the dragon is formed by carving in round and cutting patterns with intaglio lines. The mouth of the dragon is slightly open, with its upper lip slightly curled up and its comb-shaped eyebrows bulging. Behind its brain is a long mane, whose edge is shaped like a blunt knife. On both its sides are grooves. The front part of the body of the dragon is curved forward into an oval shape. There is also a round hole for hanging in the middle of the object.

Dragons are imagined and mystified by people. Dragon figures inlaid and formed by shells appeared as early as around seven thousand years ago. The Hongshan Culture, a Neolithic Age culture in China, was named after its site behind Mount Hongshan in Chifeng, Inner Mongolia, where the earliest jade ware was found. Jade was mainly found in western Liaoning, about 6,000 to 5,000 years from now. The jade dragon unearthed from Hongshan Culture is the earliest jade object in the shape of a dragon that has been found so far.

2

Animal-shaped Penannular Jade Ring

Hongshan Culture

Height 15.4 cm Width 10.5 cm
Thickness 4.5 cm
Qing court collection

This object, made of green jade, has brownish soaking-induced spots on some parts. The shape of the animal is relatively thick and bulky. It has a pig's head and large ears, which take up one third of the entire piece, and its eyes are wide open. Under its eyes are two bands of bows to represent the wrinkles, under its nose is a band of bows to depict its mouth, and the body curls in the shape of a capital letter "C". There is a gap in the place where the head meets the tail, with a large round hole in the middle. Its neck has two small holes, created by drilling from both sides, which allow the object to be worn by threading a string through it.

There were no decorative patterns on penannular jade rings of the early period, whose shape was relatively small. When unearthed, they were mostly placed at the ear part of a human skeleton, and thus seemed to be decorations for the ear. However, animal-shaped penannular jade rings of the Hongshan Culture have huge bodies, linked gaps, and holes in their backs and necks for threading cords for wearing. Therefore, they do not seem to be ear ornaments. To date, no conclusion has been reached regarding the shape of the animal. Some call them a dragon, while others, a pig or a bear. Their curved body resembles that of a dragon or snake, so it is obviously not a real entity, but a mystified image of an animal, which is generally considered as an animal-shaped entity.

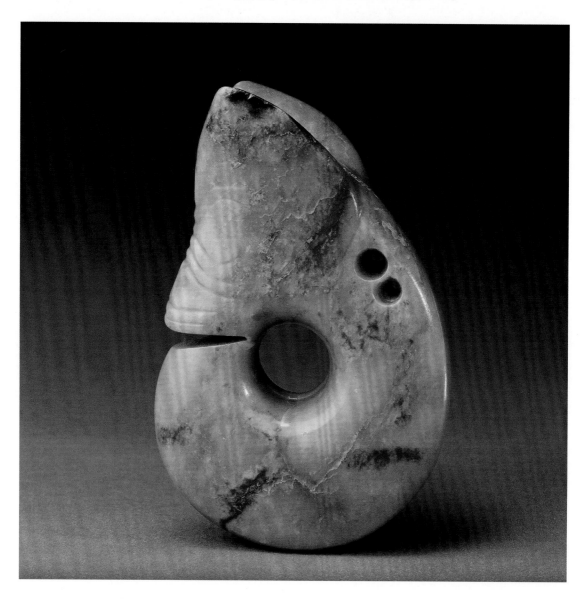

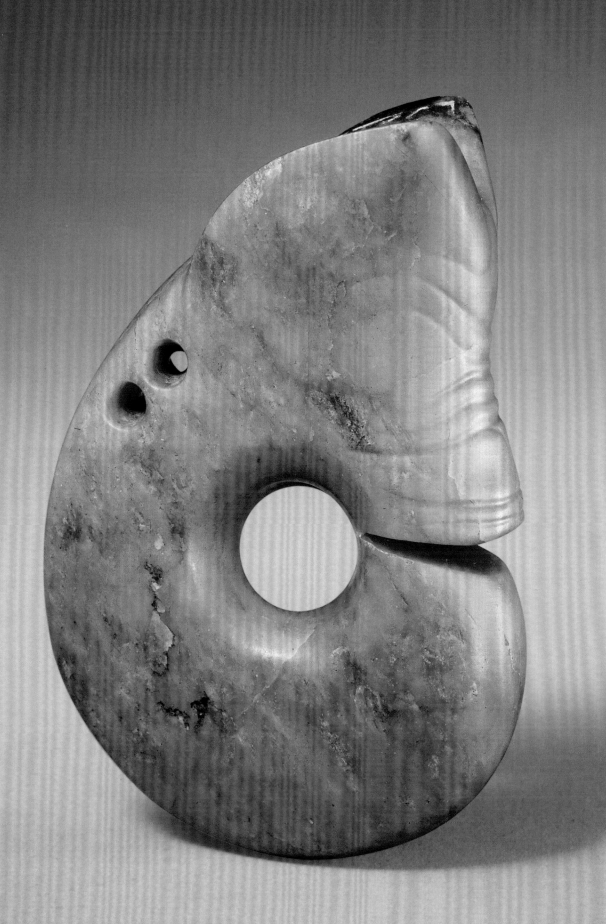

3
Jade Owl
Hongshan Culture

Height 3.7 cm Width 3.5 cm
Thickness 1.3 cm

This object is made of green jade. The body of the owl is slightly flat and carved half in round. The decorations on both sides are different. The head of the owl is triangular and carved with protruding round eyes and a hook-shaped mouth. Its two feet are tucked to its belly, and it seems to be spreading its wings to fly. The tail has a hole for threading a cord. The back also seems to have a hole, but the opening of the drilling is not present.

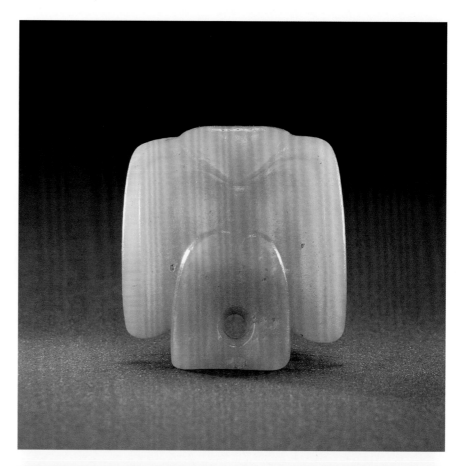

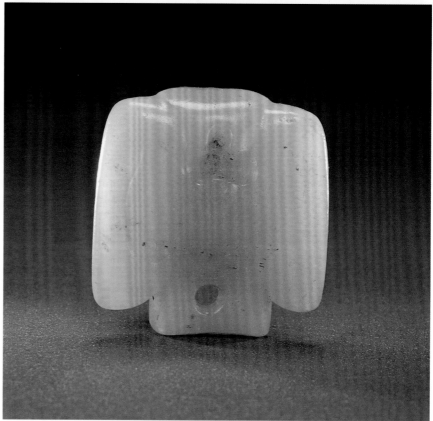

4

Hoof-shaped Jade Vessel

Hongshan Culture

Height 11.7 cm Width 9.3 cm
Thickness 6.9 cm

This object, made of bluish-green jade, has brown spots. The vessel is in the shape of a tube, with an oval cross section. The top part is larger and has a slanted opening. There are also holes on both sides of its bottom. The inner wall of the vessel has more curved cutting lines, and there are traces of drilling holes.

A considerable number of this type of vessel have been unearthed from the Hongshan Culture site, some of which were placed at the head of the human body when unearthed. Based on this, it can be assumed that they were head decorations for braiding hair. Besides this site, similar artefacts were unearthed from the Lingjiatan Site of the Neolithic Age, in Anhui, including jade slips in a jade holder, perhaps for divination.

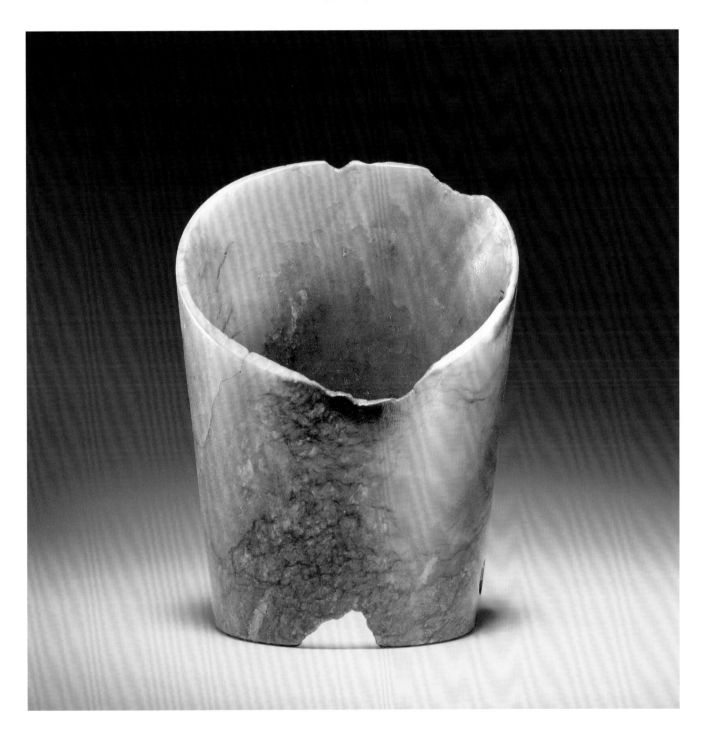

5

Jade Sitting Person

Neolithic Age

Height 14.6 cm Width 6 cm
Thickness 4.7 cm

This object, made of bluish-yellow jade, has reddish soaking-induced spots on some parts. A deified person is displayed in a crouching posture. On the top of his head are two thick and long horns, which bend forward. His face is narrow and protruded. He has long ears, a hidden nose, a red body, and a slender waist. His upper limbs are placed on his knees, and his lower limbs are in the shape of a water drop.

The jade material used for this object is similar to that of the Hongshan Culture. The facial features of the deified person are carved out with thick and shallow intaglio lines, and parts of his body still have blurred traces of carving lines. Similar jade objects were also excavated from the Neolithic sites of the present-day Hebei region. This object, therefore, might be a relic of the Neolithic Age, or a relic of the Hongshan Culture.

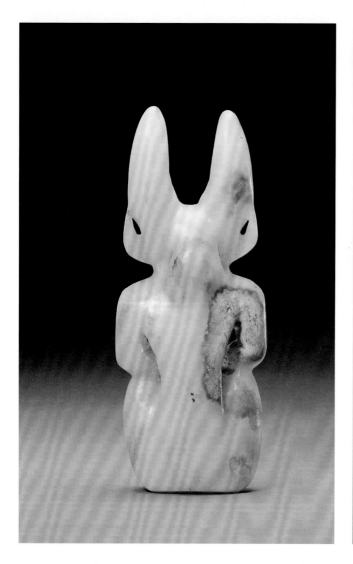
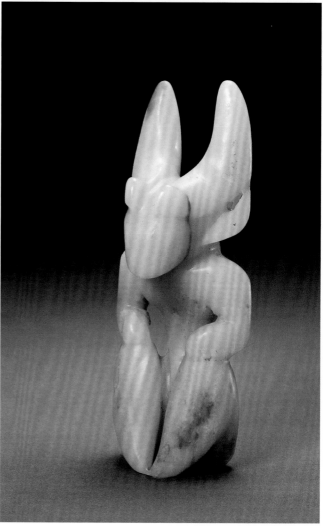

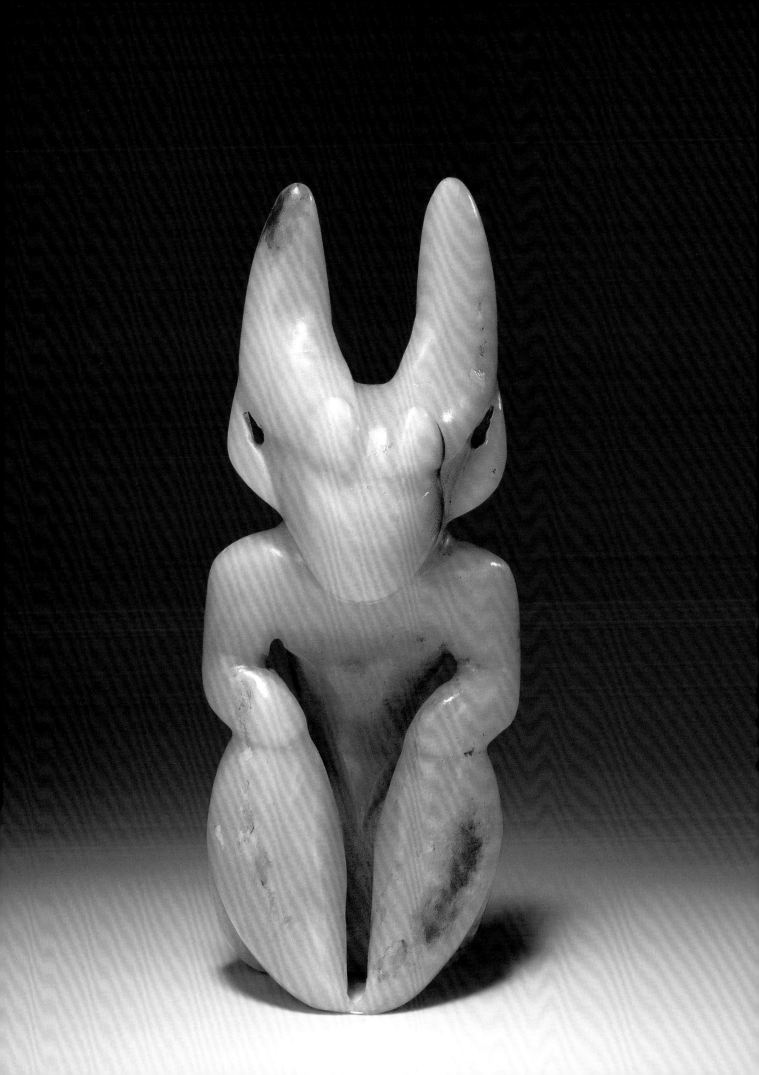

6

Three-joint Jade Tube

Liangzhu Culture

Height 6.8 cm
Exterior Diameter 8.3 cm
Diameter of Hole 6.2 cm
Qing court collection

This object, made of deep yellow jade, has traces of burning. The body of the tube is in the shape of a square pillar, square outside and round inside, with a through hole at the centre. Carved on the upper, middle, and lower parts of each of the external corners of the tube are three groups of images of deities. They all have double-circled eyes with eye corners on both sides, and rectangular noses. They wear hats, which are represented by two convex lines, and have intaglio lines carved in uneven numbers.

When this piece entered the Qing court as a tribute, it was given the name of "*wangtou*" (head of the wheel-rim) by Emperor Qianlong. The emperor matched it with a bronze inner container coated with cloisonné enamel and a lid for holding things. He also inscribed a poem on the inner wall of the jade tube and the outer wall of the bronze container, ending with his signature "inscribed by Emperor Qianlong in the autumn of the year *wuxu*" and his pastime seals with the characters of "*jixia yiqing*" (leisure pleases one's feelings) and "*dejiaqu*" (getting fine delight). The year *wuxu* is the 43rd year of the reign of Qianlong (1778 A.D. in Western reckoning).

Liangzhu Culture is an ancient culture found in the basin of Lake Taihu, and it dates back to about 5,300 to 4,000 years ago. It belongs to the Neolithic Age and was named as some early discoveries were made at Liangzhu in Hangzhou, Zhejiang. Liangzhu Culture had the burial custom of burning with sacrificial grooves, and the burnt traces of this vessel must have been the result of smoke and fire.

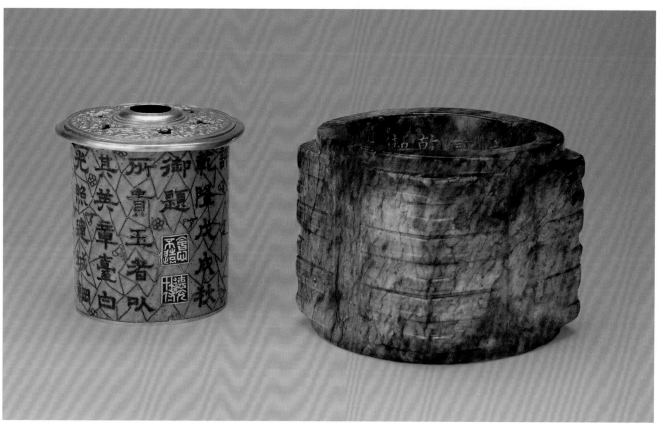

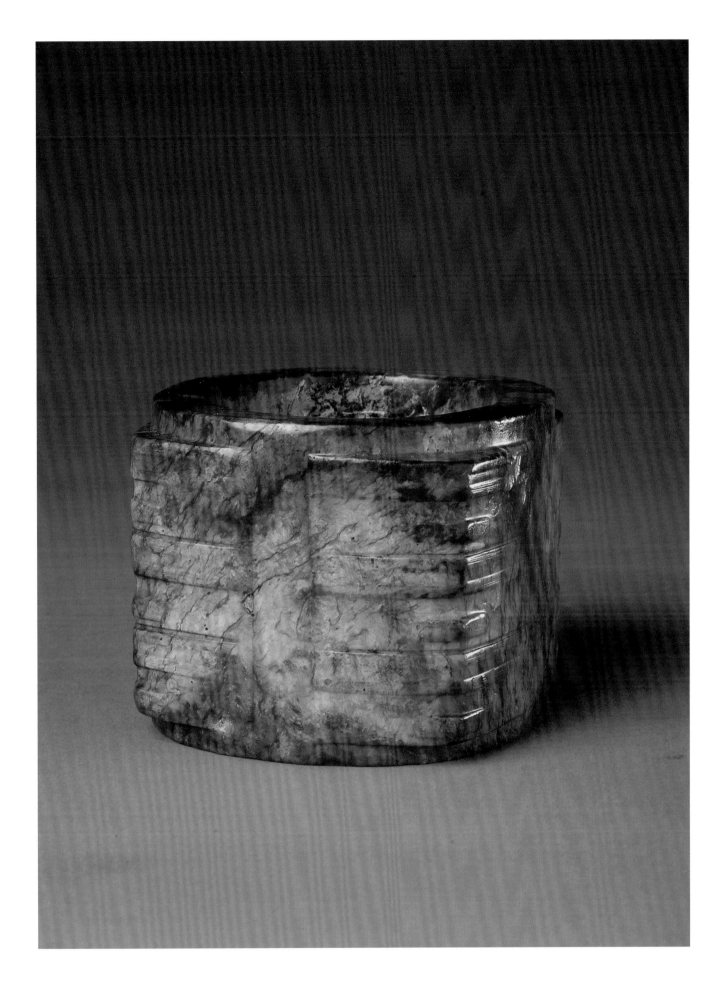

7

Twelve-joint Jade Tube

Liangzhu Culture

Height 32.1 cm
Exterior Diameter 7.5 cm
Diameter of Hole 6.3 – 7.2 cm
Qing court collection

This object, made of dark brown jade, has yellowish-white soaking-induced spots on some parts. The body of the tube is in the shape of a square pillar, square outside and round inside, with a through-hole at the centre. Its upper part is large, whereas its lower part is small. Each of the ends has a square mouth. This jade tube has twelve sections, each of which is based on the grooves as boundaries, and four sets of carved simplified deities. On the upper end of the tube at the grooves facing each other is each carved with a symbol with the pattern of a star seemingly with two wings.

Among the jade ware of the Liangzhu Culture, this type of tube with multiple sections is commonly seen. However, entities carved with all types of symbols in intaglio have so far not been verified by relics unearthed from scientific excavations.

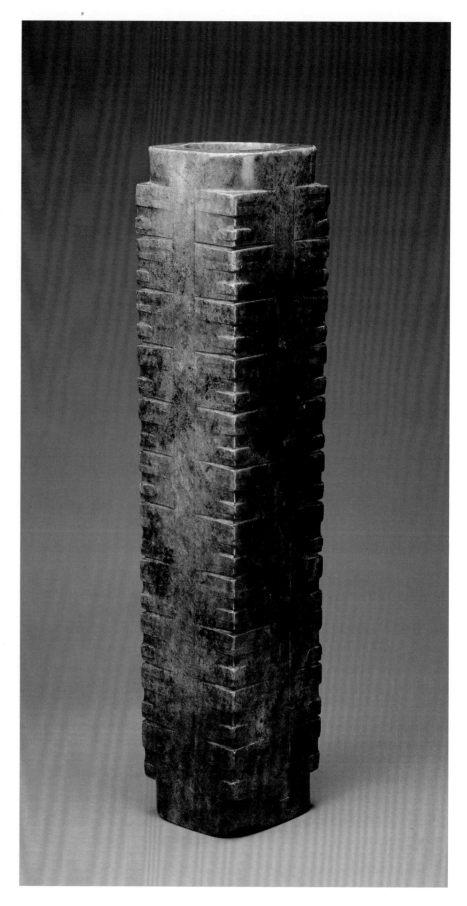

8

Plain Jade Disk

Liangzhu Culture

Exterior Diameter 14.8 cm
Diameter of Hole 3.9 cm
Thickness 1.1 cm

The quality of this dark green jade object is lower in terms of its degree of hardness and unevenness in thickness. Its outside perimeter is an irregular circle. Its surface, on the other hand, is glossy and plain, inscribed with lines of poems by Qianlong carved in intaglio and a seal engraved with the words "*Qianlong yuwan*" (Emperor Qianlong's fondling piece).

A large number of jade disks have been unearthed from the site of Liangzhu Culture. Most of them are glossy and plain, and have no decorations. Of all the artefacts unearthed from the Liangzhu Culture, jade ware is the most popular. Of the several thousand pieces of jade ware unearthed from Fanshan and Yaoshan sites, in Zhejiang, the square pillar-shaped tubes and plate-shaped disks are the most characteristic.

9

Semi-annular Jade Pendant with a Beast Mask Motif

Liangzhu Culture

Length 20.8 cm Width 8.3 cm
Thickness 0.6 cm
Qing court collection

This object, made of yellowish-brown jade, presents some blackened traces and small cracks, which may be the marks of burning. Its body is flat. Along the edges on two sides is a band of bow-strings carved in intaglio, and there is a circle of brocade background carved in intaglio and decorated with a bow-string pattern. The frontal relief displays a group of beast masks and two groups of birds. The beast masks are located in the middle, carved with fan-shaped eye sockets. Their ring-shaped big eyes are raising upward, adopting the form of an arched bridge. It has a square nose and a slightly open mouth, and it exposes its buckteeth at the corners of its mouth. The bird pattern is carved on both ends of the pendant. The birds are portrayed in profile, with exaggerated eyes and becks. The circling pattern is carved in intaglio on the beast mask and bird pattern. The backside of the pendant is also carved with circling brocade background in intaglio, and three tiny spaces are left empty. Both sides of the top of the pendant have a small round hole for threading a cord.

This object is an exceptional piece of semi-annular jade pendants with a beast mask motif from the Liangzhu Culture. There is a piece of *nanmu* plaque attached to this pendant, which is engraved with a seven-character poem by Emperor Qianlong. It can be inferred from this that it was unearthed, at the latest, during the Qianlong years of the Qing Dynasty and entered the Qing court as a tribute.

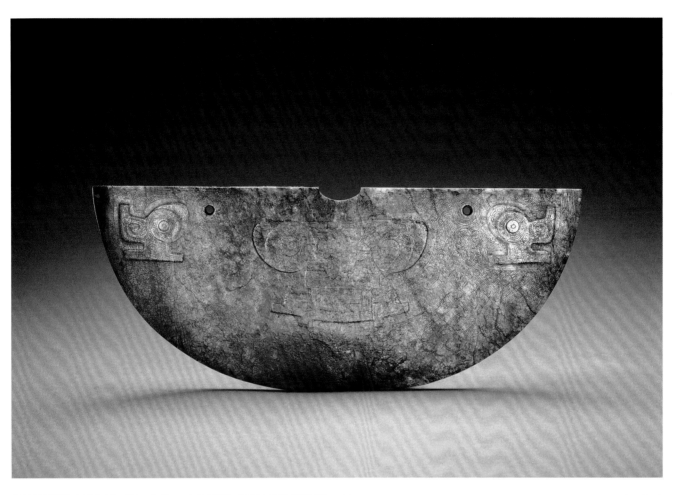

10

Rectangular Jade Chip with a Map

Lingjiatan Culture

Length 11.4 cm Width 8.3 cm
Thickness 0.7 cm
Unearthed from Lingjiatan at the Hanshan
county in Anhui in 1987

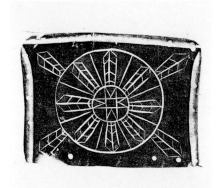

The front part of the plate-shaped body of this ivory jade object is slightly bulging. There are two concentric circles in the middle, the smallest of which is in the centre of a square. It has an external octagonal design. The largest circle is divided into eight even portions, each with a group of sceptre patterns. There are also four groups of sceptre patterns outside the large circle. In addition, on the four sides are round holes, which vary in number. The backside is slightly concaved and has no decorations.

This jade chip was placed between the turtle shells (Figure 11) when unearthed. Some researchers believe that this is related to the *River Map* (Hetu), the *Luo Chart* (Luoshu), and the Eight Trigrams. In ancient times, it was rumoured that a dragon-horse carried the *River Map* on its back to get him out of the Yellow River. Fuxi, as a result of this, formed the Eight Trigrams. The mystical turtle carrying the *Luo Chart* appeared in River Luo, and Great Yu (Dayu), therefore, divided the country into nine regions. The jade chips were placed between turtle shells, conforming to the saying of the turtle carrying on its back the *Luo Chart*. The round maps and images correlate to the world view of the ancient people, who believed that the heaven was round and the earth was square. Numbers such as two, four, and eight correspond to what is said in the *Book of Changes* (Zhouyi). There are five holes drilled on both sides of the outer perimeter, nine holes in the upper part, and four in the lower part. This matches with what is said in the *Luo Chart*. The jade chips, therefore, could be the images of the original Eight Trigrams. Other studies hold the view that drilling holes, drawing circles, and carving pictures were a kind of calendric activity, which could prove that calendric system existed in China five thousand years ago.

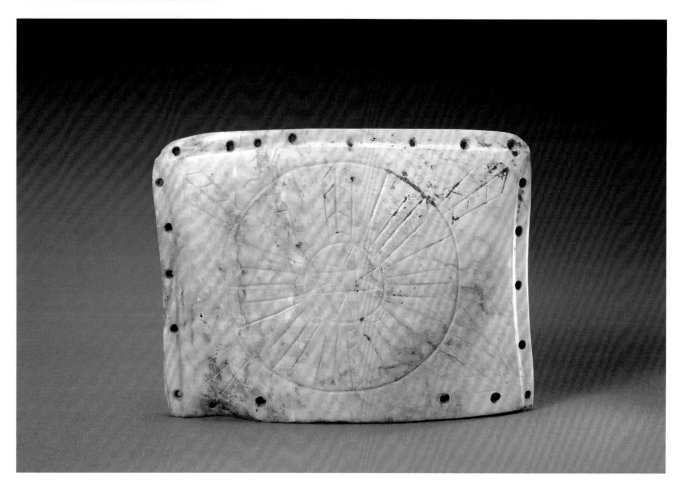

11

Jade Combiner of the Turtle Back Shell and Belly Shell

Lingjiatan Culture

Back Shell:
Length 9.4 cm Width 7.6 cm
Thickness 0.8 cm
Belly Shell:
Length 7.9 cm Width 7.5 cm
Thickness 0.5 cm
Unearthed from the tomb at Lingjiatan of the
Hanshan county in Anhui in 1987

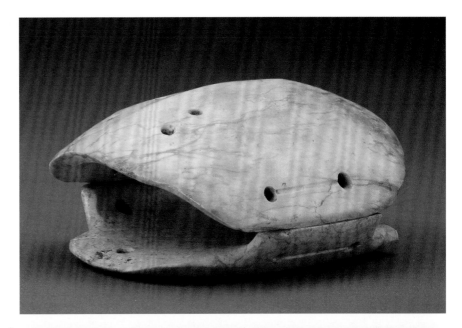

This object, made of grayish-white jade, has traces of corrosion and consists of the back shell and belly shell of a turtle. The back shell is bulging, with a convex ridge in the middle. The front part has four drill holes, each of its sides has two drill holes and concaved grooves, and the rear end has a hole which was damaged. The back end of the belly shell is flat and even, whereas the front end is curved and bulging. There is a hole drilled in the middle part. Both sides are curled up, each with two drill holes, and linked by a concaved groove, which can be tied up to the back shell.

Jade turtles had also been unearthed in the Hongshan Culture and the Liangzhu Culture. They all had drill holes on the ridge or belly, revealing that they could be a kind of pendant decoration. This turtle shell and the *Rectangular Jade Chip with a Map* (Figure 10) were unearthed simultaneously, the jade plate being placed between the shells.

The site of Lingjiatan got its name as it was discovered at Lingjiatan of the Hanshan county in Anhui, dating back to about 5,600 to 5,300 years ago. It is currently the largest site of the Neolithic Age which is kept intact in the Chaohu Basin of the lower reaches of the Yangtse River.

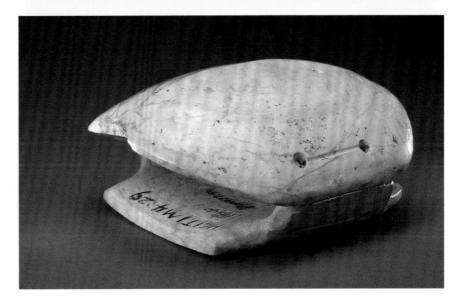

12

Jade Standing Figure

Lingjiatan Culture

Height 9.6 cm Shoulder Width 2.3 cm
Thickness 0.8 cm
Unearthed from Lingjiatan at the Hanshan
county in Anhui in 1987

This object, made of grayish-white jade, has brown soaking-induced spots on some parts. The jade figure is tabular and standing. It has a broad forehead. It wears a hat, on which a checkered pattern with intaglio lines is carved. It has a broad face and nose. Its mouth is slightly bulging, and he has a mustache on its upper lip. There is a round hole at the ear droops, where rings could be worn. It has a short neck and broad shoulders. Its arms are against its chest, and its ten fingers are stretched out. Its wrists have seven bands of narrow-sleeve patterns in light relief. It has a slender waist, with a band of slanted intaglio lines. It has long legs, and its toes are exposed. The back of the jade figure has a hole for threading a cord for wearing.

Several pieces of jade figures were unearthed from this tomb, yet this is the most exquisite and well-made. It has an appropriate proportion and elegant shape. The cutting is simple and forceful. This is the best piece of a standing figure in jade unearthed from the Neolithic Age that we have ever seen to date. Its shape should be related to a kind of witchcraft ceremony.

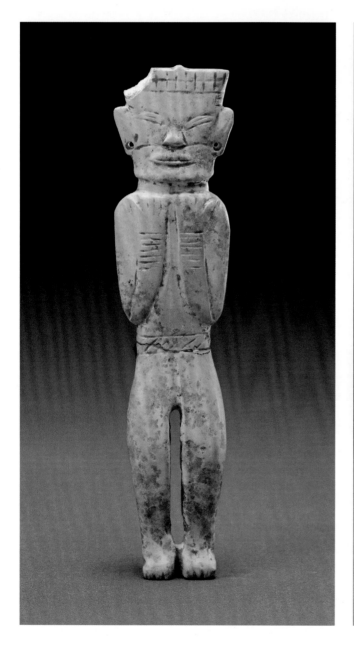
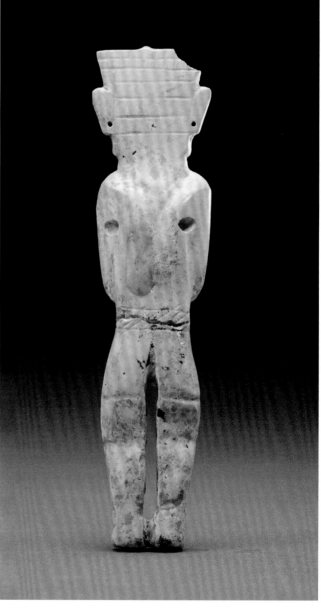

13

Semi-annular Jade Pendant with Two Tiger Heads

Lingjiatan Culture

Length 11.9 cm Width 5.8 cm
Thickness 0.4 cm
Unearthed from the tomb at Lingjiatan of the
Hanshan county in Anhui in 1987

This object, made of yellowish jade, has brown soaking-induced spots. Its body is in the shape of an arc and is plate-shaped with the edge slightly thinner. Each of the ends has the head of a tiger cut and carved in intaglio. The two tiger heads are back to back, and the body in the middle part merges as one. The mouths of the tigers are slightly open. Round pierced holes serve as the eyes of the tigers, as well as as holes for wearing pendants.

Semi-circular jade pendants first appeared at the Hemudu Culture around 7,000 years ago. Since then there have been discoveries in the sites of the Neolithic Age Culture. Most of the objects are glossy and plain, and have no decorations. A small number of them are decorated with dragon heads, dragons, and gods, amongst other patterns. However, this is the only piece that displays two tiger heads. Its craftsmanship is superb and its production, excellent. This is extremely rare.

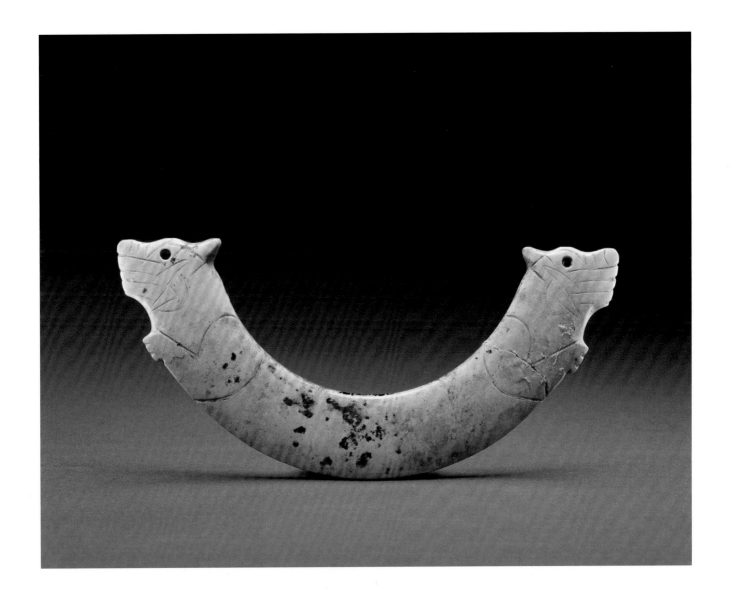

14

Jade Ladle

Lingjiatan Culture

Length 16.5 cm
Unearthed from the tomb at Lingjiatan of the
Hanshan county in Anhui in 1987

This jade object is grayish-white, due to soaking. The head of the ladle is oval, with a concave inner part. It has a long handle, on which is a concave groove with a curved section. The end of the ladle has a round hole.

The processing of this ladle is extremely elaborate, to the extent of using *tuoju*, the tool for cutting and grinding jade. This is so far the earliest known piece of jade vessel for practical use and is the only piece before the Tang Dynasty.

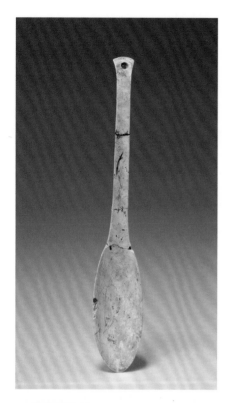

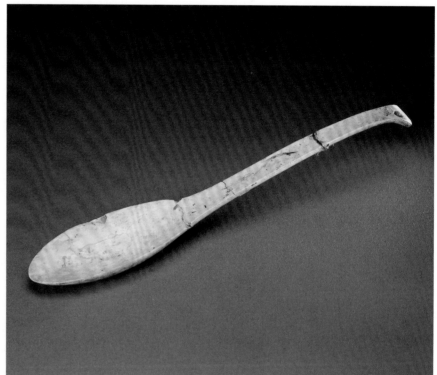

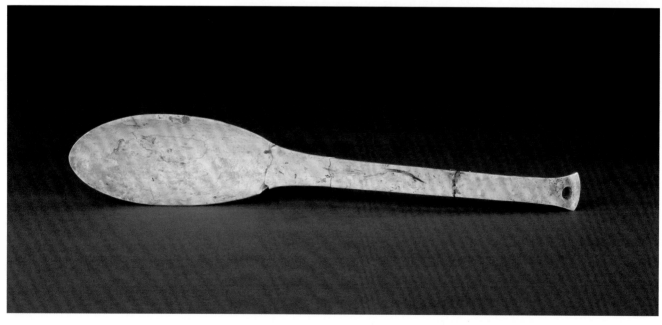

15

Knob-shaped Jade Ornament

Lingjiatan Culture

Diameter 2.3 x 1.9 cm
Thickness 1.7 cm
Unearthed from the tomb at Lingjiatan of the
Hanshan county in Anhui in 1987

This blue jade object has a higher level of transparency. The upper part of this vessel consists of a spherical surface with a superior precision. Its lower part, on the other hand, has a circle of groove, the width and depth of which are consistent.

This vessel shows a good processing skill, especially in the cutting and making of the spherical surface. The craftsman should have mastered some knowledge of solid geometry.

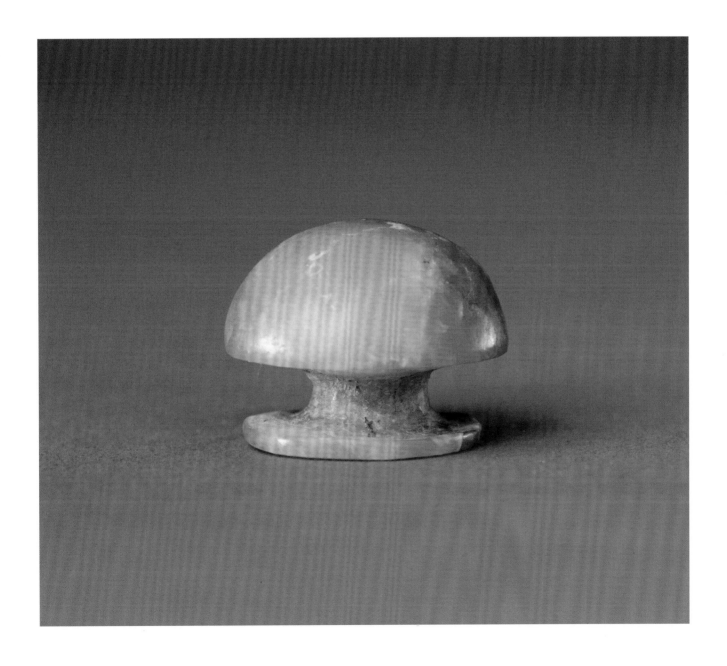

16

Jade Human Head

Shijiahe Culture

Height 6.3 cm Width 2.6 cm
Thickness 0.7 cm

This object, made of bluish-gray jade, has slightly whitened and yellowish soaking-induced spots on its surface. The human head is carved in round whereas the eyes are carved with intaglio lines. It has eyebrows, a triangular nose, a slightly open big mouth, and ears in the shape of a stick. The head wears a flat-topped hat, carved with small straight lines drawn in intaglio. It has a long neck, under which is a band of patterns that resembles a hoop. The lower end of the object has a short tenon, with a damaged hole.

This piece of jade in the shape of a human head is dignified and noble, and seems to be the image of a slave master. It shares part of the characteristics of the human head of the Shijiahe Culture, but the pattern of small intaglio lines and the shape of the ears of the figure are different and should be works related to the Culture.

Shijiahe Culture is the late culture of Neolithic Age (an age in which both bronze and stones were used) in the middle reaches of the Yangtse River, named after the group of sites at Shijiahe in Tianmen, Hubei, and dates to about 4,600 to 4,000 years ago.

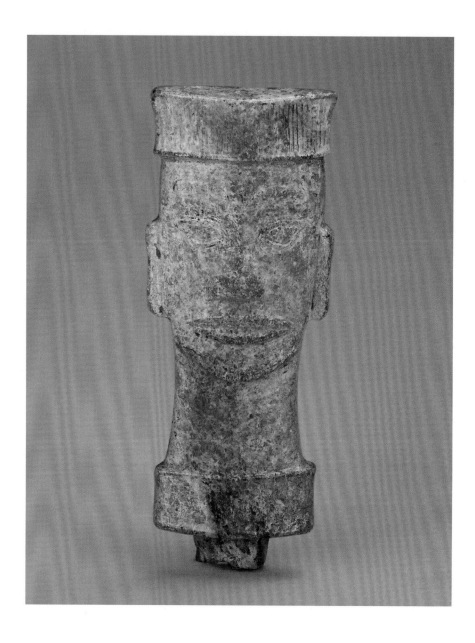

17

Jade Pendant with a Hawk Snatching a Human Head

Shijiahe Culture

Height 9.1 cm Largest Width 5.2 cm
Thickness 0.9 cm
Qing court collection

This pendant, made of bluish-yellow jade, has brown soaking-induced spots on some parts. It is in the shape of a thick plate. In openwork carving is a hawk with its head raised and its wings opened, and each of its claws snatching a human head. The shape and size of the two human heads are the same, each facing opposite directions. They have short hair, olive-shaped eyes, closed mouths, long mustaches, and a painful expression.

As this type of object was imitated during the period of Qianlong, it can be inferred that this object occurred during the years of Qianlong at the latest. However, as the date of this object has not been verified for a long time by any unearthed objects, no conclusion of its dating has been reached so far. In recent years, jade hawks were unearthed in archeological excavations in the site of Shijiahe Culture, and the hawks bear a close resemblance to those of the Qianlong period in terms of material, craftsmanship, and motifs. It is therefore possible that jade hawks can be dated to the period of Shijiahe Culture. As to the connotations of this object, there are disparate views. Some say that jade hawks are a "totem". Others say that they are a reflection of a "human sacrifice" of the ancient ancestors.

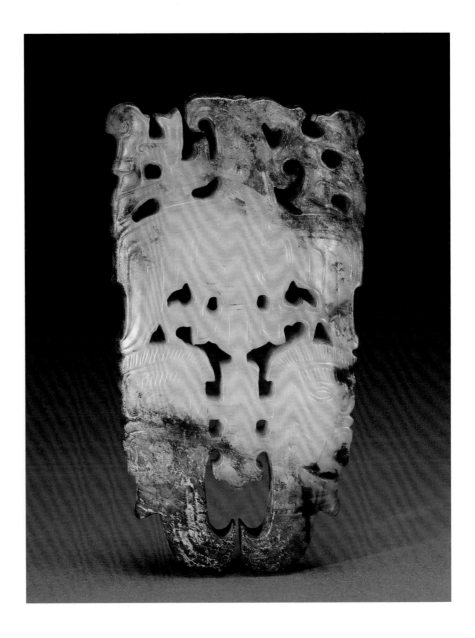

18

Rectangular Jade Ornament with a Beast Mask Motif

Shijiahe Culture

Height 3.5 cm Width 2.3 cm
Thickness 1.5 cm
Qing court collection

This ornament, made of blue jade, is heavy with soaking-induced colouring. The beast mask is in the shape of a square ladder, narrow at the top and wide at the bottom. The upper part has ears in low relief, eyes leaning slightly downward, and flat eyebrows.

The beast mask motif was widely used in the Neolithic Age. This motif was slightly exaggerated in the Longshan and Liangzhu cultures, especially the protruding eyes. The beast mask motifs of the Shijiahe Culture are mostly in the shape of a square ladder, paying special attention to the mastery of the outer contour. This object also stresses the ears of the beast mask, whereas the part below the eyes is more sketchy.

19

Jade Pendant with a Body of a Human and a Beast

Shijiahe Culture

Height 8.2 cm Width 4 cm
Thickness 0.6 cm

This object, made of bluish-green jade, has relatively whitish soaking-induced spots. Its body is flat, in the shape of a combined body of a human and a beast carved in openwork. The upper part is a human head, wearing a floral hat with cord patterns and symmetrical simplified birds. This figure has eye sockets in the shape of a date stone, a nose in the shape of a hammer club, and an oval mouth. It wears rings on its ear droops and long hair behind the ears. The human body and the beast body are intermingled in the middle part. The lower part is a beast head.

The openwork carving of this object is similar to that of the jade pieces of the Shijiahe Culture. Some features of the beast and human heads are also similar to the jade vessel patterns unearthed from the Shijiahe Culture. Based on the evidence, we can regard this object as jade ware of the Shijiahe Culture.

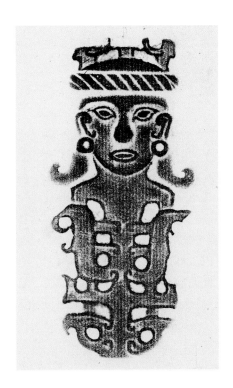

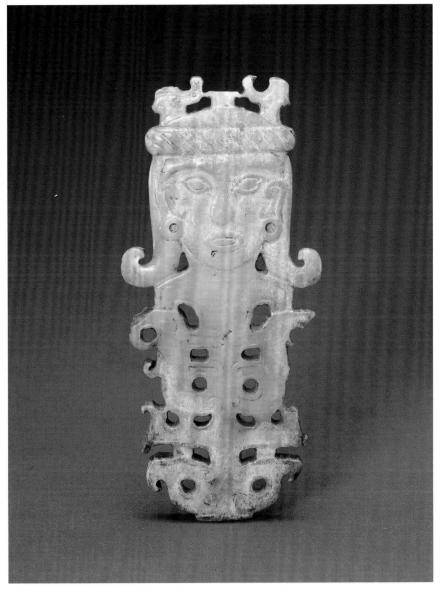

20

Jade Knife with Five Holes

Longshan Culture

Length 78.7 cm Width 12.8 cm
Thickness 0.3 cm

A large part of this dark-brown jade object is weathered. The wide end of the knife is slightly pervious to light. It has stripes of black algae. The object is in the shape of a rectangle, with one side slightly wider, and the other side narrower like a handle. The downside constitutes the blade, which is grinded from both sides and extremely sharp. The middle part has a relatively long, shallow, and wide groove, traces from breaking the stone in production.

This knife is relatively long, which is rare in similar works. Its blade is thin and sharp, and can be used for cutting. The material and features of this object are similar to the jade ware of the Longshan Culture in Shaanxi. They are ceremonial objects used in sacrifices and ceremonies.

Longshan Culture refers generally to the kind of cultural relics found in the middle and lower reaches of the Yangtse River in China in the late Neolithic Age. It belongs to the culture in which both bronze and stones were used and was named after the first discovery of knives at the Longshan town (belonging to present-day Zhangqiu) in Licheng, Shandong, dating back to around 4,600 to 4,000 years ago. It is widely found in provinces such as Shandong, Henan, Shanxi, and Shaanxi, with slightly different cultural characteristics.

21

Jade Spade with Three Holes

Longshan Culture

Length 27 cm Width 16 cm Thickness 0.8 cm
Unearthed from the Liangcheng town at the Rizhao county,
Shandong, in the early 1930s

This object, made of pale yellow jade with a tinge of green, has one of its sides deeply eroded due to soaking. Its body is flat and ladder-shaped with narrow shoulders and a wide blade. The edge of the blade is sharp, having been grinded from both sides, and slightly burst apart. The middle part of the long blade of the body of the spade has a round hole. On the upper and lower parts of one side of the hole are two drill holes, each of which has a dark blue stone plug inlaid.

This spade has been made in a systematic and orderly manner. It is wide, large, and thin. However, the purpose of the two hole plugs needs to be further examined. No trace of tying or use from the surface of the object can be observed; thus it is not a production tool, but a tool used in ceremonies, rituals, or sacrifices.

22

Jade Tube

Qijia Culture

Length 22.2 cm Width 8.4 cm
Thickness 8.1 cm
Qing court collection

This object, made of dark cyan jade, has a large area of reddish-brown soaking-induced spots. The body of the tube forms the shape of a square column, square outside and round inside. It features a through-hole at the centre, the middle part of which has a bench left behind when drilling holes. Inside the hole is a bronze container matched by the Qing court for holding things.

Qijia Culture is a culture located at the upper reaches of the Yellow River in China in the late Neolithic Age, which had entered into the stage of using both bronze and stone. It was named after Qijiaping in Guanghe, Gansu, and can be traced back to about 4,000 years ago.

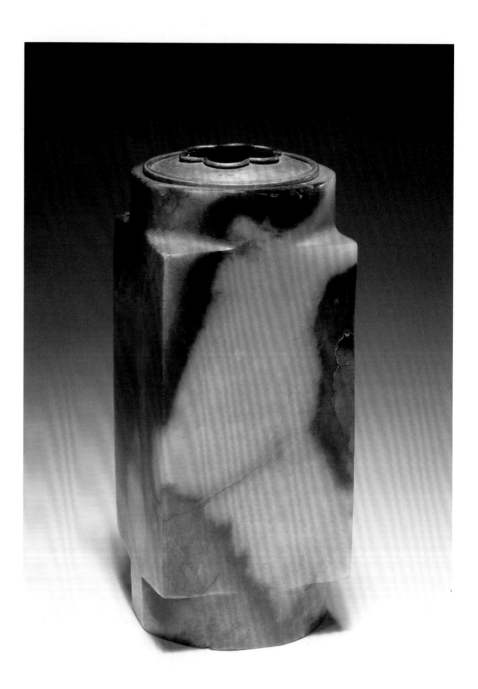

23

Jade Tablet

Late Neolithic Age

Length 31.8 cm Width 5.3 cm
Thickness 0.8 cm

The bluish-yellow surface of this tablet shows signs of weathering. The end part, on the other hand, keeps the original colour of the jade. The middle part of the object has spots with algae stripes. The object is a rectangle with two concave sides. Close to one end is a thicker hole, which can hang a long handle. The end of the knife is slightly wider but thinner.

Jade tablets first appeared in the late Neolithic Age. They were ceremonial objects used in large-scale sacrificial and ritual activities. There is a saying in the *Rites of Zhou* that reads, "Red jade tablets were used to pay homage to the south." The material and shape of this tablet has the characteristics of the jade ware of the North-western region in China in the late Neolithic Age.

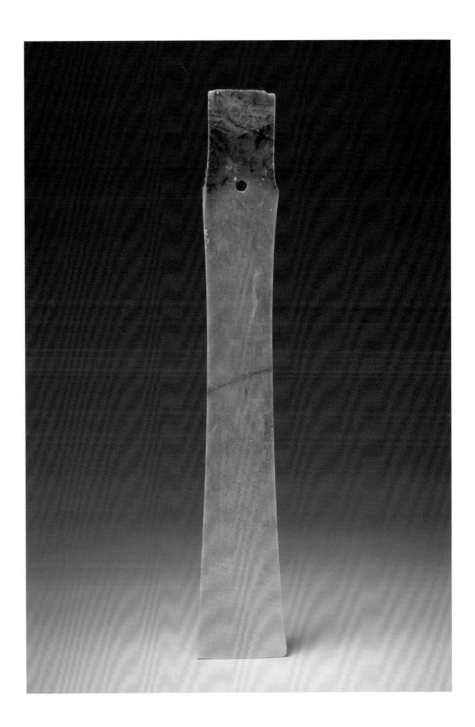

24

Jade Tablet with Beast Mask Motifs

Neolithic Age

Length 20.8 cm Width 6 cm
Thickness 1 cm

This object, made of teeth yellow jade, is partly whitened and partly brownish. The body of this tablet is long and thin. One of its ends is slightly wider and has a blade. The other end features two holes, created by drilling from both sides. The two sides that are closer to the hole are decorated with beast mask motifs, showing lines drawn and carved in intaglio.

Beast mask motifs are commonly seen decorations in the objects of the Neolithic Age. There are typical works in the jade ware of Liangzhu Culture, Longshan Culture, and Shijiahe Culture. Jade tablets of this shape were found in works of the Longshan Culture, in places such as Shandong. The patterns of this object, however, are different from those of the Neolithic Age that we know. They were drawn and carved by hand, and their age of processing and cultural connotations have yet to be studied.

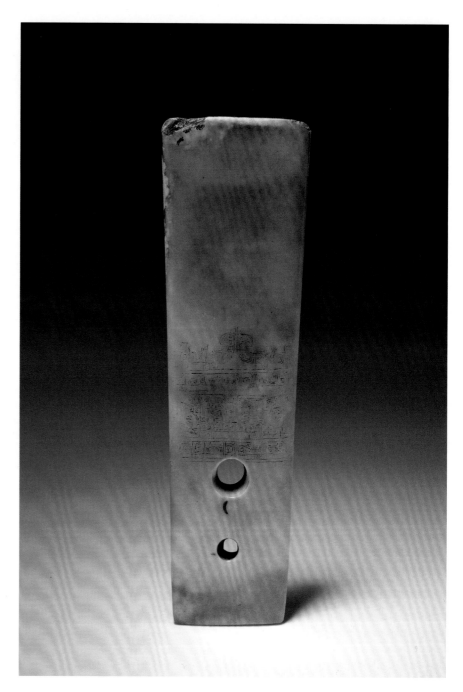

Xia, Shang, and the Western Zhou Period

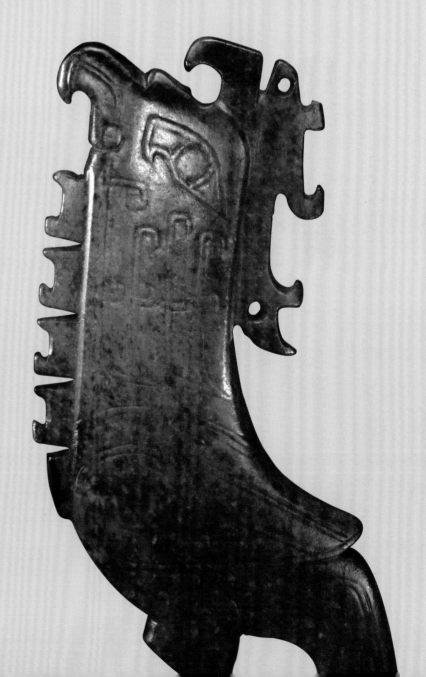

25

Jade Teeth Tablet

Xia Dynasty

Length 36.8 cm Largest Width 11.6 cm
Thickness 0.6 cm

This light brown object has dark spots and whitish soaking-induced patterns. The body of the tablet is flat and long, in the shape of a plate, and its blade is in the shape of a concave arc. This object consists of two parts: *yuan* and *nei*. The front part, which is wider, is called *yuan*. One of its sides is level and smooth, whereas the other has a groove in the middle, which is uneven in height and depth, and features intaglio lines. The rear part, resembling a handle, is called *nei*. It has a hole drilled from one side in its middle part. The place where the *yuan* and *nei* are linked is called *lan*. Both sides are carved with symmetrical protruding teeth, resembling a bird's head, and intaglio lines join the space between the teeth.

This kind of jade ware was first seen in the Neolithic Age, and continued to be used until the Western Zhou period. The small objects are slightly larger than an inch. The large ones are thought to be ceremonial vessels or vessels for the clergy. As to their designation, the *Rites of Zhou* says, "using the teeth tablet to boost the military morale." Since the publication of *Guyu Tukao* by Wu Dacheng of Qing, people generally called this type of jade ware "jade tablet" or "jade teeth tablet". Though there is a difference between the two, these designations are followed.

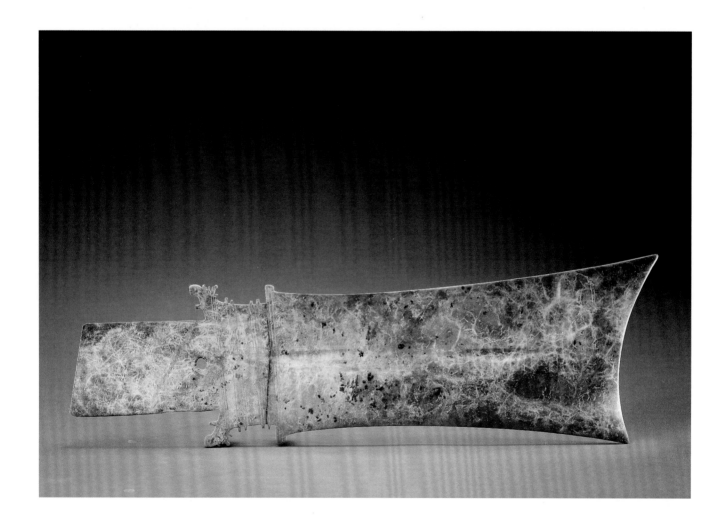

26

Jade Knife with Five Holes and Lattice Patterns

Xia Dynasty

Length 64.2 cm Width 11.7 cm
Thickness 0.4 cm
Qing court collection

This object, made of dark green jade, has brownish soaking-induced spots. Its body is flat, the shoulder is narrow, and the blade is wide. The shoulder part has five equidistant round holes. Each of the ends is decorated with two groups of lattice patterns with straight lines criss-crossing the oblique lines.

Jade knives are mostly vessels of guards of honour of the nobilities. The holes threaded are mostly in odd numbers, making it easy to tie with wooden handles. The shape, structure, and decorative patterns of this knife are fundamentally similar to the jade knife with seven holes unearthed from Erlitou in Yanshi, Henan. The only difference is that the ends of the latter do not feature any teeth patterns. From the simple and unsophisticated shape, texture, soaking-induced colour, and simple carving of the decorative patterns, it can be ascertained that this is a ceremonial object of the third or fourth phase of the Erlitou Culture.

Erlitou Culture is a culture of the Bronze Age in China, named after the Erlitou Site at Yanshi in Luoyang, Henan. It has four phases. It existed around the twenty-first to the seventeenth century B.C., and represents the culture of Xia.

27

Jade Knife with a Hawk Head and a Beast Mask Motif

Shang Dynasty

Length 10.2 cm Width 2.3 cm
Thickness 0.2 cm

This object, made of bluish-green jade, has a white flare. The knife forms the shape of a long arc while the upper part is narrow and long. On one side are traces of the textile package. There are blades on both sides of the *yuan*. Close to the *nei* is a beast mask motif, carved with double intaglio lines. There is a small hole at the place where the *yuan* and *nei* are connected. The end part resembles a hawk head, and carved under the eyes of the hawk is a leg.

This jade knife is elegantly cut and polished. It is believed to be a practical vessel that could be carried and worn.

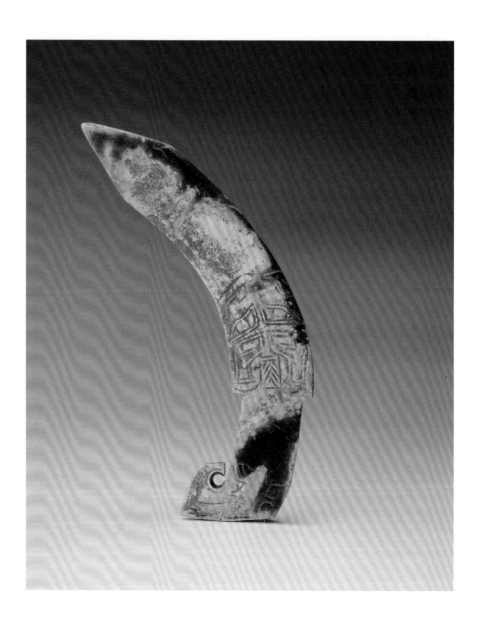

28

Jade Dagger-axe

Shang Dynasty

Length 62.6 cm Width 10.1 cm
Thickness 0.6 cm
Qing court collection

The texture of this object is fine and smooth. It is flat, long, and narrow. It features a blade in the downside and a hole on one of its ends, and can be tied to a long handle when used.

This jade dagger-axe is a ceremonial vessel of the Shang Dynasty. Rumour has it that it was unearthed at Baoji, and was in the Palace Museum collection after going through many hands. Characters have been written on this dagger-axe in seal script, carved by the posterity. The hole at the end of the object had been altered by the passage of years.

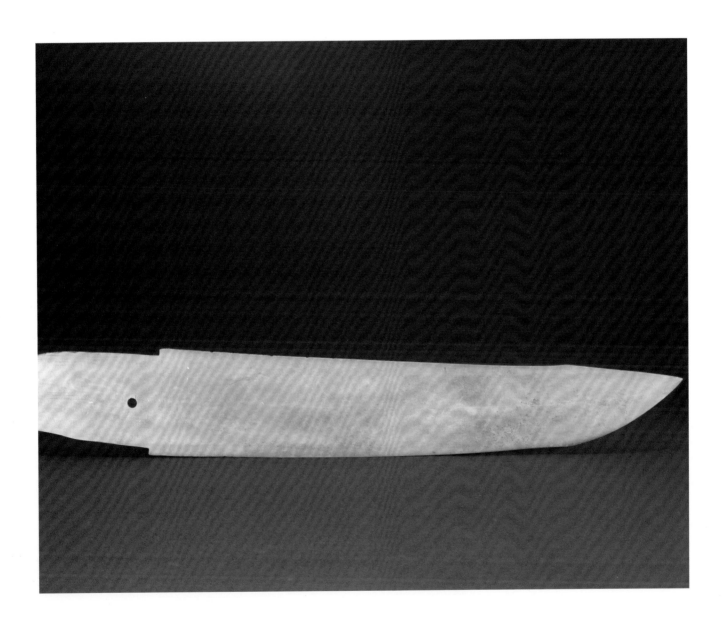

29

Jade Battle Axe with Beast Mask Patterns

Shang Dynasty

Height 15 cm Width 14.7 cm
Thickness 0.6 cm

This object, made of bluish-white jade, has brown soaking-induced spots. The body of this axe is close to a round shape. It has a curved blade, with seven small linked arcs. There is also a hole in the middle, and the diameter of its sides is slightly larger. Both sides of this object have uneven decorative teeth. The upper part and both sides of the axe are decorated with beast mask motifs.

The beast mask patterns decorating this battle axe were carved by people of later generations.

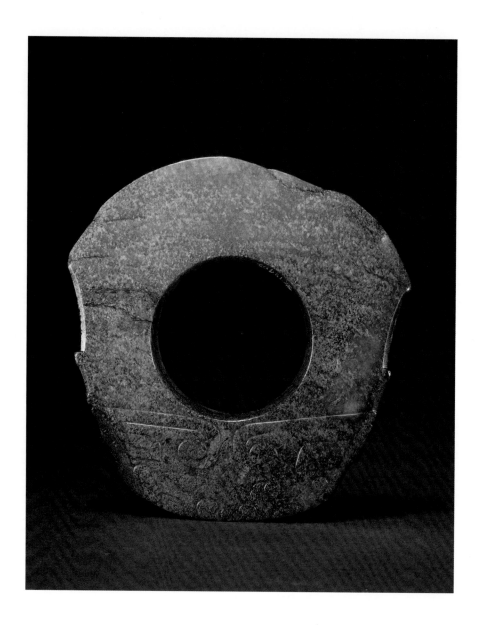

30

Elongated and Pointed Jade Tablet with Beast Mask Motifs

Shang Dynasty

Length 11.6 cm Width 1.7 cm
Thickness 1.2 cm

This dark blue jade object features white spots. The body of this tablet is long and narrow. One end is acute, and the decorative patterns are divided into the upper, middle, and lower parts. The ladder-shaped upper part is decorated with four sets of intaglio lines. The lines turn at the top end, connecting with the intaglio lines on the back side. The middle part is decorated with beast mask motifs. The lower part is narrow and long. Its bottom end is in the shape of an awl, decorated with three sets of bulging bow patterns.

Elongated and pointed jade tablets are ancient ceremonial objects. The *Rites of Zhou* records that "blue elongated and pointed jade tablets were used to pay homage to the east". Jade tablets of the Shang Dynasty have been unearthed from the Fuhao Tomb of the Yin Ruins. The objects are mainly rectangular, and decorated with stripe patterns. This kind of sharp-tipped jade tablets seems to have evolved from jade dagger-axes, which were rarely seen in the Shang Dynasty.

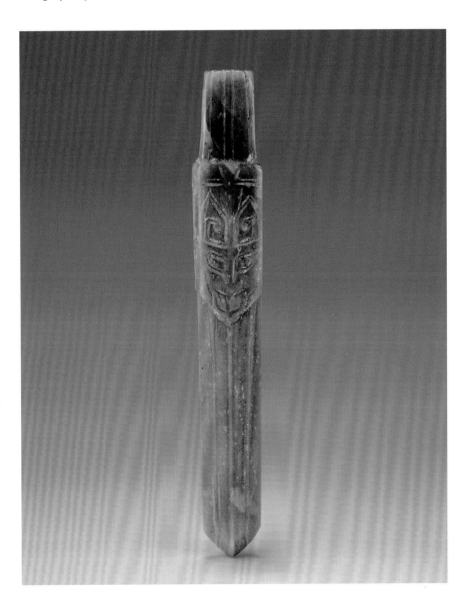

31

Handle-shaped Jade Vessel with Carved Patterns

Shang Dynasty

Length 13.7 cm Width 1.6 cm
Thickness 1.3 cm

This object, made of dark blue jade, is in the shape of a square column. It is decorated with patterns of lozenges and triangles drawn with intaglio lines. The upper part seems to have some characters, which are no longer legible, due to polishing in the process of circulating the object in later ages.

Handle-shaped objects were popular in the Xia, Shang, and Zhou periods. They were plate-shaped and widely used. Unearthed from the Xia Site of Erlitou in Yanshi, Henan, was a jade handle with different parts and carved with patterns. This object has a plain lower part with no divisions and belongs to another type.

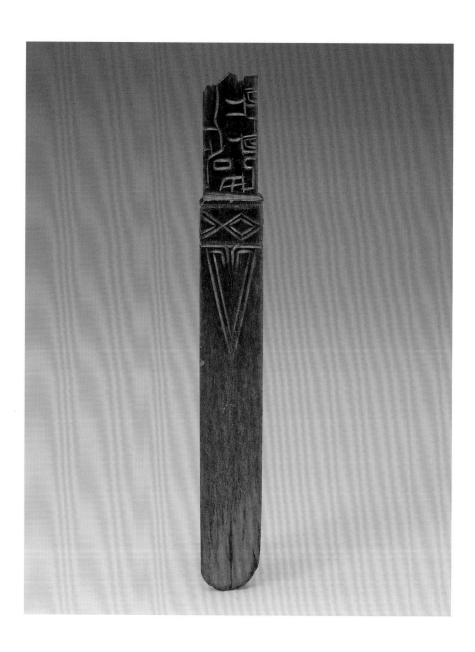

32

Jade Disk with Two *Kui*-dragons

Shang Dynasty

External Diameter 6.5 cm
Diameter of Hole 1 cm
Thickness 0.9 cm

This bluish-yellow object features white soaking-induced spots and a relatively weathered surface. This disk is round and flat. Its surface has double *kui*-dragon patterns formed by lines in relief. The heads of the dragon face each other.

The *kui*-dragon is a mythical one-legged monster in Chinese legends. It resembles a dragon. In shape, most of them are hornless and feature one leg, with their mouths open and their tails curled up. Double *kui*-dragon patterns can be seen in the jade ware of the Shang Dynasty, but they are more commonly seen on the bronze ware of the Shang and Zhou periods.

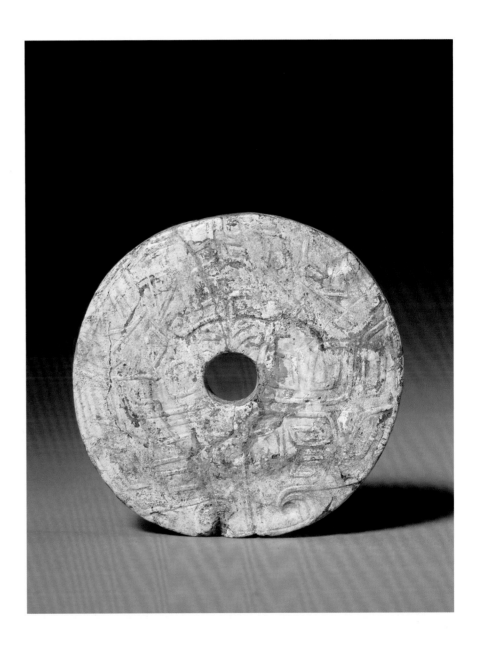

33

Jade Disk with Bulging Inner Edges

Shang Dynasty

External Diameter 12.1 cm
Diameter of Hole 6.7 cm
Thickness 1.4 cm

This object, made of bluish-white jade, has a large part whitened as a result of soaking. The disk forms a round ring. On both its sides are three groups of patterns of identical concentric circles drawn with intaglio lines. The edge of the hole has protruded lips.

Jade hoes were unearthed from Guanghan in Sichuan. The holes in the hoes had protruded lips, which had the strengthening effects. The ring-shaped protrusion in the middle of this jade disk does not serve any practical use. It is more like a kind of decoration.

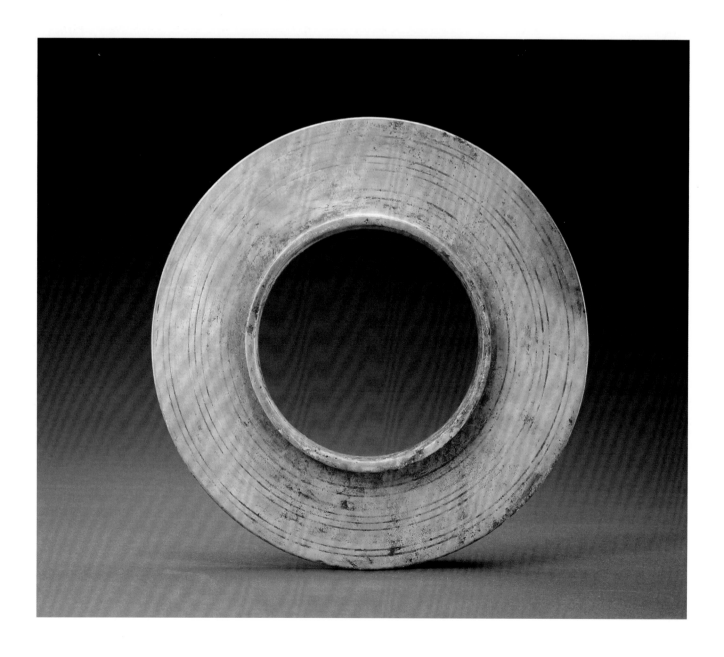

34

Jade Thumb Ring with a Beast Mask Motif

Shang Dynasty

Height 3.2 cm Diameter 2.8 cm

This object becomes yellowish-brown due to soaking. Its body is in the shape of a tub. The lower end is flat and even, the slope-shaped upper end is high in the front and low at the back, and the middle part is empty. The front part has a beast mask motif in convex carving, with the tow horns of the beast curling on the top of the forehead. It has square eyes and a volute nose, but no mouth can be seen. There is a pair of boreholes on each side of the nose for tying to a string for use. The back side close to the upper end has a deep groove.

This thumb ring is similar to the one discovered from the Fuhao Tomb at the Yin Ruins, which is probably from the same period. Thumb rings, also known as *banzhi*, were tools used in archery in ancient times. They emerged at the Shang Dynasty and became popular from the Warring States period to the Western Zhou Dynasty. When practising archery, the ring was located on the thumb, and the bow string could fit into the groove at the back. At the same time, fine strings were used to thread through the two holes and tie to the wrist. The purpose was protecting the fingers and steadying the arrow. Later, thumb rings lost their original function of holding the string when pulling the bow and became purely ornaments.

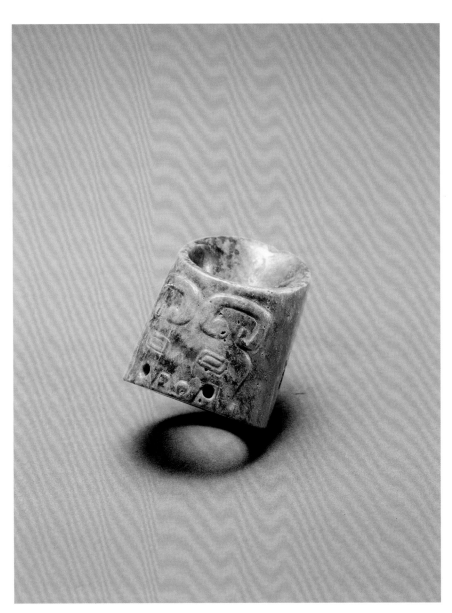

35

Semi-annular Jade Pendant in the shape of a *Kui*-dragon

Shang Dynasty

Length 8.3 cm Width 1.3 cm
Thickness 0.4 cm

This object, made of bluish-green jade, is slightly translucent. This pendant has the shape of a thin plate and is curved as a semi-circular *kui*-dragon. The dragon head, with square lips and its mouth open, is at one side. There is also a leg tucked under the belly. The body of the dragon is decorated with four sets of broken lines. The lines are carved out by squeezing and pressing with an emery wheel. The intaglio lines on the two sides are in the shape of a slope. At the other end is the tail of the dragon, the end of which has a blade, resembling a cutting knife. There are holes on the ends of the pendant for threading and wearing.

There might be two pieces of this pendant, and they could form a ring.

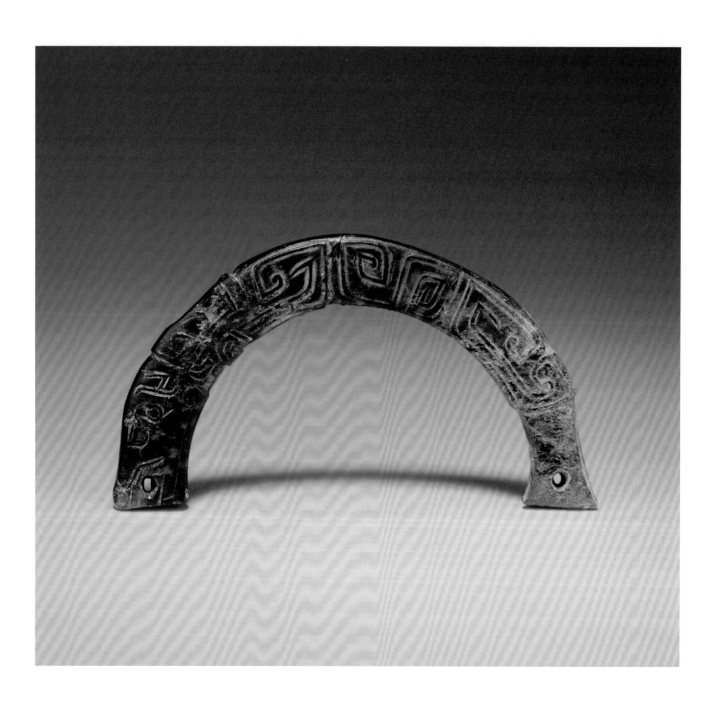

36

Semi-annular Jade Pendant with Two Birds

Shang Dynasty

Length 16.2 cm Width 9.2 cm
Thickness 0.3 cm

This chicken-bone white object, which has some parts weathered, forms the shape of a thin slab, and is curved and carved with two birds, with the ends joining each other. There are hats on birds' heads. Their eyes are in the shape of the character "*chen* (臣)", their mouth is that of a hawk, and their body is decorated with wing-feather patterns.

The shape of two birds joining together as one body is rarely seen in the semi-annular jade pendants of the Shang Dynasty.

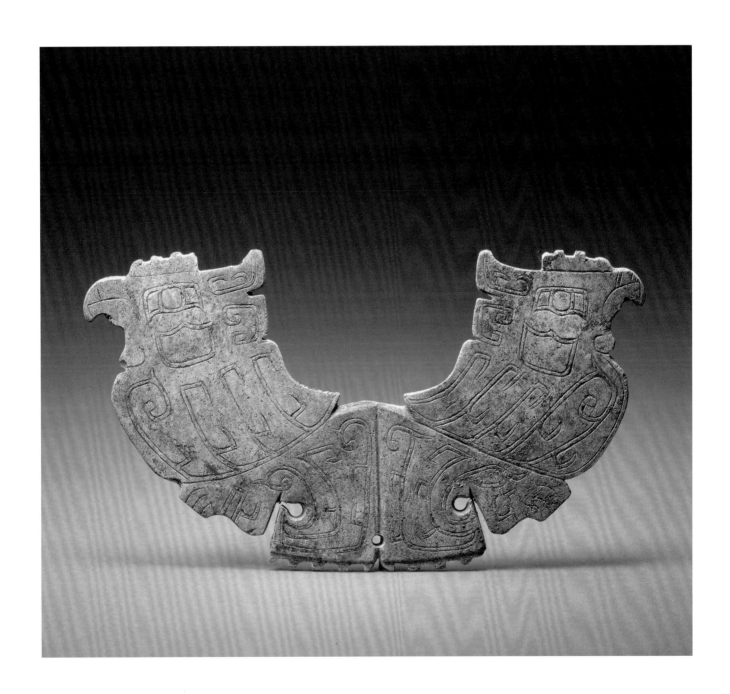

37

Penannular Jade Ring with Two Dragon Heads

Shang Dynasty

External Diameter 3.7 cm
Internal Diameter 1.5 cm
Thickness 1.2 cm

The entire body of this object has yellowish-brown soaking-induced spots, and it is difficult to deduce its original colour. The body is in the shape of a ring, with a slit. Two carved dragon heads face each other. The shape of the dragons is similar, with open mouths, square eyes, volute noses, two-pillar horns, and ears clinging close to their necks. The back is decorated with water-chestnut and triangular patterns, whereas the body is decorated with scale patterns. The two dragons' tails curl up and entwine. There is a drill hole in the mouth of one of the dragon heads, yet the drill hole on the other dragon head is not through. The tip of the tail has traces of hole-drilling.

There are many unearthed jade slit rings of the Shang Dynasty. Their shape and structure are all regulated and neat, small and beautiful. Some are slab-shaped, with both sides carved with curling dragon patterns. Others have the whole body carved in round to form animal shapes, with raised flanges in their backs and their bodies decorated with cloud, thunder, scales, and triangle patterns.

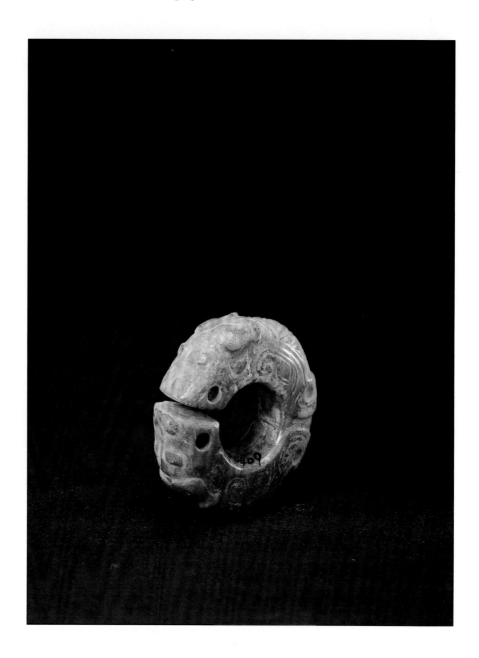

38

Jade Bodkin with a Beast Mask Motif

Shang Dynasty

Length 10.8 cm Width 2.2 cm
Thickness 2 cm

This object is verdant with yellowish-white spots at the end of its top. The upper end of the horn-shaped bodkin features a beast's head carved with intaglio lines. The part of the eyes is slightly blurred. The mouth of the beast is wide open and holds a horn-shaped article. The article is decorated with intaglio lines. The top of the article has a through hole for threading and wearing.

Bodkins were portable tools of the ancient people. Their quality is varied. The *Rites of Zhou* (Zhouli) says that "one wears a small bodkin on the left hand and a big bodkin on the right". *An Explanatory Dictionary of Chinese Characters* explains *jue* (bodkin) as "a horn for wearing, whose sharp end can be used to untie a knot". From this, it can be inferred that a bodkin is not only an article of ornament, but also a practical tool which can be used to untie a knot. The artefacts that have been discovered are jade bodkins of the early period of the Neolithic Age. Similar articles have been unearthed from the Fuhao Tomb of the Yin Ruins of the Shang Dynasty.

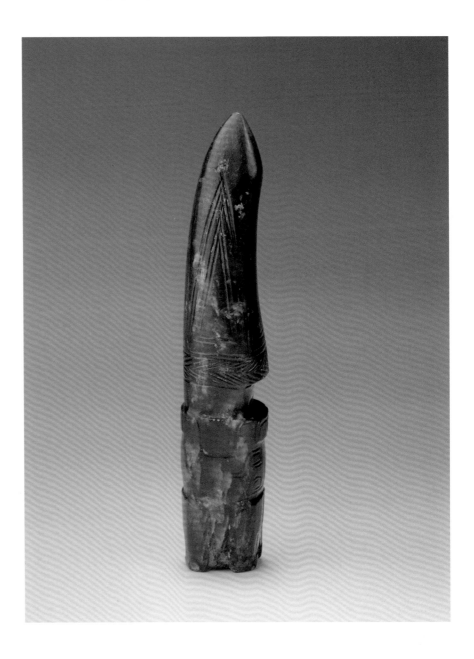

39

Jade Pillar-shaped
Vessel with
a Dragon Motif

Shang Dynasty

Height 2.3 cm
Length 6.5 cm Width 2.5 cm

This object, made of blue jade, has a large area of white soaking-induced spots. Its two ends are uneven in thickness. The face of the jade is decorated with a dragon. This dragon has *chen*-character (臣) eyes, and it is showing its teeth. It also has tube-shaped horns that stick to its neck. Its body is decorated with simple scale patterns, its four limbs are tucked under its belly, and its tail is long and curved. In the middle of the object is a hole that runs from head to tail and is connected to the small round hole under the lower part of the mouth for threading a string for wearing.

Le is the name that people of later generations give to this type of articles. It can also be generally called "tube" (*guan*), "weight" (*zhui*), or "pillar-shaped vessel". It can be worn independently or as a matching piece of a pendant set. It can also be inlaid on other articles.

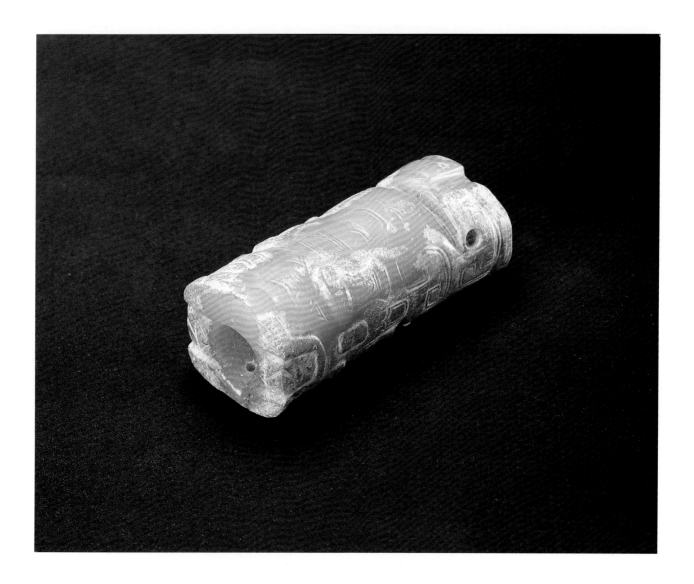

40

Jade Pillar-shaped Vessel with Dragon Motifs

Shang Dynasty

Length 7 cm
Thick End Diameter 2.1 cm
Thin End Diameter 1.6 cm
Qing court collection

This object, made of dull white jade, has yellowish-brown spots. The two ends of the body are uneven in thickness, and its surface is decorated with double-lined dragons. The middle part of this object has a hole, which can be used for threading, holding things, and inlaying.

This kind of jade ware was popular in the Shang Dynasty. However, it is suspected that the decorative patterns of this object were carved by people of later ages. When this object was collected by the Qing court, Emperor Qianlong admired it enormously, and inlaid it on a *ruyi* handle. He also inscribed with inlaid silver wires a line of a poem, along with his inscription "*Qianlong yuwan*" (fondling pieces of Emperor Qianlong).

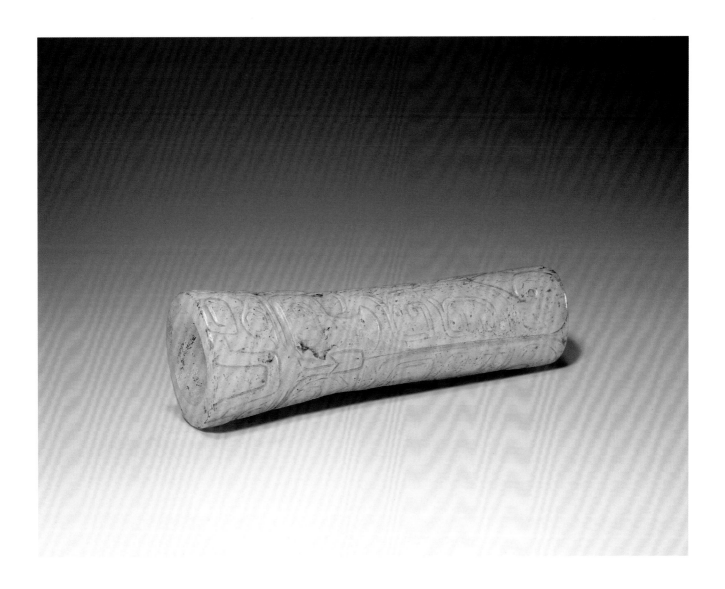

41

Jade Pillar-shaped Vessel with Goat Motifs

Shang Dynasty

Height 3 cm
Length 2.5 cm Width 2.1 cm

This jade object turns chicken-bone white, due to soaking and erosion. Its body is a circular column, and the decorative patterns are the same on both sides. Each side is carved with the face of a goat with a bold eyebrow, a *chen*-character eye, a broad nose, and cloud-shaped ears (or horns). In the middle part of the object is a hole that runs through from top to bottom, which can be threaded with a string.

Jade unearthed from the Shang Dynasty is large in number, but the one decorated with the head of a goat is rare.

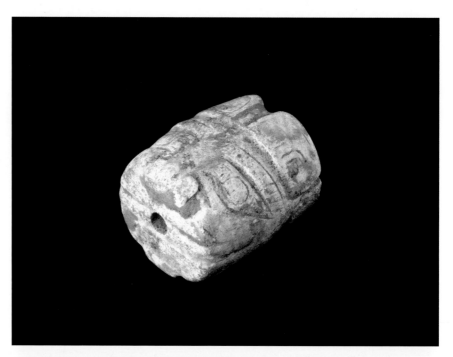

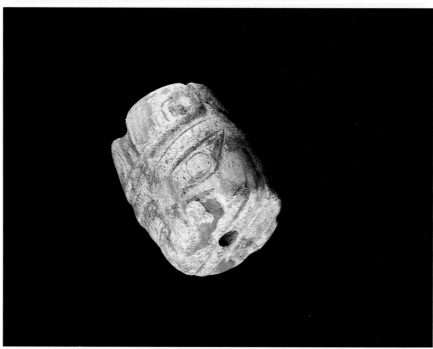

42

Jade Pillar-shaped Vessel with Cicada Motifs

Shang Dynasty

Height 6.2 cm Width 2.8 cm
Qing court collection

This object, made of bluish-white jade, has dark brown soaking-induced spots on some parts. The body is in the shape of a triangular pillar. Cicada motifs of the same shape are carved in relief on the upper and lower parts of each of the three edges. The body of the cicada has several sets of intaglio lines. The middle part of the object has a round hole that links the upper and lower parts, and can be threaded with a string for wearing.

The shape of the cicada appeared as early as the Hongshan Culture and Shijiahe Culture of the Neolithic Age. The number of these pieces, however, was relatively small. Cicadas were very popular in the Shang and Zhou periods, and the number of cicada pieces increased. By the time of Han and Wei, they became mostly burial jade ware.

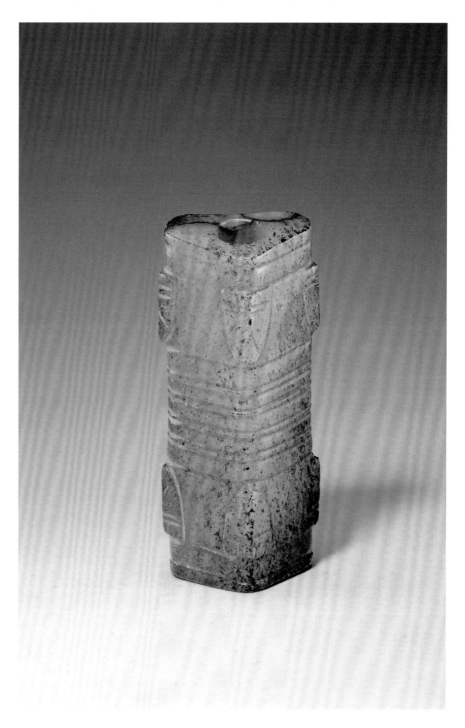

43

Jade Dragon

Shang Dynasty

Height 6.3 cm Width 4.4 cm
Thickness 2.1 cm
Qing court collection

This object, made of blue jade, has turned yellowish-brown and black, due to soaking. The junction of the head and tail of the dragon forms an irregular ring shape. The dragon's head is larger, and on its top are two tube-shaped horns. It has *chen*-character (臣) eyes, a volute nose, and an open mouth. The neck is decorated with a checked pattern in intaglio lines. The body of the dragon is relatively long. The tip of its tail coils up outward, and the upper and lower parts of its body have holes for threading and wearing.

Dragon-shaped jade pendants began to become popular in the Neolithic Age. By the Shang Dynasty, they were more varied. The carving of this jade dragon is bold, unconstrained, simple, and straightforward. It is a typical piece of jade dragon of the Shang Dynasty.

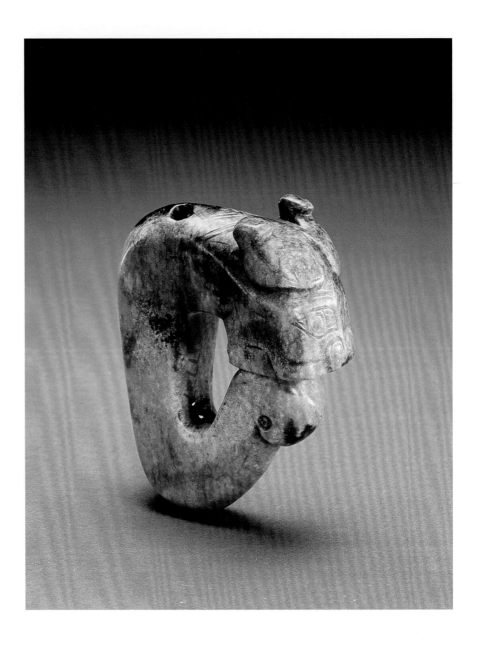

44

Jade Dragon

Shang Dynasty

Length 6.2 cm Width 1.8 cm
Thickness 1 cm

The surface of this object, made of bluish-white jade, is weathered. It represents a dragon carved in round in a crouching position. On the top of its head are two mushroom-shaped horns sticking to its back. Its eyes are like a parallelogram, slightly bulging. It has its eyes slightly open, and its mouth open. One of its legs is tucked under its belly. Its tail is large and long at the back, with its end part curling upward. The mouth of the dragon has a round hole that can be threaded for wearing.

This dragon is carved in round, which is rarely seen in the jade ware of the Shang Dynasty.

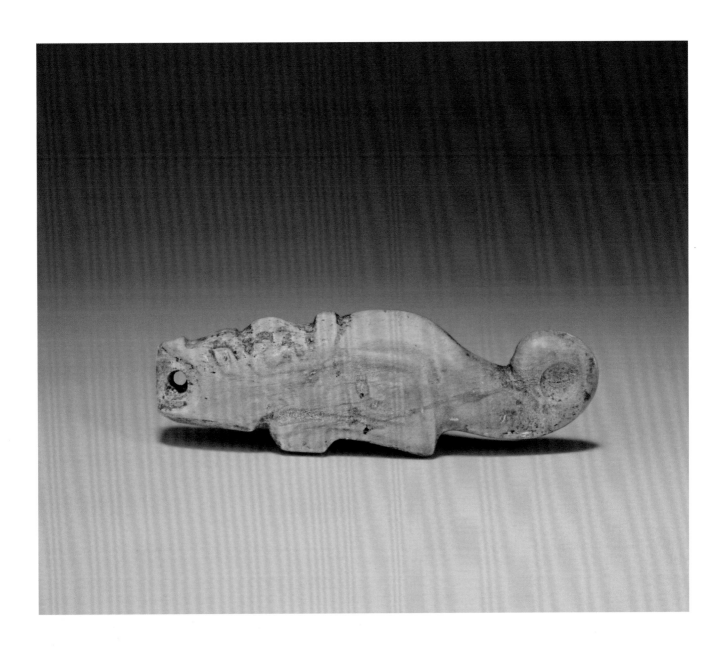

45

Jade Human Head

Shang Dynasty

Height 4.3 cm Width 3.4 cm
Thickness 1 cm

This object, made of blue jade, features a large grayish-white area that is the result of soaking. Its body is slightly flat. The front part is curved and bulging, whereas the back part is concave inside. There are double hooks in the front to decorate the human head which has *chen*-character-shaped (臣) eyes, a big nose, and a wide mouth. Its hair is carved out with short, straight, and thick intaglio lines. There is an ear carved on each side, and between the eyes, there is a pair of drill holes for inlaying or wearing.

The posture of jade human heads of the Shang Dynasty is generally of two types: looking straight or looking askance. In terms of craftsmanship, it involves round carving and plate carving. In terms of shape, it has nobility and slaves. This object seems to be a frontal image of the head of a slave. It could be an object for human sacrifices.

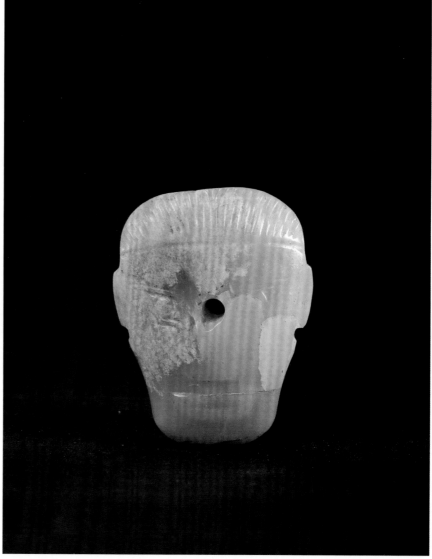

46

Jade Pendant in the Shape of an Upright Figure

Shang Dynasty

Height 8.1 cm Width 1.5 cm
Thickness 0.8 cm

This object is made of white jade. Its two sides are carved with the same shape of a human. This jade figure is in a standing posture, decorated with *chen*-character (臣) eyes. It has a square nose and a slightly opened mouth, and its hands are placed crossed on its belly. It has short legs, and its toes are carved in intaglio. The body of the object is decorated with hook-shaped cloud patterns. The leg and the bottom of the foot have two through round holes, and the bottom has a flat tenon. This shows that the function of this jade figure is holding and inlaying ornament pieces or articles in the shape of a handle.

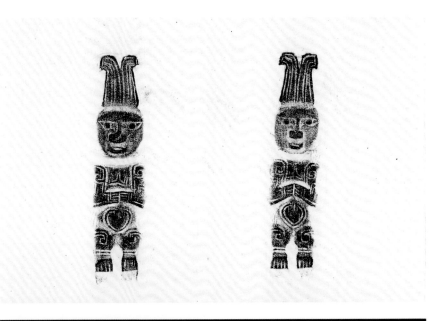

47
Jade Yellow Cattle Face

Shang Dynasty

Height 3.8 cm Width 4.6 cm
Thickness 2.1 cm

This object, made of greenish-yellow jade, has grey soaking-induced spots on some parts. Its body is flat, in an inverted ladder shape: wide in the upper part and narrow in the lower part. Both sides are carved in intaglio yellow-cattle-face patterns. The head of the yellow cattle features a pair of curved horns. It has *chen*-character (臣) eyes, and its mouth is slightly open. On its four sides are through round holes in the shape of trumpets, which can be threaded and worn.

Yellow cattle were not only animals for agriculture, they were used as "sacrificial offerings" to gods or ancestors. Sacrificial offerings, such as yellow cattle and goats, had been unearthed from the Yin Ruins. This object could be used by a merchant as a sacrificial offering to gods and ancestors.

48

Jade Hawk

Shang Dynasty

Length 9.8 cm Width 10.5 cm
Thickness 0.8 cm
Qing court collection

This bluish-yellow jade object features an aged surface and white and brown spots. The body of the hawk is slightly flat, with its wings spread out in a setting-out posture. It has a small head and big eyes, and its mouth is not clearly distinguishable.

Numerous shapes of jade birds have been seen in the jade ware of the Neolithic Age, yet they are all different from this piece. Based on studies, this article may have been made much later, perhaps in the Shang Dynasty. The fine feather patterns on the body of the hawk and it claws were carved by people in later ages.

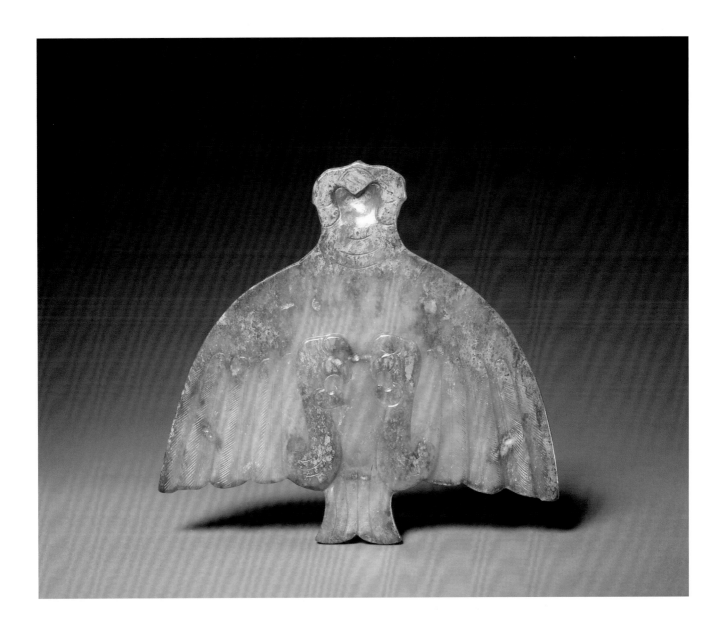

49

Jade Swallow

Shang Dynasty

Length 5.4 cm Width 2.8 cm
Thickness 0.2 cm

This object, made of blue jade, has light yellow soaking-induced spots. The body of the swallow has the shape of a thin slab. Carved in intaglio on the front are patterns of the head, eyes, claws, tail, and feathers. The tail of the swallow is polished into a thin blade, and there are patterns of intaglio lines to depict the feathers. The backside is flat and plain, and has no decorations. The rear part of the mouth has a bore hole, which can be threaded for wearing.

Jade ware in the Shang Dynasty for the most part involved birds, beasts, fish, and insects motifs. Some were realistic, while others, exaggerated, yet they all focused on carving the head part, leaving other parts relatively sketchy. Moreover, this type of animal-shaped pendant ornaments typically had blades at their tails, which could be used for simple cutting and had some practical application.

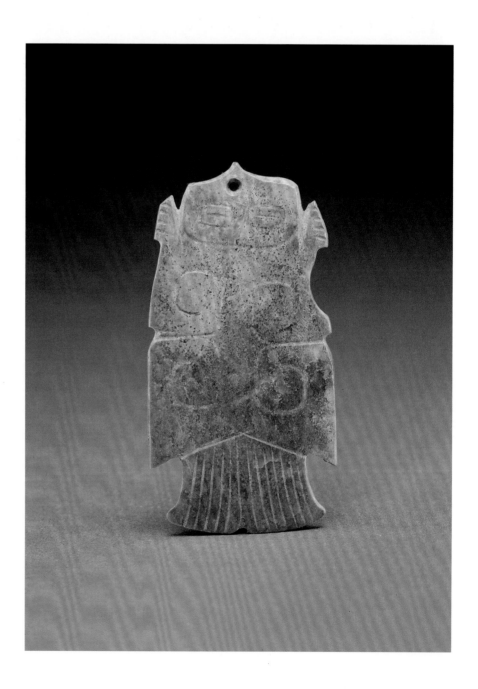

50
Jade High-crest Bird

Shang Dynasty

Height 13.1 cm Width 3.2 cm
Thickness 1.5 cm

This object, made of blue jade, has black spots. The bird is carved in round. It has a multi-layered flowery high crest, round eyes, and a hook-shaped beak. It also features cloud-shaped ears, and its wings are decorated with double hooked cloud patterns. Under its leg and tail is a short tenon, which could serve as a handle.

Taking a general view at the jade birds unearthed and handed down from the Shang Dynasty, there is, as far as we know, only one extant piece of this type of jade bird with a multi-layered tower with a high crest. The "Hymns of Shang" in the *Book of Poetry* says that "the Heaven sent a swallow down to give birth to Shang". That is to say that the ancestor of Shang was Qi, whose mother Jiandi swallowed a swallow's egg to give birth to Qi. The shape of this bird may be related to the worship of birds of the Shang people.

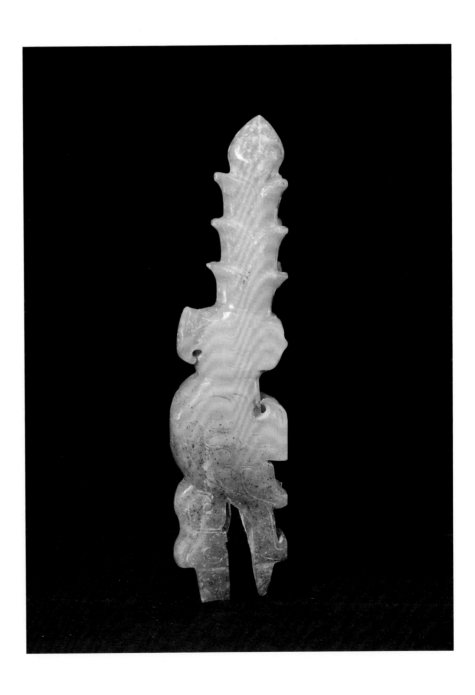

51

Jade Pendant Carved in the Shape of a Bird

Shang Dynasty

Height 9 cm Width 4 cm
Thickness 0.6 cm
Qing court collection

This object, made of grey jade, has reddish-brown and white soaking-induced spots on its surface. The pendant is flat in the form of a bird. It has *chen*-character (臣) eyes and a hooked beak. The body of the bird is relatively small with short wings and a short tail. It has five teeth before its chest. At the rear of the brain are layers of the crest. The two characters "*mu*" and "*hou*" are carved in single intaglio lines on each side of the crest, which in turn has a hole that can be threaded and worn.

This object is a gem of jade ware handed down for generations, thus is extremely valuable. The carved characters, which are similar to Oracle bone script or Bronze inscription, might be the surname or the rank of nobility of the owner of this object.

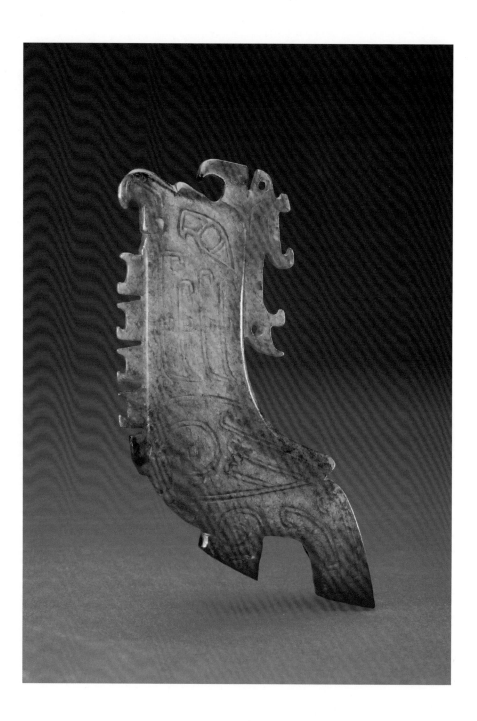

52

Jade Cicada

Shang Dynasty

Length 2.2 cm Width 1 cm
Thickness 1.1 cm

This object, which is totally whitened, features brown spots on its surface. It is carved in round in the shape of a crouching cicada. There is a hole under its belly, which links both sides.

There were many insect shapes in the jade ware of the Shang Dynasty, such as silkworms, pupas, cicadas, and mantes. However, the volume of these works is small. Some scholars hold the view that this type of jade articles were worn on strings, tied to the head, to serve as talismans.

53

Jade Gecko

Shang Dynasty

Length 7.5 cm Width 2.6 cm
Thickness 0.7 cm

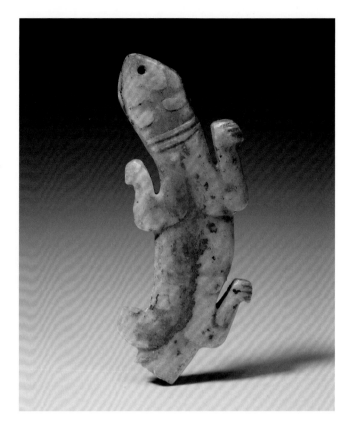

This jade is totally whitened and has black spots. It is carved in round in the shape of a gecko, whose tail and left hind leg are ruined. The upper part of the gecko has a hole for threading a string so that it can be worn.

The shape of this object is lively. It shows the subtle power of observation and the excellent ability of expression of the jade makers of the Shang Dynasty.

54

Jade Mantis

Shang Dynasty

Length 8.4 cm Width 1.2 cm
Thickness 0.5 cm

This object, made of bluish-white jade, has yellowish-brown soaking-induced spots on some parts. This mantis is carved half in round. Its body is slightly flat, and it has a small head, round eyes, a small neck, a small waist, and a broad belly. Its legs are folded forward. In the neck and under its belly are patterns of cross joints drawn with double intaglio lines.

Jade mantes are often found in tombs of the Shang Dynasty. However, articles as exquisite and lively as this one are extremely rare.

55

Jade Frog

Shang Dynasty

Height 5.2 cm Width 4.8 cm
Thickness 0.6 cm

This object, made of blue jade, has a lower degree of transparency, and part of it is whitened. The entire piece is flat in the form of a frog and has a hole at the centre. The frog is short in stature and has a big belly. Its four limbs are short and small, and its back is slightly bulging. It has broken-line patterns drawn in double intaglio lines. The belly is plain. Under the slit in the front end of the frog's mouth is a drill hole, which can be threaded with a string for wearing.

This is a typical jade frog, which is rarely seen in the jade ware of the Shang Dynasty.

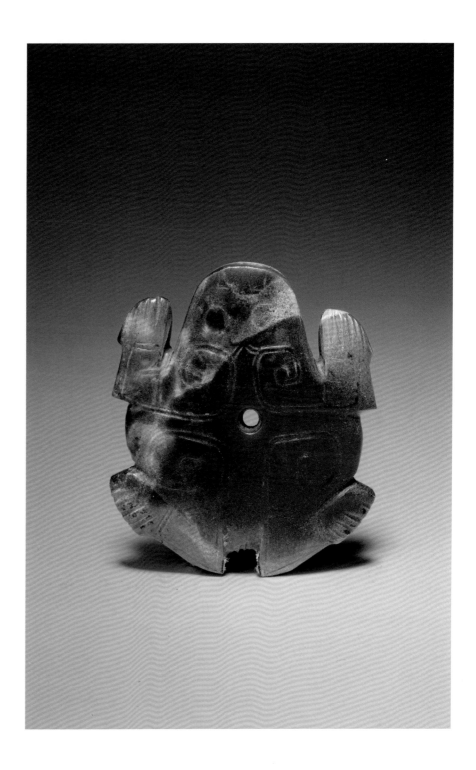

56

Jade Turtle

Shang Dynasty

Length 5.9 cm Width 4.1 cm
Thickness 1.3 cm

This object, made in blue jade, has a large area with reddish soaking-induced spots. This jade turtle is carved in round. Its head is slightly curled up, and its mouth is open. It has protruding eyes and an open mouth. There are four creases carved in thick lines drawn in intaglio. The shell is slightly bulging. Its tail is short. Its four legs are stretched forward, and patterns of intaglio lines are used to depict its claws. Under the mouth of the turtle is a pair of holes, which can be tied for wearing.

Jade turtles first appeared at the Hong-shan Culture Site. A considerable number of jade turtles of the Shang Dynasty were discovered at the site of Yin Ruins in Anyang. The carving skills and outward appearance of this piece of jade turtle have the artistic characteristics of the Shang Dynasty.

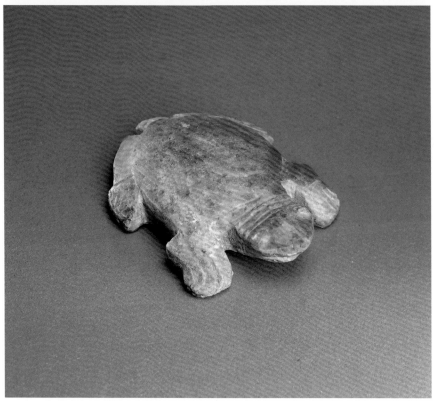

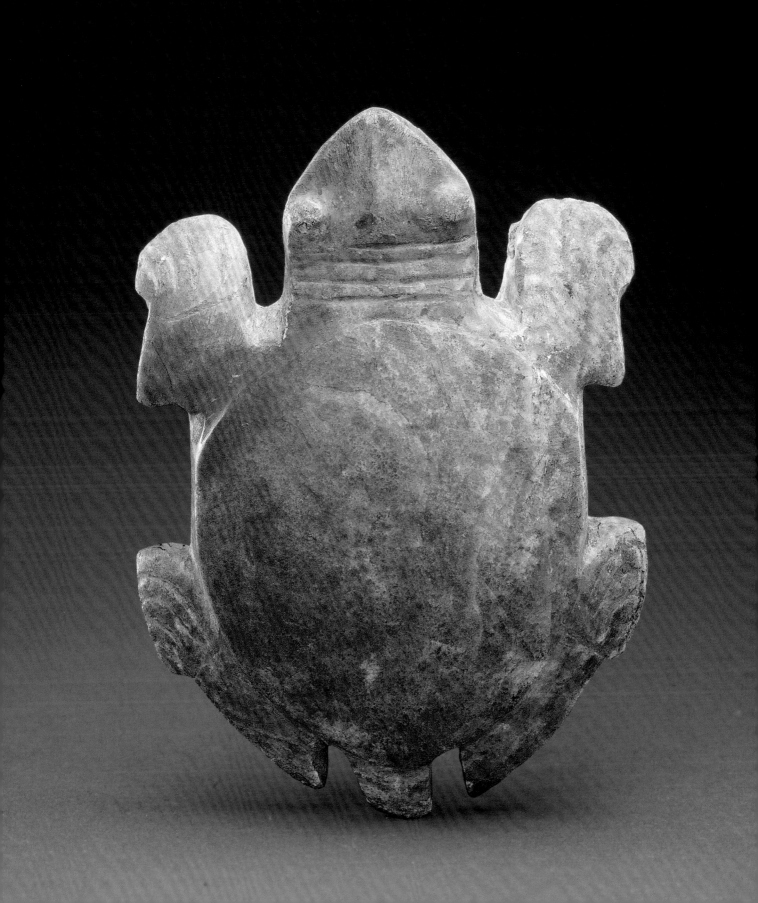

57

Fish-shaped Jade Pendant

Shang Dynasty

Length 8.5 cm Width 2.8 cm
Thickness 0.5 cm

This object, made of blue jade, has brown soaking-induced spots on some parts. The fish has the form of a plate, and its body is arched. The decorative patterns on both sides are identical. Both the dorsal and ventral fins are carved out by fine and dense intaglio lines. The slope-cutting method is used to carve out eyes, mouth, and scales. The tail part, in turn, is decorated with thick intaglio lines. The head and tail have each a hole for wearing.

58

Handle-shaped Jade with Phoenix and *Kui*-dragon Motifs

Western Zhou Dynasty

Length 17.1 cm Width 3.7 cm
Thickness 0.7 cm

This object, made of blue jade, has light green soaking-induced spots on some parts. This object, in the form of a long slab, features identical decorative patterns on both sides. The surface of the upper part has two holes. The outer side of the hole is decorated with two symmetrical phoenix patterns, and its rim has symmetrical patterns of spears and bows. The middle part is a phoenix. Its head is raised and its plume, high. It has round ears, and the tip of its beak is hooked. It has one leg trampling on the head of the *kui*-dragon on its lower part. It has a short tenon for holding things in the bottom.

Handle-shaped jade ware first appeared at the Erlitou Culture. Its usage continued from Shang to Western Zhou. The decorative patterns of Western Zhou Dynasty, however, were the most exquisite.

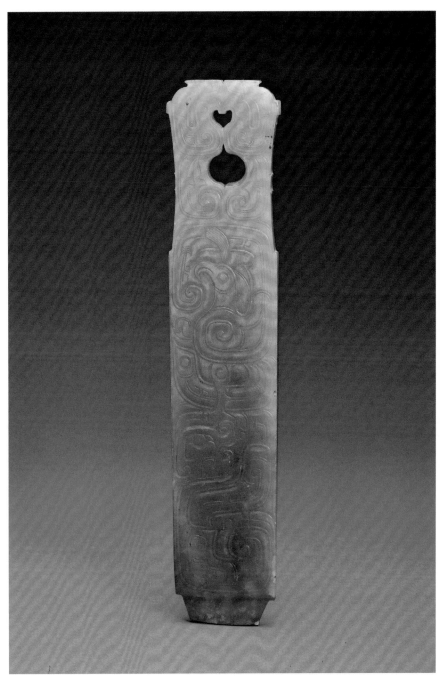

59

Jade Disk with a Tiger Motif

Western Zhou Dynasty

External Diameter 16.1 cm Diameter of Hole 5.9 cm
Thickness 0.4 cm

This object, made of bluish-green jade, has white soaking-induced spots on some parts. The body of this disk is flat with a slit. It is in an irregular round shape with a hole in the middle. The decorative patterns on the sides of the object are identical. Along the rims is a wide edge, on which tiger patterns have been carved with double-hooked intaglio lines. The tiger is leaning on one side. Its eyes are shaped as a *chen*-character (臣), and its body has spotted patterns.

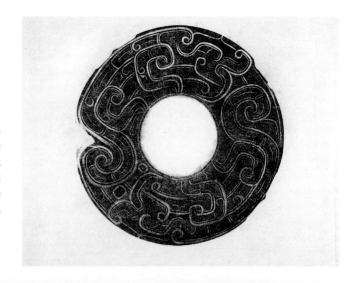

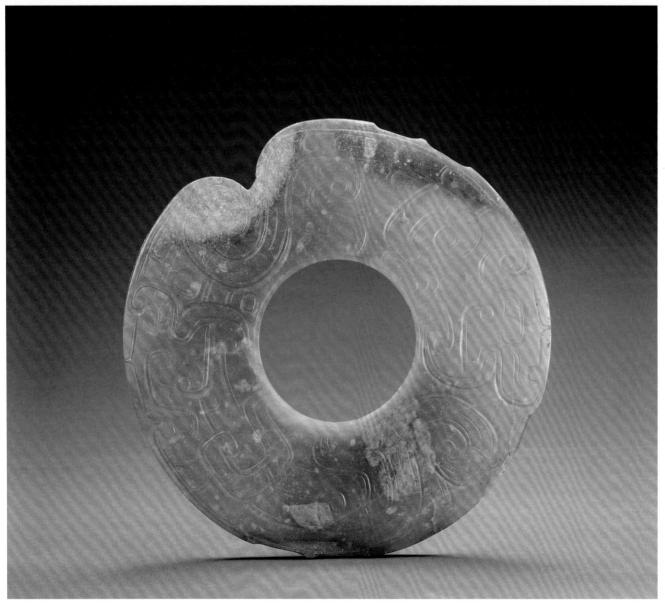

60

Jade Pendant with Dragon and Phoenix Motifs

Western Zhou Dynasty

Length 2.9 cm Width 2.8 cm
Thickness 0.25 cm
Qing court collection

The surface of this jade has colour variations, brownish and slightly translucent. This pendant is in the form of a slab and in the shape of a hook. It is carved with dragon and phoenix patterns linking the upper and lower parts. The dragon, which is on the upper part, has short horns, long eyes, small ears, curled-up lips, and one leg. The phoenix, which is on the lower part, has a short neck, an exaggerated beak, and a bulging chest. Its tail is curled up and entwined with the body of the dragon. Most of the patterns on the bodies of the dragon and phoenix consist of intaglio lines. This pendant features some holes that allow it to be worn as a body ornament.

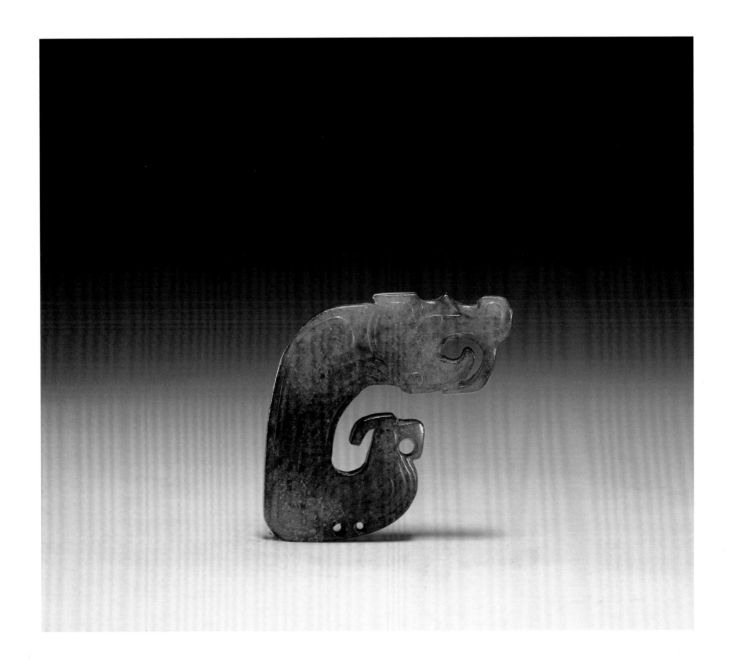

61
Human-dragon-shaped Jade Pendant

Western Zhou Dynasty

Length 8.3 cm Width 1.5 cm
Thickness 0.4 cm

This object, made of bluish-yellow jade, has brownish soaking-induced spots on some parts. The pendant is in the form of a slab, with a carved human figure and two dragons decorating both sides. The figure, looking askance, has almond-core eyes, a triangular nose, and volute ears. One dragon is at the back of the figure's brain and on the top of the head. The head of the dragon hangs downward in a reverse way. It has round eyes, open mouth, cloud-shaped ears, and a curled-up tail. Another dragon is depicted between the chest and the belly of the human figure. It is opening its mouth, putting out its tongue, and curling up the end of its tail in the form of a hook, creating the body, hands, and feet of the human figure. The end of the dragon's tail, on the top of the head of the human figure, has a round hole for threading a string.

Gods, dragons, and phoenixes were the most common patterns of decoration on jade pendants of Western Zhou Dynasty, and they were objects of worship for people of the Zhou Dynasty. This piece merged two dragons and a human figure, constituting a new form of combination in the Liangzhu Culture, whose typical patterns were gods and beast masks. Thus, this pendant has distinctive features of the time.

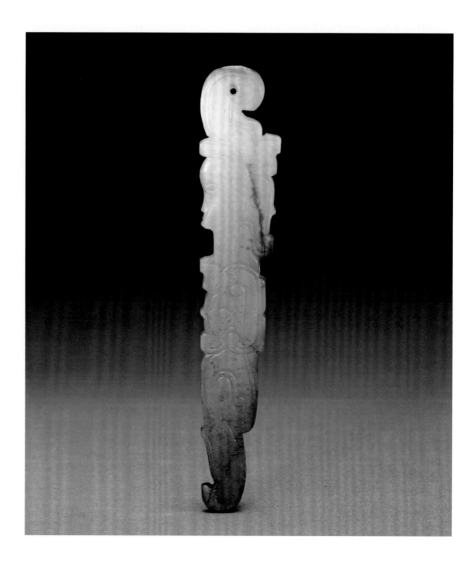

62

Human-shaped Jade Pendant in Openwork Carving

Western Zhou Dynasty

Length 6.9 cm Width 2.6 cm Thickness 5 cm
Qing court collection

This bluish-white jade object features light brown soaking-induced spots on some parts. The entire body is in the form of a slab, carved in openwork in the shape of a god, who embraces his knees with his hands and squats to one side. It has legs and feet like a dragon, and seems to have a tail. Behind his brain and in front of his chest is each decorated with a dragon head. The upper part of this object has a small round hole for tying a string for wearing.

This jade pendant is a combination of a human figure and a dragon, which was commonly seen in the jade ware of Western Zhou Dynasty, and it exudes a feeling of mysteriousness.

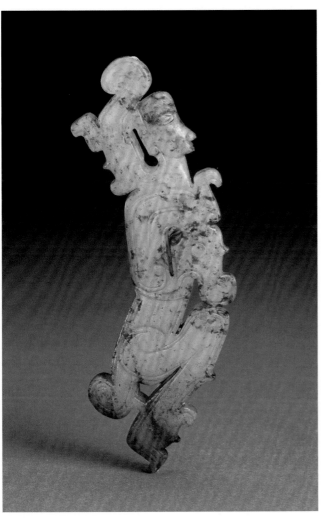

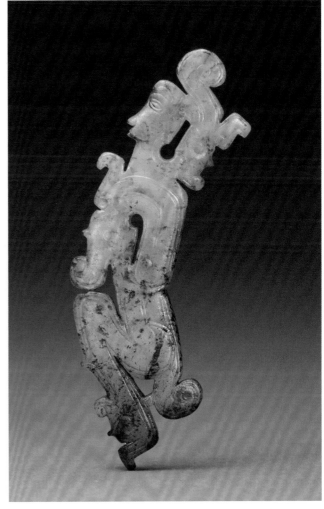

63

Dragon-shaped Jade Pendant

Western Zhou Dynasty

Length 5.2 cm Width 4.8 cm
Thickness 0.6 cm

This object, made of blue jade, has brown soaking-induced spots. Its openwork body is flat, and represents a coiling dragon. The upper middle part of this object has a round hole for threading a string, which would allow it to be worn.

A dragon is a symbol of authority in ancient times, yet with the passage of time, its shape has undergone changes. This jade dragon is typical of the Shang and Zhou periods.

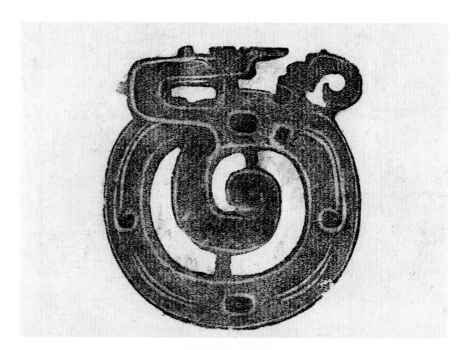

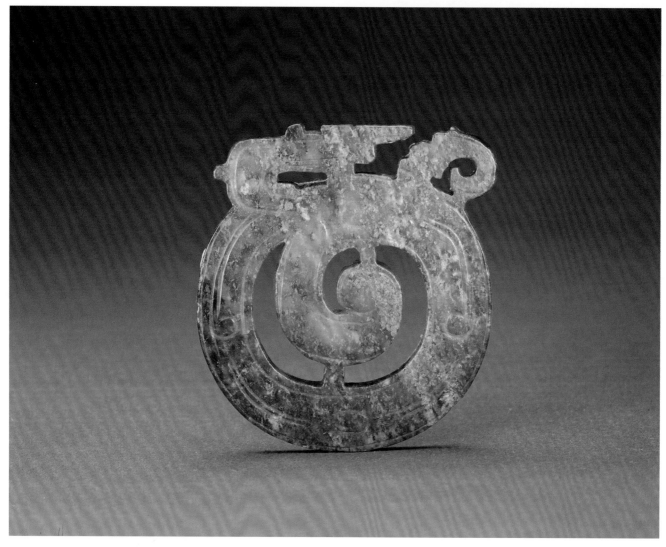

64

Human-shaped Jade Pendant in Openwork Carving

Western Zhou Dynasty

Length 7.5 cm Width 2.2 cm Thickness 0.2 cm

This object, made of bluish-white jade, has brown soaking-induced spots. The body of the pendant is flat and features an openwork human figure. He wears a hat and embraces his knees with both hands, in a squatting posture. The top of the hat has a small round hole, which allows a string to be tied for wearing.

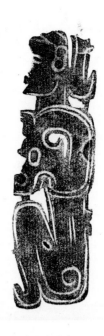

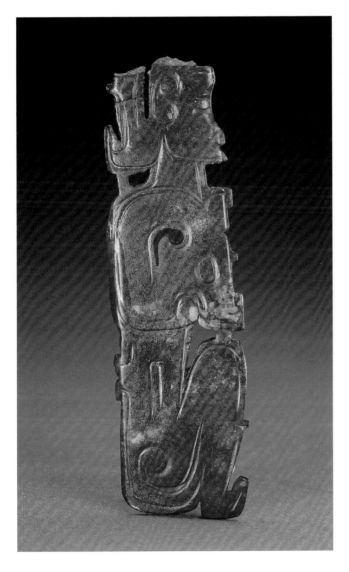

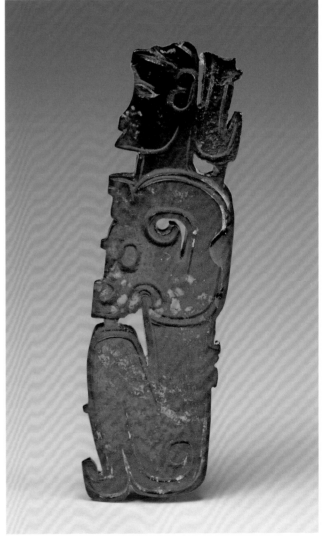

65

Semi-annular Jade Pendant with Dragon Motifs

Western Zhou Dynasty

Length 16.6 cm Width 8.7 cm
Thickness 0.75 cm
Qing court collection

This object, made of bluish-yellow jade, has darker brown soaking-induced spots. It is in the form of a slab and is semi-circular in shape with its two ends concave or convex. Carved in intaglio on both sides as decorations are identical double-dragon patterns. The dragon heads are on the ends, and they look askance, with their big eyes and upper lips curled up. The tops of the heads have manes, and the bodies of the dragons are shaped like a linking hook. Each of the two ends of this pendant has a round hole for tying to a string for wearing.

An extremely complicated jade pendant system emerged in the Western Zhou period. Most of the pendants were used at the front of the body. Of all the jade pendant sets, semi-annular occupied the largest proportion. This object is large in size and has exquisite decorative patterns. It is a rare gem of jade pendants in the Western Zhou Dynasty.

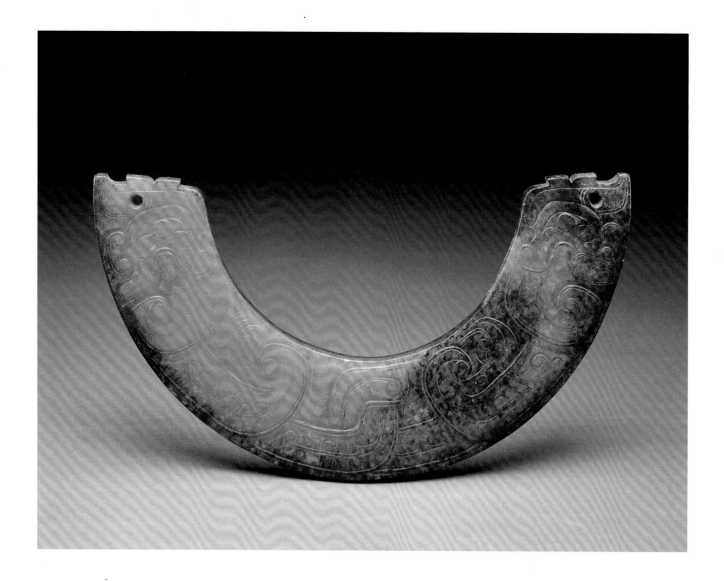

66

Jade Ornament
Inlaid with a Beast Mask Motif

Western Zhou Dynasty

Height 3.1 cm Length 5 cm
Thickness 0.3 cm
Qing court collection

This object, made of bluish-white jade, has relatively heavy brown soaking-induced spots on some parts. The body of this object is in the form of a slab, resembling a rectangle. The middle part is bulging and is carved with a beast mask motif. Some parts are in openwork carving. The edges vary according to the designs of the beast masks.

The special feature of this object is that its middle part can be divided into two symmetrical parts that resemble the pattern of a coiled dragon. There were more ornaments with beast mask shapes in the jade ware of the Shang Dynasty. However, there was an obvious drop in the Western Zhou period. This object, therefore, is especially valuable.

67

Jade Ornament Inlaid with an Owl

Western Zhou Dynasty

Length 4.5 cm Width 2.6 cm
Largest Thickness 1.5 cm
Qing court collection

This object, made of bluish-green jade, has dark brown soaking-induced spots on some parts. Its body is in the form of a slab. The front part is curved and protruded, resembling the shape of a tile. The upper part has the head of an owl in relief, with a bulging top. It has big ears and round eyes, and its hooked beak turns inward. The wings and claws are carved with intaglio lines, whereas the lower part is decorated with bow patterns. The rear side is inwardly concave. The edges on the four corners have each a drill hole, which can be inlaid for decoration.

Eastern Zhou to the Southern and Northern Dynasties

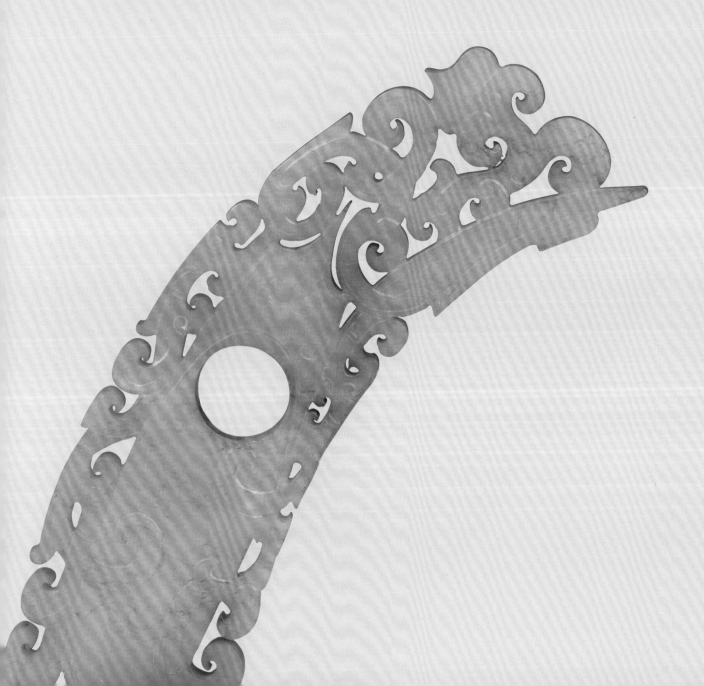

68

Semi-annular Jade Pendant with Dragons Carved in Openwork

Spring and Autumn period

Length 9.6 cm Width 4.2 cm
Thickness 0.4 cm

This object, made of bluish-yellow jade, has reddish soaking-induced spots. The pendant is in the form of an arc, with one end wide and the other end narrow. Carved in openwork on both sides are four dragons. The two ends are dragon heads facing each other sideway. In the middle are two dragon heads looking at each other. The bodies of the dragons are intertwined.

The shape of this pendant is special. It must have been used as a jade pendant set. The decorations of the four groups of dragon heads are typical patterns of the period from the Western Zhou to the Spring and Autumn period. The carving skill is superb. This piece is a gem of jade ware of this period.

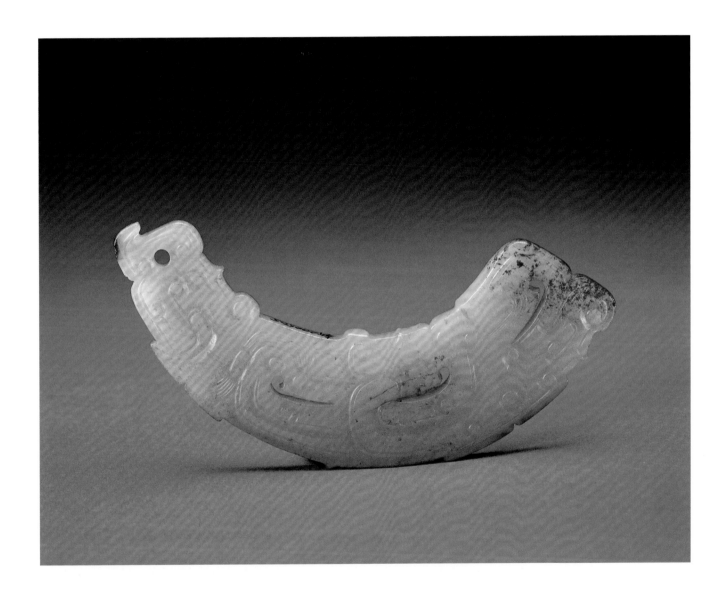

69

Jade Tiger

Spring and Autumn period

Length 7.7 cm Width 2.2 cm
Thickness 0.3 cm
Qing court collection

This object, made of bluish-white jade, has dark brown soaking-induced spots on some parts. The body of the object is flat and thin, openwork carved with a tiger shape. The tiger lowers its head in a crouching position, and curls its ears backward. It has round eyes, and its mouth is slightly open. Its four legs are folded forward, and its tail curls up backward. The body of the tiger is decorated with spotted patterns in double lines. The mouth, tail, and body have each a round hole for threading and wearing.

Jade tigers first appeared in the Shang Dynasty, and they became numerous and more elaborate by the Spring and Autumn period. This piece is a typical example.

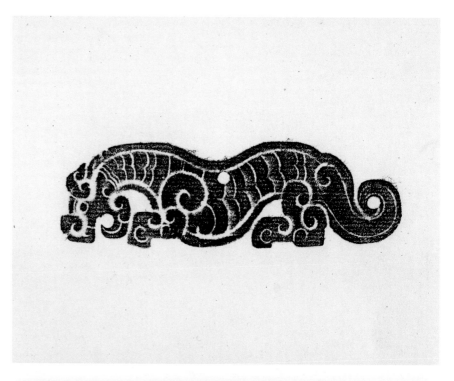

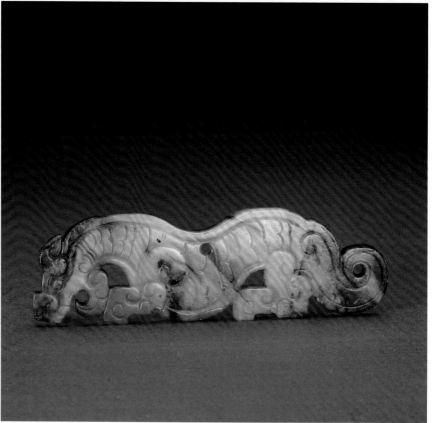

70

Jade Ornament Inlaid with a Beast Head Motif

Spring and Autumn period

Length 4.6 cm Width 3.9 cm
Thickness 0.3 cm
Qing court collection

This object, made of blue jade, is slightly translucent and is covered with purplish-brown soaking-induced spots all over. The body is rectangular as well as tabular. Both sides have teeth. The face is decorated with beast masks in double intaglio lines. The forehead has cloud patterns. It has flat eyebrows and eye sockets in the form of a water chestnut. Its mouth is wide, flat, and slightly bulging. It has square-shaped ears.

In Shang and Western Zhou dynasties, the beast mask patterns on jade ware were slightly ferocious. After the Spring and Autumn period, the design of the beast mask became close to a square, and the lines on the forehead elaborate and beautiful. This piece has distinctive features of the time and is one of the most representative works of the Spring and Autumn period.

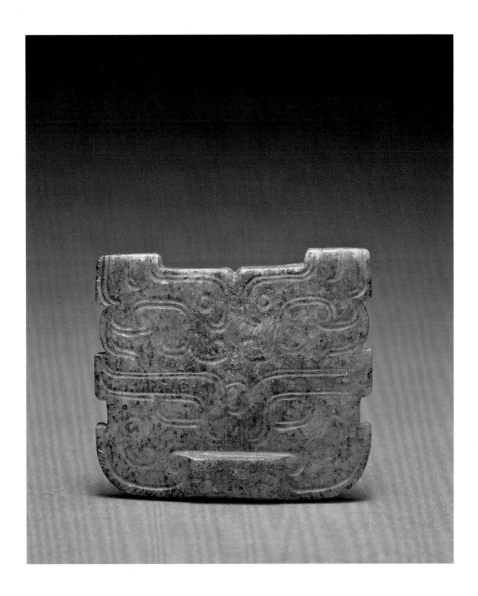

71

Jade Teeth Disk

Spring and Autumn period

External Diameter 7.2 cm
Diameter of Hole 4.3 cm
Thickness 0.7 cm
Qing court collection

This object, made of bluish-white jade, has brown soaking-induced spots. This ring-shaped disk is rather thin, and its outer edges exceed the four corners. The surface of the object is covered with hook-shaped cloud patterns with intaglio lines.

This type of jade objects was first seen in the Neolithic Age. They were unearthed from the sites of Dawenkou Culture and Longshan Culture, and they were still seen in tomb burials in the Spring and Autumn period. There are different inferences on the uses of this type of jade ware. Some say that they were witchcraft tools. Others say that they were just tools. Wu Dacheng, in his book *Guyu Tukao*, gives it the name *xuanji* (the North Star). Xia Nai calls it *yabi* (teeth disk), which is followed here.

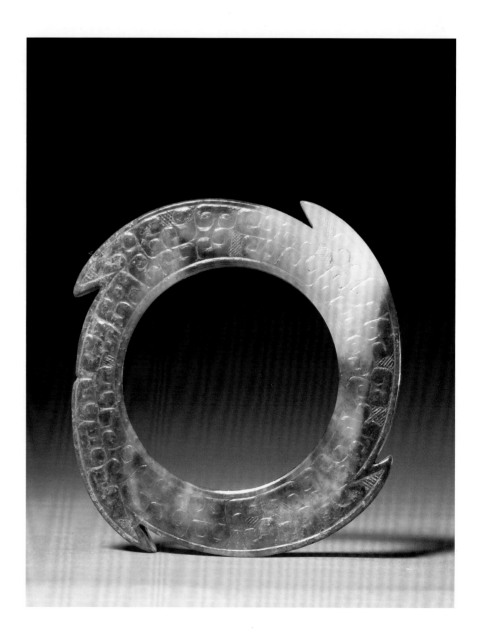

72

Jade Human Head

Spring and Autumn period

Length 6 cm Width 3.5 cm
Thickness 0.9 cm
Qing court collection

This slab-shaped object, made of bluish-white jade, is covered with dark brown soaking-induced spots. Its front part is slightly convex, and its back side is internally concave. Both sides of the object are straight-looking human faces, whose eyes, nose, and mouth are decorated with deformed *kui*-dragon patterns, although they differ slightly in the details. The upper and lower parts of this object have each a slant through hole for tying a string.

The decoration style of this human head has distinctive features of the middle and late Spring and Autumn period. This is the only piece that has been found so far, so it is considered a rare piece.

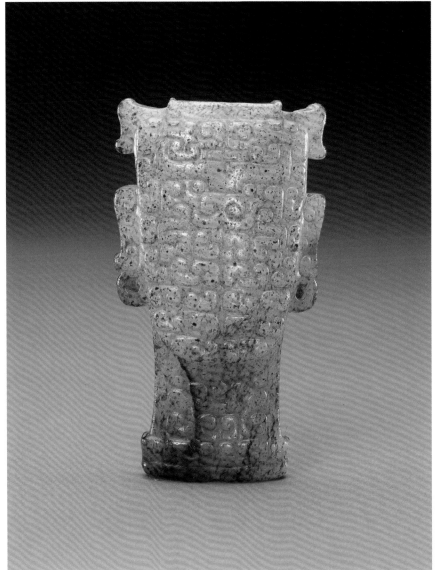

73

Jade Ornament with a Phoenix Carved in Openwork

Spring and Autumn period

Length 6.3 cm Width 3.6 cm
Thickness 0.4 cm

This object, made of blue jade, has light brown soaking-induced spots. The front part is slightly bulging, and the backside is rather concave. The entire body is carved with a *kui*-phoenix in openwork. The eyes, beak, and feathers of the *kui*-phoenix are carved as decorations in the front part of the object. The backside is without any decorations.

Patterns of dragons and phoenixes in the early Spring and Autumn period were relatively abstract. The decorative patterns were elegant, unconventional, and forceful, and the techniques of openwork carving were rather mature. The *kui*-dragon phoenix pattern was the geometrical patternization of the image of a phoenix, which is similar to a *kui*-dragon. The phoenix in general has small and long *chen*-character (臣) eyes, wears a comb on its head, and features a hawk's beak. It has transformed wings and body. It has a long tail wing. Occasionally, a phoenix with a leg or a claw is seen.

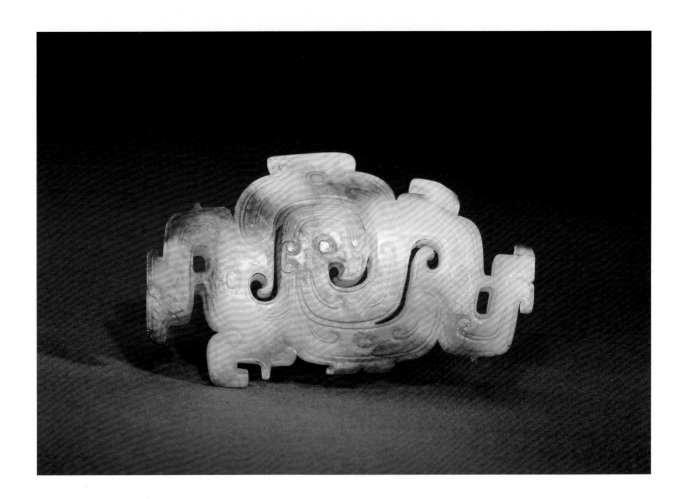

74

Semi-annular Jade Pendant with Two Beast Heads

Warring States period

Length 14.6 cm Width 5 cm
Thickness 0.5 cm
Qing court collection

This object, made of blue jade, is in the form of a slab and shaped like an arc. It is relatively wide, and its inner edge is short and small. The ends are simplified beast heads, with oval eyes and lips in the shape of a broken square. The surface of the object is decorated with protruding spiral grain patterns, resembling grain sprouts. There is a hole in the middle part of the upper end of the body of the object, which allows it to be hanged.

This type of large semi-annular jade pendants was not commonly seen in the jade pendants of the Warring States period. It must have been a kind of ceremonial vessel. It is said in the *Rites of Zhou* (Zhouli) that "the dark yellow jade pendant was used to pay homage to the north". This is to say that in ceremonial activities, a semi-annular jade pendant is placed facing north to pay homage to this direction.

75

Semi-annular Jade Pendant with Two Dragon Heads

Warring States period

Length 9.4 cm Width 3.8 cm
Thickness 0.5 cm
Qing court collection

This object, made of bluish-white jade, has brown soaking-induced spots on some parts. Its body is in the shape of a slab and shaped like an arc. The sides of the object consist of two sideway dragon heads. Both dragons have pointed lips and open mouths. The middle part is decorated with spiral grain patterns. The lower part is a *chi*-dragon and a bird carved in openwork. The head of the dragon faces upward. The body of the dragon is cut in the middle, split to the two sides. The bird and the head of the dragon is intermingled.

This pendant has a novel shape and special decoration patterns, with a strong feel of mysteriousness. The *chi*-dragon is a deified beast in ancient legends. Patterns of *panchi*-dragons were popular during the Warring States period and became even more popular in the Han Dynasty.

76

Semi-annular Jade Pendant with Two Beast Heads (A Pair)

Warring States period

Length 17 cm Width 7.3 cm
Thickness 0.5 cm

This object, made of Hetian jade of bluish-white colour, has dark brown soaking-induced spots on some parts. Its body is flat and semi-circular. Both its sides are decorated with the same patterns, whereas the ends depict the beast head, ring eyes, and a slightly opened mouth, resembling a rhinoceros. The body of the pendant is decorated with bulging grain patterns, and its lower part is carved in openwork with hooked cloud patterns. The upper part of the body of the object has holes for threading.

This object consists of two pieces, made of a single piece of jade, which can be matched. The edges are inscribed with lines of a poem by Emperor Qianlong of the Qing Dynasty, which are combined as one. It is also engraved with the signature of the emperor "*Qianlong*" and "*yuwan*" (fondling pieces of the emperor).

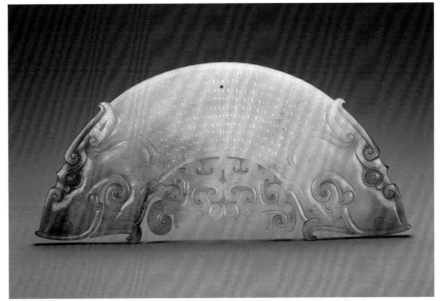

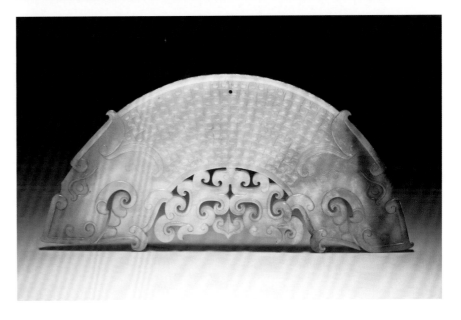

Semi-annular Jade Pendant with Two Dragon Heads Carved in Openwork

Warring States period

Length 13.5 cm Width 7 cm
Thickness 0.3 cm
Unearthed from the Yanggong village of the
Changfeng county in Anhui in 1977

This object, made of blue jade, has earthy yellow soaking-induced spots all over its body. The body is a thin tablet in the shape of two dragons. Carved in openwork are dragon heads at both ends, in the posture of looking back. Both of them have cloud-shaped horns, almond eyes, and open mouths. Their upper lips are curled up, and their lower jaws are crescent-shaped. Their bodies are coiled and lined, and decorated with hook-linked grain patterns. The outer portion of the lower part of the body of the dragon is decorated with coiled *kui*-dragon patterns.

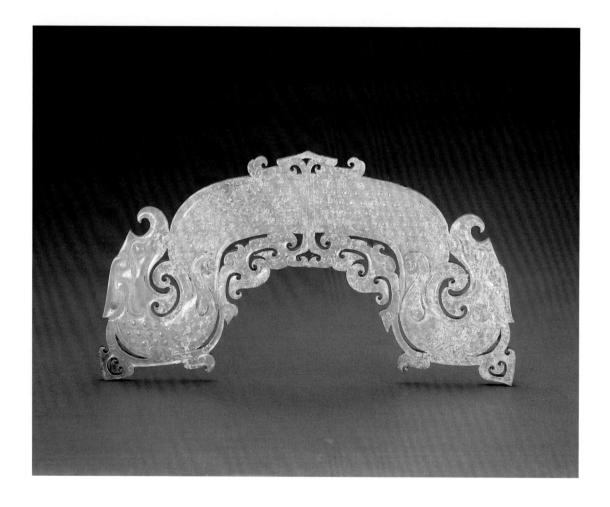

78

Semi-annular Jade Pendant with Two Edged Phoenixes

Warring States period

Length 13.7 cm Width 6.2 cm
Thickness 0.3 cm
Unearthed from the Yanggong village of the
Changfeng county in Anhui in 1977

This object, made of greyish-white jade, has spots on its surface and is as gloss as a glass. The body is in the form of a tablet and in the shape of a semi-circular jade disk. Both sides are carved with the same grain patterns and cloud patterns. There are also symmetrical broad teeth patterns carved on its edge. The top part has two phoenixes back to back carved in openwork.

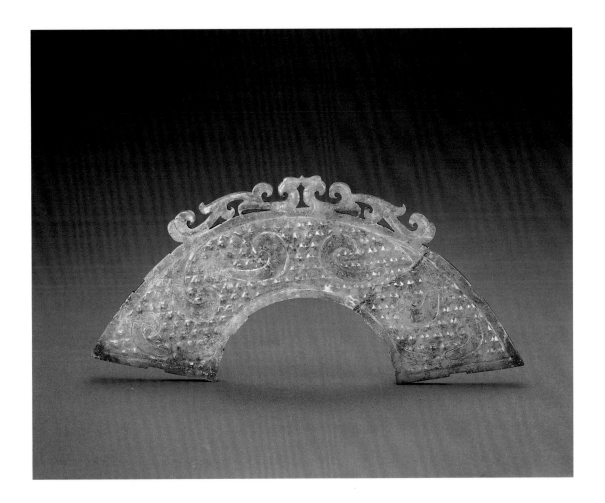

Jade Ring with a Duck Head

Warring States period

Ring Width 5.7 cm
Qing court collection

This object, made of blue jade, has reddish brown spots. The main body is an oval ring, decorated with three rounds of cord patterns. One side of the ring features a protruding head of a duck. It is a small head with a big beak, covered in full with cloud patterns.

According to the shape and structure of this ring, it seems to have been used along with hook-shaped vessels. From the knowledge of the jade ware of the Warring States, vessels with duck heads are extremely rare. This ring is, therefore, a great treasure.

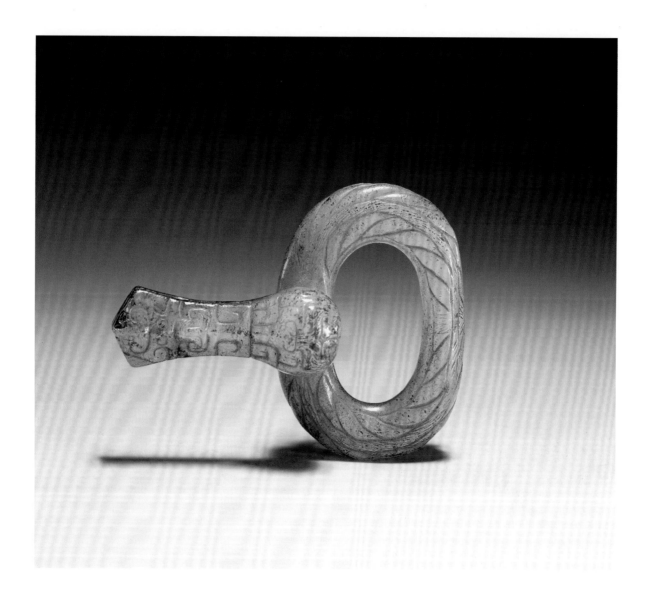

80

Jade Pendant with Two Dragons Carved in Openwork

Warring States period

Length 7.8 cm Width 5.4 cm
Thickness 0.4 cm
Qing court collection

This object, made of white jade, has yellow spots. The main body is decorated with double dragons with their back in opposite directions carved in openwork. The heads of the dragons are relatively large, with long and curled-up lips. Their bodies are thin, long, and coiled in a U-shape. Fine and dense scales decorate the body. In front of each of the two dragon heads is a coiling snake, a bird's head, and a curved body.

Most of the jade pendants of the Warring States used two symmetrical dragons as decoration, and focused on the carving of the dragon head. This was the typical shape. The coiling snake (*panhui*) pattern was popular in the Spring and Autumn and Warring States periods. The use of coiling small snakes (*hui*) to form geometrical patterns was commonly seen in bronze and jade ware. The snakes are usually represented with a triangular or round head, a pair of protruding round eyes, and scales on the body.

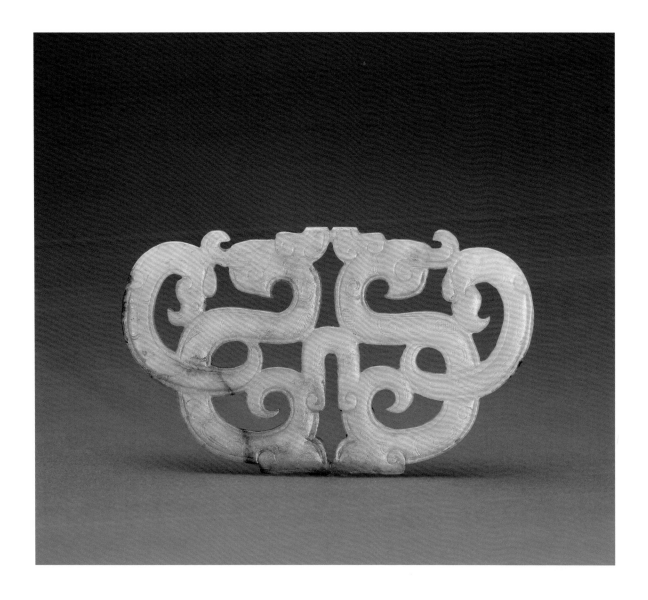

81

Jade Pendant in the Shape of a Dragon Carved in Openwork

Warring States period

Length 21.4 cm Width 10.9 cm
Thickness 0.9 cm
Unearthed from the Yanggong village of the
Changfeng county in Anhui in 1977

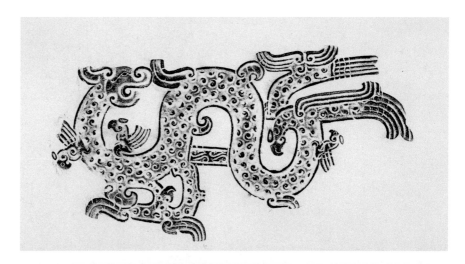

This object, made of bluish-yellow jade, has different shades of greyish and brownish soaking-induced spots, and its surface has a layer of vitreous lustre. The dragon-shaped body of the object is relatively thick and carved in openwork. The dragon is opening its mouth and turning its head back. Its body is decorated with grain patterns. The dragon's neck and tail have respectively a phoenix-like bird carved in openwork, shaped like a phoenix. The middle part of the dragon's body has a drill hole, and carved on the horizontally connected beam on the lower part of the drill hole is a dragon-shaped motif.

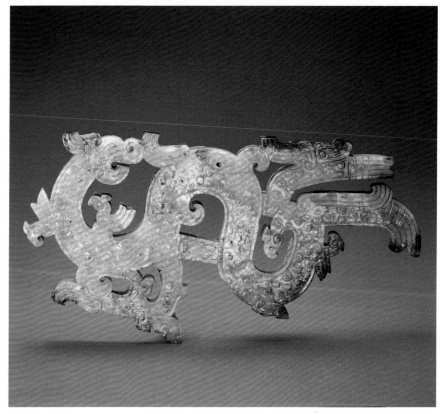

Pendants with conjoined bodies of dragons and phoenixes were unique in the Warring States. This object, which is large in size, exquisite, and in perfect condition, is extremely rare. This object is one of the two jade pendants of the same design that were unearthed from a tomb simultaneously. When unearthed, these two jade pendants were placed on the left and right sides of the pelvis of the human skeleton. There was also a large jade disk on the chest and a small disk on both sides of the knees. Based on the evidence, these five pieces of jade could be a set of jade pendants, which showed the noble status of the person in the grave.

82

Jade Disk with Two Phoenixes Carved in Openwork

Warring States period

External Diameter 9 cm
Diameter of Hole 2.5 cm
Thickness 0.4 cm
Qing court collection

The object is made of white jade. The disk is flat, decorated with identical patterns on both sides. The surface of the disk is decorated with small and sparse grain patterns. The inside and outside edges are flat and without patterns. There is a phoenix carved in openwork in each side of the disk. The front half of the phoenix resembles a beast and has one leg. The rear half of the body is small and long, with a manifold tail.

The phoenix is a traditional design on ancient jade ware. Its shape varies from period to period. The phoenix patterns on the jade ware of the Warring States were mostly carved in openwork. Regarding the shape, it was represented with a small neck, a hooked beak, beast legs, and a manifold tail, and was lively and exaggerated, which had a great impact on the jade ware of the Han Dynasty.

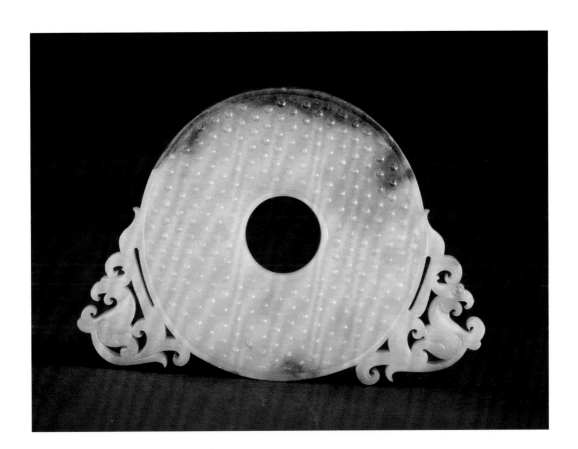

83

Jade Disk with a *Chi*-dragon and Two Phoenixes

Warring States period

External Diameter 11.5 cm
Diameter of Hole 4 cm
Thickness 0.3 cm

This object, made of the Hetian white jade in Xinjiang, has brown soaking-induced spots on some parts. Its round body is relatively thin. Both sides of the disk are decorated with hooked cloud patterns. In the hole of the disk there is a *chi*-dragon carved in openwork, with its mouth open and its chest raised. There is a round of bulging flanges on the outer and inner edges of the disk. Each of the sides of the outer edge has an exaggerated phoenix carved in openwork. The body of the phoenix is small and long, broken into two S-shapes. The crown of the phoenix is like a flower creep, and the end of the crown is curled into a ring shape for threading a string. The tail of the phoenix is slightly bent inward, forming a ring shape, which allows it to be tied to other jade pieces.

This jade disk seems to be a major ornament piece of a large pendant set.

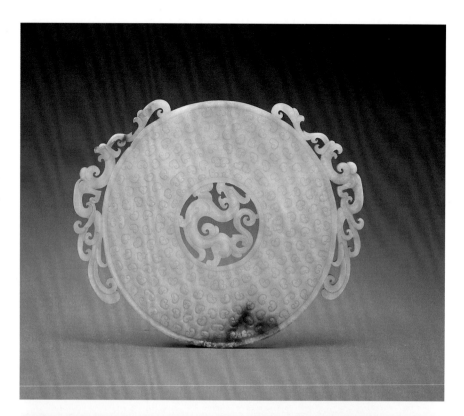

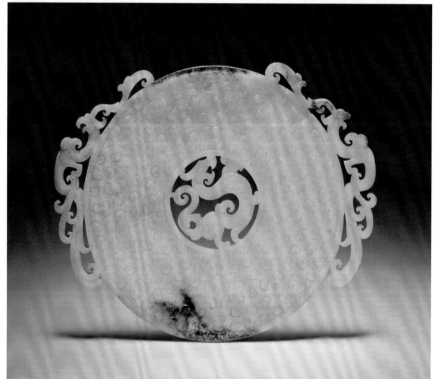

84

Jade Disk with Beast Mask and Silkworm Motifs

Warring States period

External Diameter 16.5 cm
Diameter of Hole 4.8 cm
Thickness 0.3 cm
Unearthed from the Yanggong village of the
Changfeng county in Anhui in 1977

This flat object, made of bluish-green jade, has brown soaking-induced spots on its surface, with some patches of white fog. The patterns of both sides of the disk are identical, with two rounds of bow patterns in intaglio to divide the disk into the inner and outer areas. The outer area is carved with three groups of double-body beast mask patterns, whereas the inner area is carved with lying silkworm patterns. Each edge of the inner and outer areas is carved with a band of bows.

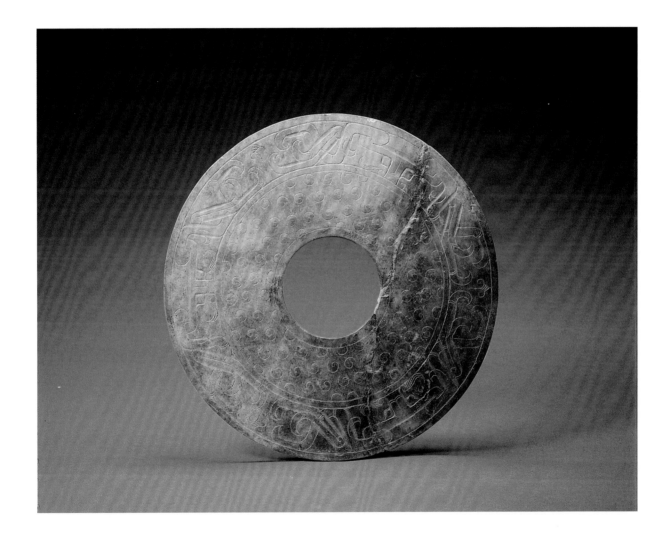

85

Jade *Chongya* with a Dragon Head

Warring States period

Length 12.1 cm Width 2.2 cm
Thickness 0.5 cm
Qing court collection

This object, made of bluish-white jade, shows different variations of green. The body is long and curved. One end is rather wide, and the other is sharp. Its surface is decorated with various sideway dragon patterns. The dragon head is exaggerated, and its body features fine scales. The cutting and polishing are fine and detailed. The wide end has a hole for threading a string for wearing as decoration.

This object is a component of a jade pendant set that the nobility of the Warring States period could wear on their chest. It is used to be worn at the lower end of the pendant set.

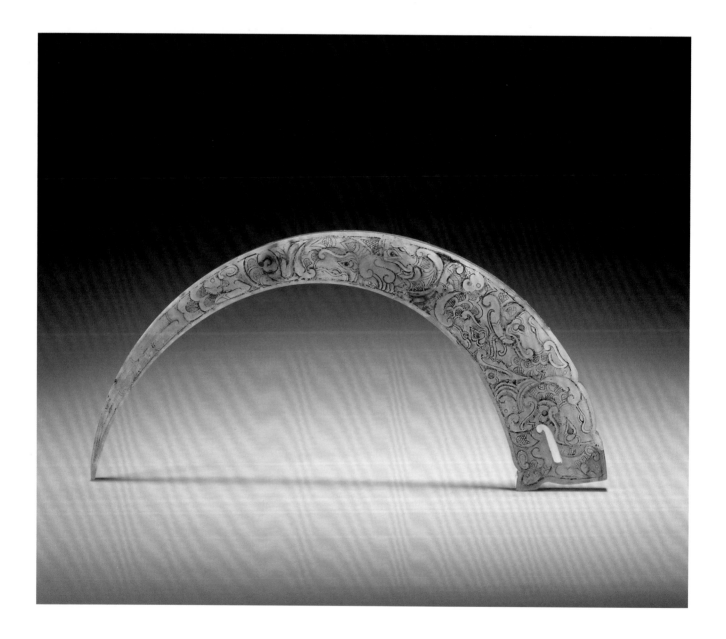

86

Jade Lamp with Linked-hook Clouds

Warring States period

Height 12.8 cm
Plate Diameter 10.2 cm
Diameter of Leg 5.9 cm
Qing court collection

This object, made of greenish-white and slight yellowish jade, has brown soaking-induced spots on some parts. The lamp is carved in round. The base, column, and legs are formed by carving and joining with tenons. The upper part features a round-shaped lamp base. There is a protruding mouth in the shape of a petal in the middle and hook-shaped cloud patterns in the outer wall of the base. The column of the lamp is thin and long. Its upper part is in the shape of a bud, and its lower part is in the shape of a drum, covered in full with decorations of the cloud and thunder patterns. The leg of the lamp is rather small. Its surface is carved with convex patterns of calyxes and the receptacle of a persimmon. The bottom of the leg is also carved with the aforementioned patterns, whereas its perimeter has hook-shaped cloud patterns.

The design of the lamp is exquisite and unique, with an appropriate proportion, tight inlaying and joining, and elaborate decorative patterns. This is the only piece of this type that has been found so far.

Jade Bodkin with a Dragon Head

Warring States period

Length 11.5 cm Width 2.5 cm
Thickness 0.5 cm
Unearthed from the Yanggong village of the
Changfeng county in Anhui in 1977

This object, made of blue jade, has relatively heavy whitish soaking-induced spots in some parts. Its appearance is like a beast horn or tooth, and the decorative patterns on both sides are identical. The upper end is wider, with a dragon head carved in openwork, and the tip of its lower end is also decorated with tow patterns.

Bodkins had already appeared in the Neolithic Age. By the Han Dynasty, bodkins gradually lost their function of untying knots and changed into pendant ornaments for children to hang on the side of the body. As bodkins originally had the function of unknotting, the wearing of jade bodkins carried the implication that when children came of age, their intelligence would be exceptional, and all the problems and difficulties in the world would also be solved.

88

Jade Standing Figure

Warring States period

Height 6.1 cm Width 1.9 cm
Thickness 0.5 cm
Qing court collection

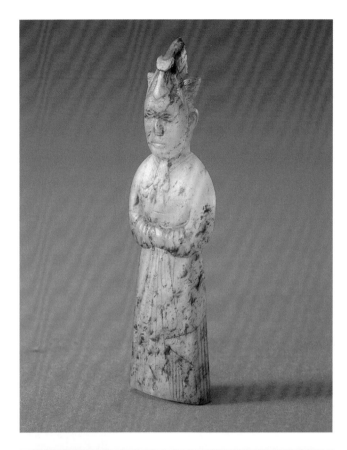

This bluish-white jade object has a relatively large number of brown soaking-induced spots. The jade figure is carved in round. Its long hair is plaited, going up from the back of the brain, and curls at the top. It wears a high hat on its head, with the string knotted under the nape of the neck. The figure wears a long robe with the right piece on the front and narrow sleeves. It is in an upright posture with its hands folded. It wears a long drooping belt at its waist, and seems to have a cloak on its back. The wrinkles on the clothes are represented with fine lines drawn in intaglio, fluent and smooth.

At present, there are considerable discoveries of jade figures of the Warring States. Most of them are tablets, and figures carved in round are rarely seen. The clothing of this jade figure is rather special and provides valuable material for the study of social life in the Warring States. When it was collected by the Qing court, it was supplemented with an album and a brocade casket.

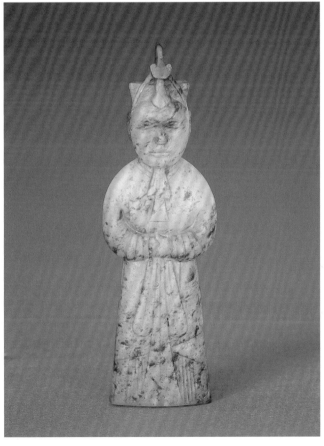

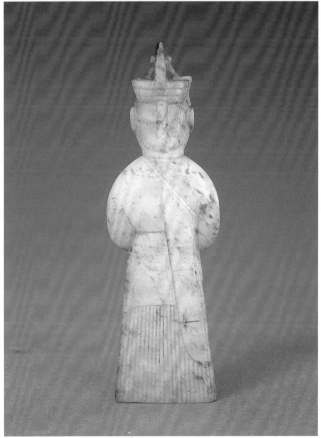

Jade Crouching Tiger

Han Dynasty

Height 2.5 cm Length 3.9 cm
Width 4.6 cm
Qing court collection

This bluish-white jade object has dark brown soaking-induced spots. It depicts a jade tiger carved in round. Its head is raised, it looks forward, and its eyes are protruding. It is opening its mouth and exposing its teeth. Its ears stick backward, and its tail droops and curls in reverse. Its front legs are stretching out, whereas its rear legs are tucked, in a crouching posture.

The appearance of tiger images on jade ware emerged from the Shang Dynasty and continued to the Warring States, with the image of the tiger decreased gradually. This object is a live sketch, and its decorative patterns are simple. It is similar to the style of carving of the Han Dynasty, so it is thought to be from that period.

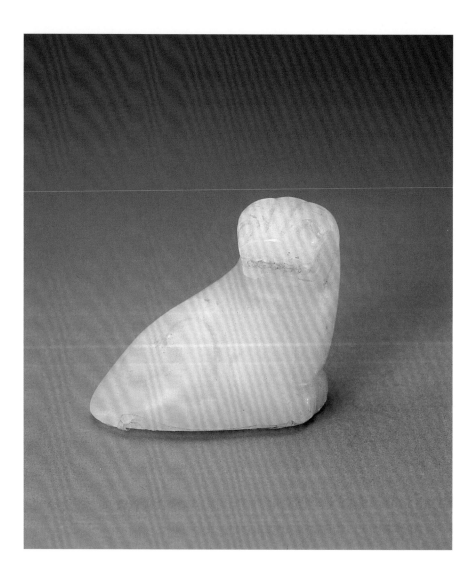

90

Jade Thumb Ring with a *Kui*-phoenix

Han Dynasty

Length 12.5 cm Width 3.6 cm
Qing court collection

This bluish-white jade object has reddish soaking-induced spots. The ring is in the form of an arc and tablet-shaped. There is a *kui*-phoenix carved in openwork on the upper part of the body. The tail of the phoenix extends to the lower part of the perimeter. Its middle part is a long circle, with a hole. Cloud patterns are carved with intaglio lines in the border of the circle, merging with the *kui*-phoenix patterns as a body.

The entire body of this object is curved like a bridge, and its shape is influenced by semi-annular jade pendants. The openwork carving is extremely exquisite, and makes it a representative piece of work of the Han Dynasty.

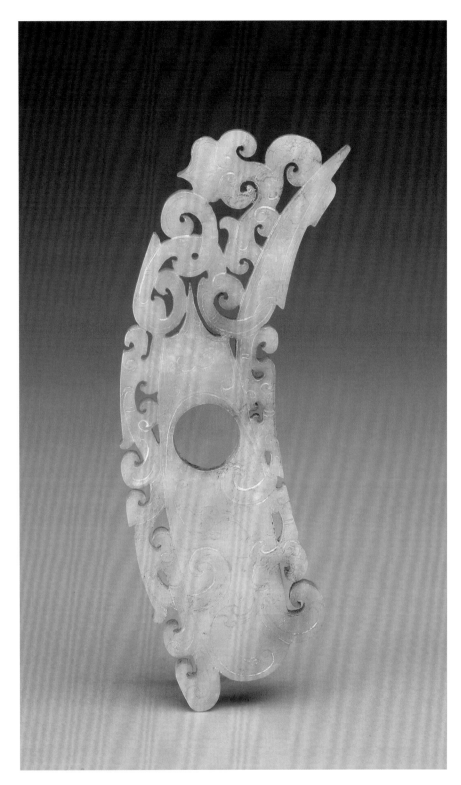

Jade Ornament with a *Chi*-dragon Carved in Openwork

Han Dynasty

Height 6.4 cm Width 4.3 cm
Thickness 0.7 cm
Qing court collection

This object is white, fine, and glossy. It has soaking-induced spots on some parts. The body of this object is in the form of a thick tablet and has a rim. Both sides are carved in openwork with drawings. The main drawing on one side is a *chi*-dragon. It has a large head and a bent body, with a tail of cord pattern design. The drawing on the other side is a tiger head.

The use of drawings of *chi*-tigers was popular on the jade ware of the Han Dynasty. Most of the imperial seals of kings, emperors, and feudal lords used buttons of white jade *chi*-tigers. This object, therefore, must have been used by someone of a high status. The shape of this object is strange, and its carving, elaborate. It could be a pendant worn on a human body, or it could be inlaid ornaments in the lower end of a sword sheath.

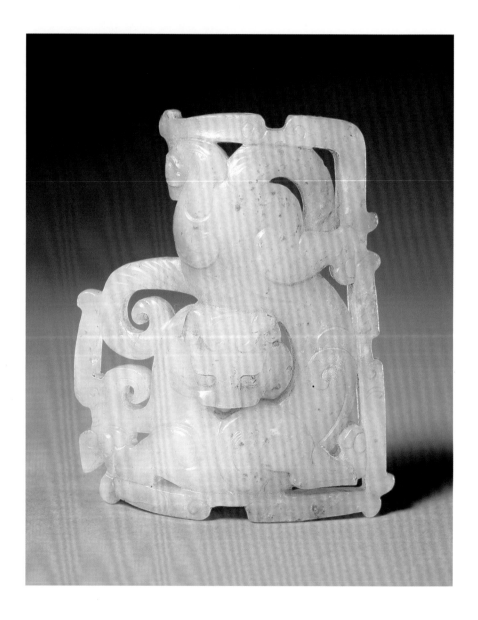

92

Yanmao Jade

Han Dynasty

Length 2.4 cm Width 1.2 cm
Thickness 1.2 cm

This white jade object forms a long and square column, with a hole in the middle. Each of the four sides of its outer wall is engraved with two lines of inscriptions written in intaglio and clerical script, with a total of thirty-two characters.

This object is a kind of jade pendant ornament of the Han dynasty. As the first line started with the two characters "*yanmao*", it was thus named. This object has the same shape, connotation, and use of *gangmao*. Besides, *A History of Han* (Hanshu) calls *gangmao* and *yanmao* as the "two *yin*", which is suspected to be a typo inscription error of "two *mao*".

93

Gangmao Jade

Han Dynasty

Length 2.4 cm Width 1.2 cm
Thickness 1.2 cm

This object, made of white jade, has slightly brown soaking-induced spots on its surface. It is a long square column, with a hole in the middle. Each of the four sides of the outer wall has two lines of inscriptions written in intaglio and clerical script, totalling thirty-four characters.

This object is a kind of jade pendant ornament of the Han Dynasty. As the first line started with the two characters "*gangmao*", it was thus named. The jade to be used depended on the status of the person. This is one of the two pieces as a set, but the characters carved were different.

94

Jade Flying Horse

Han Dynasty

Height 5.5 cm Length 7.5 cm
Width 3 cm
Qing court collection

This object is made of blue jade. As it had been burnt, its surface turned grayish black, and there are no clear skein clefts, which shows that its texture is originally of high quality. It has a flying horse carved in round in a crouching posture. The head of the horse is relatively small. It has low eyebrows, square cheeks, a slightly open mouth, and a short mane. The sides of the body are decorated with feathered wings, which are formed by feathers in the front and rear groups. Its tail is curled up, and the end of the tail droops. The three legs are tucked under the belly. The right front leg steps on the ground, with the intention of standing up.

The horse is an animal that is commonly seen in jade ware. It appeared as early as in the Shang Dynasty, but mostly in tablets. It was not until the Warring States period and the Han Dynasty that there were more works carved in round.

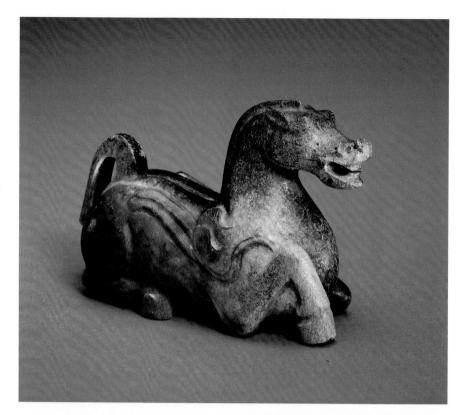

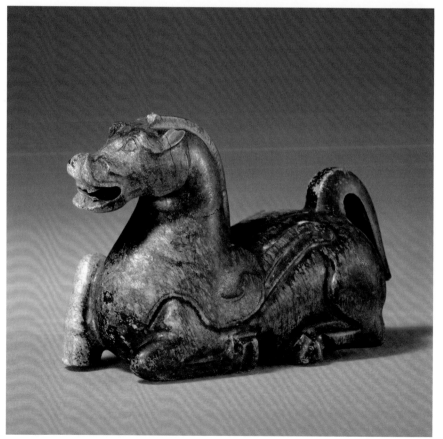

95

Jade Crouching Goat

Han Dynasty

Height 3.1 cm Length 5 cm
Width 2.2 cm
Qing court collection

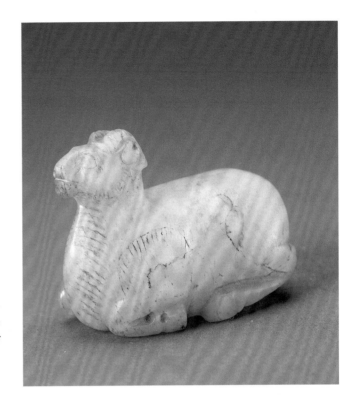

This object, made of bluish-gray jade, has brown soaking-induced spots on some parts. It depicts a crouching goat carved in round. Its head is raised, looking forward. The eyes are formed by adding curved lines outside circles. The two horns are in a C-shape. Under the neck are wool patterns. One of the front legs is crouching, and the other, rising. The rear legs crouch on the ground.

Jade goats started to be made as early as in the Shang Dynasty. They gradually faded away after the Western Zhou Dynasty, but reappeared in the Han Dynasty. Most of the jade goats of the Han Dynasty are carved in round. A large majority of jade goats are for pressing down things or decoration. As *yang* (goat) is homophonous with *xiang* (good), it carries the meaning of auspiciousness.

96

Jade Crouching Turtledove

Han Dynasty

Height 2.2 cm Length 5.3 cm
Width 3.1 cm
Qing court collection

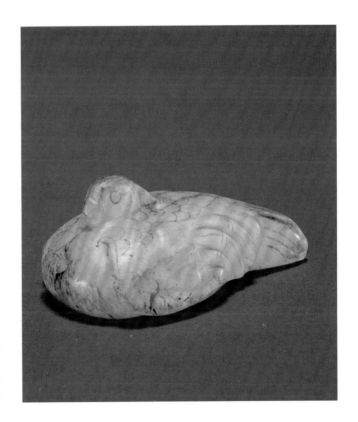

This object is bluish-white, pale, and aged. It features a small-headed crouching turtledove carved in round. The top of its head has long feathers. It has a hooked beak and a short neck. The wings and tail of the turtledove are decorated with striped long feathers, and its body has scales in the shape of small feathers.

This object is the head of a turtledove stick. The Han people believed that turtledoves could not be choked on food. The government, therefore, gave turtledove-head sticks to old people to wish them luck and longevity. In "Chapter 5: Records of Rites and Ceremonies" in *A History of Later Han* (Houhanshu), it is said, "People aged seventy were given jade sticks….When they were eighty or ninety, they were treated with more courtesy. They were given jade sticks with a long ruler, and the head of the stick was decorated with a turtledove's head. As turtledoves were birds that could not be choked on food, they hoped that the old people would not be choked on food."

97

Jade *Pixie* Animal

Han Dynasty

Height 3 cm Length 10.9 cm
Width 4.5 cm
Qing court collection

This object, made of bluish-white jade, has a large area of brown and reddish-yellow soaking-induced spots. The *Pixie* animal is carved in round. Its head stretches forward, and its mouth is slightly open. It has horns on the top of its head. It features a thick neck and a short body with wings on both sides. The wings are formed by feathers of the front and rear groups. Its four short and thick legs crouch on the ground.

Pixie was an auspicious animal in the imagination of the ancient people. Several types of auspicious animals have been discovered since the Han Dynasty. They have different shapes and complicated designations, being called either *tianlu* (heavenly emolument) or *pixie* (fabulous animal). They all carry the connotations of luck and auspiciousness. A piece of jade *pixie* animal, which closely resembled this piece, was unearthed from a Han tomb at Weiling in Shaanxi. The fact that these two similar pieces were discovered in different periods and in different areas illustrates that jade pieces with the *pixie* animal were popular in the Han Dynasty.

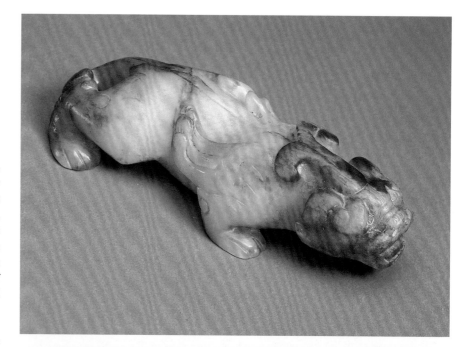

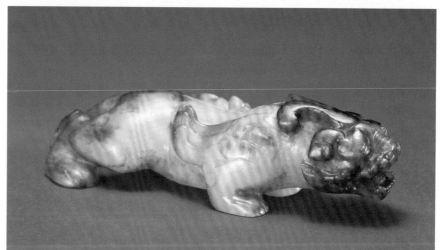

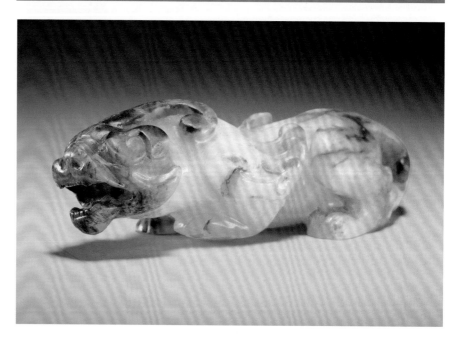

98

Jade Bottle with a *Kui*-phoenix Motif

Han Dynasty

Height 12.3 cm
Diameter of Mouth 6.9 cm
Diameter of Leg 6.8 cm
Qing court collection

This object, made of bluish-white jade, has brown soaking-induced spot. The bottle is barrel-shaped and has a round bulging lid whose surface is decorated with hooked cloud patterns. Bulging in the middle is a multi-petal knob, and the edge of the knob is decorated with a whirlpool and small flower petals. The perimeter features three side knobs carved in relief. The outer wall of the bottle is a bulging *kui*-phoenix in the shape of folded belts, interlaced with grain patterns. On one side of the bottle is a ring-shaped handle with a cloud-shaped plate decorated with a beast mask motif. The bottom support has three hoof-shaped legs.

Bottles were mainly wine-containers in the Han Dynasty. This type of bottle was rather popular in the Han Dynasty, with different materials, such as bronze, lacquer, or jade. The bronze bottle of the Han Dynasty unearthed from Youyu county in Shanxi in 1962 had inscriptions such as "wine-warming bottle", which was the basis on which the designation of this type of object was made.

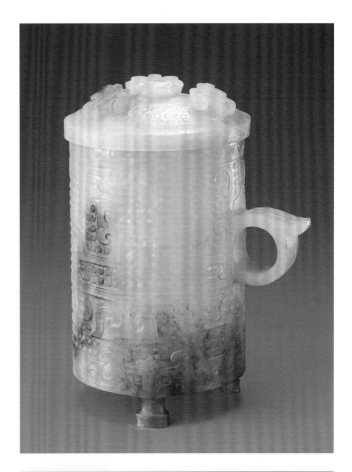

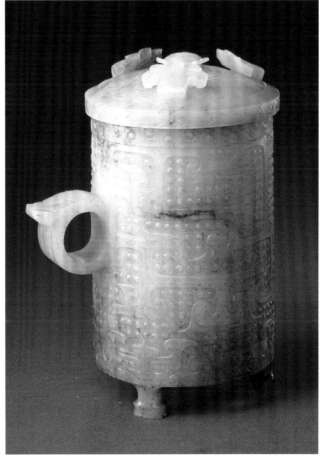

99

Large Jade Disk with Grain Patterns and Characters "*Changle*" (Eternal Bliss)

Eastern Han Dynasty

Full Height 18.6 cm Disk Diameter 12.5 cm
Diameter of Hole 2.6 cm Thickness 0.5 cm
Qing court collection

This object, made of bluish-brown jade, has deep brown soaking-induced spots on some parts. The body is flat, round, and with edges. Both sides of the disk are decorated with bulging grain patterns. Carved in openwork on the inner and outer edges is a band of bow patterns. Carved in openwork on the edged places is an inscription of the two characters "*changle*" (eternal bliss). On both sides of the characters are symmetrical *chi*-tigers also carved in openwork.

The width of this object roughly doubles the diameter of the hole, which conforms to "Explanations on Jade" in *Erya*: "The width is the double of the hole diameter, and this is called *bi* (disk)." This disk was handed down to the Qing Dynasty and was collected by the court during the reign of Emperor Yongzheng, and this was how the name settled on. Emperor Qianlong loved this disk. He composed a poem and engraved it in seal script on its outer edge. He signed with the characters "*Qianlong wushen yuti*" (inscribed by Emperor Qianlong in the year of *wushen*). Qianlong *wushen* corresponds to the 53rd year of Emperor Qianlong (1788 A.D.).

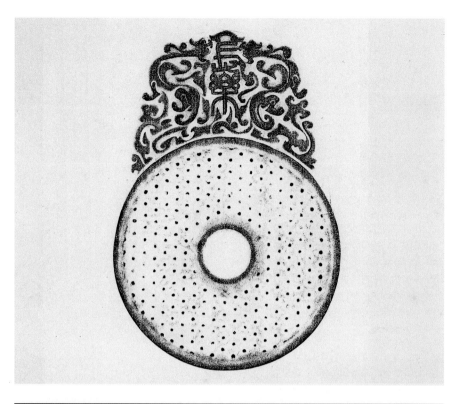

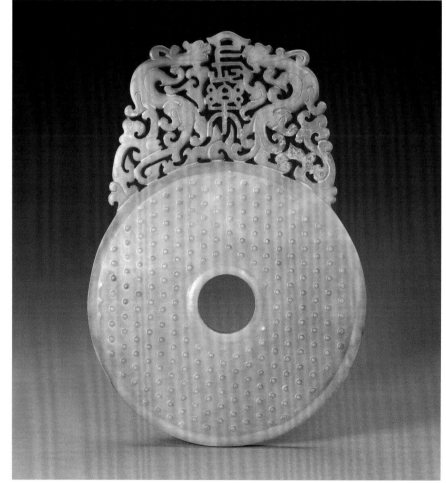

100

Large Jade Disk with Grain Patterns and Characters "*Yishou*" (Longevity)

Eastern Han Dynasty

Full Height 13.2 cm Disk Diameter 10.5 cm
Diameter of Hole 2.7 cm Thickness 0.5 cm
Qing court collection

This object, made of yellowish-white jade, has dark red soaking-induced spots on some parts. The body is flat, round, and with edges. Both sides of the disk are decorated with bulging grain patterns. The inner and outer edges are decorated with a band of bow patterns. The edges have a *chi*-dragon and a dragon, embracing the two characters "*yishou*" (longevity) carved in openwork.

Edged disks were very popular from the Warring States period to the Western and Eastern Han dynasties. But it was only in the tombs of the Eastern Han that disks carved in openwork and engraved with inscriptions were found. Of all the pieces handed down, there are only two pieces in the collection of the Qing court. They entered the inner court during the years of the reign of Emperor Yongzheng.

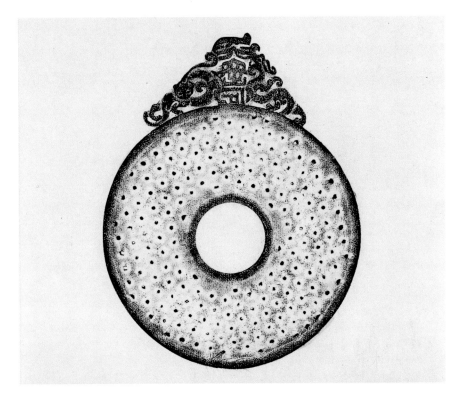

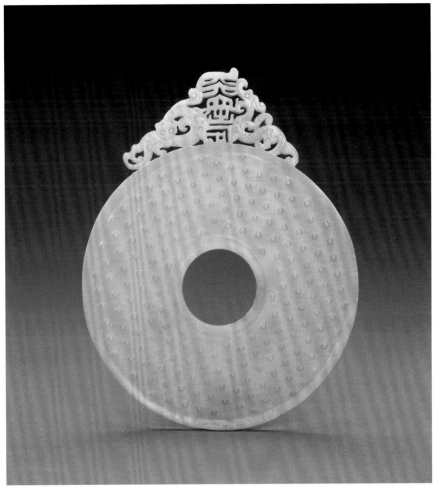

101

Jade Handle-washer with *Chi*-dragon and Dragon Motifs

Eastern Han Dynasty

Height 2.8 cm
Length 16.8 cm Width 14 cm
Qing court collection

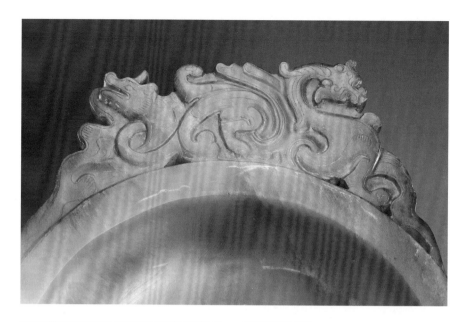

This object, made of bluish-yellow jade, has deep brown soaking-induced spots on some parts. The washer has a round mouth, a broad edge, a vertical wall, and a shallow and flat base. The outside of the rim of the mouth is flat in the shape of three tablet handles, decorated with drawings in intaglio lines. The first is decorated with patterns of a *chi*-dragon and a dragon. They are back to back, and the body is hidden amidst clouds and water. The second has dragon patterns, and the third, a small handle, with decorations that look like either clouds or bird's heads.

The washer is a tool in a study for holding water to wash brushes. In the period of the Eastern Han Dynasty, jade stationery was used frequently. But this is the only piece of jade washer in this form.

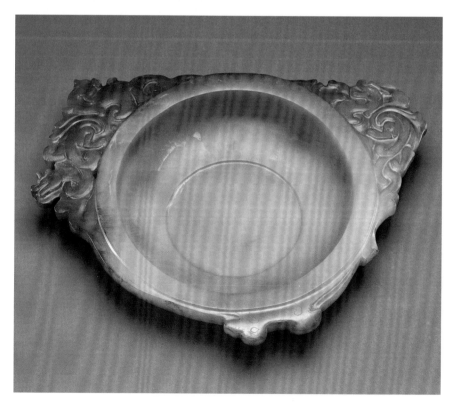

102

Cicada-shaped Jade Mouthpiece

Han Dynasty

Length 6.1 cm Width 2.9 cm
Thickness 0.8 cm
Qing court collection

This object, made of white jade, has earthy brown soaking-induced spots. The body of the piece is flat, its centre is slightly thicker, and the sides are gradually thinner. It is carved in the shape of a cicada, with a protruding head and eyes. The front and the back sides have broad intaglio lines to carve out some parts, such as the head, chest, belly, wings, and tail. The tail and wings are in the shape of an inverted triangle. A sharp point can be observed at the tip of the end.

Jade cicadas appeared as early as in the tombs of the Hongshan Culture, usually as a pendant ornament. It was not until the time of Han and Wei dynasties that it served as a mouthpiece, placed into the mouth of the dead. The majority of jade cicada mouthpieces of the Han Dynasty had vivid images. The cutting may be simple, yet it was strong and forceful. The lines were firm, and every cutting was sharp. They usually did not have holes. Some jade cicadas had holes, allowing them to be used as pendant ornaments.

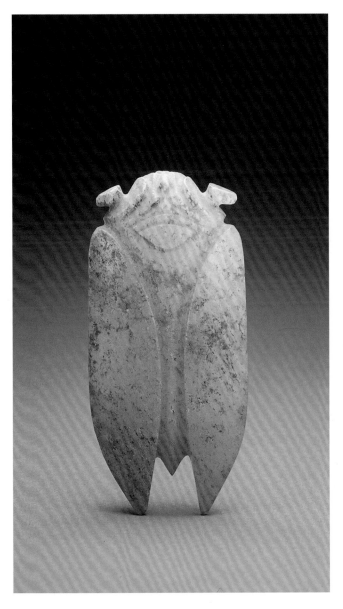
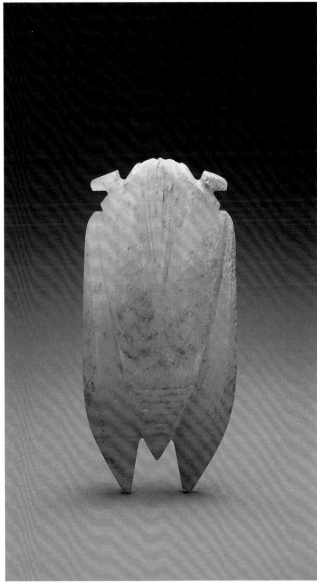

103

Jade Belt Hook with a *Chi*-dragon

Han Dynasty

Height 2 cm
Length 7 cm Width 1.6 cm
Unearthed from the Daisheng Tomb at
Haizhou, Jiangsu in 1977

This object, made of blue jade, has a layer of brown soaking-induced spots. The head of the hook is in the shape of a beast's head. The body of the hook is carved in openwork as a *panchi*-dragon. The back of the hook has a knob, which can be tied.

The craftsmanship of this hook belt is superior. It is a typical piece of hook belts with a *chi*-dragon motif in the Han Dynasty. Belt hooks became popular in the Warring States period, and they were used in various ways. This type of short hook is used to buckle into a belt. The head of the hook is on the downside so that it can be used for hanging things.

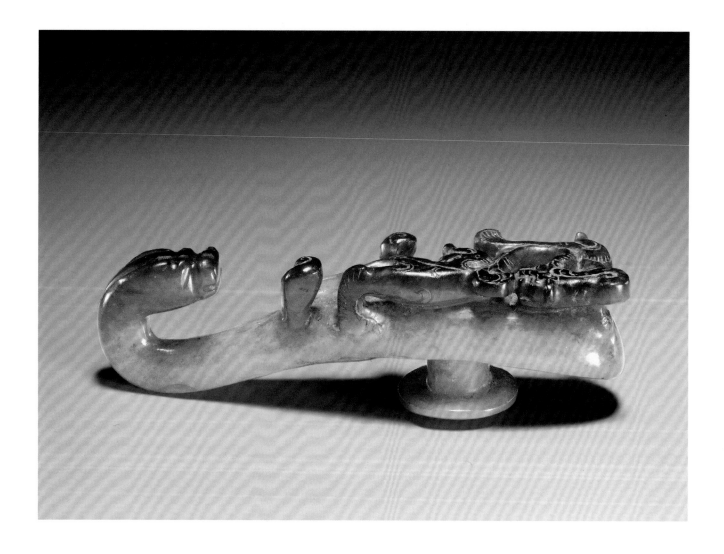

122

104

Jade Belt Hook with a Bird Head

Han Dynasty

Height 2.1 cm
Length 3.9 cm Width 1.9 cm
Unearthed from the Daisheng Tomb at
Haizhou, Jiangsu in 1977

This bird-shaped belt hook, made of bluish-white jade, has small black spots. The head of the hook represents a bird's head, whereas the belly of the hook is a bird's body. The feathers of the wings are formed by terse, thick lines in intaglio. The back of the hook has round buttons.

The carving of this work is simple but forceful, or what the people of the Qing Dynasty called the style of "eight cuts of the Han Dynasty", carving out works with a few cuts.

105

"Gong"-shaped Jade Vessel

Han Dynasty

Length 3.1 cm Width 3.1 cm
Thickness 0.8 cm
Qing court collection

This object, made of dull blue jade, has red soaking-induced spots. This vessel, which forms a square tablet, has its middle part protruding and the both sides concave to form grooves, resembling the character "gong". Between the two grooves is a hole, which can be stitched for decoration.

This kind of work was popular in the Han Dynasty and Ming Dynasty. It was an ornament piece stitched on clothes as decoration.

106

Pixie-shaped Jade Inkstone Water-dripping Pot

Han Dynasty

Height 5.3 cm Width 4.7 cm
Qing court collection

This object, made of bluish-white jade, has yellowish-brown soaking-induced spots on some parts. The shape of the jade is followed in carving the crouching *pixie* animal. The animal is nodding its head, opening its mouth, and curling its long tail from the lower part of the body up to the front part. On the body of the *pixie* animal are three little *pixie* animals in different postures carved in relief. This piece is empty inside and has a hole on the top of its head.

This object was a vessel for storing water in the Han Dynasty. It was used in the studio for dripping water when grinding an inkslab. Similar jade ware has been unearthed from the area of Yangzhou, with a silver lid on the top of its head.

107

Jade Beast Head

Han Dynasty

Length 4.2 cm Width 3.6 cm
Qing court collection

This object, made of dull blue jade, has yellowish-brown spots. It is a beast head carved in round. It has round eyes, thick eyebrows, and horns on its head.

This work was an inlaid ornament. It served as the head of a sword or a stick.

108

Jade Sword Nose with *Chi*-dragons

Han Dynasty

Height 10.1 cm Width 2.15 cm
Thickness 2.2 cm
Qing court collection

This object, made of white jade, has slightly heavy brown soaking-induced spots on its end part. Mother and son *chi*-dragons are carved in relief in the square nose of the sword. The large *chi*-dragon has a bent body and a long tail. The small *chi*-dragon, on the other hand, is sketchy in the shape of its body. The back of this vessel has a hole, which can be threaded with a string.

This kind of jade ware was found frequently in sites of the Han Dynasty. It was usually decorated at the middle part of a sword sheath, which was called by the ancient people *zhi* (nose), and its decorative patterns were mostly beast masks, grains, clouds, and *chi*-dragons. This nose was made in a complicated way, and it constitutes a gem of this type of work.

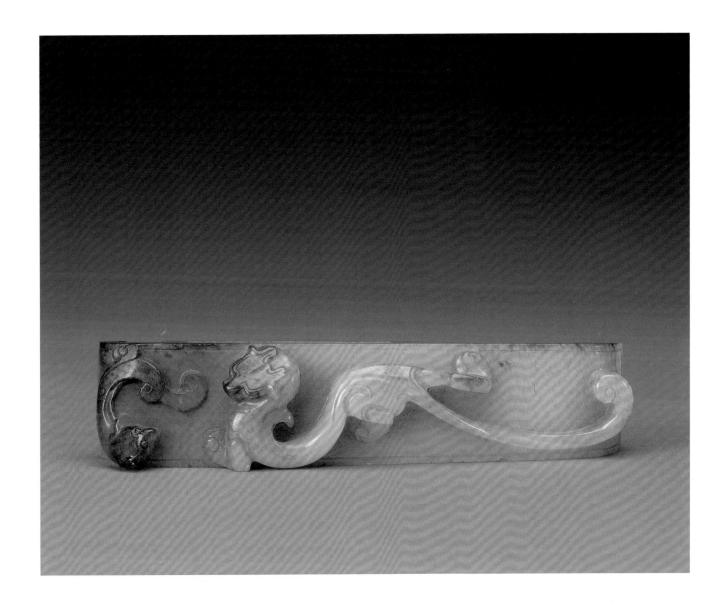

109

Jade Sheath Ornament with a *Chi*-dragon

Han Dynasty

Height 10.3 cm
Width 7 cm
Thickness 1.1 cm
Qing court collection

This object, made of blue jade, has slightly pale reddish and soaking-induced colours. The body of the sheath ornament is carved in openwork with hooked cloud patterns. Carved in round in its middle part is a crouching *chi*-dragon. The body of the dragon is short, small, and curved, with only two front limbs. Its head seems to have been broken due to injury. The broken place is taken as the head, which is carved with two eyes. The upper side of the object is flat and solid, and its other side has a hole for holding tenons.

Sword ornaments comprise the decoration of the lower part of a sword sheath. This ornament is larger in volume, unique in its shape, and exquisite in its carving. It is a gem in the art of the Han Dynasty.

110
Jade Sword Head with Whirlpool Patterns

Han Dynasty

Diameter 3.5 cm
Thickness 1.1 cm
Qing court collection

This object, made of white jade, has brown spots. The body is in the form of a round tablet. The surface is concave, like a plate. The surface of the middle part is bulging and spherical, decorated with whirlpool-like spiral lines in intaglio, and the periphery is decorated with cloud patterns with intaglio lines.

This work is the decoration of the end part of a sword handle, known as "sword head". During the time of Han Dynasty, swords inlaid with jade were known as "jade swords" (yujujian). They were a kind of pendant swords. Jade ornaments were inlaid at the end of the sword handle, between the sword handle and the brand, and the middle and lower parts of the sword sheath. Their designations are not unified. However, they are generally called the jade sword head, jade sword guard, jade sword nose, and jade sheath ornament.

111

Jade Sword Guard with Beast Mask Motifs

Han Dynasty

Height 2.2 cm Width 5.5 cm
Thickness 1.7 cm
Qing court collection

This object, made of white jade, has brown spots. Both sides of the guard are decorated with identical beast mask motifs. Its cross section has the shape of a water-chestnut whereas the middle part is thicker. The upper and lower parts have holes that allow a sword tenon to get through.

This work divides the handle and brand of a sword. It was used to protect the hands and serve as decoration. It is commonly known as the "guard of a sword". This type of guard is small and elegant and was popular in the Han Dynasty. But it is worth noting that it was only used in jade swords.

112

Jade Pigs
(A Pair)

Han Dynasty

Height 2.9 cm Length 11.2 cm Width 2.3 cm
Height 3.1 cm Length 11.4 cm Width 2.6 cm

These objects, one made of blue jade and the other made of reddish-brown jade, are two jade pigs carved in round in the shape of a long pillar. Relatively thick intaglio lines are used to decorate the facial features, the tail, and the legs, which are in a crouching posture.

Jade pigs, also known as *yuwo* and *yutun*, are frequently found in the tombs of the Han and Southern and Northern dynasties. This kind of burial jade ware is usually placed in the hands or under the arms of the dead, symbolizing wealth.

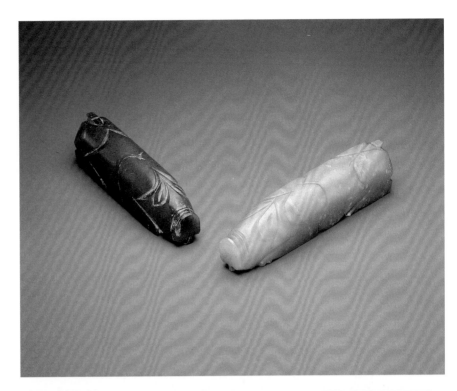

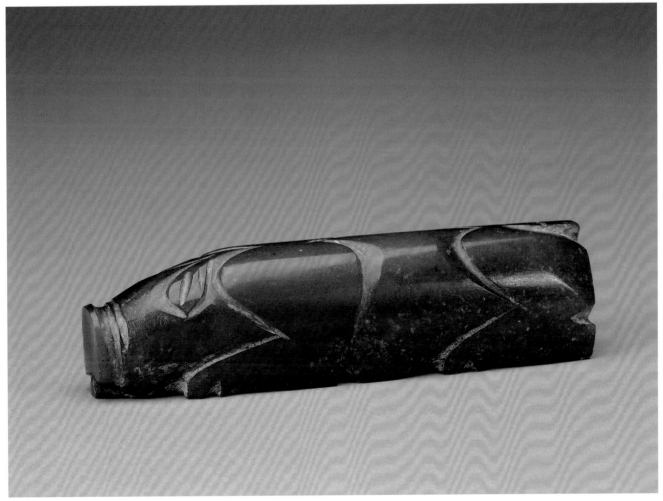

113

Jade Wengzhong
(Two Pieces)

Han Dynasty

Height 4.3 cm Width 1 cm

These objects, made of dark blue jade, have gray soaking-induced spots. Their bodies are flat, and carved in semi-round. The two images of Wengzhong are identical, and their shapes are simple. The top of their heads has long hair in a bun. The eyes and mouth are decorated with lines carved in intaglio. The waist has two bands of thick horizontal bows to represent their folded hands. They wear a long robe, stand upright, and look straight ahead. One of the pieces has the upper part of the body interlocked with fine gold wires. The waists of these two objects have holes for threading and wearing.

According to records in the *Annals of Ming Unification* (Mingyitongzhi), Wengzhong, surnamed Ruan, was a native of Annan of the Qin Dynasty. He was thirteen feet tall. His strength and courage were extraordinary. He was an awesome and courageous general feared by the Xiongnu. When he died, the First Emperor of Qin (Qin Shi Huang) made a bronze statue of him. Using his image as a pendant ornament might have served as a talisman for protection against demons.

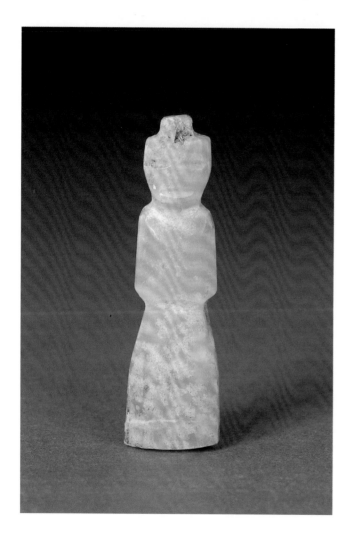

114

Jade Pendant with Dancers (Two Pieces)

Han Dynasty

Left: Height 4 cm
Width 2.2cm
Thickness 0.2 cm
Right: Height 4 cm
Width 2 cm
Thickness 0.3 cm

Left: This object, made of bluish-gray jade, has heavy soaking-induced colour on some parts. The body of the object is flat and triangular. Both sides are decorated with a jade figure in intaglio lines. This figure is dancing, with its long sleeves falling to the ground and its long skirt trailing on it. One of its hands dances over the top of its head, while the other hand was thrown between the sides of the waists. On the head and under the leg is a small hole each for tying a string for wearing.

Right: This object, made of deep blue jade, has light brown colour due to soaking and erosion. The body of this pendant is flat and triangular. It represents a dancer carved in openwork with fine intaglio lines. Its long skirt trails on the ground. One of its hands is raised over the top of the head, and the other hand is thrown between the sides of the waist. On the head and under the leg is a round hole each for tying a string for wearing.

115

Thumb-ring-shaped Jade Pendant with *Chi*-dragons Carved in Openwork

Han Dynasty

Height 7.3 cm
Width 5.7 cm
Thickness 0.4 cm
Qing court collection

This object, made of bluish-white jade, has brown spots on some parts. The pendant is in the shape of a tablet. The middle part forms the shape of a chicken heart. At the centre is a large hole. The two sides of the hole are carved in openwork with cloud and *chi*-dragon patterns.

This pendant evolved from the bow-pulling tool *she*. Since the Warring States period, *she* evolved into a tablet form that could no longer be used for pulling bows, but it was used more frequently as decoration. The wearing of jade thumb rings of the ancient people showed on the one hand, their technique in shooting, and on the other hand, their ability of making decisions.

Thumb-ring-shaped Jade Pendant with *Chi*-phoenixes Carved in Openwork

Han Dynasty

Height 7 cm Width 5.3 cm
Thickness 0.8 cm
Qing court collection

This object, made of white jade, has brown spots on some parts. The pendant is in the form of a tablet. The middle part has the shape of a chicken heart. The centre has a large hole, and there are *chi*-phoenixes carved in openwork on the two sides.

In works and records of the Song and Yuan periods, jade pendants of this kind were called *chijue*. They were popular in the Han Dynasty. By the time of Song and Ming, a large number of imitation works appeared.

117

Jade Stem Cup with Clouds

Han or Wei and Jin dynasties

Height 9.7 cm
Diameter of Mouth 4.6 cm
Diameter of Leg 3.5 cm
Qing court collection

This object, made of bluish-white jade, has deep brown soaking-induced spots on some parts. The rim of the cup is round, and it has a deep belly, a stem leg, and a ring-shaped handle. The outer wall of the cup is decorated with bow patterns and floating cloud patterns.

This form of jade cup first appeared in the Qin Dynasty, and became very popular in the Qin, and the Western and Eastern Han dynasties.

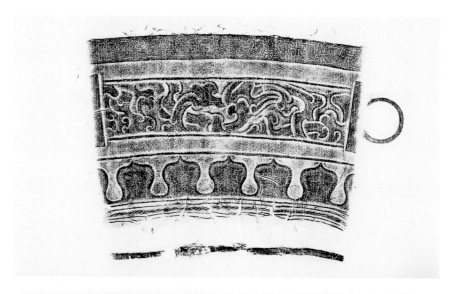

118

Jade Seal with a *Chi*-dragon and a Ring-shaped Button

Wei and Jin dynasties

Height 5.1 cm Length 5.1 cm
Thickness 0.5 cm
Qing court collection

This object, made of bluish-white jade, features brown spots on its surface. There is a *chi*-dragon carved in openwork. Its thin and long body is coiled into a ring shape. It has a curled-up tail. The front and rear feet step on its tail. Standing next to the side of the body of the dragon is a bird. The upper part of the vessel has a ring-shaped button with cord patterns, whereas its lower part has a square seal, with the character "*zhang*" carved in intaglio. The vessel has rings for tying strings and wearing it on the sides of the body as a pendant ornament.

A pendant ornament in the ring shape carved with coiling dragons was very popular in the Wei and Jin periods; however, it is rare to find one with a seal in the lower part. This seal is carved with a person's name and is believed to be carried around by the owner for use, but its exquisiteness makes it an ornament as well.

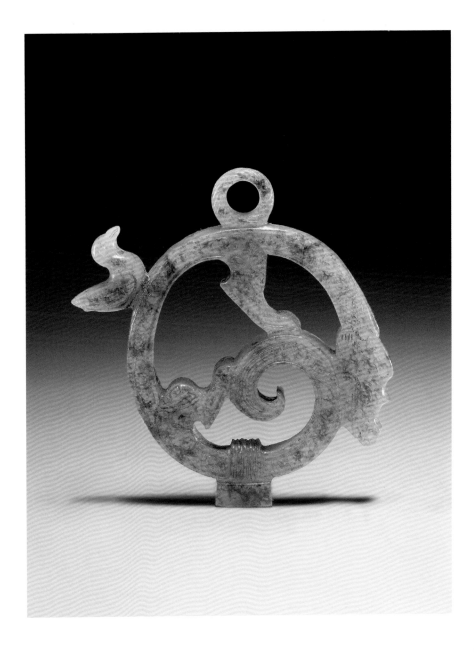

119

Semi-annular Jade Pendant with Cloud and Tiger Motifs

Wei and Jin dynasties

Length 7.8 cm Width 5 cm
Thickness 0.5 cm

This object, made of bluish-white jade, has yellowing on some parts. The body of the pendant is flat, forming a semi-ring shape. On one side is a tiger with a raised head and a stuck-out chest carved with intaglio lines and in light relief. Its ears are upright, and its eyes look straight ahead. It is opening its mouth and exposing its teeth. Its tail is curled up, and its legs are upright. It walks on its side, and the body of the tiger seems to have wings. The other side has "cross-shaped" floating clouds carved with intaglio lines, intersecting with other intaglio lines for joining. Each of the ends of the pendant has a round hole for tying a cord.

This vessel is the only rare semi-annular jade pendant piece decorated with a tiger motif in the Wei and Jin periods. Its "cross-shaped" floating cloud patterns were popular decorations of the Wei and Jin and the Southern and Northern dynasties.

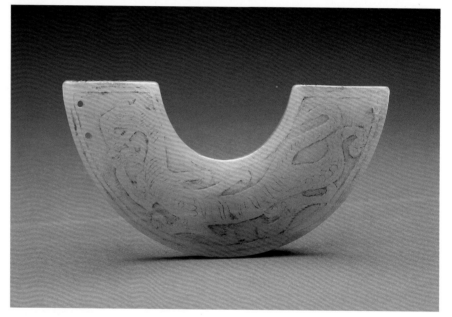

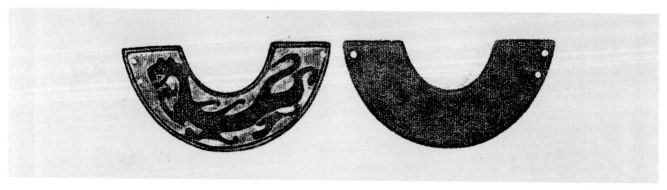

120

Jade Flying Horse

Wei and Jin dynasties

Height 4.2 cm
Length 7.8 cm Width 2.6 cm
Qing court collection

This object is made of bluish-white jade. It depicts a flying horse carved in round. The flying horse is in a crouching posture. Its head is raised, and it looks ahead. It is opening its mouth and exposing its teeth. Three of its legs are tucked under its belly, whereas its front leg steps on the ground. It features wings on both sides of the body. Its feathers and mane are carved with fine lines.

This vessel should be a jade weight. Its shape has the style of the sculpture of the Han Dynasty, but there are variations in the details.

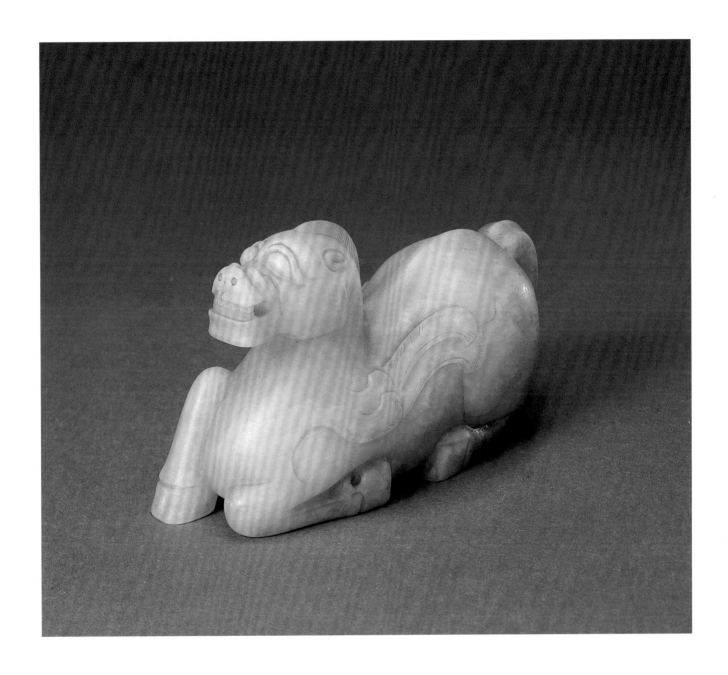

121

Jade Crouching Beast

Wei and Jin dynasties

Height 3.8 cm
Length 7.8 cm Width 2.5 cm
Qing court collection

This object, made of dull blue jade, has soaking-induced spots. It is a crouching beast carved in round, shaped like a horned rabbit. Its round eyes take a level look. Its four limbs have hoofs and are tucked under its belly. It also features a short tail. There are various intaglio lines decorating the body.

The shape and decorative patterns of this vessel have the style inherited from the Han Dynasty. It should be a continuation of the works of jade weights of the Han Dynasty.

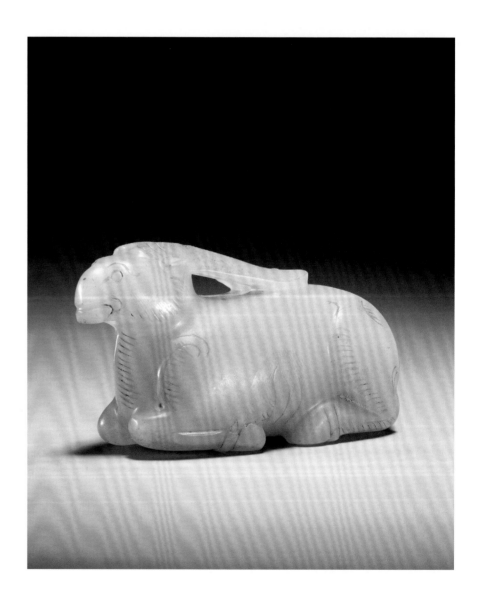

122

Top Gem of Jade Girdle Pendant with a Rosefinch Motif

Southern and Northern Dynasties

Length 9.6 cm Width 3.9 cm
Thickness 0.3 cm
Qing court collection

This object, made of dark blue jade, has a large area of reddish soaking-induced spots. Its body is flat and in the shape of a cloud's head. The decorative patterns on both sides are different. The front side is decorated with a rosefinch, with a long crown and a three-forked tail. It holds a pearl in its mouth and stands with its wings spread. Surrounding the rosefinch are drifting flowers and floating clouds. The backside is decorated with flame-like floating clouds, merging with belt-shaped double line patterns. The centre of the upper end of the pendant has a crescent-moon hole for tying a pendant.

The top gem of a jade girdle pendant is the uppermost horizontal jade of a jade pendant set. The decorative patterns on both sides differ, and its shape has clear features of its period. This has important value of reference when dating jade ware of the same type or in the same period.

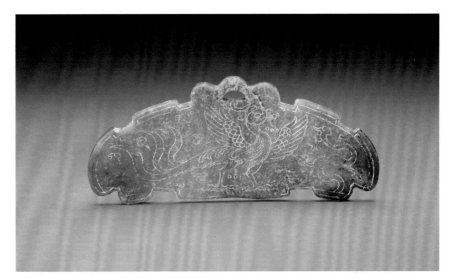

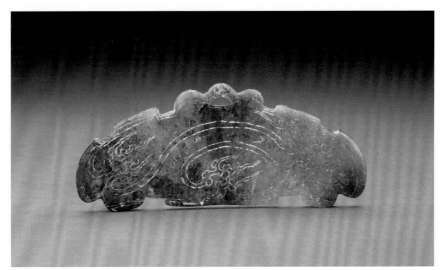

Sui and Tang to Ming Dynasties

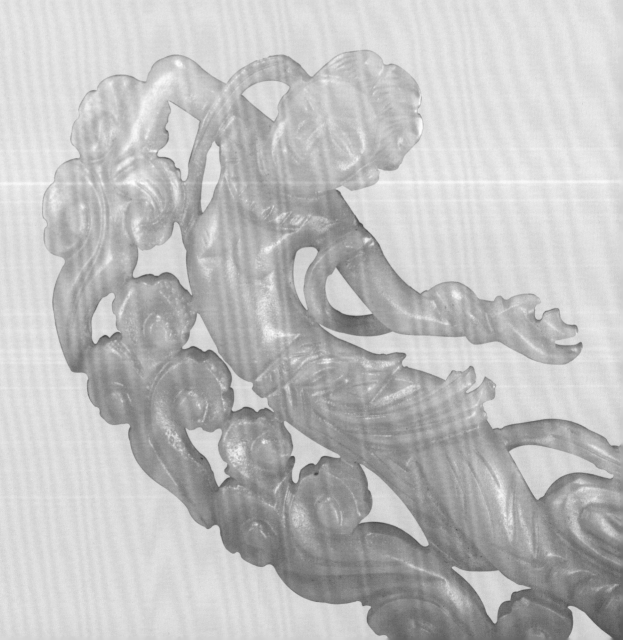

123

Oval Jade Cup with Figure Motifs

Tang Dynasty

Height 5 cm
Diameter of Mouth 14.9 x 8.5 cm
Diameter of Leg 1.7 cm

This object, made of dull white jade, has yellow spots. The cup resembles a boat whereas its mouth is oval. The wall of the cup is relatively thick. It includes a disk-like leg. The outside of the cup has six figures with large gowns and loose girdles carved in intaglio lines, in the postures of drawing out wine, raising a cup, holding a cup, clapping hands, holding a plate, and holding a pot respectively. The scene shows people of the Tang Dynasty having a gathering of intellectuals to dine and drink. The outer wall of the leg of the cup is carved with a band of cloud patterns in the shape of bundled grass.

This jade cup resembles a wine cup but does not have any handles. It was a transitional shape when the wine cups of the Warring States, the Han and Wei dynasties, and the Six Dynasties were evolved into the wine vessels of the Tang and Song periods. The patterns of the figures and the sitting postures follow the early Tang style.

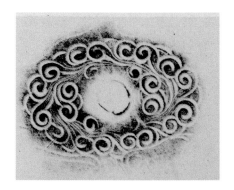

124

Jade Ornament with a Northern Barbarian Riding an Elephant

Tang Dynasty

Height 5.5 cm Length 7.4 cm
Width 2.4 cm
Qing court collection

This blue jade object is carved in round with a northern barbarian riding an elephant. The barbarian has round eyes and a nose, and is wearing tight clothes. Its right arm dances over its shoulders, and its left arm, placed before its chest, rides on the back of the elephant. The elephant is in a crouching posture, with its four limbs prostrated on the ground. The head of the elephant is relatively small, as well as its ears and eyes. Its trunk, on the other hand, is long.

Works with the motif of elephants first appeared in the jade ware of the Shang and Zhou periods. From the Warring States period to the Han Dynasty, works with the motif of elephants were, on the contrary, rare. The reappearance of jade elephants in the Tang Dynasty was closely related to the wide use of tamed elephants in this period, which also showed that the motifs of the Tang Dynasty jade ware became generalized and part of their life. Regarding the way the figures were created, the jade figures of the Tang Dynasty, in comparison to those of the Han Dynasty, had a great variety of clothing and images. Dancers of the Han Dynasty were more dignified and full of court aura, while dancers of the Tang Dynasty were more agile and lively.

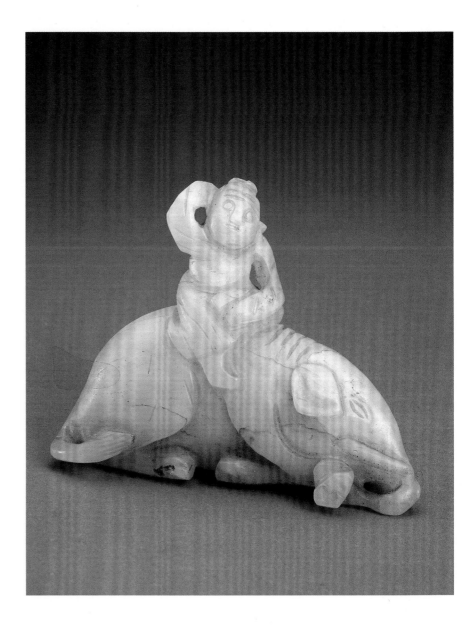

125

Jade Northern
Barbarian Dancer

Tang Dynasty

Height 5.5 cm Width 2.7 cm
Thickness 1.5 cm

This object, made of bluish-white jade, is yellowish-brown on some parts due to soaking. It has a northern barbarian carved in round. He is wearing a round hat and a long wide-sleeved robe. He also has a belt tied to his waist. His hands dance before the chest and after his head respectively. The front and rear legs are interlocked, in the posture of dancing.

The shape of this work is lively and of a relatively high artistic level. The motif of northern barbarians appeared frequently in the jade ware of the Tang Dynasty. They showed, in the main, the images of Middle and West Asian people sojourning during the Tang Dynasty.

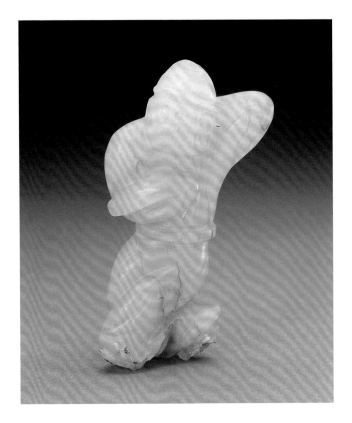

126

Jade Northern
Barbarian Playing a Lion

Tang Dynasty

Height 5.7 cm Width 2.2 cm
Qing court collection

This object, made of dull white jade, features yellow spots. It has a northern barbarian, carved in round, wearing a visor on his head. He wears a coat with double blazers and long sleeves in the upper part of his body, and a pair of trousers in the lower part. His left foot stamps on a little lion prostrated sideward, in a playing posture.

There are many works of Yuan and Ming jade ware with the motif of people playing with lions. In general, the lions are larger in size, with ferocious features and full of movement so as to show the valiance of the lion players. This is the only piece of jade carving of a lion player in the Tang Dynasty. Yet this young lion is relatively small, and its movement is not clear. The lion player, however, appears to be tall. The static and the dynamic form a stark contrast.

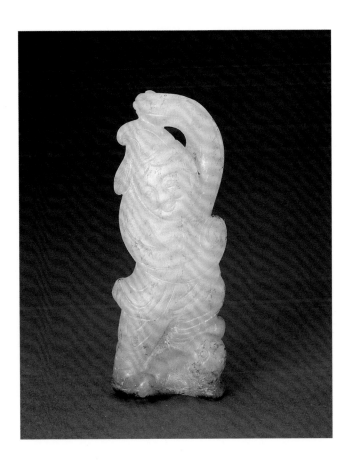

127

Jade Lion

Tang Dynasty

Height 1.5 cm
Length 6 cm
Width 4.5 cm

This object, made of bluish-white jade, has brown spots on some parts. This is a crouching lion carved in round. Its head rests on an object. Its mane is knotted into a bun. It has round protruding eyes and a curled-up nose, and is opening its mouth and exposing its teeth. Its front claws stretch out, and the tips of the claws are sharp. Its rear leg is bent like a bow. The small tail droops and coils. There are fine hair on its body.

Some "*sancai*" (tri-coloured glazed pottery of the Tang Dynasty) crouching lions were unearthed from the Underground Palace of the Famen Temple. Their shape is similar to this object, proving that it was an object of the Tang Dynasty. According to the records, it was during the Han Dynasty that lions began to be introduced from the Western Regions to China. From then on, the shape of a lion began to appear in all sorts of artefacts. However, the making of a lion with jade began with the Tang Dynasty at the earliest, and this object is an example.

128

Jade Crouching Beast

Tang Dynasty

Height 3.1 cm Length 5 cm Width 2 cm
Qing court collection

This object, made of bluish-white jade, has yellow spots. This is a crouching beast carved in round. Its head is carved in a complicated way. It has thick eyebrows, ring eyes, an S-shaped nose, and a broad mouth. There are patterns of fine and intaglio lines on its eyebrows, mouth, and cheeks. It has a thick neck and a bent body. It lies on the ground with its four limbs bent forward. The tail is divided into three forks. Two of them are curled up sideward. The middle fork is raised up.

129

Jade Jar with Three Turtledoves

Tang Dynasty

Height 6.4 cm
Diameter of Mouth 4.9 cm
Diameter of Leg 5 cm
Qing court collection

This object, made of bluish-white jade, has brown soaking-induced spots on some parts. The jar has a round mouth, and the edge of mouth is slightly exaggerated. It has a short neck, a bulging belly, and flared feet, whose walls have three holes. Along the outer edge of the belly of the jar are three carved turtledoves. They all have raised heads, round eyes, and slightly open mouths. They spread their wings and stand in a circle. The top plume and the edge of the mouth are linked. The foot is carved on the leg of the jar.

The heads of the turtledoves in this jar can be threaded with a string so that the piece can be hung.

130

Jade Crouching Horse

Tang Dynasty

Height 4 cm
Length 6.8 cm Width 3 cm
Qing court collection

This object was burnt, and its entire body is black, losing the original colour of jade. It is a crouching horse carved in round. The middle part of the top of its forehead is bulging. Its neck is short and thick. It has a broad chest and a short body. Its four limbs are tucked under its belly, and its tail is long and droops. The trunk part is curled up. The trunk of the tail, carved in openwork, has a hole.

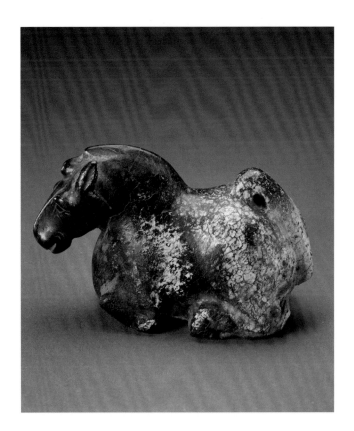

131

Jade Hairpin Head with a Red Phoenix Carved in Openwork

Tang Dynasty

Length 11 cm Width 4.8 cm
Thickness 0.2 cm

This object, made of white jade, has no wrinkles. The body of the object is flat in the shape of a water drop, and relatively thin. The methods of carving in openwork and carving with intaglio lines have been used to decorate the object with the motif of a red phoenix facing the morning sun. The phoenix is in a crouching posture. It has a large head and a small neck. Its wings are short and broad, with their ends back-slabbing. Carved under the body of the phoenix are patterns of curly grass and peonies. The lower part of the object has small through holes for hanging pieces. Inlaid on one end of the hairpin head is a gold ornament coated with silver. The body of the hairpin is broken and lost. From the traces of breaking, it should be of silver quality.

There have been jade hairpins at present and in the past. However, this is the first piece with the head of the hairpin made in jade and the body of the hairpin in gold. Furthermore, Jade ware with the decoration of a phoenix appeared early, but the combination of phoenixes, grass, and flowers, especially peonies, carved on a jade object began with the Tang Dynasty, and this is a representative piece.

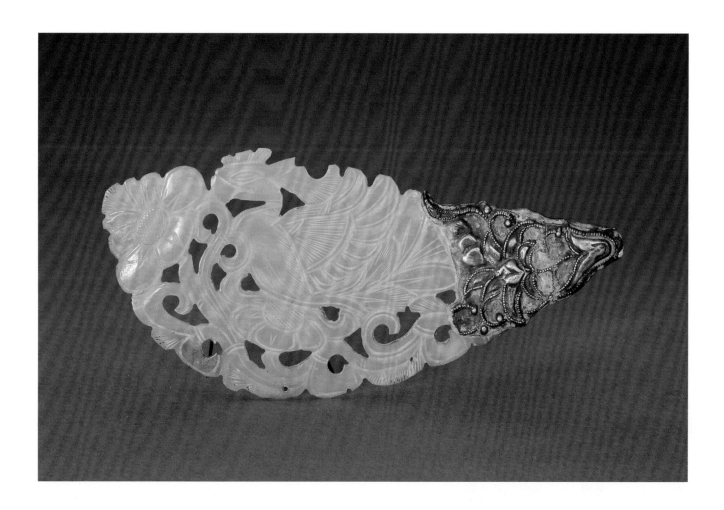

132

Jade Comb Back with Two Birds

Tang Dynasty

Length 5.7 cm Width 2 cm
Thickness 0.2 cm

This object, made of bluish-white jade, is yellowish on some parts due to soaking. The upper part of this tablet forms the shape of an arc. The decorative patterns on both sides are identical and represent two flying birds. The lower side of the comb back has a tenon for inlaying the teeth of the comb.

From the Tang Dynasty onwards, the jade carved artefacts in China gradually moved to elegance in processing, and their style became drastically different from those of the previous dynasties. The phoenix motif was a popular motif on the bronze ware of the Shang and Zhou dynasties, and it was continuously used in later dynasties, but with different styles and characteristics. The Tang phoenix motif was decorated with fine, dense, short, straight, and parallel lines carved in intaglio, generating an impression of vividness.

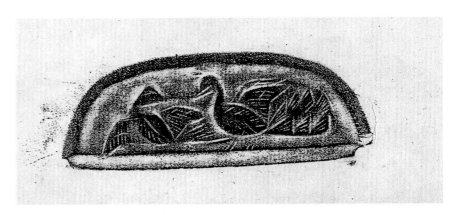

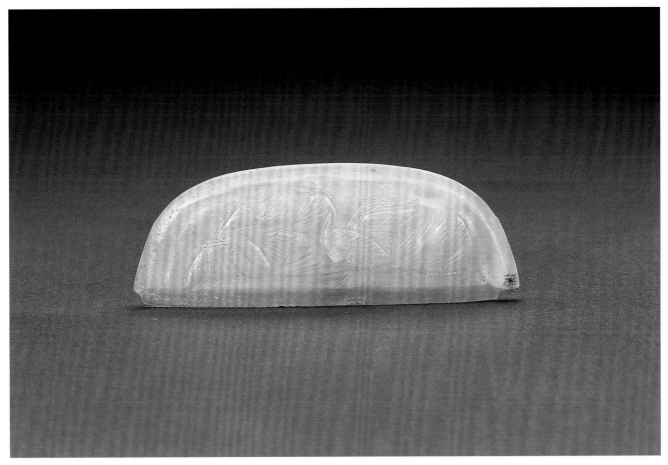

133

Jade Comb with Two Birds

Tang Dynasty

Length 10.5 cm Width 3.5 cm
Thickness 0.4 cm

This object, made of bluish-green jade, has earthy soaking-induced spots on some parts. The body of the comb is flat and thin, with a semi-circular shape. The decorative patterns on both sides are identical. It is made by carving the birds in openwork with the addition of lines carved in intaglio. The centre of the upper part of the comb has three flowers with similar shapes. Each of the sides shows a bird, with their heads facing each other. They are spreading their wings to fly, and their long tails curl down. The lower part is cut into the teeth of the comb according to the shape of the jade.

The jade combs that have been discovered so far are still works of the Shang dynasty and the Warring States period. Jade combs of the Tang dynasty differ from those of the previous periods. In terms of shape, combs before the Tang dynasty were mostly in a long semi-oval shape, whereas those of the Tang dynasty were in a semi-circular shape. In terms of decoration, combs before the Tang dynasty did not have any decorative patterns, or they might be decorated with patterns of *kui*-phoenixes and beast masks. Combs of the Tang Dynasty were mostly decorated with flowers and birds. In terms of teeth, those prior to the Tang Dynasty were long and coarse, whereas those of the Tang Dynasty were dense and fine.

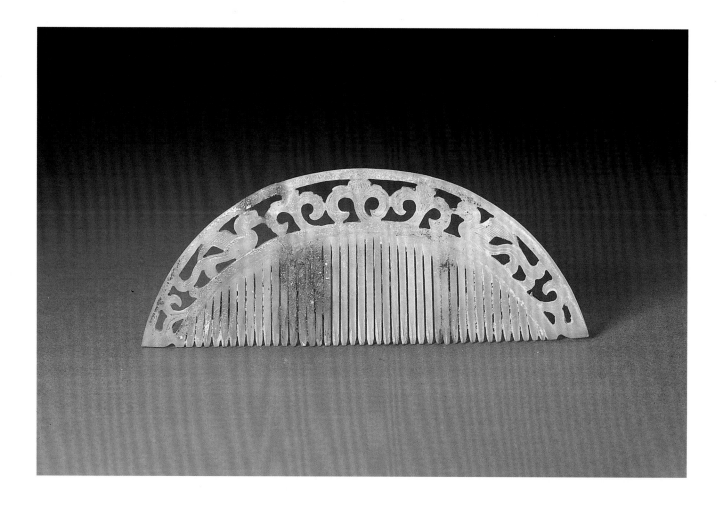

134

Jade Flying Apsara

Tang Dynasty

Height 4.6 cm Width 8.6 cm
Thickness 0.6 cm

This object, made of pale white jade, has a small amount of dull yellow soaking-induced spots on some parts. The entire body is in the form of a tablet. A flying apsara is carved in openwork. The upper part seems to be naked, and she wears a skirt in the lower part. It is in the posture of flying and dancing. A long draper floats to the back of the body, and under the body are clouds carved in openwork.

No jade flying apsaras have been found in the archeological excavations of the Tang Dynasty, but a few pieces of them were found in the sites of Liao and Jin. This work has been handed down from the past. The shape of its figures and the cloud patterns have the characteristics of jade designs of the Tang Dynasty. It must be a jade object of the Tang Dynasty.

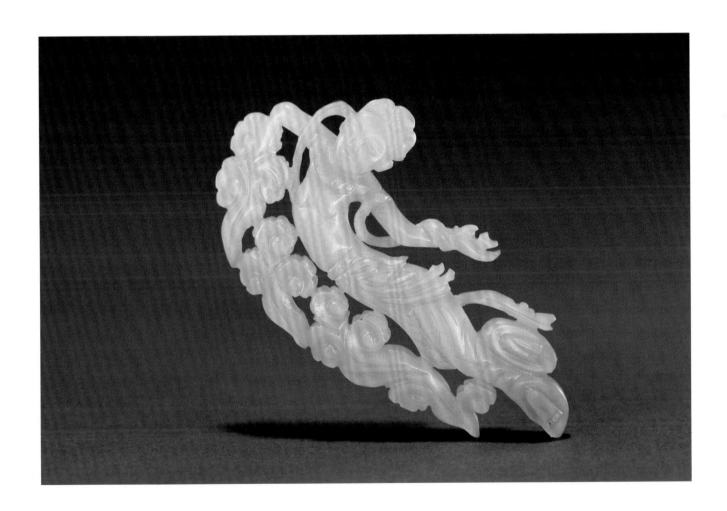

135

Jade Belt Plaque with a Northern Barbarian Presenting a Treasure

Tang Dynasty

Length 6.5 cm Width 6.2 cm
Thickness 1.2 cm
Qing court collection

This object, made of white jade, is slightly transparent. The belt plaque is in a flat square form. The front side shows a picture of a northern barbarian presenting a treasure carved in relief. The barbarian is on the carpet with one knee. He has curly hair, a high nose, and deep eyes. He has a draper with clouds on his shoulder and holds a tray with a pearl in flames in his hands.

In traditional lucky Chinese patterns, there were themes of tribute, such as northern barbarians or foreign tribes presenting a treasure. The intention is to show the respect and submission of the peripheral states or nationalities to the rule of the imperial court in the Central Plains. The Tang Dynasty was very active in economic and culture exchanges with foreign states, and the image of northern barbarians was commonly seen in its artistic works.

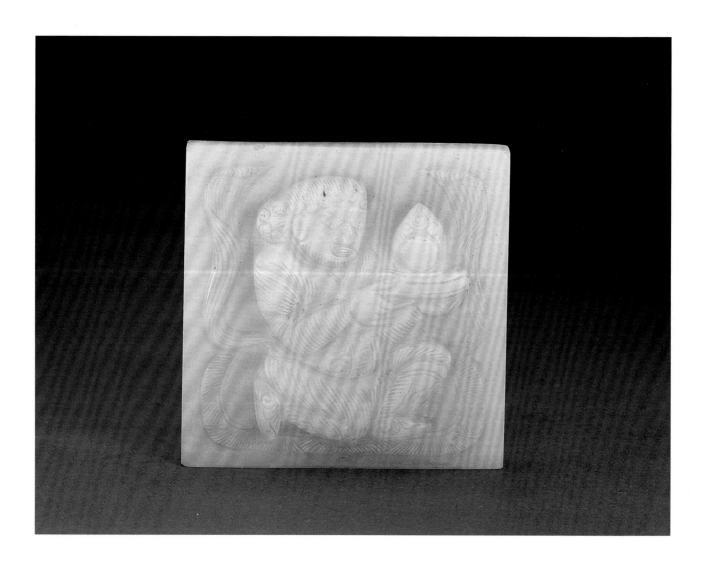

136

Ten-cornered Jade Cup with *Chi*-dragon Handles

Song Dynasty

Height 4.6 cm
Diameter of Mouth 10 cm
Diameter of Leg 5.6 cm
Qing court collection

This object, made of bluish-white jade, has brown soaking-induced spots on some parts. The body is in the shape of a decahedron, and the outside of the mouth is edged. It has a vertical wall, which is plain both inside and outside. It has decahedral legs. Both sides of the cup have handles, the upper part of which is decorated with patterns of clouds and a *chi*-dragon whereas the lower part of which features a simplified *kui*-dragon pillar.

The shape of this cup, which is decahedral, was especially trendy during the Song period. This was shown in ceramics, as well as gold and silver, and lacquer objects. The decorative patterns of this cup are classic and elegant, and it is a gem in jade carving with practical value.

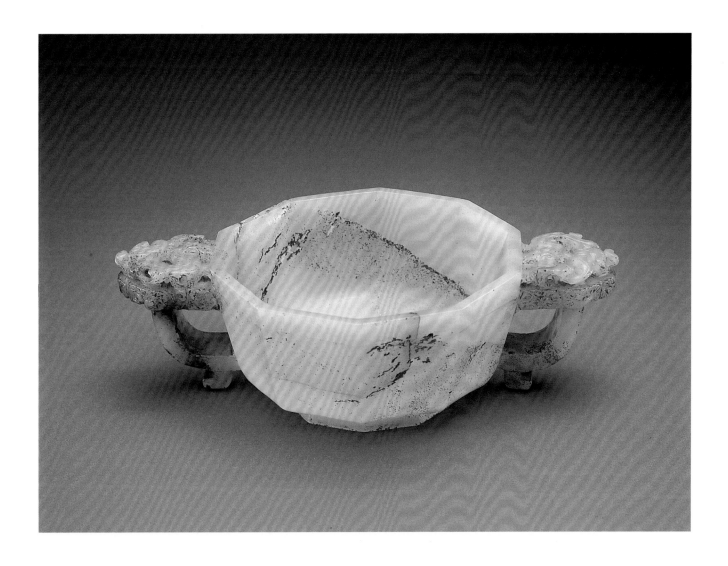

137

Jade Cup for Ceremony and Music with Two Upright Figure Handles

Song Dynasty

Height 7.5 cm
Diameter of Mouth 11.4 x 11 cm
Diameter of Leg 4.5 cm
Qing court collection

This object, made of bluish-white jade, has brown soaking-induced spots on some parts. The cup has a round and slightly contracted mouth. It has a vertical wall narrowing downward and a ring foot. The inner wall of the cup is carved in relief with patterns of thirty-two clouds in the shape of a glossy ganoderma. Its outer wall is carved in relief with a scene depicting a ceremony and musical instruments on the brocade ground with wall and chequered patterns. There are ten musicians in groups of five. They are sitting or standing, and holding musical instruments, such as flutes, drums, gongs, reed pipes, and the *pipa*. The middle is decorated with a little deer, with its mouth holding glossy ganodermas. Each of the sides of the cup is carved in openwork with a celestial lady standing on the cloud as the handle.

This cup was an item passed down from the Qing court collection. This type of silver cup was unearthed from sites of the Song Dynasty, providing a basis for its dating. It can also be seen that there are imitation artefacts with dates engraved in the Qing court collection.

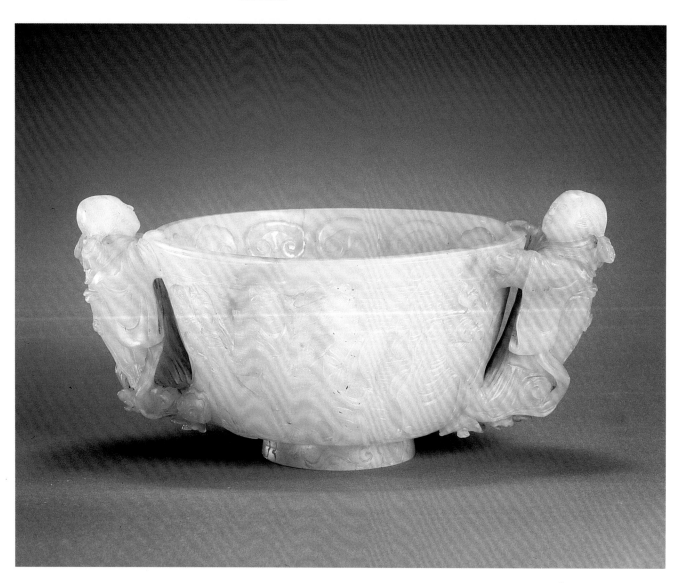

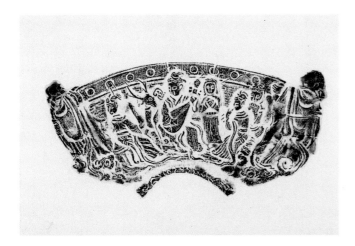

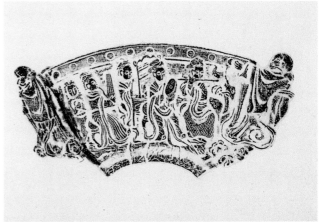

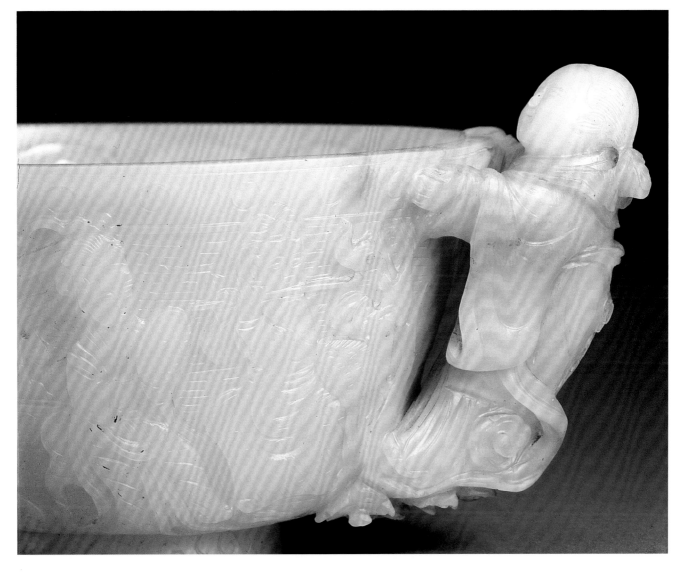

138

Single-handle Jade Cup with Flaming Pearl Motifs

Song Dynasty

Height 4 cm
Length 18 cm Width 12 cm
Qing court collection

This object, made of bluish-white jade, has light brown soaking-induced spots. This cup has a round mouth, a shallow curved wall, and a curved base. The inner and outer walls are plain, without patterns. The side of the cup has a ring-shaped handle, the upper end of which is decorated with a triangular handle with patterns of flaming pearls.

This jade object is the only piece of its kind. Only the ceramics of the Song Dynasty had something similar. Decorating a jade object with flaming pearl patterns was first seen in the Tang Dynasty.

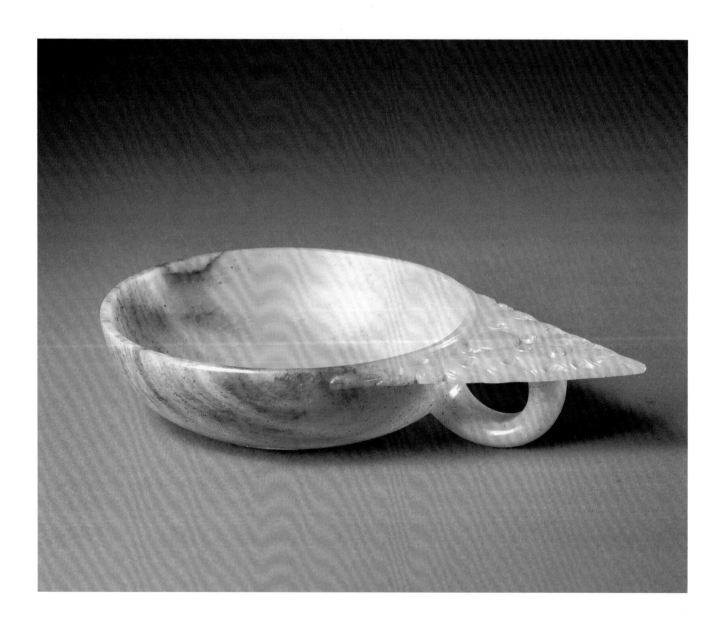

139

Dragon-handled Jade Cup with Petals

Song Dynasty

Height 6 cm
Diameter of Mouth 9.5 cm
Diameter of Leg 4.2 cm

This cup, made of white jade, seems to have been burnt and heavily weathered. The cup has a thick base. The mouth, whose edge is contracted outwards, forms five petals. It also has a ring foot. Carved on one side of the cup is a dragon, with small eyes and curled lips. The dragon's mouth joins its front limb at the edge of the cup. The body of the dragon is long and bent. The front section features the handle of the cup, whereas the rear section has a coiling dragon on the wall of the cup in high relief. The body of the dragon is decorated with scales, and the side of its body shows patterns of peony flowers and leaves.

This cup is a famous piece that has been handed down for generations. The motif of a dragon flying among peonies was mostly seen in the artefacts of the Song and Ming periods. The shape of dragons in many works is elegant and beautiful, and peonies are carved and drawn in a concise way. This cup is a representative piece of the Song and Ming periods.

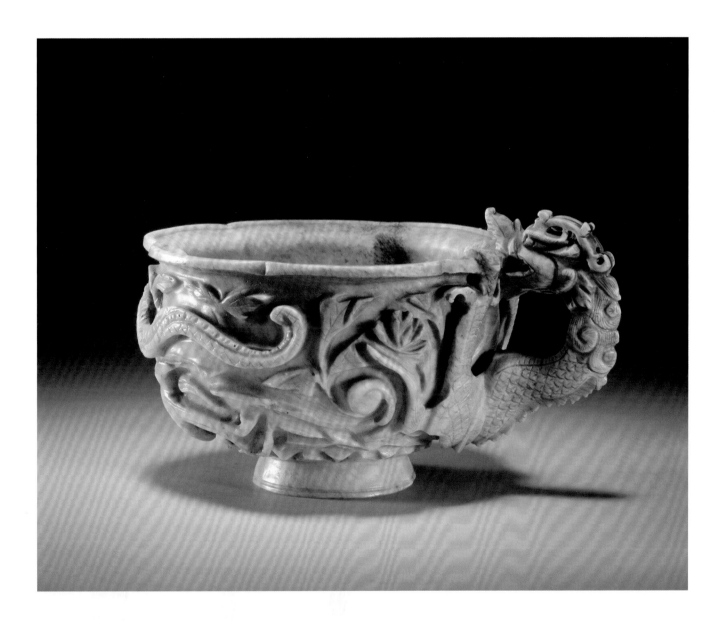

140

Jade Strange Beast

Song Dynasty

Height 5.2 cm
Length 6.1 cm Width 2.5 cm
Qing court collection

This object, made of dull white jade, has reddish stripes and gossamer. It represents a strange beast carved in round and in a crouching posture. It has a raised head, a horn, spiral ears, flat eyebrows, upturned tips of the brows, and round eyes, and is opening its mouth and exposing its teeth. Its neck is short and thick, and its chest, broad. Its four limbs are tucked under its belly. Its tail with three buns of features sticks close to its thigh.

Literature of the Song and Yuan dynasties called this type of jade beast as *pixie* (fabulous animal). This work has the beast mask style of the Song Dynasty. Its shape and features correspond closely to what was recorded in the literature of the Song and Yuan dynasties. It should be a typical jade *pixie* of the Song Dynasty.

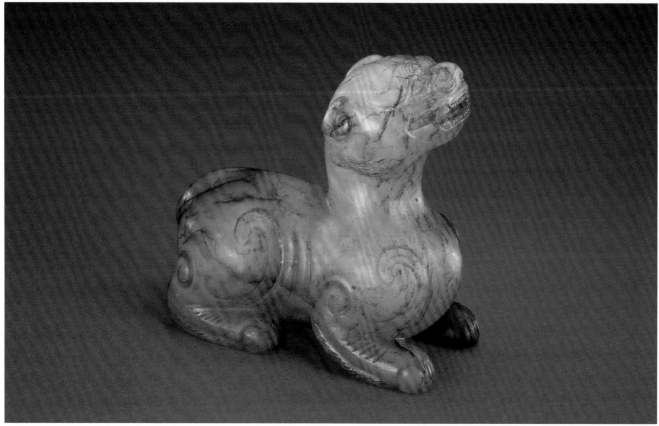

141

Jade Crouching Dog

Song Dynasty

Height 2.5 cm
Length 7.7 cm Width 4.5 cm

This object, made of white jade, has reddish spots. The dog has a long body and a slender waist. It is lying on the ground, turning back its head and lowering its ears. It has a bell under its neck. Its two front legs support each other. It seems to stretch its rear leg to scratch its neck.

A crouching beast of the Liao Dynasty was unearthed from the Inner Mongolia region, which is similar to this piece. It can thus be inferred that this is an animal carved in jade in the Song and Liao periods.

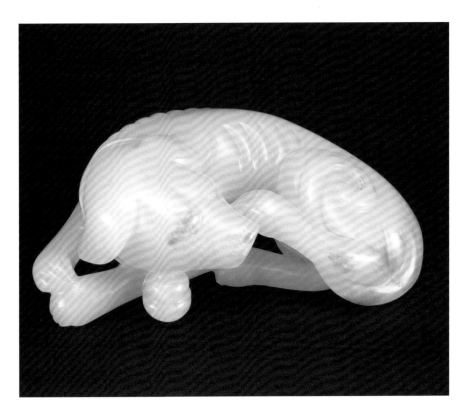

142

Jade Crouching Deer

Song Dynasty

Height 3.9 cm
Length 4.8 cm Width 1.4 cm
Qing court collection

This object, made of white jade, has been burnt and dyed, leading to the blackening of some parts. It represents a deer, carved in round, prostrating on the ground. It has a straight neck and cloud-like horns. It seems to be turning back its head.

There were a considerable number of deer-shaped jade objects during the Song, Liao, and Jin periods, and pendants, with lotus flowers in the lower parts of some objects.

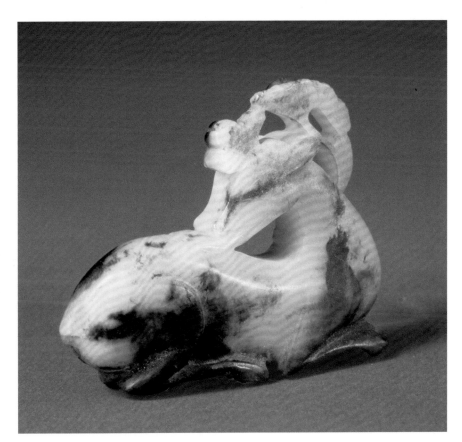

143

Lotus-shaped Jade Pendant

Song Dynasty

Height 1.5 cm Length 6.5 cm Width 3.2 cm
Qing court collection

This object, made of bluish-white Hetian jade, has gray and dark brown soaking-induced spots on some parts. A blooming lotus floating on the water is carved following the shape of the jade. The upper end of the object has a pair of small through holes for wearing.

The decoration of lotuses on jade ware first appeared in the Tang Dynasty. As a lotus emerges out of mud without dirtying itself, lotuses in Chinese traditional culture have the implication of high integrity. Besides, the lotus is often used as a decoration in Buddhism to symbolize the Sukhavati (pure land in the West).

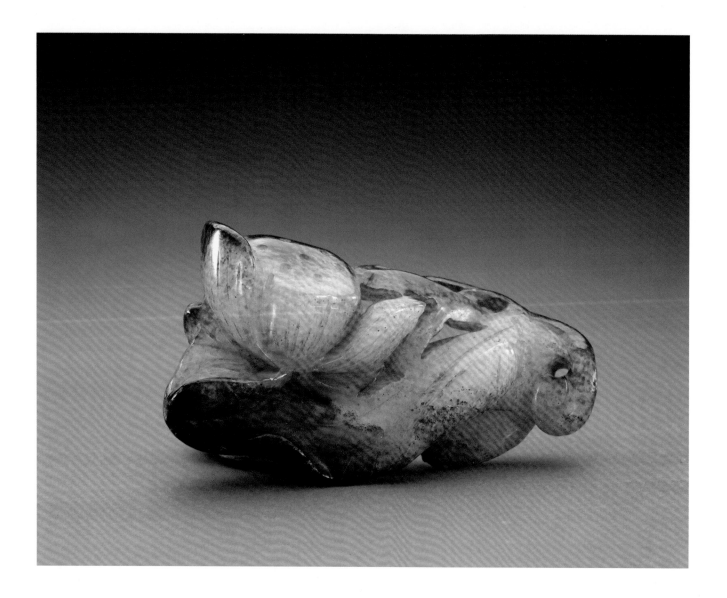

144

Jade Pendant with a Peacock

Song Dynasty

Length 5.5 cm
Width 4.5 cm
Thickness 0.8 cm
Qing court collection

This object, made of bluish-white jade, has light brown soaking-induced spots. The entire body is decorated with a peacock carved in openwork and fine lines in intaglio. The peacock has a raised head, round eyes, a pointed beak, and a long tail that droops and floats at the back, spreading its wings to fly. It is surrounded with clouds in an S-shape, and the outer periphery is decorated with a floral border. The pointed top part has a small round hole for tying a string.

The shape of this work is lively and real, and it constitutes a representative piece of peacock jade ware of the Song Dynasty. Realistic peacocks on jade ware were first seen in the Tang Dynasty. Most of them were lively and real, and had great impact on similar works of later ages. Before that, there were indeed decorations resembling peacocks, such as phoenixes and rosefinches, yet they were mythical birds, not the real objects.

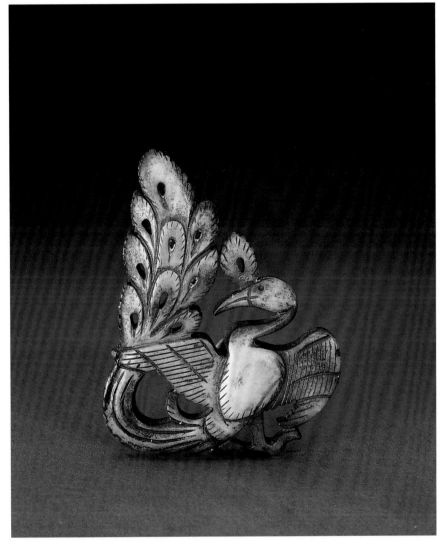

145

Phoenix-shaped Jade Pendant

Song Dynasty

Height 5 cm Width 3.3 cm
Thickness 0.3 cm
Qing court collection

This object, made of white jade, is relatively fine and moist in its texture. The body of this pendant is a tablet, carved in openwork in the shape of a phoenix. The head of the phoenix is relatively large. The tail is in the shape of three rows of streamers. Under its beak is a blade of celestial grass.

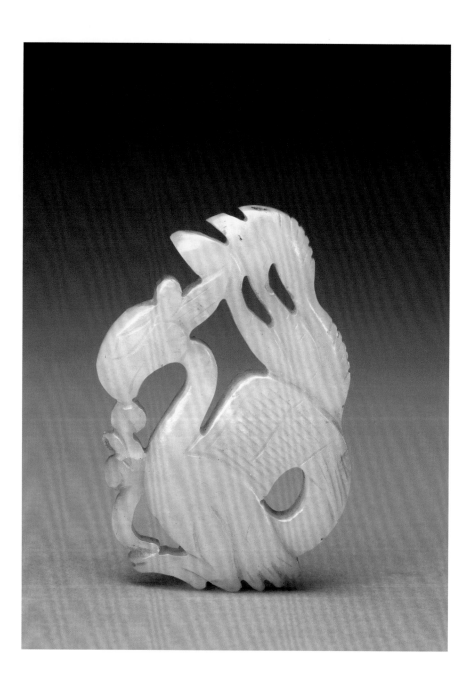

146

Jade Pendant with Two Cranes

Song Dynasty

Length 7.5 cm Width 5.7 cm
Thickness 0.9 cm
Qing court collection

This object is made of white jade. The body of the pendant is flat and round. The two cranes, carved in openwork, are dancing together, with clouds under their feet. They hold a decorative ring together, which can be threaded with a string for wearing.

Similar jade ware was discovered in the tombs of the Jin Dynasty in the Fangshan area of Beijing. It is therefore clear that this type of jade pendants with double cranes were popular in the Song and Jin periods.

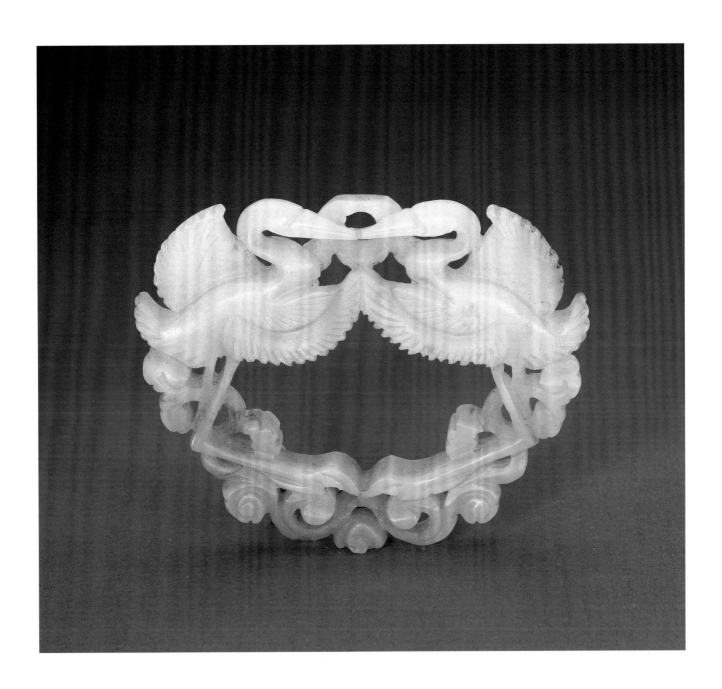

147

Jade Weight with a Duck Carved in Openwork

Song Dynasty

Height 3.5 cm
Length 3.1 cm Width 1.7 cm
Qing court collection

This object is made of white jade. The techniques of carving in round and carving in openwork have been used to cut and make a crouching duck. It has round eyes, a flat beak, and a long head. Its wings are curled up with the tips held together. The tip of the tail curls up as well. Its feet are hidden in the lower part of its body. The feathers in different parts are decorated with fine, long, and curved lines in intaglio. Its belly has a round hole.

The shape of this work is lively and vivid, like a vivacious duckling combing its feathers, which shows the acute power of observation and great skill in artistic presentation of the maker.

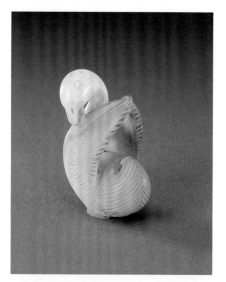
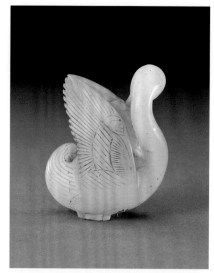
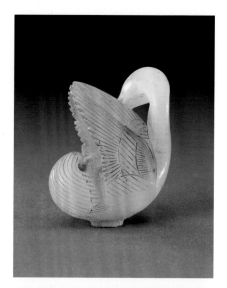
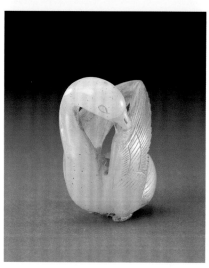
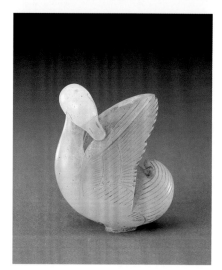
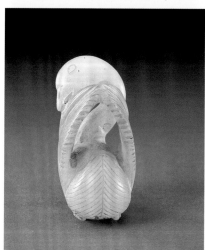

148

Jade Figures Carrying Heavy Things

Song Dynasty

Height 3.4 cm Width 2.2 cm
Thickness 1.8 cm
Qing court collection

These objects, made of bluish-white jade, have brownish-yellow spots on the surface. They represent two little figures with a hat carved in round. Both figures are of the same size and shape, and both of them have their hands at the back of their body, carrying heavy things and standing with their waist bent.

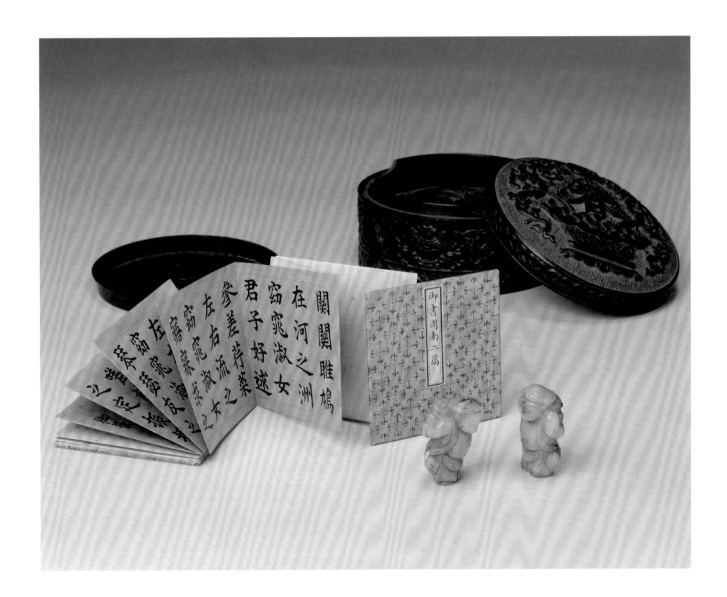

149

Jade Crouching Horse

Song Dynasty

Length 6.5 cm Width 3.8 cm
Thickness 1.4 cm
Qing court collection

This object is made of white jade and has a small number of yellow spots. Its body is slightly flat. A horse, carved in round, seems to be turning back its head and crouching. Its belly does not touch the ground. Its rear limbs and one of its front limbs are slightly bent. The right front limb seems to step on the ground with the intention of rising. The mane of the horse is knotted into a few buns and hangs down. The long tail swings from the back of the thigh to the front.

The shape of this horse is inherited from the works of art of the Tang Dynasty. It focuses on the muscles. The four limbs and the body are divided by a deep concave line. This was a typical piece of art in the style of the Song and Ming periods.

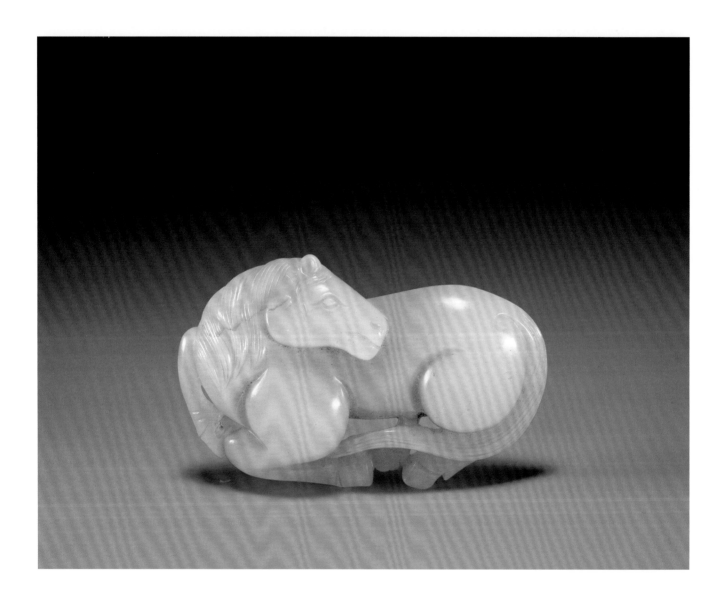

150

Jade Belt Ornament with a Dragon

Song Dynasty

Length 8.4 cm Width 4.4 cm
Thickness 1.8 cm
Qing court collection

This object, made of white jade, has no faults. The object is rectangular, and its middle part is carved in openwork with clouds and a dragon. The head of the dragon is up. The front part has a round hole for inlaying a pearl. The perimeter has sixteen linked pearls. The lower part has a flat ring for hanging things, whereas the sides have holes for threading a string.

In the Song and Jin periods, bead jade belts were clothing ornaments of a higher class. According to "Records of Carriages and Clothes" (Yufuzhi) in *A History of Song*, after the demise of the Jin Dynasty, the Southern Song obtained the national treasures of the court of Jin, including the "Jade Belt with Clouds and Dragon Ground in Openwork" and the "Jade Girdle Belt with Bead Rings".

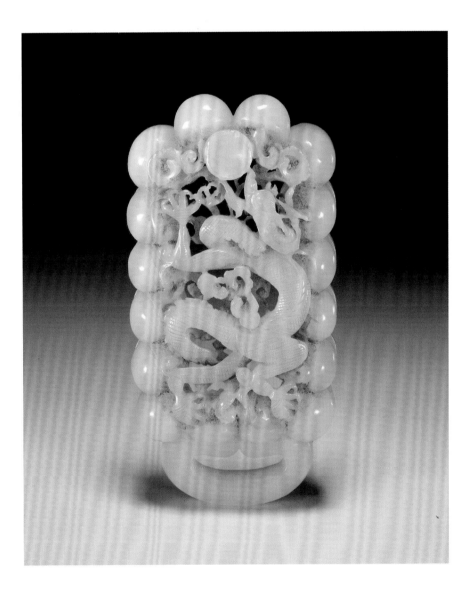

151

Jade Belt Ornament with Gumbo Flowers Carved in Openwork

Song Dynasty

Height 6.4 cm Width 6.4 cm
Thickness 1.1 cm
Qing court collection

This object, made of white jade, has brown soaking-induced spots. The object is round, resembling a thick tablet. Carved on the upper part of the body is a gumbo flower, under which are its branches and leaves carved in openwork. Both sides of the object have holes for threading and wearing.

The image of the flower and leaves carved in this work is concise and accurate, with a smooth and mellow surface. In the Song Dynasty, there emerged a trend in carving works involving big flowers, big leaves, dense designs, less deletions, and smoothness, with less edges and corners. This style continued into the early period of the Ming Dynasty, and jade ware of this period was under its influence. This work can be taken as an example.

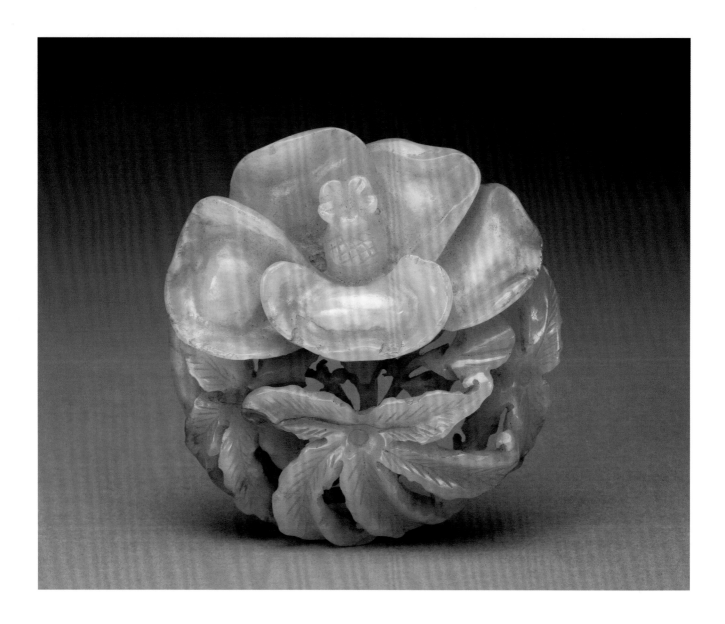

152

Lock-shaped Jade
Pendant with Peonies
Carved in Openwork

Song Dynasty

Height 8.7 cm Width 6.3 cm
Thickness 0.7 cm
Qing court collection

This object, made of white jade, is in the form of a tablet. It is in the shape of a traditional lock, and the entire body has peony flowers and leaves carved in openwork. The upper part is empty and has a cross beam.

Lock-shaped pendants comprise primarily neck ornaments for children. They are commonly known as "longevity locks" or "life-entrusting locks", meaning that the pendants serve as protective talismans.

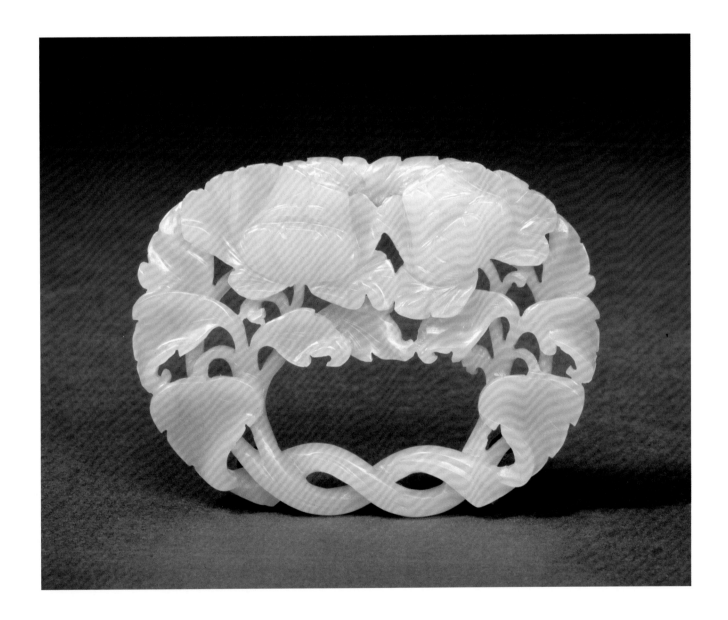

153

Jade Belt Ornament with a Turtle Nest and a Lotus Leaf

Song Dynasty

Length 6.3 cm Width 4.5 cm
Thickness 1.4 cm
Qing court collection

This object, made of clean and white jade, is slightly translucent. It is square, in the shape of a curled-up lotus leaf. Both sides of the lotus leaf are carved with leaf veins with double lines in intaglio. The middle part of the leaf has a turtle carved in openwork, with its mouth spitting out auspicious clouds. The back of the leaf has stems coiling round. Both sides form the shape of a ring for threading and wearing.

People in ancient times believed that turtles were long-living and auspicious. In the *Records of the Grand Historian* (Shiji) written by Sima Qian, *Baopuzi* by Ge Hong of the Jin Dynasty, and *Bowuzhi* by Zhang Hua of the Jin Dynasty, it is said that a turtle of a thousand years old would rest on lotus flowers. This type of theme for jade carving can, therefore, be named as "turtle nest" or "turtle swimming".

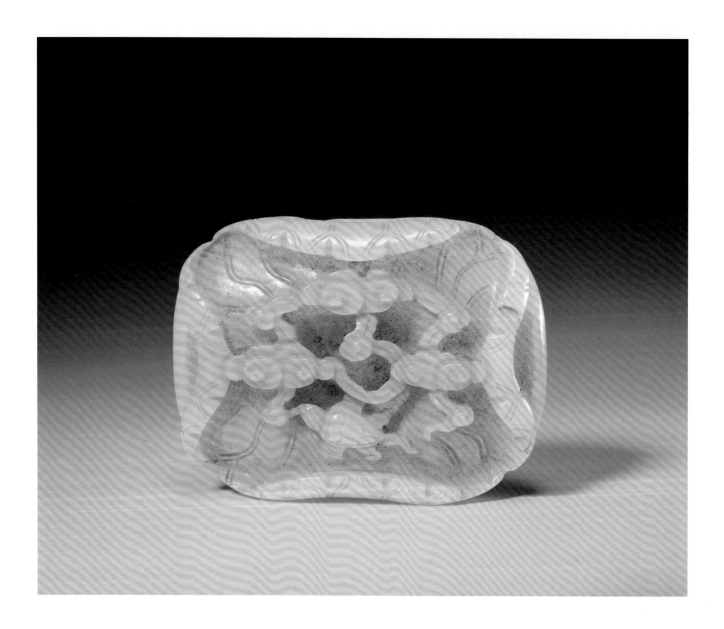

154

Jade Censer Top with Pines, Deer, and Figures Carved in Openwork

Song Dynasty

Height 3.9 cm
Diameter of Base 3.6 x 2.5 cm
Qing court collection

This object, made of dull white jade, is yellowish in some parts. The entire body is decorated with drawings carved in openwork. The pine trees form forests. The trees are tall and dense. Under a pine tree, an elderly person walks forward with a stick in his hand. He is accompanied by deer and egrets on both sides. The deer is loaded with a travel bag. Behind, there is a boy who goes along carrying books, a *qin* zither, and a bottle gourd.

Works of this type, which comprise mainly vessels and buttons, are flat and glossy at the surface for ease of clasping and taking. During the Ming and Qing dynasties, this type of work was often used as a button for the lip of a vessel. It is therefore called "censer top".

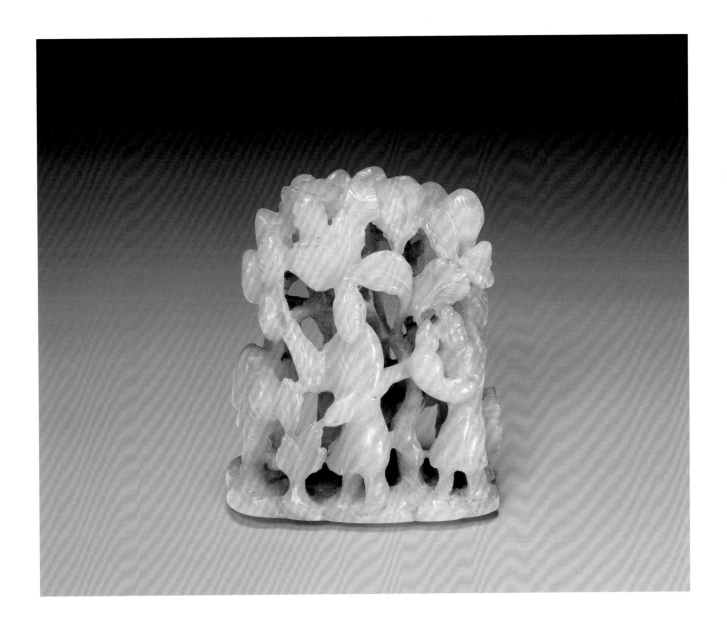

155

Jade Miniature Landscape with Figures Carved in Openwork

Song Dynasty

Height 6 cm Length 15.5 cm Width 10.5 cm
Qing court collection

This object, made of bluish-white jade, has light black soaking-induced spots. The object is in an olive shape, with patterns of drawings carved in openwork. In the front side there is an elder with a long mustache and a bun. He wears a long robe, holds a stick, and sits back in a forest. Behind him, there are pine trees and mountain rocks, as well as a red-crowned crane, under whose feet there are little birds looking for food. On the branches of the pine trees are lanterns hanging. The other side has a page boy, holding an S-shaped *ruyi* with a glossy ganoderma. There is a little deer accompanying him, and they are surrounded by flowers in full blossom. The bottom of the vessel is flat and polished and have through holes for knotting.

The so-called "miniature landscapes" are display pieces carved in round, with landscape backgrounds for the most part. During the Song and Ming periods, jade miniature landscapes were simple in its structure and did not pay much attention to the layout, proportion, and rules. The jade mountains of the Qing court, often based on famous paintings, showed the scene in three dimensions. They had a stronger artistry, and were known as "jade drawings".

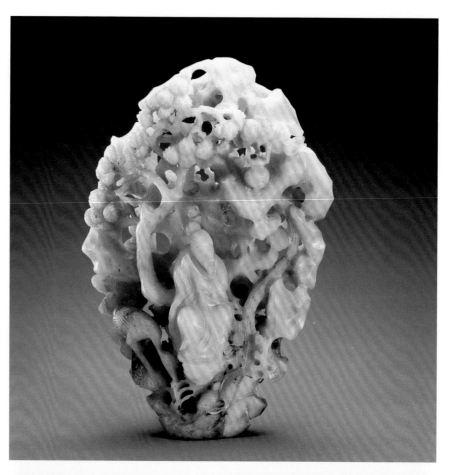

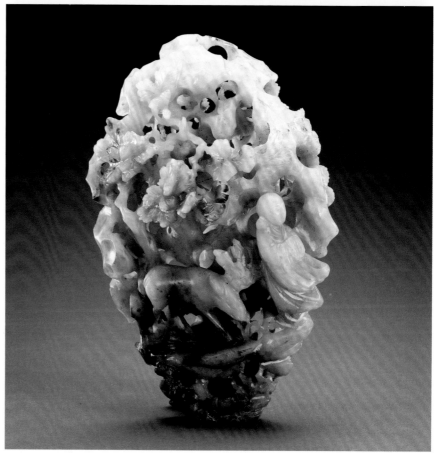

156

Jade Ornament with Figures Carved in Openwork

Song Dynasty

Length 9.3 cm Width 8 cm
Thickness 0.9 cm
Qing court collection

This object, made of bluish-white jade, has brown soaking-induced spots on some spots. The body of this object is flat. The method of multi-layer carving in openwork is used on the front side to depict an old woman and her maids. The old woman stands on the side of the pool with her arms extended. There is also a turtle swimming in the water, which seems to carry the meaning of "freeing a captive creature". Behind her are two maids. One is standing and has a stick in her hand. The background features pine trees with strong and thick branches, set off by a glossy ganoderma and a longevity stone, representing a paradise on earth. The back of the object is plain and its four corners have little inclined holes for tying, knotting, or inlaying things.

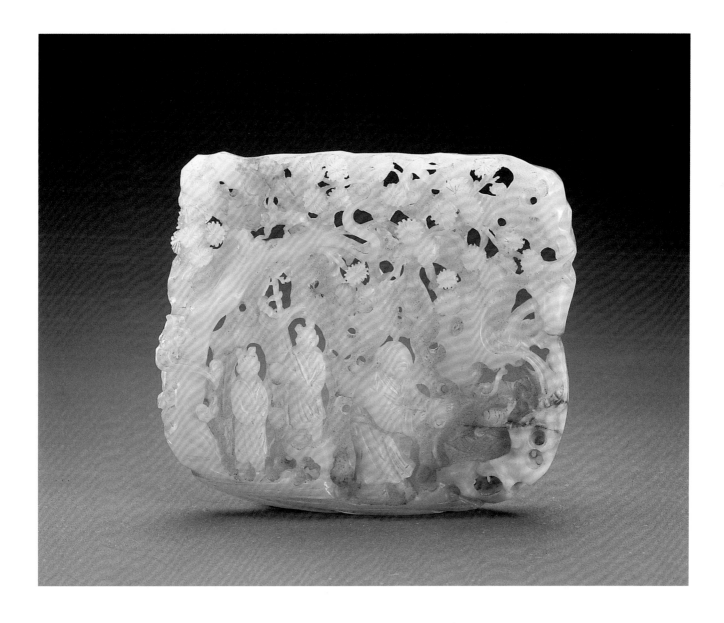

157

Jade Boy Holding a Lotus Aloft

Song Dynasty

Height 7.2 cm Width 2.8 cm
Thickness 1.1 cm
Qing court collection

This object, made of bluish-white jade, has brown skin colour, the colour of an uncut jade, on some parts. The body is rather flat. It is carved with a boy wearing a jacket with patterns of the character "*mi*" and a pair of long trousers. He has a long silk belt in his waist, and his hands hold aloft a blossoming lotus flower while he is dancing and leaping.

The lotus is a traditional flower in China. In the Song and Yuan dynasties, jade ware decorated with patterns of lotus flowers and leaves, such as fish lotuses and lotus flower lanterns, were numerous. *Song Shi Chao* claims that "the Lantern Festival is near, brightly lit lanterns form thousands of spots to look at lotus children". *Lian* (lotus) is homophonous with *lian* (on end), meaning "there is surplus for years on end" and "getting sons year after year".

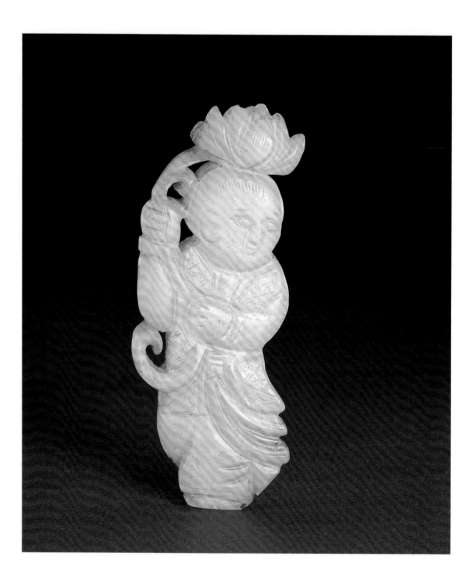

158

Jade Ornament with a Gyrfalcon Catching a Swan

Jin Dynasty

Length 5.9 cm Width 3.9 cm
Thickness 1 cm
Qing court collection

This object is made of white jade. It features a swan carved in openwork, spreading its wings as if about to fly. A gyrfalcon stands on the head of the swan, spreading its wings and lowering its head. It seems to be pecking at the head of the swan. The legs of the gyrfalcon are tied with ribbons, showing that it is domesticated.

Gyrfalcons are a kind of ferocious falcon. During the time of Liao and Jin, the northern tribes, such as the Khitans and Nüzhens, had the custom of catching swans with their domesticated animals, as recorded in detail in *A History of Liao* and *A History of Jin*. The clothing system of the Nüzhens stipulated even clearly that clothes should be decorated with a falcon catching a swan. It is also said that the decoration of gyrfalcon catching a swan expresses the intention of the Nüzhens to conquer the Central Plains with their courage and military power.

159

Jade Belt Ornament with a *Chi*-dragon Carved in Openwork and a Peony

Yuan Dynasty

Length of Side 5 cm
Thickness 1.5 cm
Qing court collection

This object is made of white jade. It is a square in form and a tablet in shape. The four corners are concaved inward. The body of this object is a *panchi*-dragon carved in openwork and a large peony flower, with their leaves and branches intertwined.

This work is a piece of a jade belt ornament set. It carving is exquisite, manifesting the advances in jade carving skills. Most of the works of arts of the Yuan Dynasty were dragons flying among peonies. This kind of *chi*-dragon and peony motif was also common in the Yuan Dynasty.

160

Jade Lion

Yuan Dynasty

Height 7.2 cm Width 4.6 cm
Thickness 1.6 cm
Qing court collection

This object, made of bluish-white jade, features brown spots. It has a lion carved in openwork. The top of the lion's head has a curled mane in the shape of the character "*wang*". The lion is holding a long belt in its mouth and is raising its right front limb to step on a silk ball. The left front limb is upright, whereas its rear limb is bent, in a crouching posture. It has a long tail, whose end is forked. The end sticks to the back, reaching the top of the head. Under the body of the lion is a lotus leaf, with its edges curling outward. A hole goes from the bottom of the centre of the leaf to the top of the head of the lion. It can be threaded for wearing.

This object is in the Qing court collection. It is matched with a casket for documents, and the surface of its top reads "*xianzaotenghui*" (the celestial algae jumps with brilliance) in clerical script. Inside the document it has the seal marks "*guxitianzi*" and "*bazheng maonian zhibao*". Besides, there is a water-ink painting of "Narcissus on a Rock" and an inscription.

161

Jade Ornament Piece with a Tiger and an Oak Tree

Yuan Dynasty

Length 12 cm Width 3.2 cm
Thickness 0.7 cm

This object, made of blue jade, has a layer of blackish-brown colour on its surface, which has been dyed manually. The object is in a tablet shape. The middle part has a ferocious tiger in relief, with a long and thick tail. The body has patterns of tiger skins with long stripes. The area surrounding the body of the tiger is covered in full with large leaves of the oak tree, and under the leaves are some branches.

Jade ware of the Yuan Dynasty has more tiger decorations, which is related to the hunting life of Mongolian tribes. It also shows their valiant character.

162

Jade Censer Top with Two Babies

Yuan Dynasty

Height 6.3 cm Width 4.9 cm
Thickness 2.5 cm
Qing court collection

This object, made of bluish-white jade, has yellowish jade colour on some parts. It represents a large tree with dense branches and leaves and a great amount of fruit carved in openwork. Standing under the tree are two infants. They have buns on their heads and wear small Chinese button-front gowns, holding aloft a small person. They seem to be playing. The background is decorated with mountain rocks and glossy ganoderma.

The craftsmanship of this object is coarse and simple. The shape of the figures is lively, realistic, and full of the flavour of life.

163

Jade Hat Top with a Dragon

Yuan Dynasty

Height 4.8 cm
Diameter of Base 5.3 x 3.7 cm
Qing court collection

This object is made of white, smooth, and moist jade. The whole body is carved in openwork with a dragon prostrated amongst the peony branches and flowers. The four sides are decorated with floating clouds.

Inlaying jade into crowns has been practised since ancient times. Jade is placed in the middle part of a hat to be its front part, or at the top of the hat to be its button. The Mongolian tribes live in areas where the latitude is relatively high, and the weather is cold and chilly. For a major part of the year, Mongolians need to wear hats. They therefore pay special attention to the top and button of this garment. They often use valuable materials and exquisite craftsmanship to produce the tops and buttons of their hats. This hat top is made of fine and glossy jade, which is faultless, and it must have been used by the nobility of the Yuan Dynasty.

Flower Patterned
Jade Cup

Yuan Dynasty

Height 5.1 cm
Diameter of Mouth 8.5 cm
Qing court collection

This object, made of bluish-white jade, has blackened on some parts due to burning. The mouth of the cup is in the shape of a sunflower. Its wall is curved, and the centre of the inner base represents a pistil. The outer wall is carved in openwork with the branches and leaves of a gumbo forming the handles and the saucer.

At present, many jade cups of the Yuan Dynasty have been discovered. They are mostly decorated with flowers and figures. Their cutting is free and forceful, and the traces of the knives and drills can be observed. This cup, in addition to its shape, decoration patterns, and colours, which are characteristic of the Yuan jade ware, shows clearly the artistic style of the period in its carving and polishing.

165

Jade Belt Ring with a Dragon Head

Yuan Dynasty

Hook Length 7.9 cm Belly Width 2.9 cm
Thickness 2.2 cm
Ring Length 4.1 cm Ring Width 3.8 cm
Thickness 2 cm
Qing court collection

This object, made of white jade, has dark brown spots resulting from burning, and is accompanied by yellow soaking-induced spots. The object is divided into the hook and the ring. An end of the belt hook is carved in openwork with patterns of lotus flowers. Its back has a button in the shape of a lotus leaf. The other end of the head of the hook is decorated with a beast mask. The front and back sides of the mouth of the ring have hidden cloud patterns. The head of the ring depicts a dragon carved in openwork.

The shape and patterns of this object have the stylistic characteristics of jade ware of the Yuan Dynasty. The lotus patterns on the belly of the hook use mostly the skin colour of the jade, a method commonly used in the jade ware of the Yuan Dynasty. Belt hooks decorated with dragon motifs were perhaps exclusively used by emperors of the Yuan Dynasty.

166

Jade Mark Stamp with a Dragon Button

Yuan Dynasty

Full Button Height 4.2 cm
Length 5.8 cm Width 5 cm
Qing court collection

This object, made of bluish-white jade, has yellowish soaking-induced spots on some parts. The upper part of the object has a dragon carved in openwork as its button. The four legs of the dragon are prostrated on the back of the stamp. Its body is bent, its head is lowered, and it has a long mane on its back. Two forks of the three-forked tail curl to two sides, and the fork in the middle dashes upward and joins with the mane. The stamp is rectangular in shape, and its characters are carved in relief.

A mark was a symbol (ya) on the documents and contracts in the ancient period used as a signature or in lieu of a signature. It was a kind of evidence of promise, and most mark stamps were found in the Yuan Dynasty. This is because the Mongolians and the alien people, who served as officials during the Yuan Dynasty, found it difficult to write the Chinese characters and they, therefore, adopted this method. In a section of the second volume entitled "Cutting Name Seals" in the work *Records of Stopping Plowing* (Chuogenglu) by Tao Zongyi of the Yuan Dynasty, it is said, "Most of the Mongolians and alien people who are now serving as officials cannot hold brushes and sign. They usually use ivory or wood carvings and stamp their marks. The ministers and the first-ranked attendants, when they receive an imperial decree, use jade mark stamps to sign." This is a jade mark stamp with a dragon button. It might have belonged to the emperor.

167

Imitation Antique Jade Cup with a Cloud Handle

Ming Dynasty

Height 12.6 cm
Diameter of Mouth 5.7 x 5.1 cm
Diameter of Leg 5.5 x 3.5 cm
Qing court collection

This object is made of bluish-white jade. The body of the cup is slightly flat. It has an oval mouth and an oval ring foot. The lid button represents a crouching beast, whereas its surface is decorated with patterns of clouds and *chi*-dragons. The body of the cup shows patterns of clouds and *chi*-dragons in low relief. It also has a ring-shaped handle, decorated with patterns of imitation antique clouds.

Jade cups are believed to have appeared in the Western Zhou period. From the Tang and Song dynasties to the Ming Dynasty, jade cups were mostly short and thick, and did not have jade lids. Usually, the cups were matched by lids of other materials. The body of this cup and its lid were made with a single piece of jade. The jade stone that was used was larger, and the craftsmanship was superb. It is a gem of the jade cups from the Ming Dynasty.

168

Imitation Antique Jade Cup with the Signature of *"Zigang"*

Ming Dynasty

Height 7.8 cm
Diameter of Mouth 5.4 cm
Diameter of Leg 3.8 cm
Qing court collection

This object, made of bluish-white jade, has amber soaking-induced spots. The cup has a round mouth, with edges that contract outward. It has a contracted neck, a deep belly, and a high leg. The neck is decorated with a large number of characters *"shou"* (longevity), and the space in between is decorated with *kui*-dragon patterns and four halberds. Its belly is decorated with patterns of linked rings and bird motifs in convex carving, under the belly are patterns of imitation antique cicada motifs, whereas its foot is decorated with key-fret patterns. On one side of the cup is a single handle with a *kui*-dragon. A pattern of the Buddhist swastika (卍) is carved in openwork under the handle. The outer side of the handle features two halberds, on which the word *"Zigang"* are engraved in seal script.

The word *Zigang* refers to Lu Zigang, who was a well-known jade-maker during the reigns of Jiajing and Wanli periods of the Ming Dynasty. He was active mainly in the Suzhou area. The jade ware that he made was very much sought after. It is recorded in *Taicang Zhou Zhi* that "a person in the prefecture known by the name of Lu Zigang used a knife to do carving and cutting, and his skills were unparalleled. The jade hairpin that he gave to the court valued at fifty-six pieces of gold per piece". His extant works usually have seals with different characters of the same pronunciation *"Zigang"*.

169

Jade Cup with "Universal Spring with Deer and Cranes" and Figures

Ming Dynasty

Height 7.5 cm
Diameter of Mouth 7.8 cm
Diameter of Leg 4.7 cm
Qing court collection

This object, made of blue jade, has brown soaking-induced spots on some parts. This cup has a round mouth, a deep curved wall, and a short ring foot. In the outer wall, a full scene with cranes, deer, and figures is carved in openwork. There are seven elderly people shaded by the peach and pine trees. Some of them are watching paintings, others are picking peaches or playing chess, and still others are just standing there quietly. On their side are deer and cranes accompanying them. The floor is decorated with glossy ganoderma, narcissus, and bamboo branches.

The patterns carved on this cup are elaborate, with plenty of meaning. The people watching paintings and playing chess are "a gathering of intellectuals under the shade of a pine tree", which carries the meaning of literati interest and charm. The combination of deer and cranes, together with the combination of pine trees and longevity peaches, is homophonous with "*Liuhetongchun*"(six harmonies in spring), carrying the auspicious meaning that the entire world is in spring, thus everything on earth is prosperous.

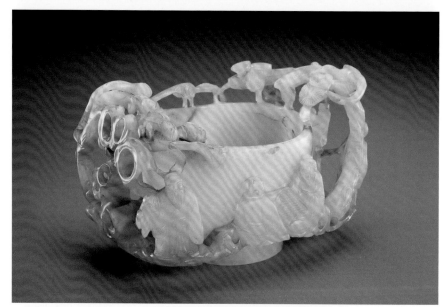

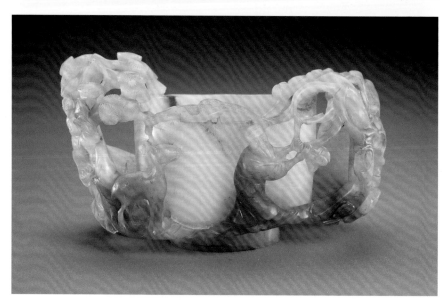

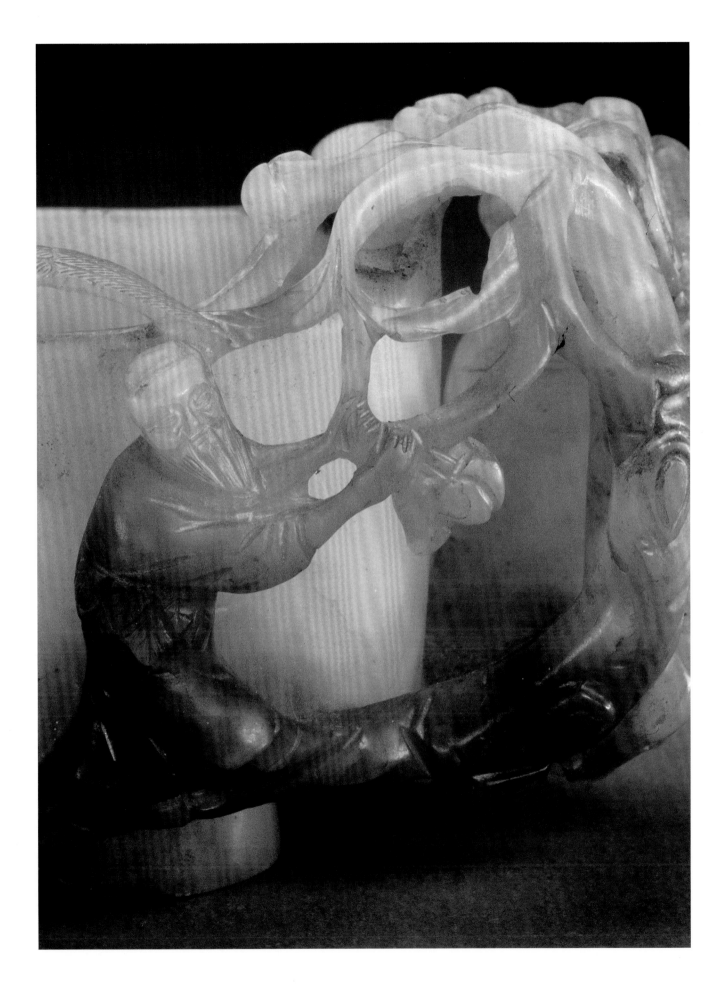

170

Jade Cup with a Sunflower Carved in Openwork

Ming Dynasty

Height 4.5 cm
Length 13 cm Width 9 cm
Qing court collection

This cup is made of blue jade. The body of the cup forms the shape of a sunflower. The inner and outer walls of the cup are carved in the shape of petals. The inner base of the cup is carved in relief with pistils and web patterns. The outside of the cup is carved in openwork with plucked branches of chrysanthemums, peach blossoms, lotus flowers, and plum flowers curling round the wall of the cup. Their branches and leaves serve as the handle of the cup and its base foot respectively.

The shapes of the jade cups of the Ming Dynasty are varied, and their decorations are plentiful and colourful. Cups in the shape of flowers and fruit carved in openwork are especially abundant. There also emerged a large number of auspicious patterns, and this cup is an excellent piece in this regard.

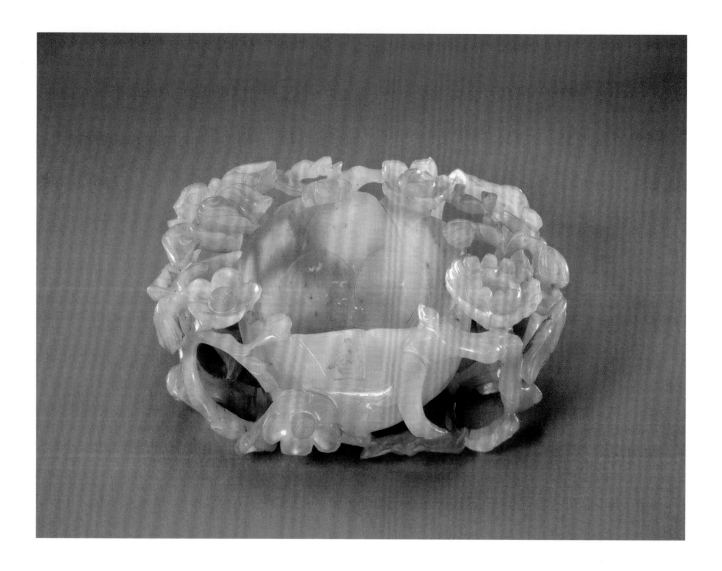

171

Jade Horn Cup

Ming Dynasty

Height 20.8 cm
Diameter of Mouth 6.5 x 4 cm
Diameter of Leg 6.7 x 3.2 cm
Qing court collection

This object, made of bluish-white jade, has brown soaking-induced spots on some parts. The body is in the shape of an inverted beast horn. It has an oval mouth and a deep belly, and the upper part of the outer wall is decorated with a transformed *kui*-dragon carved in openwork. A dragon is carved on the lower part of the cup. It is raising its head and opening its mouth to hold the cup. The tail of the dragon curls up and serves as the handle.

This style of cup is rarely seen. A piece was unearthed from the Tomb of the Nanyue King in the Western Han Dynasty in Guangzhou, which was extremely similar to the shape and structure of this cup. It seems to be a typical example of a piece of imitation antique jade ware of the Ming Dynasty.

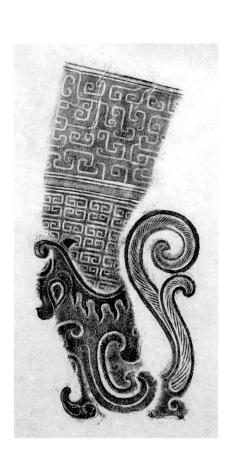

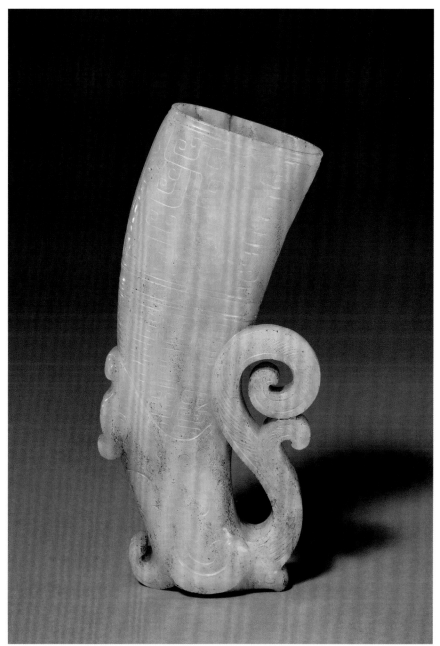

172

Jade Nuptial Cup with the Signature of *"Zigang"*

Ming Dynasty

Height 8.3 cm
Length 11.2 cm Width 9.8 cm
Qing court collection

This object, made of bluish-white jade, has brown soaking-induced spots. The cup is in the shape of two cups joining together. They have round mouths, vertical walls, and their bases have feet decorated with beast mask patterns. One side of the body of the cup has a phoenix carved in openwork as the handle. The other side has two *chi*-dragons climbing the wall of the cup also carved in openwork. A band of cord is carved in openwork, decorating the vicinity of the mouth and the foot. The place where the two cups connect features a square decoration, on which the two characters *"wanshou"* (eternal longevity) are carved in seal script. The wall of the cup is also carved in relief with characters in seal script. The mouth of one of the cups reads "nuptial cups" (hejinbei), and its body is carved with a poem written by Zhu Yunming. On the mouth of the other cup it says, "made by Zigang" (*Zigang zhi*).

Drinking the nuptial cup was a part of the wedding ceremony in ancient times. It involved the bridegroom and the bride to drink cross-cupped wine from one another's cups. Nuptial cups were cups used in a wedding ceremony for drinking cross-cupped wine. Zhu Yunming (1460 A.D. – 1527 A.D.), *Zi* Xizhe and *hao* Zhishan, was a famous calligrapher in the Ming Dynasty, known as one of the "Four Talents of Wu (Suzhou)". He was a contemporary of Lu Zigang, and they came from the same village.

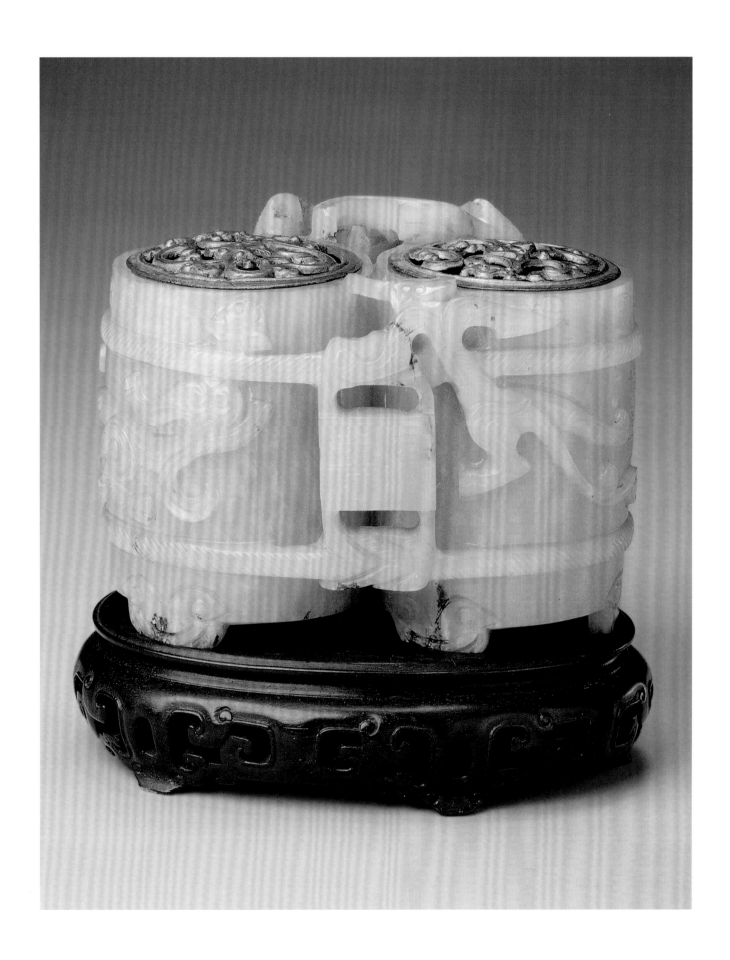

173

Jade Cup with Two *Chi*-dragon Handles Carved in Openwork

Ming Dynasty

Height 5.4 cm
Diameter of Mouth 8.3 cm
Diameter of Base 4.3 cm
Qing court collection

This object is made of bluish-white jade. This cup has a round mouth and vertical walls. There are *chi*-dragon-shaped handles carved in openwork on both sides. The front limb of the dragon is mounted to the mouth of the cup. The head of the dragon has the shape of a flat tablet. It has a single horn, which is linked to the mouth of the cup. The body of the dragon is hunched up to serve as the handle, whereas the rear foot of the dragon steps on the body of the cup. The dragon has a long tail stuck to the body of the cup.

A cup with a double *chi*-dragon handle was a typical style in the Ming Dynasty. Identical works were unearthed from the Ming Tombs in the Beijing district. Many of such cups were also handed down from the past.

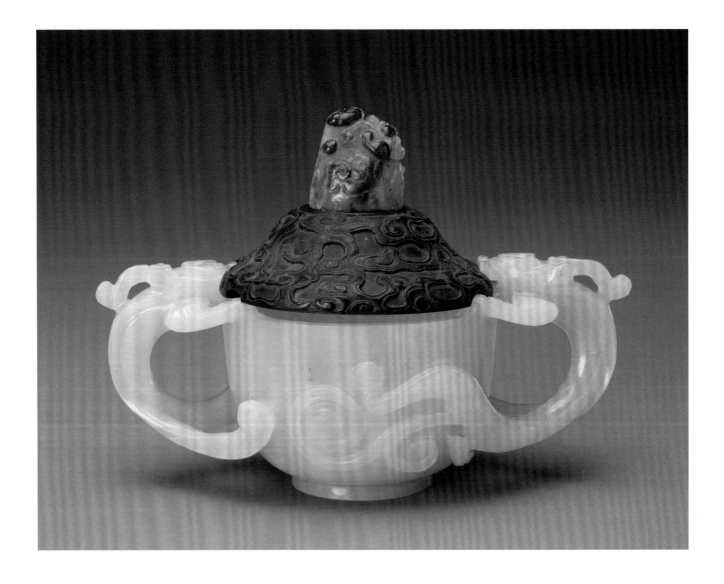

174

Jade Washbasin with Leechee

Ming Dynasty

Height 6 cm
Diameter of Mouth 11.5 × 6.5 cm
Diameter of Leg 6.5 × 4.5 cm
Qing court collection

This object is made of blue jade, and is an imitation of a bronze washbasin. The outside wall has patterns of leechee in low relief. On one side is a spout, and on the other side, a *kui*-dragon-shaped handle.

Washbasins were used for washing in the Pre-Qin period and were commonly made of bronze. The decorative patterns of the Ming Dynasty differed in earlier to later periods. In the early period, flowers and birds were mostly used to carry the meaning of luck. In the late period, the motifs were mostly related to Daoism, with longevity as the central content. This object is decorated with leechee patterns, symbolizing wealth, and is an example of the popular decorative patterns on the jade ware of the early Ming Dynasty.

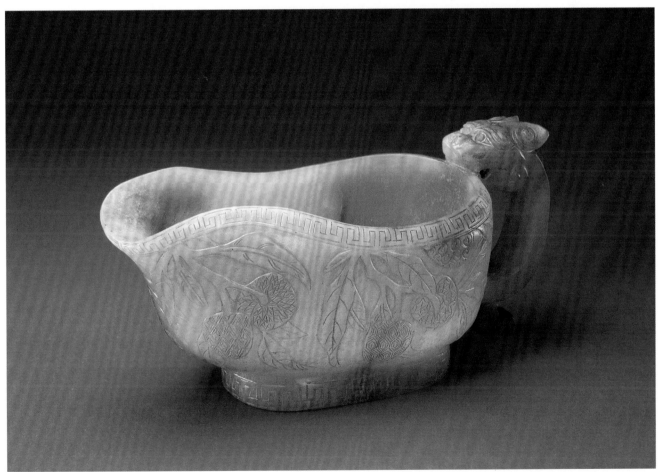

175

Square Jade Censer with Beast-swallowing Handles and the Character "*Shou*" (Longevity)

Ming Dynasty

Height 9.8 cm
Diameter of Mouth 12 x 9.3 cm
Diameter of Leg 8 x 5.9 cm
Qing court collection

This object, made up of bluish-white jade, has yellow spots. The censer has a long square mouth, a vertical wall, and a square foot. On both sides of the body are beast-swallowing handles. The edge of the mouth is decorated with deformed key-fret patterns. Its neck is decorated with patterns of *kui*-dragons. The four corners and central space feature bulged halberds. The belly is decorated with nail patterns, and the space in between is decorated with the character "*shou*" (longevity). The outer wall of the foot is also decorated with *kui*-dragon patterns.

The censer top has wooden lips, which are carved in openwork and inlaid with silver wires matched by the Qing court. It has a button decorated with mandarin ducks and lotus leaves. Carved inside the lid is the character "*bing*" (the third) in regular script.

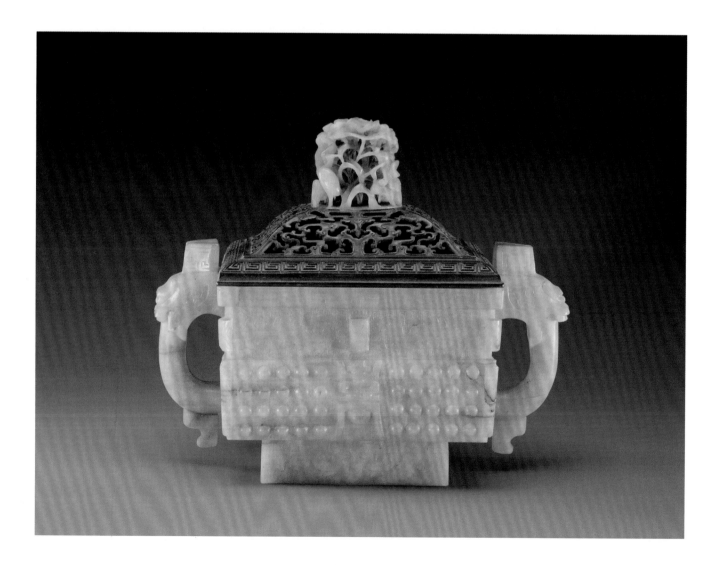

176

Jade Censer with a Beast Mask and Two Beast Handles

Ming Dynasty

Height 6.6 cm Length 15 cm Diameter of Mouth 9.1 cm
Qing court collection

This object, made of bluish-yellow jade, has some spots. It is an imitation of a bronze food-container. Its round mouth is slightly contracted, and it has a short neck, a bulging belly, and a ring foot, whose edge is contracted outward. Both sides of the body have beast-swallowing handles. The neck features a halberd and is decorated with a beast mask carved in relief. The space in between is decorated with a transformed *kui*-dragon. The belly is decorated with vertical stripes.

This censer has a jade knob and a wooden lid, matched by the Qing court. A bronze food-container, apart from being a container for food in the Shang and Zhou periods, was also a ceremonial vessel.

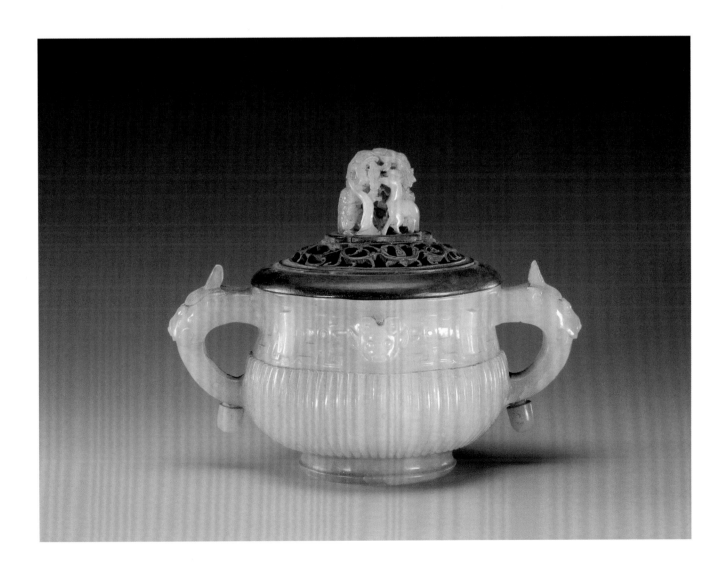

177

Chicken-heart Jade Pendant with Two *Chi*-dragons

Ming Dynasty

Length 7.7 cm Width 4.4 cm
Thickness 1.8 cm
Qing court collection

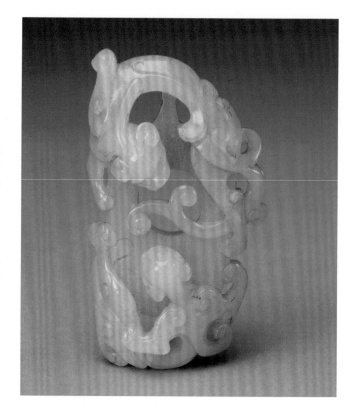

This object is made of fine and glossy jade. The middle part of the pendant is in the shape of a shield, which closely resembles a chicken heart. Both the upper and lower parts have a curling *chi*-dragon.

The making of this object is exquisite and has a classic flavour. It is a representa-tive piece of jade ware with a *panchi*-dragon motif of the Ming Dynasty. This type of work became popular in the Warring States period. It evolved from the "thumb ring" used to protect the hand when pulling a bow. It was therefore called "a pendant in the style of a thumb ring". There were many imitation objects in the Song and Ming periods, known as *chijue*.

178

Jade Pendant with a *Panchi*-dragon Carved in Openwork

Ming Dynasty

Length 5.9 cm Width 4.5 cm Thickness 0.5 cm
Qing court collection

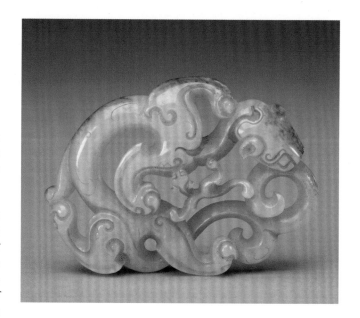

This object is made of white jade and is yellowish-brown that is manually aged. Its entire body is carved in openwork with a *panchi*-dragon, coiling its body in a ring shape as a pendant ornament.

A *chi*-dragon is a type of dragon. The ancient people regarded jade with a *chi*-dragon motif as a high-class pendant ornament to show nobility, and it also had the implication of fending off demons. Ever since the Song Dynasty, the colour of most imitation antique jade ware was aged, which was particularly popular in the Ming Dynasty. It is recorded in *Eight Treatises on the Nurturing of Life* (Zunshengbajian) by Gao Lian that "…recently, jade makers in Suzhou model *chijue* and hooks and rings of the Han and Song dynasties. They use jade with pale yellow and assorted colours or jade with light dark colour and carve them by following the patterns to pass off as being made in the ancient time, thus fetching high prices". This object is a representative piece of imitation of the ancient to make old jade ware in the Ming Dynasty.

179

Jade Plate with Landscape and Figures and a *"Zigang"* Signature

Ming Dynasty

Length 3.5 cm Width 2.4 cm
Thickness 0.5 cm
Qing court collection

This rectangular plate, made of white jade, has black spots and fragmented patterns as it experienced burning. On one side is a landscape in low relief, and on the other, a line of a poem in relief and cursive script "the jackdaws resemble thousands of dots, and the flowing water passes around a solitary pine tree". The upper part and the side edge of the plate have a *kui*-dragon carved in openwork. The side edges at the lower part of the dragon have a small seal carved with a round bead joining with a square bead, on which are engraved characters "*zi*" and "*gang*" respectively.

The line of the poem that was carved on this plate must have derived from the poem entitled "Looking at the Wilds" (Yewang) by Yang Guang, Emperor Yang of the Sui Dynasty, which runs, "The jackdaws fly like dots, and the flowing water passes around the solitary village."

180

Jade Vase with the Character *"Shou"* (Longevity) and Two *Kui*-dragon Handles

Ming Dynasty

Height 11 cm
Diameter of Mouth 3.6 x 2.6 cm
Diameter of Leg 3.5 x 2 cm
Qing court collection

This object is made of bluish-white jade. Its mouth is oval. It has a long neck. The body of the vase is slightly flat, and under it is an oval ring foot. The lid button is in the shape of a standing beast, and its edges and the mouth of the vase are decorated with wave patterns. The neck of the vase is in turn decorated with the character *"shou"* (longevity) in relief. Both sides of the character, as well as the lower part, have a lotus with intertwining branches. On both sides of the vase are handles, each of which is carved with a big-headed *kui*-dragon. The body of the dragon is thin and long and bent, like streamers.

This jade vase is a display item. It is empty inside and can be used to store things. Most utensils of the Ming Dynasty were lidless. However, this object has a jade lid linked to the body. It is a rare piece of the Ming Dynasty.

181

Flat Jade Vase with Landscape and Figures

Ming Dynasty

Height 9.9 cm
Diameter of Mouth 2.8 x 2.6 cm
Diameter of Base 4.6 x 2.8 cm
Qing court collection

This object is made of bluish-white jade. It has a round mouth and a long neck. The body of the vase is wide and flat, with a flat base. The edge of the mouth is decorated with a band of key-fret patterns. Carved on one side of the belly of the vase is a straw hut in a mountain, which depicts a tall tree in front and two elderly people under the tree facing each other, seemingly having a conversation. Carved on the other side is an old path in a tall mountain with an old man standing on a high place. Another old man carrying a *qin* zither and walking with another person seems to imply that he is carrying a *qin* zither to visit a friend.

The pattern of this work is extremely simple and concise, yet it focuses on the layout and aura of the composition and carries far-reaching implications. In addition, it was made with thin and low relief. It is a representative piece of the jade ware decoration in the Ming Dynasty.

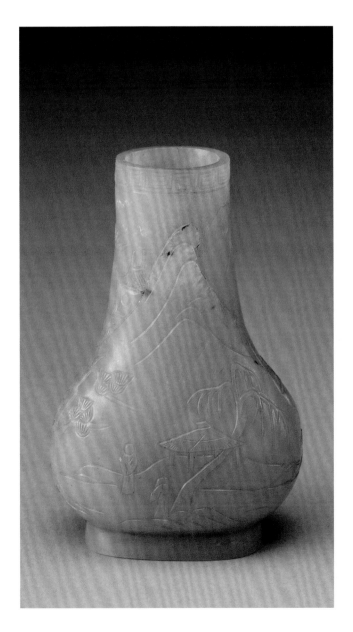

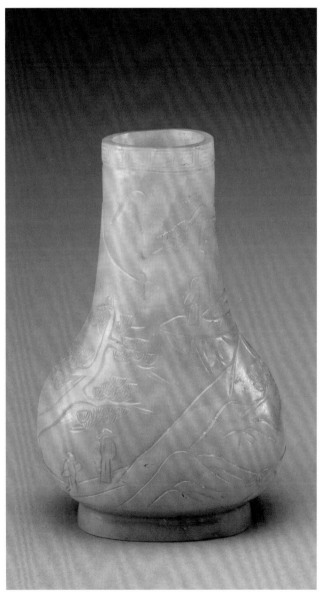

182

Jade Ewer with Lotus Petals and the Character "*Shou*" (Longevity)

Ming Dynasty

Height 27.8 cm
Diameter of Mouth 7.8 x 5.2 cm
Diameter of Leg 9.2 x 6.5 cm
Qing court collection

This blue jade object has a flat square mouth, narrow shoulders, a long square belly, and six hanging-cloud feet. It has an attached lid, decorated with lotus petals. The lid button represents a crouching beast. The body, shoulders, and belly of the ewer are decorated with three layers of lotus petals, with the character "*shou*" (longevity) written on them. The lower part of the belly is decorated with beast masks. The body of the ewer has a handle and a symmetrical spout. The handle is in the shape of a beast, and the spout is decorated with a row of small halberds.

The jade pots of the Ming Dynasty included a type of high ewers, which was wide at the upper part and narrow at the lower part. Most of these ewers were decorated with the character "*shou*" (longevity). Some ewers of blue jade with the character "*shou*", which were popular, were unearthed from the Dingling Tomb, where Emperor Wanli was buried.

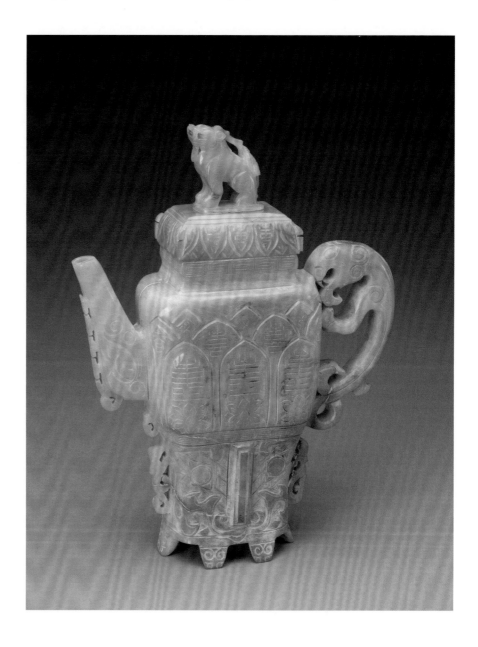

183

Square Jade Ewer with a Dragon Handle and a Phoenix Spout

Ming Dynasty

Height 15.9 cm
Diameter of Mouth 6.9 cm
Diameter of Base 9.8 x 8.8 cm
Qing court collection

This blue jade ewer has a square mouth. Its body is in the shape of a square, slightly flat, and its base is flat. It is attached to a square lid. The lid button represents the god of longevity in a sitting posture. The character "*shou*" (longevity) in seal script is carved in relief in the belly of the ewer. The body of the ewer has symmetrically placed handle and spout. The handle shows a transformed *kui*-dragon, whose head is rather large. The spout is carved in openwork with the shape of a phoenix. The phoenix has a raised head, and its head feathers are linked to the body of the ewer.

The craftsmanship of this ewer is superb, making it a rare piece of the jade ware of the Ming Dynasty. Dragons and phoenixes are traditional motifs in Chinese artistic works, thus represent the male and the female, heaven and earth, and they are also used to refer to the emperor and empress.

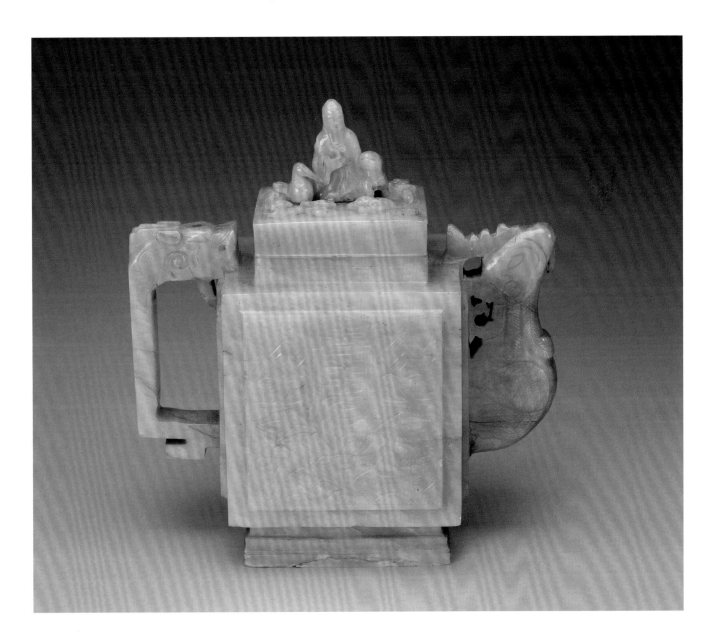

184

Jade Ewer with Eight Immortals

Ming Dynasty

Full Height 27 cm
Diameter of Mouth 7.8 x 6 cm
Diameter of Leg 8.2 x 6.5 cm
Qing court collection

This object is made of blue jade. The ewer has a flat and round body, an oval mouth, a small neck, a broad belly, and a ring foot. It is attached to a jade lid, whose button is carved in openwork with the god of longevity riding on a deer. The surface of the lid is decorated with a red-crowned crane and auspicious clouds. The rim of the lid and the edges of the mouth and foot are carved with a band of "*shan*" (山) characters. The neck has two five-line poems in relief and cursive script, conveying the blessing of longevity. The belly of the ewer is carved with the Eight Immortals, flowers and grass, and mountain rocks. The body of the ewer has the handle and spout in symmetrical positions. The spout has a round mouth. Close to the belly is a swallowing beast, which merges with the jade plates carved in openwork at the neck. The handle represents a *kui*-dragon, which is decorated with a strange beast carved in openwork.

Ewers were a kind of jade ware of the Ming Dynasty with great characteristics. Their shape was borrowed from other types of art. The drawing and text of this ewer are mostly under the influence of Daoism. Contents such as the God of Longevity, Eight Immortals, the sea house adding in lots, and the abode of immortals contains the auspicious connotations of offering birthday congratulations, which was commonly seen in the middle and late periods of the Ming Dynasty.

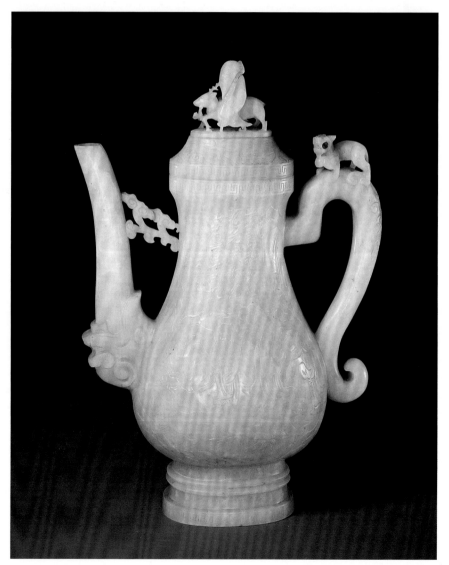

185

Square Jade Goblet with Beast Masks and Halberds

Ming Dynasty

Height 17.1 cm
Diameter of Mouth 8.6 x 8.3 cm
Diameter of Leg 8.6 x 8.3 cm
Qing court collection

This goblet is made of blue jade. It has a turf and is suffused with vitreous lustre. It has a square mouth, the edge of which turns outward. It also has a long body, a contracted waist, and a square ring foot. The body of this object is divided into three sections, each with eight tooth-shaped halberds. The upper and lower parts of the halberds are decorated with transformed cicadas, and the middle part is decorated with beast masks.

Bronze goblets and bronze beakers were examples of wine vessels of the Shang and Zhou periods, and they were also ceremonial objects. This goblet borrowed the characteristics of the bronze goblets and beakers, and was a hybrid of the two. The cicada and the beast mask patterns are classical in flavour. Among the imitation antique jade made in the Ming Dynasty, this piece is one with a stronger flavour.

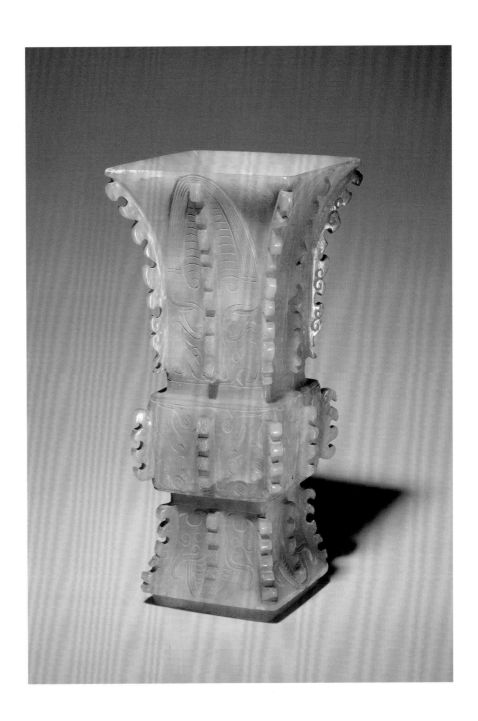

186

Round-mouth Jade Goblet with Legs of Three Boys

Ming Dynasty

Height 9.3 cm
Diameter of Mouth 4.4 cm
Diameter of Leg 3.6 cm
Qing court collection

This object is made of blue jade and has some vitreous lustre. This goblet has a round mouth and is slightly pursed. It also features a long body and a contracted waist. The base of the object has three feet, carved in the shape of three children holding a tray aloft. The body of the goblet is divided into the three parts. The upper and lower parts are decorated with wavy banana leaves. The waist part is bulging and decorated with beast masks and four bamboo-shaped halberds.

This goblet has exquisite carving and a unique shape. It imitates but does not stick to the ancient. The shape of the feet being held aloft by three children is creative, and the dressing of the children has the typical characteristics of the Ming Dynasty.

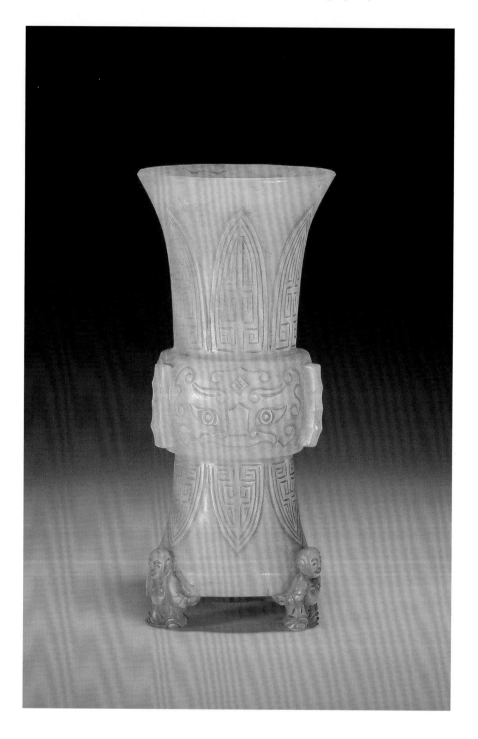

187

Jade Belt with Dragons Carved in Openwork

Ming Dynasty

Longest Belt Plate 14.9 cm Width 5.4 cm
Thickness 0.9 cm
Qing court collection

This object is made of green jade and has a deep green colour. The jade belt consists of a belt board and a leather belt. There are twenty pieces of belt boards. Of these, eight are broad and long boards, six are peach-shaped, four are narrow and square stripes, and two are the heads of the belt. All of them are decorated with dragons carved in openwork. The dragon has a raised head and an open mouth. His mane is draped at the back. Its body has two wings, and it threads through the curled-up flowers and leaves.

The shape and structure of the jade belts in the Ming Dynasty differed greatly from the previous dynasties. The patterns were more consistent, and the number of the boards on the jade belts were also regulated and unified, setting the standard at twenty pieces. *A History of the Ming Dynasty* (Mingshi) and *Ming Hui Yao* have detailed records of this. Besides, the jade belts of the Ming Dynasty were mostly made up of Hetian fine white tallow jade or blue jade, but works with green jade were extremely rare.

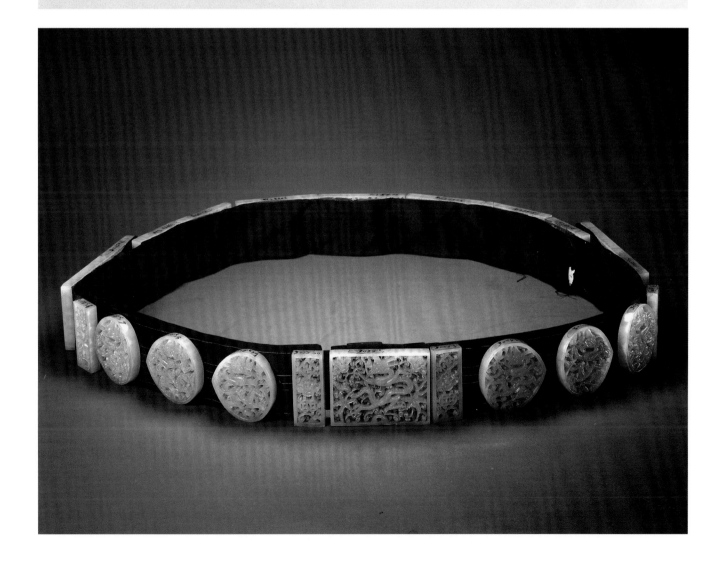

188

Square Jade Box with a "*Zigang*" Signature, Landscape, and Figures

Ming Dynasty

Height 6.2 cm
Diameter of Mouth 7.8 cm
Diameter of Leg 6 cm
Qing court collection

This object is made of blue jade. This box has a square mouth, vertical walls, and square ring feet. It also includes a lid, with a landscape painting and figures in low relief, and a line of a poem, which runs, "The red peaches contain the overnight rain, and the green willows carry the morning mist." The body and the edges of the four sides are decorated with patterns of flowers of the four seasons. The base has a signature signed by Zigang.

The poem inscribed on this object derives from a line in "Rustic Happiness" No.6 by the Tang poet Wang Wei, which runs, "The red peaches contain the whole overnight rain, and the green willows carry the morning mist."

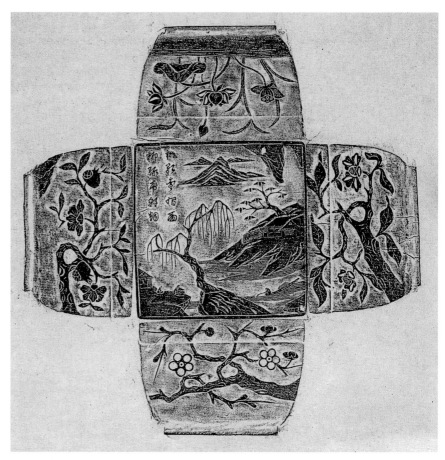

189

Mountain-shaped Jade Brush Rest

Ming Dynasty

Full Height 4 cm Width 9.5 cm
Qing court collection

This object is made of white jade. The brush rest shows high and low mountains, with six big or small ranges. Between the ranges are spaces for resting the brush. The lower part has a wooden base.

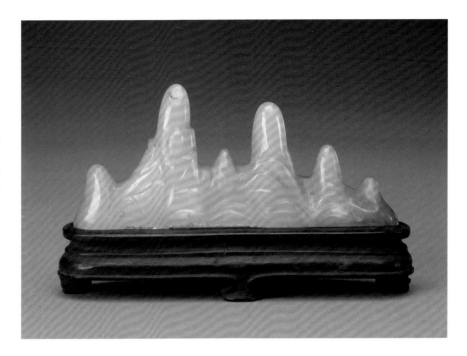

190

Jade Inkstone Water-dripping Pot with a Deified Beast

Ming Dynasty

Height 8.9 cm
Length 15.6 cm Width 9.2 cm
Qing court collection

This object, made of bluish-white jade, has reddish-brown soaking-induced spots on some parts. It has a tiger-like deified beast carved in round. The beast has horns, and seems to be looking back. The body is hollow and can be used to store water. The upper part of the mouth has a beast button dripping pillar.

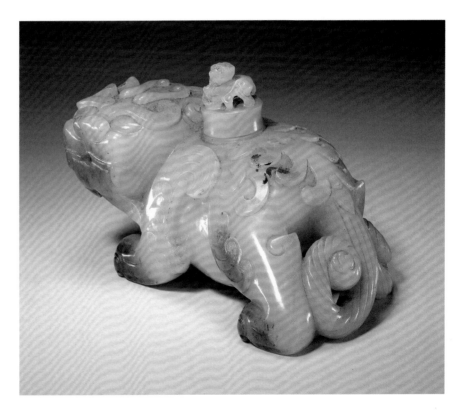

191

Jade Incense Pot with a *Panchi*-dragon Carved in Openwork

Ming Dynasty

Height 14.1 cm
Diameter of Mouth 3.3 cm
Diameter of Base 3.3 cm
Qing court collection

This object is made of blue jade. This incense pot is cylindrical and has a round mouth. The wall of the cylinder has a *panchi*-dragon carved in openwork. The cylinder is empty inside and can hold burning incense. The lower part has a bronze base, and the upper part has a bronze pavilion-shaped top.

An incense pot is an indoor fumigation utensil. It burns incense inside, and smoke comes out from the holes of the wall. There had been fumigation utensils from the ancient time. The Boshan Censer of the Han Dynasty is a utensil for burning incense.

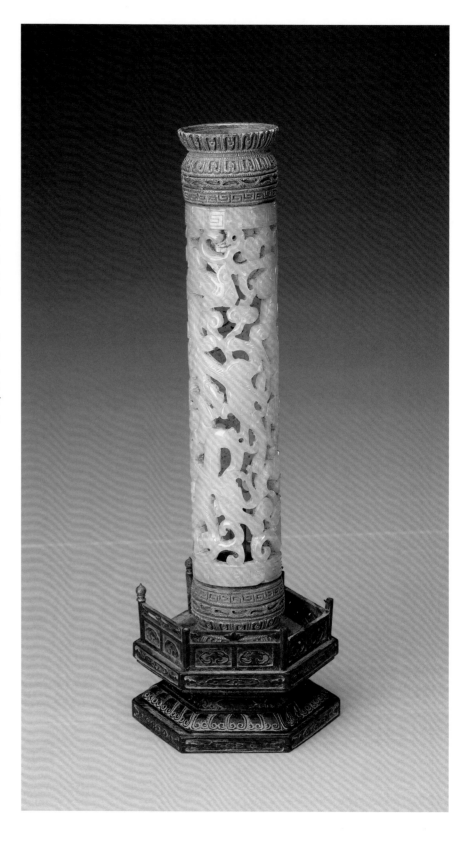

192

Jade Miniature Landscape with Deer and Monkeys Carved in Openwork

Ming Dynasty

Full Height 21 cm Width 11.4 cm
Qing court collection

This object, made of blue jade, is dyed and has spots of weathering on some parts. The main body represents a huge mountain rock, like the Taihu Rock, with many holes. There is a tall tree in front of the rock. The upper part of the tree has a large patch of leaves on its branches. There is a monkey sitting on a branch, clutching another branch with its front arm. Under the tree is a deer, raising its head, as if looking at the monkey.

This work uses the homophony of *hou* (monkey) with *hou* (official position) and *lu* (deer) with *lu* (emolument), carrying the hidden meaning of becoming a lord and getting a promotion in officialdom.

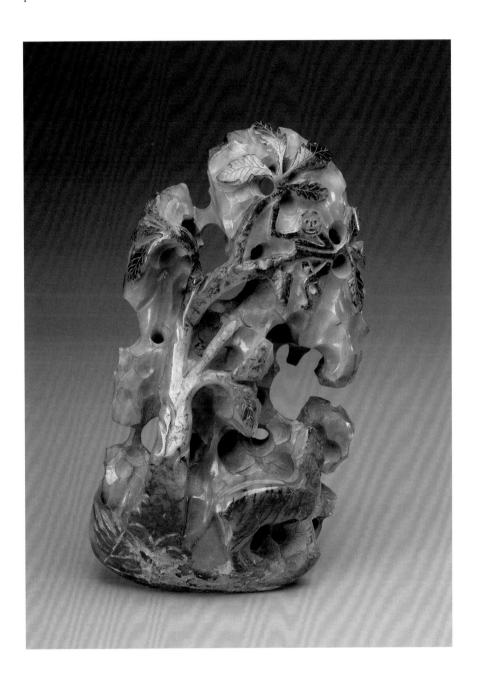

193

Jade Ornament with "Universal Spring with Deer and Cranes"

Ming Dynasty

Length 8.5 cm Width 7.2 cm
Qing court collection

This object, made of blue jade, has dark brown soaking-induced spots on some parts. The front of the object is bulging. Multi-layered openwork carving and relief lines were used to make the two deer. One deer is lowering its head to seek food, whereas the other is turning back its head to look upward. In the sky, the red-crowned cranes are flying. The space in between is decorated with trees and grass, such as pine branches and glossy ganoderma, forming a picture of "Universal Spring with Deer and Cranes". The middle part of the back of the object is concave. The outer edge has a thick and broad edge ring. In the outer part of both sides of the ring is a small round hole for threading a cord for wearing.

"Universal spring with deer and cranes" (*luhetongchun*) and "universal spring in the heaven, the earth, and the four directions" (*liuhetongchun*) are homophonic. They carry the meaning of universal peace, longevity, and luck.

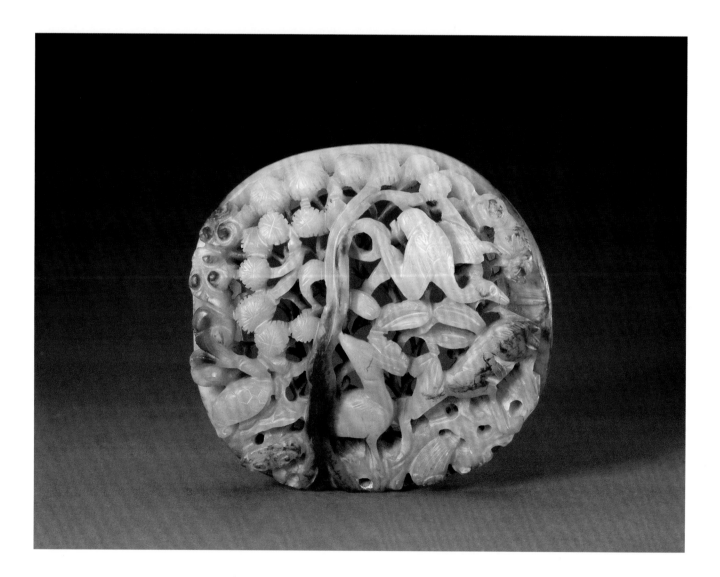

194

Jade Display Piece with a Hawk and a Beast

Ming Dynasty

Height 5 cm
Length 4.8 cm Width 2.5 cm
Qing court collection

This object is made of bluish-white jade and represents a single-horned deified beast with its entire body carved with flame patterns. The beast is prostrated on the ground and looking back. A hawk, about to spread its wings, stands on the back of the beast. It curls down its tail, and its beak is connected to the mouth of the beast.

The beast in this work is exaggerated and deified, whereas the hawk is a genuine live sketch. It manifests the strong shaping power of the creator.

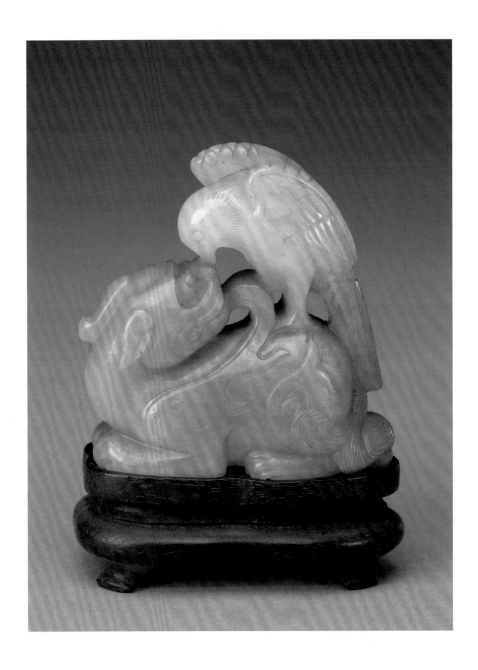

195

Jade Crouching Lion

Ming Dynasty

Height 4.6 cm
Length 9.3 cm Width 4 cm
Qing court collection

This object, made of bluish-white jade, represents a crouching lion carved in round with its long tail coiling back. It has hair under its jaw. Its eyes were drilled by using a pipe drill. The rear limb is tucked, stuck to the belly, and there is a partition between the limb and the belly.

The figure of the lion was in the literature of the Han Dynasty and was treated as a ferocious beast in legends. However, the shape in the picture is vastly different from the real animal. The jade belt chips with lion patterns were stored in a cellar during the Tang Dynasty and unearthed from the Hejia village in Shaanxi. The decorating patterns are lions of the African Grassland, which showed people's deep understanding of the lion. In the Song and Ming periods, there was the practice of drawing a tiger by copying a cat. The lion in this work looks like a lion, and it also resembles a dog. In any case, the carving is elaborate and has a strong periodic characteristic.

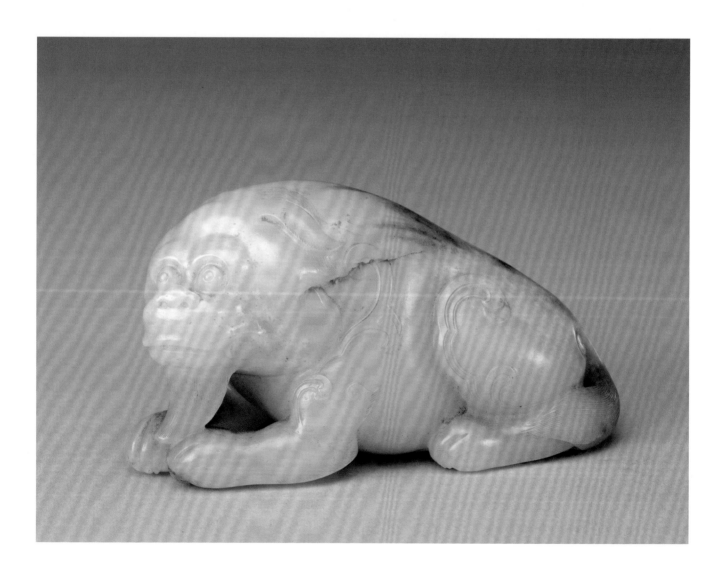

196

Jade Disk with Two *Chi*-dragons and Grain Patterns

Ming Dynasty

External Diameter 8.4 cm
Diameter of Hole 2.7
Thickness 0.7 cm
Qing court collection

This object is made of bluish-white jade. This disk is in a round form and a tablet shape. Its centre has a hole. On one side are two *chi*-dragons carved in relief, whereas the other side is decorated with grain patterns.

There are many extant disks from the Ming Dynasty. The most common design of jade disks involves two *chi*-dragons and grain patterns.

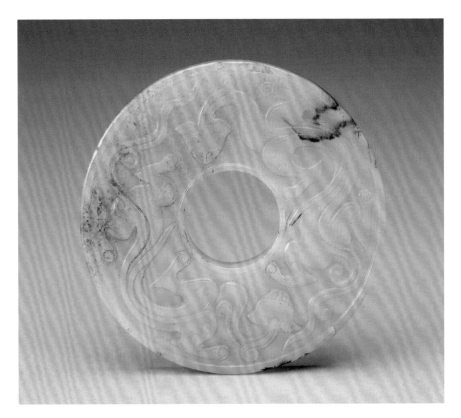

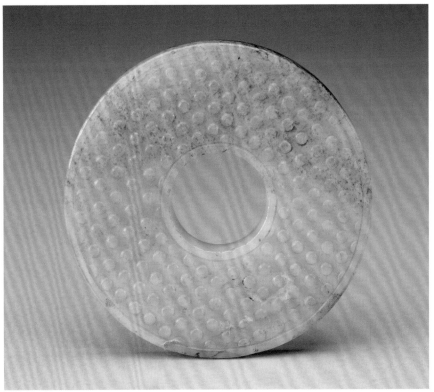

197

Jade Tablet with Seawater, a Lake, a Cliff, and Three Stars

Ming Dynasty

Height 16.5 cm Width 6.3 cm
Thickness 0.7 cm
Qing court collection

This object, made of bluish-white jade, is yellowing on some parts. The main body is slightly thin, with one side slightly concave, and the other side featuring flange lines. Both sides are decorated with patterns of bulging sea water, a lake, a cliff, and three stars. The edges on both sides of this tablet are decorated with *kui*-dragons carved in openwork.

The pointed head of the upper part of this tablet is relatively short, which is a characteristic of jade tablets of the Ming Dynasty. The lower part of the tablet has a red sandalwood base matched in the Qing Dynasty. The four edges are decorated with the twelve imperial emblems symbolizing the royal power, and the base is engraved with the words "*Youyu shier zhang*" (the twelve imperial emblems of *Youyu*).

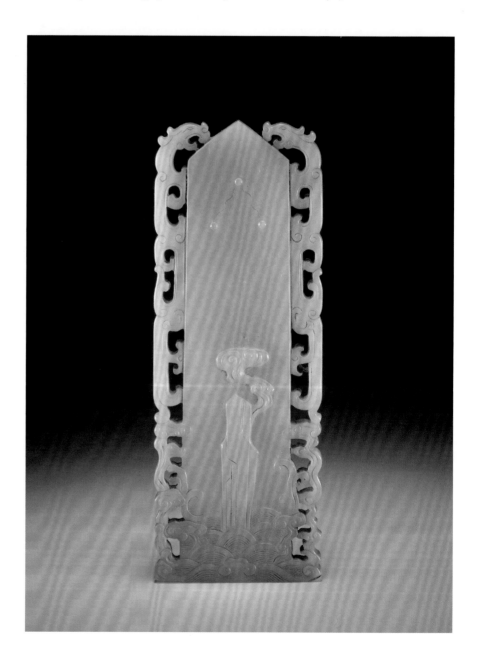

198

Jade Bodhisattva Riding a Beast

Ming Dynasty

Height 11.5 cm
Length 8.1 cm Width 5.2 cm
Qing court collection

This object, made of blue jade, is slightly translucent. It features a Bodhisattva riding on the back of a beast carved in round. The beast prostrates on the lotus terrace and seems to be looking back.

In Buddhist scriptures, the image of Manjusri is usually one who holds a sword of wisdom and rides on the back of a lion. This is a metaphor of using the sharp sword of wisdom to cut off troubles and the majestic roaring of the lion to frighten demons. This work seems to have this meaning. The figures have U-shaped faces. The wrinkles are expressed with straight and curved lines. This is the typical style of the figures carved in jade during the Ming Dynasty.

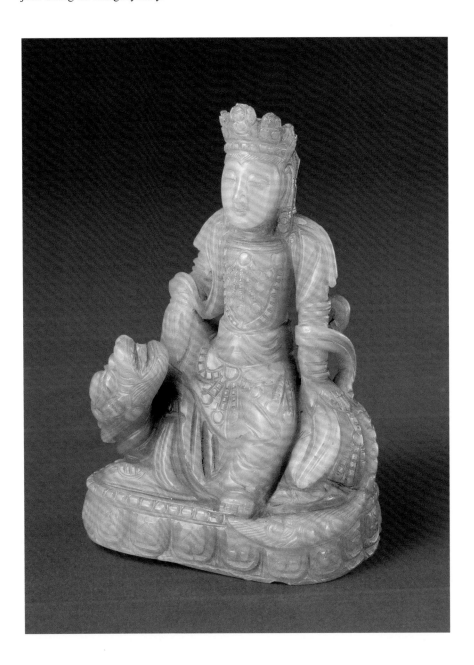

Qing Dynasty

199

Jade Knob with a *Panchi*-dragon and the Seal Mark "*Xuanwen Zhibao*"

Kangxi period

Height 5.4 cm Length of Side 8.4 cm
Qing court collection

This object is made of blue jade. It is a knob carved with a *panchi*-dragon. The front of the seal is square. The inscription on the seal, reading from right to left, is "*xuanwen zhibao*", written in seal script in relief.

This seal is the imperial seal of Emperor Kangxi, which can be observed on page two of *Kangxi Baosou*. This seal is a masterpiece of the imperial seals of Emperor Kangxi.

200

Jade Inkslab Box with Kangxi's Signatures

Kangxi period

Height 1.8 cm Length 6.9 cm Width 6 cm
Qing court collection

This object, made of blue jade, is divided into the lid, the bottom, and the inkslab. The lid and the bottom of the box are carved in jade. The right, left, and upper parts of the surface of the lid are carved with a *kui*-dragon in low relief, and the space in between is carved with a poem in relief and in seal script. It also has the signatures of "*zi*" and "*ang*". Carved inside the lid of the box are upturned lotus leaves carved in relief, with the space in between resting a three-legged gold toad. The back of the bottom of the box has a square seal carved in intaglio and written in seal script with the characters "*yongbao*". Another square seal carved in relief and written in seal script with the characters "*qingshang*" also appears. The inner part of the base has a bulging inkslab support in the shape of an ancient bell. The inkslab is cut and made with *songhua* stones in the shape of an ancient bell. The back of the inkslab has a four-character mark of Kangxi (Kangxinian *zhi*) carved in intaglio and written in clerical script.

The design and craftsmanship of this object are extremely exquisite. The lid, base, and inkslab parts merge with groove tenons in relief or in intaglio. The inkslab placed in this object is well fitted and faultless. It is a valuable piece of artwork of the early period of the Qing Dynasty.

201

Imitation Antique Jade Ring with a Hoisting Tackle and Yongzheng's Signature

Yongzheng period

Full Length 7.4 cm
Large Ring Diameter 4.8 cm
Small Ring Diameter 2.6 cm
Thickness 1.2 cm
Qing court collection

This object, made of bluish-black jade, has numerous black stripe spots. The surface is black and shiny. It is clear that the stripes blackened due to burning. This object has two rings linked to each other, and it has linked tenons on one side. The surface of the ring is slightly concave, decorated with grain patterns. Both sides of the small ring near the tenon are carved with two bats in relief, and the side of the small ring is engraved with a four-character mark of Yongzheng (Yongzhengnian *zhi*) in seal script.

The ancient people called the jade ware with big and small rings linked as "hoisting tackle rings". Literature has it that most of the hoisting tackle rings of the Yuan Dynasty were square-shaped, like the character "*lü*". This piece, however, is a round ring, which probably imitates antique jade ware made during the time of the reign of Yongzheng.

202

Jade Mountain with the Painting of "Great Yu Curbing the Flood"

Qianlong period

Height of Jade Mountain 224 cm
Width 96 cm Height of Base 60 cm
Qing court collection

This object, made of blue jade, has numerous bun patterns. The contour of the jade is followed when "Painting of Great Yu Curbing the Flood" is carved in round. The main body of the object represents the steep high mountains. Carvers cut the mountains and rocks on the cliffs and dredge the water channels. It is a bustling scene that reproduces in a lively way the experience of Great Yu leading the people to curb the flood, which is recorded in historical books. The jade mountain is placed on a gold-inlaid bronze base that is decorated with mountains, rivers, trees, and rocks, making it grand, magnificent, and spectacular.

The front of the jade mountain is carved with a square seal with a seal mark "*wufuwudaitang guxitianzi zhibao*" and a round seal with a seal mark "*tian'en baxun*". Engraved on the upper part of the back of the mountain is a round seal with a seal mark "*guxitianzi*". The middle part has inscriptions of Emperor Qianlong in clerical script "Great Yu curbing the flood from the jade mountain of Mileta" and "inscribed by Emperor Qianlong in the year *wushen*". The lower part of the jade mountain has a poem and annotations inscribed by Emperor Qianlong, as well as three seals by the emperor with seal marks "*bazheng maonian zhibao*" , "*guxitianzi zhibao*", and "*youri zizi*". The *wushen* year of the reign of Qianlong is the 53rd year of Qianlong (1788 A.D.).

According to documents of the Qing court, this jade mountain weighs 10,700 catties, and it took three years to transport it from the Mileta Mountain in Xinjiang to Beijing. Later, based on the design drafted by a Song person, the jade was transported to Yangzhou for cutting and making, and it took six years to complete the work. When the work was done, it was placed at the Hall of Happiness and Longevity (Leshoutang) in the imperial palaces until now.

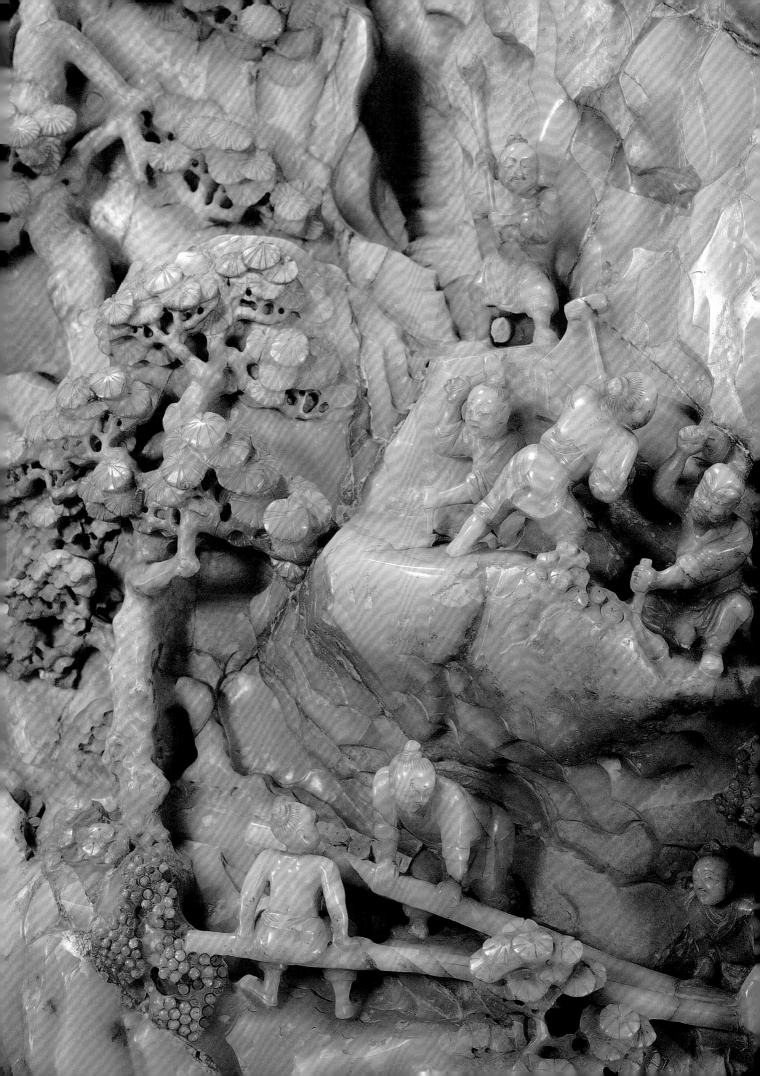

203

Jade Mountain with the Painting of "Nine Old Men at Huichang"

Qianlong period

Height of Jade Mountain 114.5 cm
Width 90 cm Height of Base 41 cm
Qing court collection

This object, made of dark blue jade, has bluish-white jade skin on some parts. It has the painting of the "Nine Old Men at Huichang" carved in round. On the high mountain are rocks and stones scattered everywhere. In the mountain are also tall pine trees and green bamboo. A mountain waterfall surrounds the steps, with pavilions and terraces setting off each other. In the mountain, there are nine old men. Some are sipping tea, others are playing chess, and still others are playing a string musical instrument. Beside them are children carrying the stringed musical instrument and brewing tea. In the empty space on the upper part of the mountain rock are the inscriptions, signatures, and seals of Emperor Qianlong, such as "Picture of Nine Old Men at Huichang", "*guxitianzi*", and "*Qianlong bingwunian zhi*" (made in the year of *bingwu* in the Qianlong period). At the back of the mountain is a poem by Qianlong carved in intaglio in regular script. The lower part of the jade mountain features a large bronze base. The year of *bingwu* in the Reign of Qianlong is the 51st year of the reign of Qianlong (1786 A.D.).

This object is made of Hetian jade in Xinjiang, weighing about 832 kilograms. The "Nine Old Men at Huichang" depicts the story of a gathering of nine old men, including Bai Juyi, Hu Gao, and Ji Min, at the Fragrant Hill in Luoyang, Henan, in the fifth year of the reign of Huichang of the Tang Dynasty (845 A.D.).

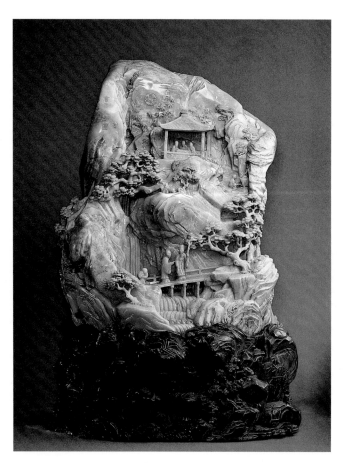
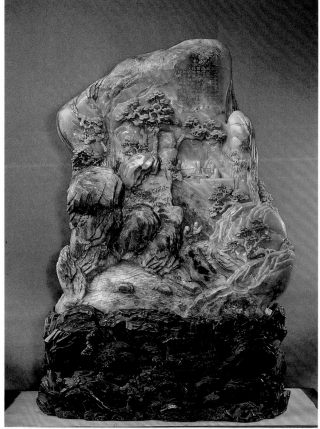

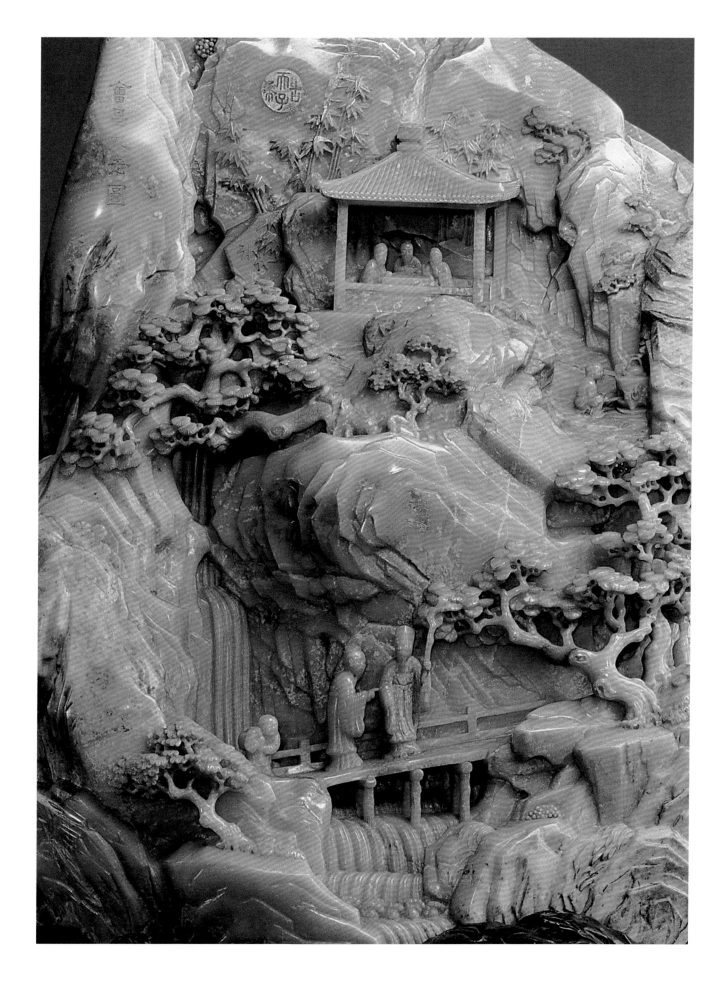

223

204

Jade Chime with Gold-traced Clouds and Dragons

Qianlong period

Height of Stand 350 cm Width 340 cm
Single Musical Stone: Long Shares 35 cm
Short Shares 23.3 cm
Qing court collection

This object, made of green jade, has sixteen single chimes with the same shape and size to form a set. The front and back sides of each chime are decorated with gold-traced clouds and dragons.

Chimes were important musical instruments in the Chinese imperial court music, which was played in the Qing court. Chimes are identical in its external appearance and size. The thickness of the chimes is to distinguish the high and low notes to match the twelve basic notes and four supplementary notes. The thinner the body of the chime, the lower the sound it generates. The names of the notes correspond to those of the chime bells.

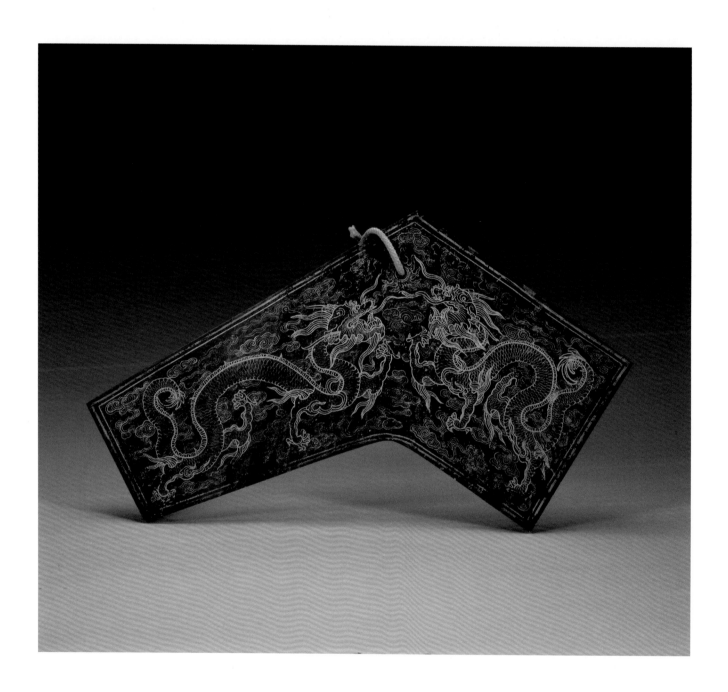

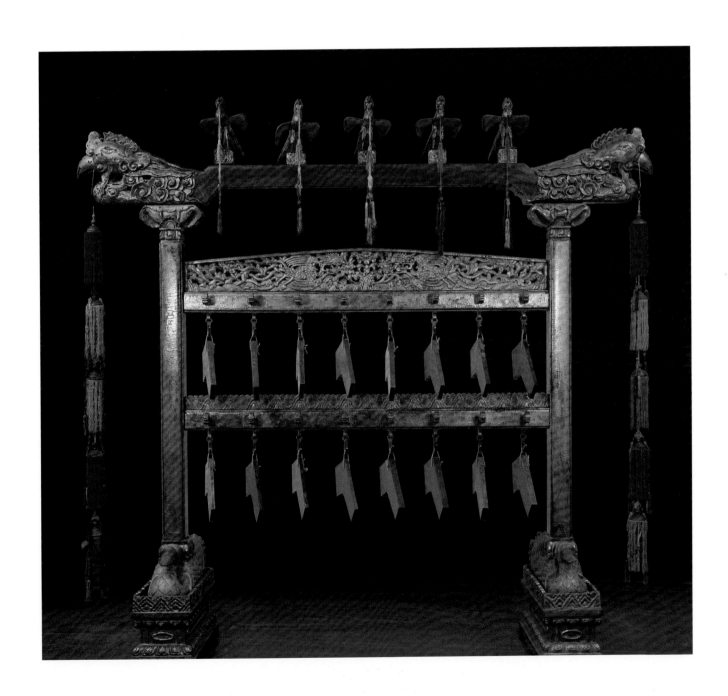

205

Large Jade Vat with Nine Dragons

Qianlong period

Height 70 cm Width 119 cm
Qing court collection

This object, made of bluish-green and white jade, is formed by mixing magma of two colours. The body of this vat is huge, following the contour of the jade. The upper part is slightly broader. The outer wall has nine dragons carved in relief and patterns of seawater. The base of the vat is carved with an inscription of "A Record of Jade Vat" by Emperor Qianlong, whereas the lower part is matched with a bronze base with seawater patterns.

This vat is made of jade from Hetian, in Xinjiang, and weighs about 5,000 catties. It took four years for jade-makers in Yangzhou to complete the exquisite cutting and polishing, and the work was completed in the tenth month of the 45th year of the reign of Qianlong (1780 A.D.). It represents the level of jade craftsmanship in Yangzhou during the reign of Emperor Qianlong.

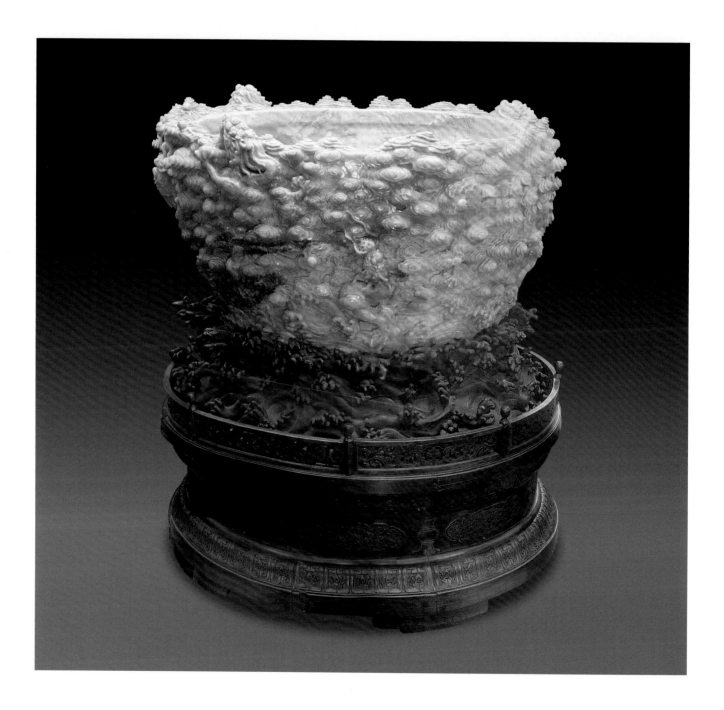

Jade Pot with Loose Ring Beast Handles and Motifs of Wild Ducks and Fish

Qianlong period

Height 42.6 cm
Diameter of Mouth 12.7 cm
Diameter of Leg 13 cm
Qing court collection

This object, made of blue jade, is the imitation of an antique bronze pot. It has a large mouth, a long neck, a round belly, and a ring foot. The outer part of the mouth has a poem by Emperor Qianlong carved in clerical script and the inscription "*Qianlong renwu yuti*" (inscribed by Emperor Qianlong in the year of *renwu)*. There are also two seals with seal marks "*huixin buyuan*" and "*dechongfu*". The neck is carved with a coiling *kui*-dragon, whereas the belly and the upper part of the belly have two bands of fish and birds carved in relief. The body of the pot has three beast handles holding loose rings. The outer base is engraved with an inscription in clerical script "*Daqing Qianlong fanggu*" (imitation antiques made in the years of Qianlong of the Qing Dynasty). The *renwu* year of Qianlong is the 27th year of Qianlong (1762 A.D.).

A few pieces of this kind of duck pots were made in the years of Qianlong. They were large in size and engraved with poems inscribed by the Emperor.

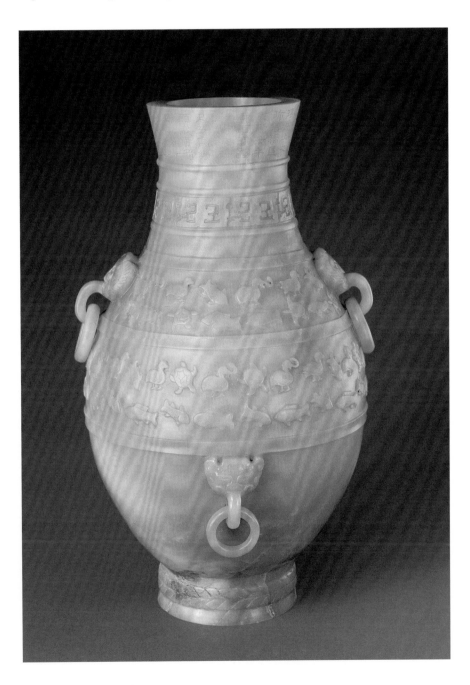

207

Jade Celestial Sphere Vase with a Dragon Playing with a Pearl

Qianlong period

Height 44.5 cm
Diameter of Mouth 9.7 cm
Diameter of Base 19.5 cm
Qing court collection

This object is made of black jade with varied colours. It resembles a ceramic celestial sphere with a straight mouth, a long neck, a ball-shaped belly, and a flat base. The body of the vase has a dragon carved in relief. The tail of the dragon climbs around the neck of the vase, and its body and head extend to the greater half of the belly of the vase. The front of the dragon is carved with a flaming pearl to show the traditional motif of a swimming dragon playing with a pearl. The lower part of the belly of the vase is decorated with patterns of seawater, lakes, and cliffs. The centre of the base features a four-character mark of Qianlong (Qianlongnian *zhi*) in seal script.

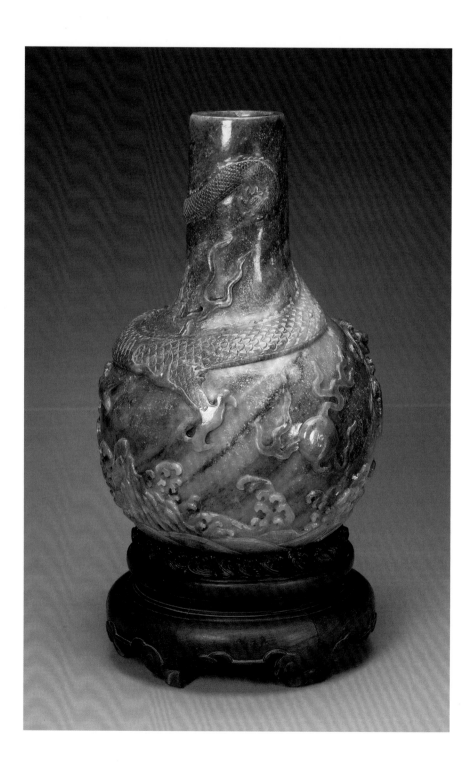

208

Jade Vase with the Painting of "*Xiuxi* Literary Gathering at the Lanting Pavilion"

Qianlong period

Height 31.2 cm
Diameter of Mouth 10.3 x 5.5 cm
Diameter of Leg 9.2 x 5.1 cm
Qing court collection

This object, made of blue jade, has a mouth in the shape of a petal. It also has a short neck, a flat belly, and a ring foot in the shape of a petal. Both sides of the belly are bulging to admit light. On one side is a painting of "*Xiuxi* Literary Gathering at the Lanting Pavilion", carved lightly and filled with gold. Carved on the upper part of the other side is a seal mark "*Qianlong chenhan*" in seal script and an inscription "*shihebi chang*" (when the time is right, the brush can move smoothly). The lower part has the entire text of the "Preface to the Lanting Pavilion" carved and filled with gold. This is followed by Qianlong's imperial inscription, which mentions that it was made in the 22nd year of the reign of Qianlong (1757 A.D.), when Emperor Qianlong made his second tour to the south. This vase is attached to a lid. The body of the vase has two flat beast-swallowing handles.

"*Xiuxi* Literary Gathering at the Lanting Pavilion" refers to the event that took place on the third day of the third month in the ninth year of the reign of Yonghe (353 A.D.) in East Jin, when Wang Xizhi, together with forty-one other people, including the literary figures such as Xie An and Sun Chuo, gathered together at the water side of the Lanting Pavilion at the north foot of Mount Kuaiji, to play the game of drinking water from a winding river with one wine cup to ward off evils (qushuiliushang). Wang Xizhi wrote a preface to mark this gathering of intellectuals with poems and prose, which is the well-known "Preface to the Lanting Pavilion".

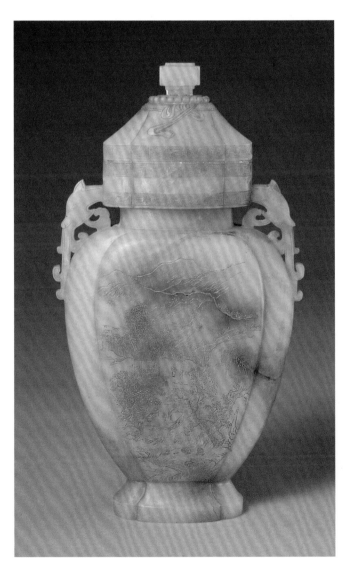

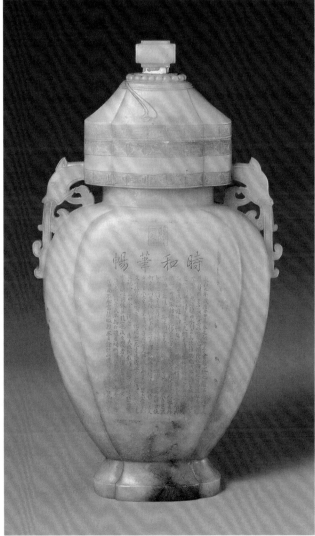

209

Five Sacrificial Jade Utensils

Qianlong period

Height of Censer 25.3 cm
Diameter of Mouth 12.8 cm
Diameter of Belly 15.5 cm
Height of Candle Stand 38.5 cm
Diameter of Base 12.7 cm
Height of Flower Holder 28.5 cm
Diameter of Mouth 18.9 cm
Diameter of Base 9.7 cm
Qing court collection

These objects are made of quality blue jade of Xinjiang. They consist of one censer, two candlesticks, and two flower holders. They are all decorated with patterns in low relief. The lower part has an enamel base.

The censer has the shape of a tripod, with a flat mouth turning outward, a bulging belly, and three beast-swallowing feet. Its neck has a pair of symmetrical court cap handles. Its neck is carved with the word "*shou*" (longevity) interspersed with the Buddhist swastika (卍). The belly, on the other hand, is decorated with beast masks. The censer has an attached lid, the top of which has four knobs in the shape of linked clouds, with bands of cord. The surface of the lid is hidden with four transformed and linked bat patterns.

The candlestick is formed with a base foot, a two-section pillar, and two trays joined by a copper chain. The outer part of the top of the tray is decorated with a band of lotus petals, whereas the upper section of the pillar is decorated with transformed clouds. The inner side of the big tray is decorated with four groups of transformed clouds patterns, while the outer side is decorated with patterns of the character "*ren*" (人) in a slanted way and with beast masks. The middle part of the lower section of the pillar is surrounded by the character "*shou*" (longevity), and other spaces are decorated with patterns of bats. The upper and lower parts represent cloud patterns. The base foot is decorated with drooping clouds and beast masks.

The shape of the flower holder is inspired by bronze wine goblets, and is formed by inlaying and joining three sections. Its round mouth is outward and splay. It has a long neck, a bulging belly, and a high splayed ring foot. The middle part has two bats holding the word "*shou*" (longevity), and the upper and lower parts represent banana leaves in wavy positions. The inner part includes a container to hold flowers.

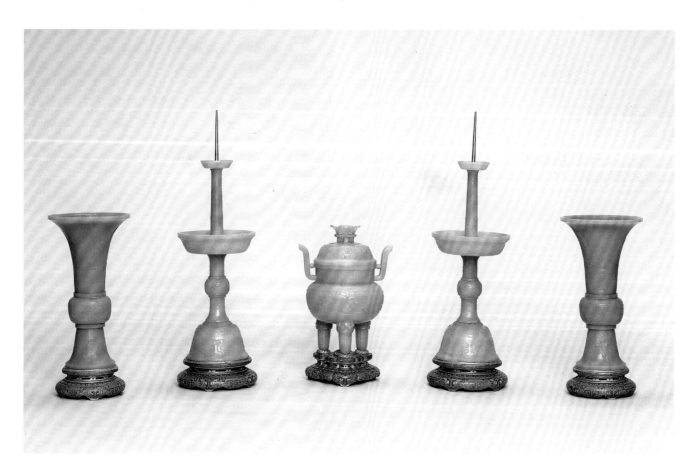

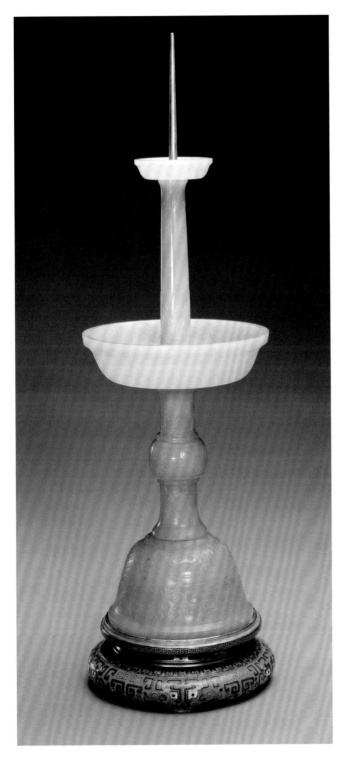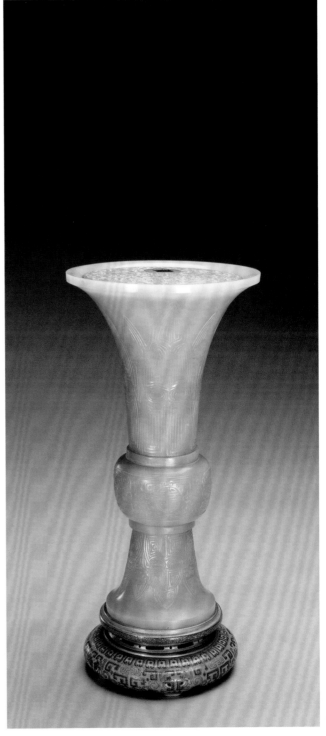

210

Jade Wine Vessel with Beast Mask Motifs

Qianlong period

Full Height 18.7 cm
Diameter of Mouth 15.8 x 7.4 cm
Diameter of Leg 7.7 x 4.2 cm

This object is made of quality white jade from Xinjiang. It consists of a vessel and a lid. The decorations on the entire body are carved with the use of carving techniques, such as relief, openwork, and intaglio. The lid is decorated with a crouching beast with two horns, whose spine is carved with an arched knob with a loose ring. The middle of the outer wall of the vessel has a groove, and both the upper and the lower parts are separated by four symmetrical halberds. The upper part has a *kui*-dragon, whereas the lower part, beast masks. The upper part of the foot has a band of banana leaves. The handle is shaped as a beast head swallowing a *kui*-dragon. Inside the lid, a poem was inscribed by Emperor Qianlong in regular script together with an inscription "inscribed by Emperor Qianlong in the spring of the year of *jihai*". There are also two seals with the intagliated seal marks "*bide*" and "*langrun*". The base of the inner part of the vessel is carved in intaglio with three vertical imitations of antique inscriptions. The outer side of the base is carved with the words "*Daqing Qianlong fanggu*" (imitation antiques made in the years of Qianlong of the Qing Dynasty) in clerical script. The year *jihai* is the 44th year of the reign of Qianlong (1779 A.D.).

This wine vessel was made by imitating the bronze Sikou vessel of the Zhou Dynasty recorded in the *Bogu Tu* (later also recorded in *Xiqing Gujian*). Its shape is elegant, and its craftsmanship, superb. The jade is glossy, moist, and slightly translucent. The black spots inside it bear close resemblance to the spots on bronze vessels. This was a favourable piece of Emperor Qianlong.

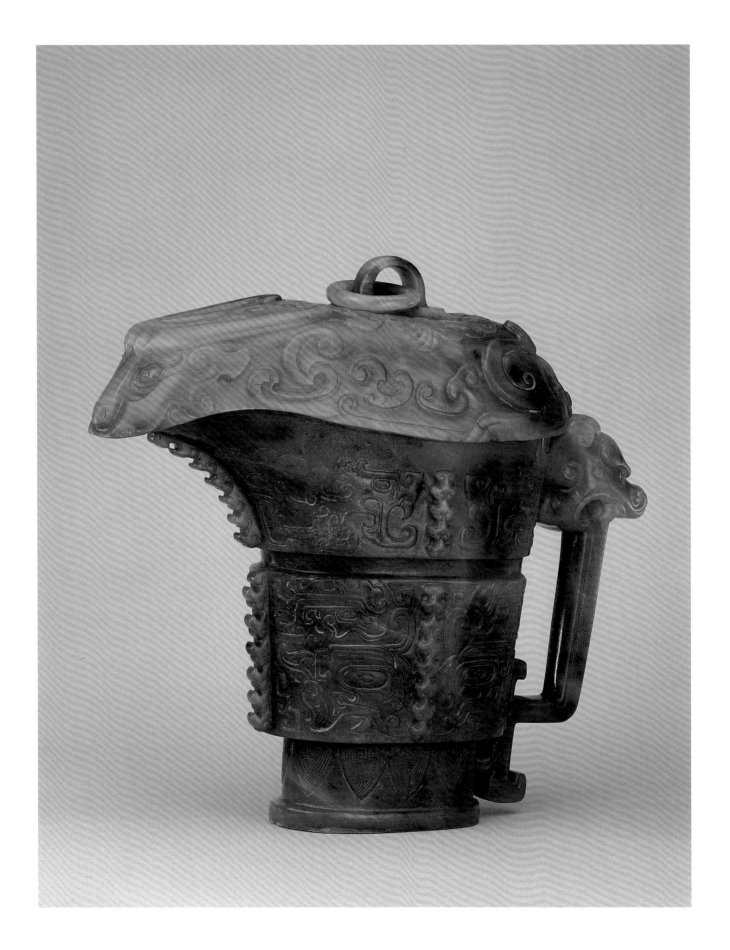

211

The Three Things of Jade Censer, Bottle, and Box with Chrysanthemum Petals

Qianlong period

Height of Censer 20 cm
Diameter of Mouth 12.5 cm
Distance of Leg 5 cm
Height of Bottle 13.5 cm
Diameter of Mouth 2.8 cm
Diameter of Leg 3.2 cm
Height of Box 4.7 cm
Diameter of Mouth 6.9 cm
Diameter of Leg 4.8 cm
Qing court collection

This object, made of bluish-white jade, is lustrous, moist, and faultless. The censer has a round mouth, thick lips, a bulging belly, and three nail feet. It also has an attached lid, with a round knob in the shape of a chrysanthemum bud. The lid and the entire body of the vessel are carved with chrysanthemum petals. It has two bridge-shaped handles. The bottle has a round mouth, a long neck, a vertical belly, and a ring foot. Its belly is carved with patterns of chrysanthemum petals, and its deep chamber can hold copper spade pillars. It has two handles. The box has the lid locked up with the vessel, as well as a round mouth and a ring foot. The surface of the lid opens the light, and the inner side of the lid has bulging lotus flower patterns. The lid and the wall of the vessel are decorated with chrysanthemum petals.

The three things of censer, bottle, and box were popular set utensils in studios during the Qing Dynasty. The censer was for burning incense, the box was for storing incense materials, and the chamber inside the bottle could hold a spade for shoveling incense ashes. They could also serve as display items.

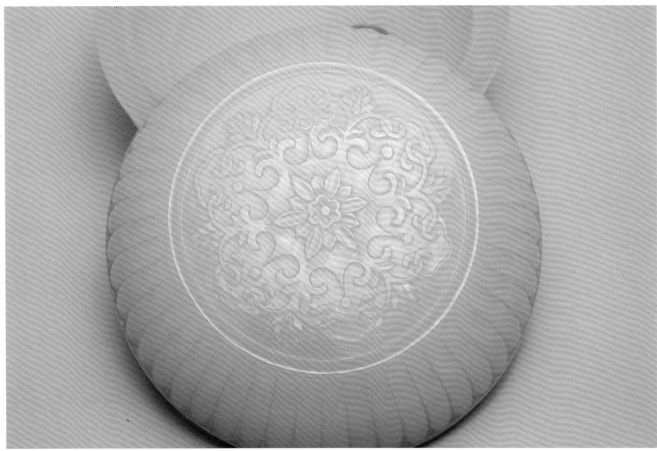

212

Jade Table Screen with a Lamp to Aid Reading

Qianlong period

Height 8.4 cm Width 11.2 cm
Thickness 1.3 cm
Qing court collection

This object is made of blue jade. The front of the screen has a straw hut in a mountain carved in relief, and the environment is refined. An elderly person sits under a lamp to read a book, served by a boy who stands beside him. At the edge of the fret of the back is a poem by Emperor Qianlong in clerical script carved in intaglio, with a signature at the end that reads "giving a lamp to aid reading". It also has the signature of "written by Minister Cao Wenzhi" and a seal mark "*chengzhi*" (Minister Zhi). The screen is matched in its lower part with a base in green jade.

A table screen was an important display item in the court of the Qing Dynasty. It could be used as a utensil in a studio, or placed on tables for display. They were usually matched with rosewood frames and wooden bases. This table screen has a base in jade, which shows its value. Cao Wenzhi (1735 A.D. – 1798 A.D.), *zi* Zhuxu and *hao* Jinwei, was a native of the She county in Anhui. He obtained the degree of *jinshi* (Advanced Scholar) in the 25th year of the reign of Qianlong (1760 A.D.), and served in positions such as Imperial Censor of the Left Capital and Minister of Treasury. His son Cao Zhenyong was an important official in the ministry and a well-known calligrapher in the Jiaqing and Daoguang periods.

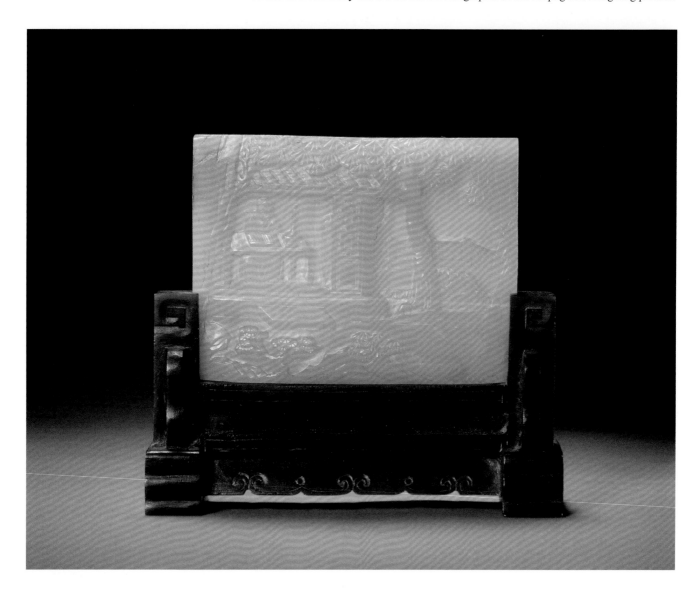

213

Jade Miniature Landscape with Mountain Houses and Ten Thousand Pines

Qianlong period

Height 20.6 cm Length 28 cm
Width of Base 4.6 cm
Qing court collection

This object, made of blue jade, represents overlapping mountain ranges. The front side is carved with a huge pine forming a shade amidst the mountains, interspersed with pavilions and towers. The middle part of the mountain is surrounded with rising auspicious clouds. Carved on the clouds is a poem of a mountain house with ten thousand pines, written by Emperor Qianlong in clerical script. The back is carved with steep cliffs and decorated by pine trees.

Jade miniature landscapes were numerous in the Qing Dynasty. The carving and cutting of these mountains are exquisite and full of the flavour of paintings. They are display items of a high artistic value.

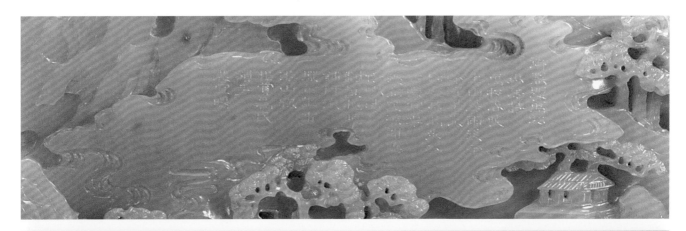

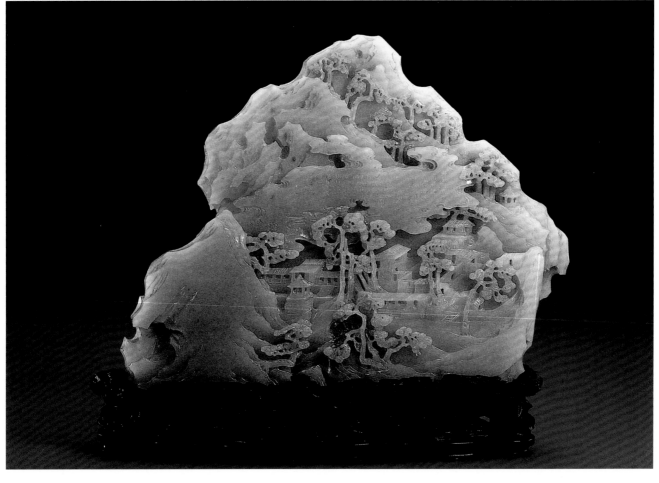

214

Jade Miniature Landscape with Ladies under the Shade of a Chinese Parasol

Qianlong period

Length 25 cm Width 11 cm
Height 15.5 cm
Qing court collection

This object is made of white jade, with a large area of yellowish-brown jade skin. A garden scene is carved in round. The main body represents a gate pavilion, which is hidden under the shade of a Chinese parasol. The front features a door post and a tiled eave. It has a round gate hole. The gate has two gate leaves, one of which is closed, and the other is opened. A ray of light comes through the crack between the gate and its frame. A lady leans on the gate, standing with a jar in her hands. Another lady standing beside the gate post holds the glossy ganoderma. The two ladies seem to look at each other through the crack, and they also seem to intend to talk to each other. The two sides in front of the gate, with the use of the colour of the jade, are carved into a Chinese parasol, rockery, and high plantain trees. Under the tree are stone terraces and stone seats. The base of the vessel has the signature and a poem written by Emperor Qianlong, ending with an inscription "*Qianlong guisi xinqiu yuti*" (inscribed by Emperor Qianlong in early autumn of the year *guisi*), and the seals have the words "*tai*", "*pu*", "*qian*", and "*long*". The year *guisi* in the reign of Qianlong is the 38th year in the reign of Qianlong (1773 A.D.).

It can be inferred from the signatures and poem inscriptions of Emperor Qianlong that this vessel was made with the residual materials of the tribute jade of Hetian after scooping a bowl, and the vessel was cut and made by jade makers of Suzhou. The conception and design of this vessel is the same as the table screen of the *Jade Miniature Mountain with Ladies under the Shade of a Chinese parasol* in the Palace Museum, but the figures and layout are more vivid than that of the tablet screen. This vessel can be considered as a unique piece in the history of jade carving.

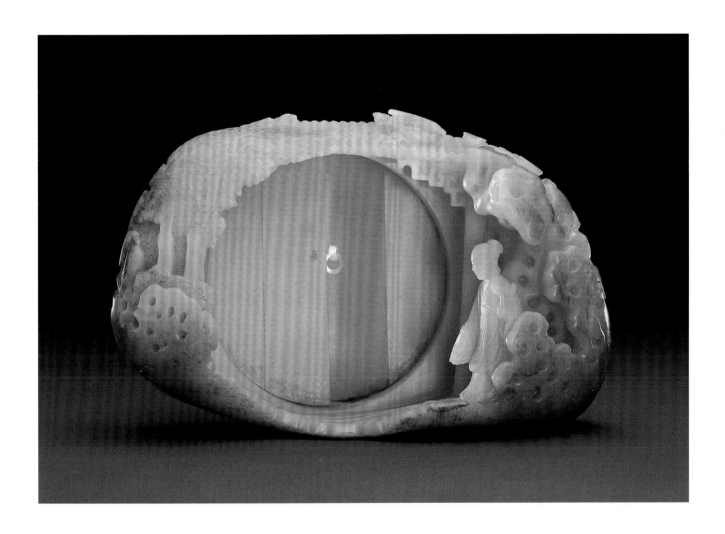

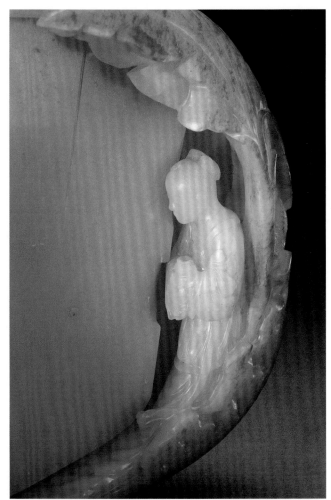

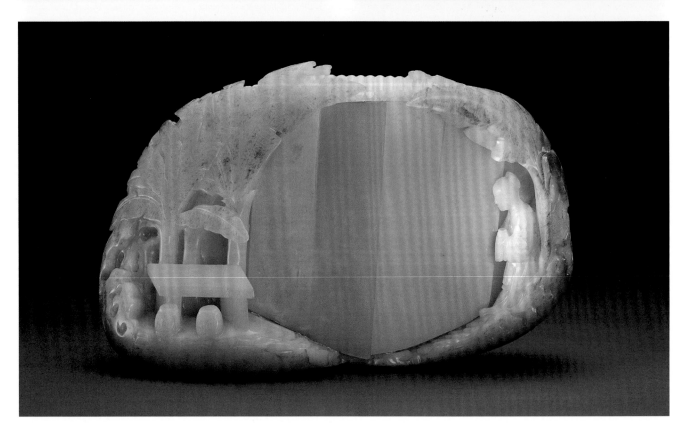

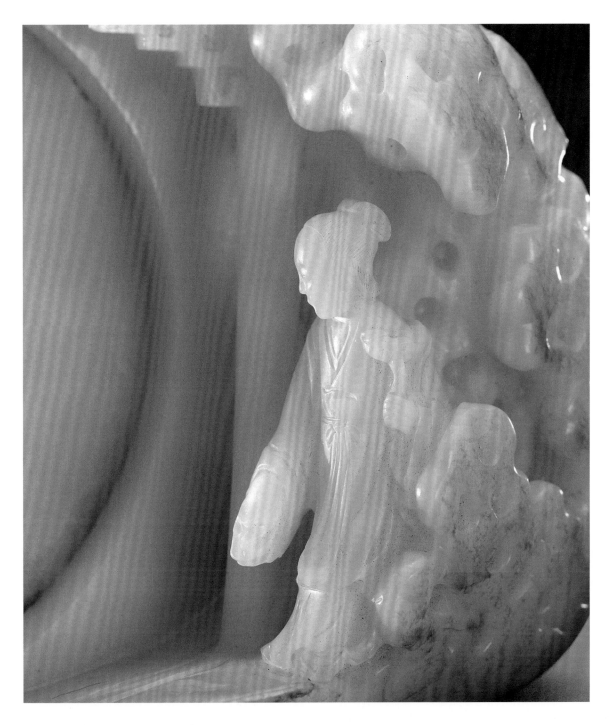

215

Jade Incense Holder with a Painting of Picking Herbs

Qianlong period

Height 17.9 cm Diameter of Mouth 3.6 cm
Diameter of Base 3.6 cm
Qing court collection

This object is made of bluish-white jade. This holder has a round mouth, a vertical wall, and a round base. The wall of the holder is carved in openwork with a painting of landscape and figures. It has a small pavilion with upturned eaves standing on a precipitous mountain rock, and beside it is a towering pine tree. An elderly person stands in front of the pavilion, and raises his head to watch the children who play among the wisteria in the middle of the mountain. Under the feet of the elderly person is a gurgling stream. There is also a basket beside him, full of hand-picked glossy ganoderma. The empty space on the upper part of the patterns is carved with the poem entitled "On Qiu Ying Picking Herbs", written by Emperor Qianlong in regular script and filled with gold.

Jade incense holders were display utensils for the Qing court. Some are large, and others are small. The small ones are usually placed on incense tables or serve as stationery. They are mostly carved in openwork for fumigating smoke.

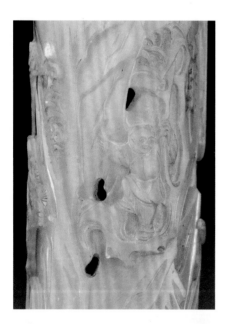

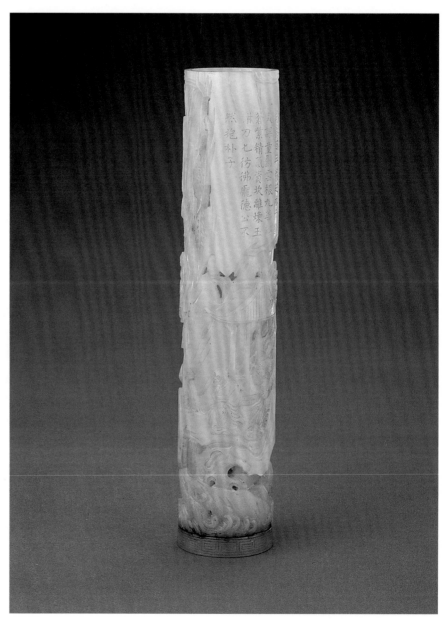

216

Jade Poem Album on the Thirty-six Peaks of Mount Huangshan

Qianlong period

Height 11 cm Length 21.5 cm
Width 12.5 cm
Qing court collection

This object is made of blue jade. It has four albums, carved in line the magnificent scene of the thirty-six peaks of Mount Huangshan. It is based on the painting of "The Thirty-six Peaks of Mount Huangshan" by Yinxi, Prince Shen of the Second Rank. The upper part of each peak is carved with the name of the peak and a poem written by Emperor Qianlong entitled "On the Painting of the Thirty-six Peaks of Mount Huangshan by Prince Shen". Each album has nine peaks, so there are thirty-six poems. This title includes the first album of nine sections, depicting the scenery of nine peaks, which are Fuqiu, Furong, Cuiwei, Feilong, Tiandu, Zishi, Diezhang, Songlin, and Zhibo respectively. The head and end of each album have seal marks "*yanyulou bao*" and "*bishu shanzhuang*". Rubbings of this jade carving have been made to package with the albums.

It can be speculated from the seal that this set of poem albums was collected in the Smoke and Rain Tower of the Imperial Summer Resort.

244

1

1.1

1.2

1.3

1.4

1.5

1.6

1.7

248

1.8

1.9

217

Jade Bell and Jade Pestle

Qianlong period

Height of Bell 18.4 cm
Diameter of Mouth 9.7 cm
Length of Pestle 12 cm Height 4.3 cm
Qing court collection

This object is made of blue jade. This bell is formed by combining a jade handle with a jade bell. The upper part of the handle has the shape of a five-section pestle, with the head of the Buddha carved in the middle. The lower end is carved in intaglio and in regular script with a four-character mark of Qianlong (Qianlongnian *zhi*). The outer wall of the bell is decorated with Buddhist motifs, such as lotus flowers, Sanskrit, wheel-shaped tassels, and pestles. Hanging inside the bell is a jade drooping hammer.

The pestle has three sections. The handle part in the middle has a four-character mark of Qianlong (Qianlongnian *zhi*) carved in intaglio and in regular script. Both sides of the handle are decorated with a lotus flower tray, with the head of a five-section pestle.

Vajra bells and pestles are Buddhist ritual objects of Tibetan Buddhism. They have complicated and far-reaching Buddhist implications. The few pieces of jade bells and pestles in the Palace Museum collection are modelled on and made from the bronze bells and pestles of Tibetan Buddhists. Their shape is extremely elaborate and real.

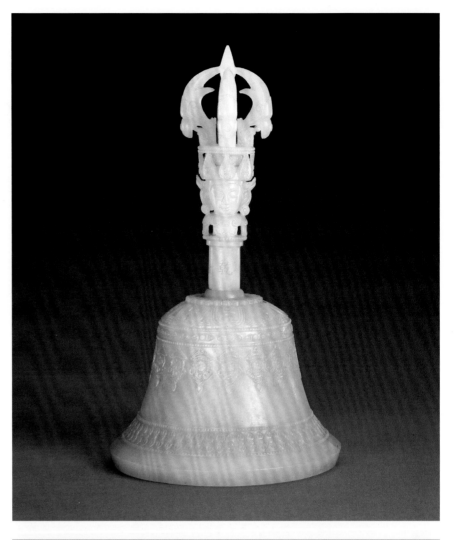

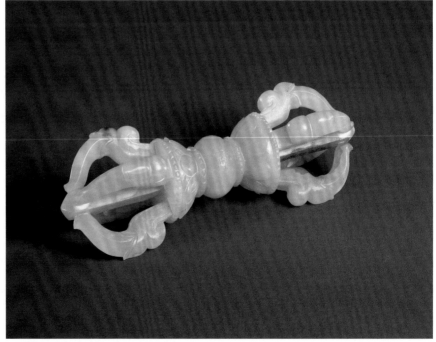

218

Matching Jade Wine Cup (A Pair)

Qianlong period

Height 13.5 cm
Width of Mouth 8.1 cm
Thickness 4.5 cm
Qing court collection

This object is made of bluish-green jade and has some black spots. The two cups combine to form a wine cup. The cup is in the shape of a half *jue*. On one side of the mouth of the cup are a spout and a pillar. Two prostrated beasts are also carved. One has a beast head, and the other has a bird head. The belly of the cup is decorated with a *kui*-dragon and has three halberds. Under the belly are three feet, decorated with imitation antique cloud patterns. The base of the cup has a four-character mark of Qianlong (Qianlongnian *zhi*) carved in intaglio and written in clerical script.

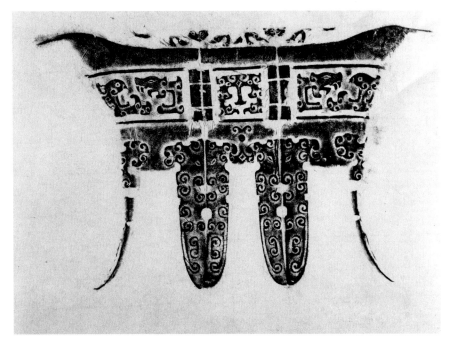

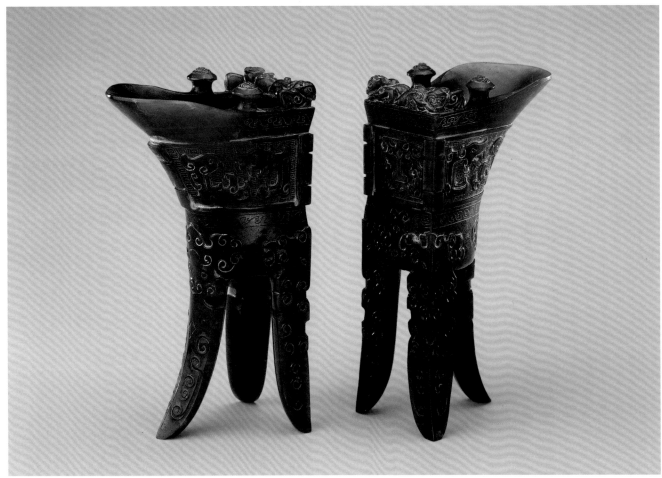

219

Jade Alms Bowl with Seven Buddhas

Qianlong period

Height 8 cm Diameter of Mouth 14.5 cm
Qing court collection

This object is made of white jade. This alms bowl has a wide mouth, a deep belly, and a flat base. Its belly is carved in relief with seven figures of Buddhas. The seven Buddhas have close resemblance in shape. Their hands are in the posture when they are expounding the Buddhist doctrine, sitting cross-legged on the lotus seats. At the back, there is the light of the Buddha. The base of the alms bowl is carved with seawater patterns, spinning out seven waves, corresponding to the number of Buddhist figures.

The seven Buddhas refer to Shakyamuni and the previous six Buddhas who appeared before him, including Vipasyin, Shikhin, Vishvabhu, Krakucchanda, Kanakamuni, and Kashyapa. These seven Buddhas all entered into rest, and they are known as "The Past Seven Buddhas". According to some studies, in the 22nd year of the reign of Qianlong, when the Emperor took a tour to the south and reached Suzhou, he saw and was greatly impressed by the alms bowls offered at the Kaiyuan Temple. He later ordered to produce an imitation jade alms bowl for offering to the Buddhist temple inside the palaces. This alms bowl might be the one the Emperor instructed to make.

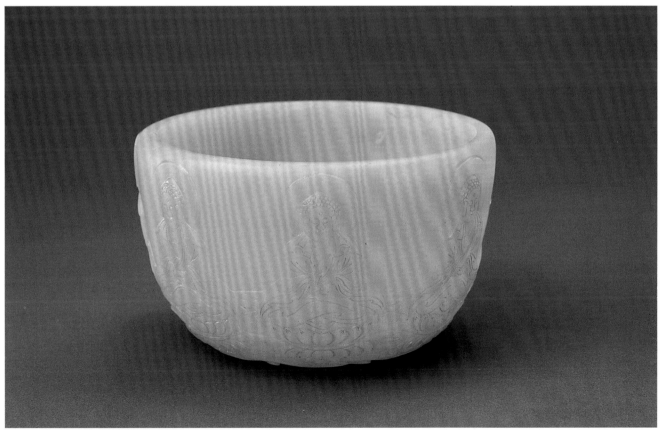

220

Jade Alms Bowl Engraved with Buddhist Sutra

Qianlong period

Height 8.6 cm
Diameter of Mouth 10.9 cm
Diameter of Base 9 cm
Qing court collection

This object is made of green jade and has some white spots. It has a contracted mouth, a deep arc-shaped belly, and a flat foot. Engraved along the edge of the mouth, the words "*Bore boluomiduo xinjing*" (The Prajna Paramita Heart Sutra) can be observed. On the outer wall of the bowl, the text of the sutra is engraved in vertical lines and in regular script, with all the words filled with gold.

An alms bowl is a food container for Buddhist monks. It is said in *A Biography of Faxian* that Buddhist alms bowls were originated from Vaiahali, in ancient India. Buddhist patriarchs used them to contain vegetarian food, and they were later introduced to China.

221

Fish-shaped Jade Box with Emerald Inlaid with Precious Stones

Qianlong period

Height 2.9 cm Length 24.9 cm
Largest Width 8 cm
Qing court collection

This box is in the shape of a fish. It has a mouth for a lid to be fixed. It is carved out of a block of emerald, which includes pea green, tinges of verdant green, and a patch of violet. The fish eyes are formed by inlaying two pieces of glass-like emerald and two pieces of crystal, inlaid with pearls as pupils of the eyes. The two fish whiskers coil to the sides. The fins and the backs are inlaid with seventy pieces of ruby. The box and the inside of its lid are carved with a poem entitled "Jade Fish of Hendusitan", written by Emperor Qianlong in regular script and filled with cinnabar. It is followed by square seal marks "*Qianlong xinhai yubi*" and "*bide*" in relief. There is an inscription of Qianlong after the poem. The year *xinhai* of the reign of Qianlong is the 56th year of the reign of Qianlong (1791 A.D.).

From the poem and inscriptions, it can be learned that when Qianlong saw the jade fish, he recalled the story of sending a letter in a fish's belly, and he therefore wrote a poem into the fish's belly. It is scientifically proved that this box was not the Hindustan jade ware mentioned in the poem, but a fake object made by a Chinese craftsman.

Hendusitan is a transliteration of "Hindustan". According to history, it was in the northern part of India, comprising Kashmir and the western region of Pakistan. Hindustan jade ware was in fact Islamic jade ware. It was an extremely valuable and special kind of jade ware in the Qing court. Emerald (*fei cui*), also known as emerald jade, green jade, hard jade, or Myanmar jade, is a kind of jade. Generally, in China, the emerald in red is known as *fei*, and that in green is called *cui*.

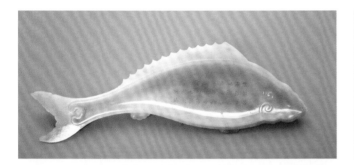
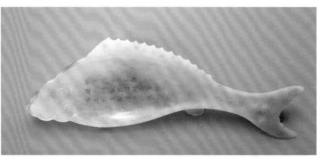

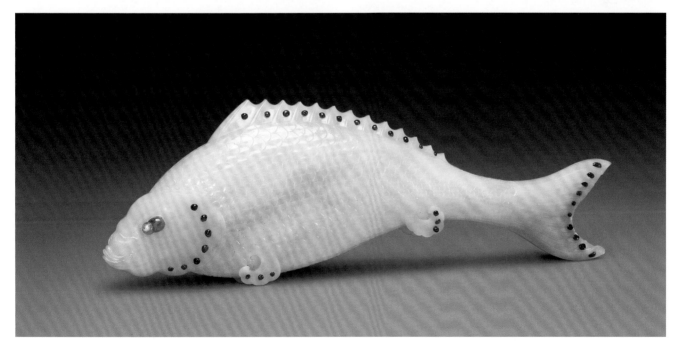

222

Jade Cup and Saucer with Dragons

Qianlong period

Height of Cup 3.8 cm
Diameter of Mouth 6.3 cm
Diameter of Leg 3.3 cm
Height of Saucer 2.5 cm
Diameter of Mouth 17 x 11.9 cm
Diameter of Leg 13.8 x 9 cm
Qing court collection

This object, made of bluish-green jade, has dark spots. The entire vessel is divided into two parts: the cup and the saucer. The cup has a round mouth, an arc-like wall, and a ring foot. The outside wall is decorated with clouds in low relief and two dragons carved in openwork as handles in the sides. The base of the foot is carved in intaglio with the inscription "*Qianlong yuyong*" (for the imperial use of Emperor Qianlong) in clerical script.

The saucer is rectangular in shape with round corners, and it has an oval foot. At the centre is a cup stand carved with lotus petals, and at both sides are relief designs of two dragons playing with a pearl. The base of the foot is carved in intaglio with the inscription "*Qianlong yuyong*" (for the imperial use of Emperor Qianlong) in clerical script.

Cups with saucers were popular in the Song Dynasty. Regarding those of the Ming and Qing periods, the saucers were mostly shallow plates. This object is a representative piece of jade cups with saucers in the Qing Dynasty.

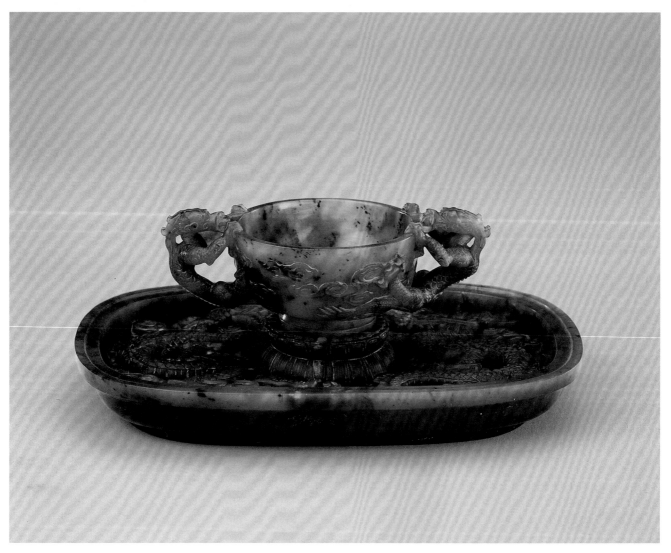

223

Jade Bowl with an Inscribed Poem

Qianlong period

Height of Bowl 4.4 cm
Diameter of Mouth 13 cm
Diameter of Leg 5.5 cm
Diameter of Jade Tray 11.6 cm
Diameter of Hole 5.7 cm
Height of Hole 1.9 cm
Qing court collection

This object, made of dull blue jade, is semi-transparent, and has striped-type spot patterns. This bowl has a round and slightly pursed mouth, a shallow belly, and a ring foot. The outer wall is carved with a poem written by Emperor Qianlong in clerical script, and an inscription at the end "inscribed by Emperor Qianlong in the spring of the *yiwei* year". The emperor also wrote in red legend and in seal script on a pastime seal "*dechongfu*". The base has the inscription "*Qianlong yuyong*" (for the imperial use of Emperor Qianlong) carved in intaglio and in seal script. The *yiwei* year of the reign of Qianlong is the 40th year of the reign of Qianlong (1775 A.D.).

The jade tray of this bowl is actually a jade ring of the Shang Dynasty, which was a kind of pendant ornament, also known as a breast ring. The broad edge of the ring is carved with a poem by Emperor Qianlong written in regular script. As the bowl tray of the Song Dynasty was close in shape to this jade ring, Emperor Qianlong mistook this ring for a bowl tray.

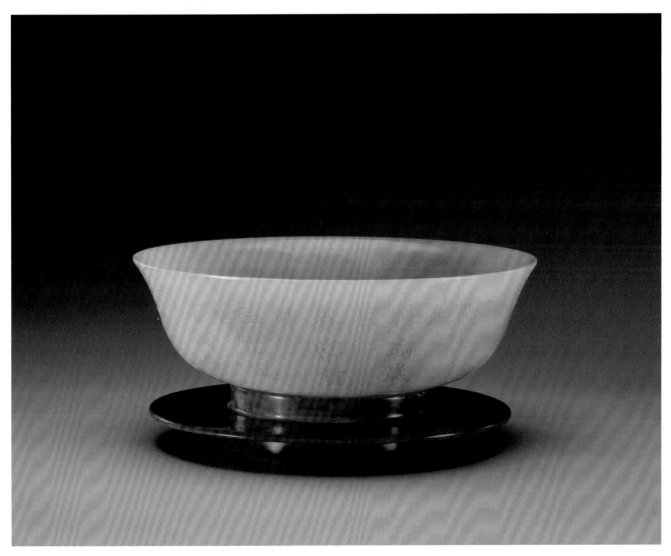

224

Jade *Ruyi* Sceptre with an Imperial Poem and a Coiled Dragon

Qianlong period

Length 44.7 cm Width of Head 10.5 cm
Qing court collection

This object is made of bluish-white jade and has spots. It is carved out of an entire block of jade. The head of the sceptre is decorated with flaming pearls and clouds, and on the head is carved a poem made by Emperor Qianlong, with the words "*yuzhi*". The front side of the handle has a coiling dragon carved in openwork, and the back side features the words "respectfully presented to Your Highness, by Official Sanbao".

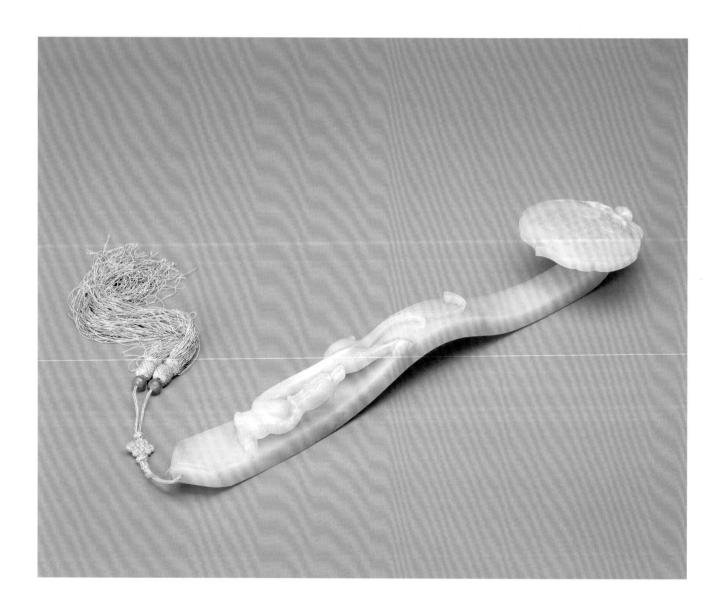

225

Dipper-shaped Jade Brush with Landscape and Figures

Qianlong period

Length 21.4 cm Diameter 2.4 cm
Qing court collection

This object is made of blue jade. The shaft of the brush is empty. The top of the brush is inlaid with green jade at one end and the brush peck, inlaid with green jade, is at the other end. The shaft is decorated with a full landscape and figure painting with the use of the carving techniques of relief and openwork. The upper part has dangerous steep cliffs, floating clouds, flying cranes, and ancient pines. Grotesque grass grows in the cracks between rocks. In the middle part is an old man pointing his finger at the distant sky, watching the crane flying and appreciating the fine scenery. The lower part features mountain rocks, trees, flowing streams, and a small child tending a fire to brew tea.

The dipper-shaped brush is large and gained its name from the fact that the nib of the brush is fixed onto a dipper-shaped device. It is mainly for writing large characters, and it is also used in drawing Chinese paintings.

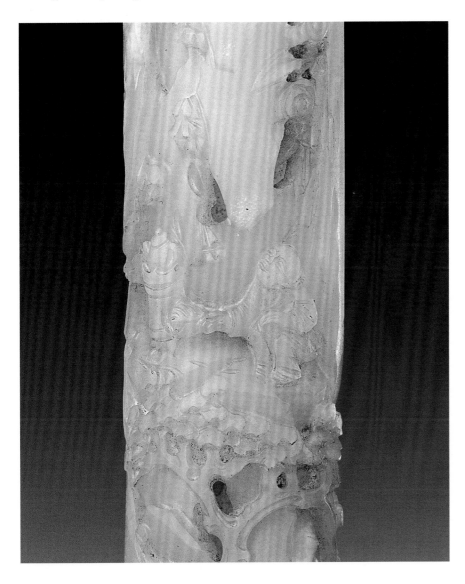

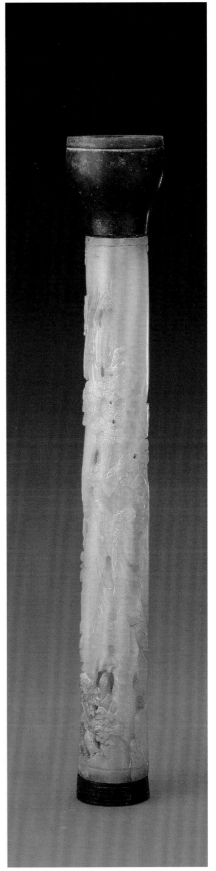

226

Jade Brush Holder with the Painting of "Literati Gathering at West Garden"

Qianlong period

Height 15.6 cm Diameter of Mouth 11.9 cm
Distance of Leg 3.5cm
Qing court collection

This object is made of green jade. This brush holder has a round mouth, a vertical wall, and a deep belly, and the lower part has five short feet at an equal distance. The entire scene of the outer wall is carved with the painting of "Literati Gathering at the West Garden". In the middle of the scene, scattered mountain rocks can be observed, with the pine, bamboo, flowers, and grass setting off each other. Over ten elderly people are practising calligraphy, drawing paintings, holding conversations, watching the scenery, or touching the cliff to cut characters. It is a scene of a literati gathering. The centre of the base of this vessel is carved in intaglio with a four-character mark of Qianlong (Qianlongnian *zhi*) in clerical script.

The West Garden is the residence of Wang Shen, who was the son-in-law of Emperor Shenzong of the Northern Song Dynasty. In the early years of Yuanfeng, Wang Shen invited sixteen people, including Su Shi, Su Zhe, Huang Tingjian, Mi Fu, Cai Zhao, Li Zhiyi, Li Gonglin, Chao Buzhi, Zhang Lai, Qin Guan, and Master Yuantong to have a garden party. They were all men of letters with refined tastes, specialized in literature and painting and well versed in ancient and modern learning. As this was such a distinguished gathering, Mi Fu put it down in writing, Li Gonglin recorded it in a painting, and there was therefore the saying of a "Literati Gathering at the West Garden". Some famous painters of the Northern and Southern Song, Ming, and Qing dynasties had paintings with the same theme.

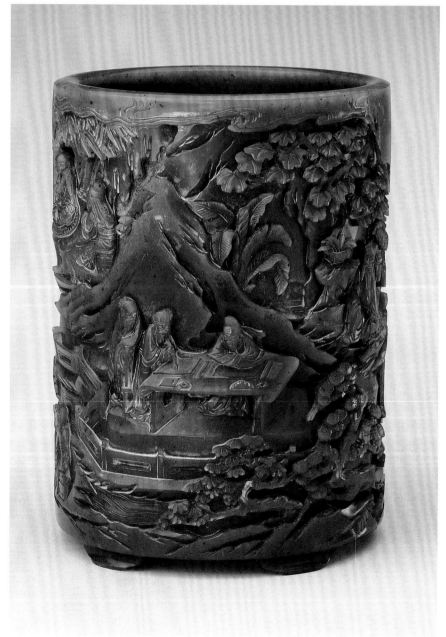

227

Jade Pendant with *Kui*-phoenixes Carved in Openwork and Characters "*Changyi Zisun*" (Prosperity for Descendants)

Qianlong period

Length 13.5 cm Width 8.1 cm Thickness 0.5 cm
Qing court collection

This object is made of white jade and has no flaws or spots. This pendant is in the shape of a tablet. Its upper part has two *kui*-dragons carved in openwork, facing each other. The tops of their heads have cloud patterns. The lower part has two *kui*-phoenixes carved in openwork and characters "*changyi zisun*" (prosperity for descendants) written in seal script. The edges on the left and right sides are carved with a four-character mark of Qianlong (Qianlongnian *zhi*) and "*fuzi yibaibashibahao*" (No. 188 in the *fu* series) in clerical script. This jade pendant is placed in a *nanmu* box and a *nanmu* letter.

The jade pendants made in the Qing court followed, for the most part, the way jade pendants made in the Han Dynasty, but with variations and a more elaborate and exquisite decoration and shape. This pendant is made by imitating the "Good for Descendants" pendant in the Han Dynasty. It was, however, smaller in size and yet richer in design and contents.

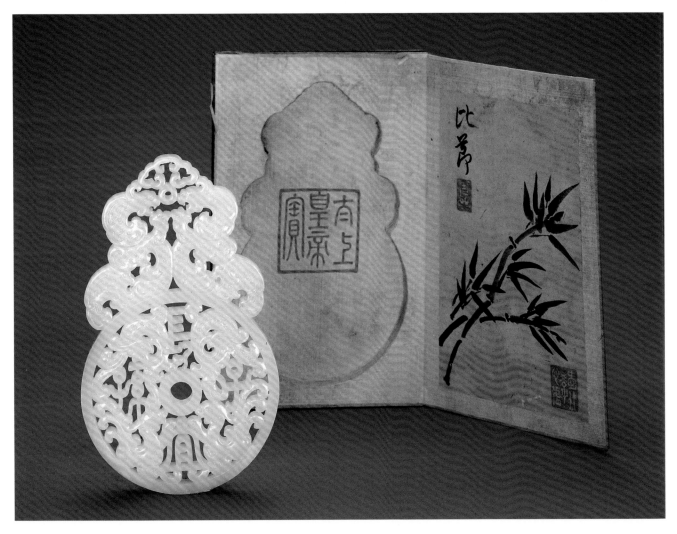

Jade Thumb Ring with a Hunting Scene, Jade Thumb Ring with Towers and Pavilions, and Jade Thumb Ring with Figures

Qianlong period

Thumb Ring for the Hunting Drawing:
Height 2.35 cm Diameter 3.1 cm
Thumb Ring for the Towers and Pavilions
Drawing: Height 2.25 cm
Diameter 3.35 cm
Thumb Ring for the Figure Drawing:
Height 2.25 cm Diameter 3.3 cm
Qing court collection

This object is made of white jade and the original colour of the jade can be seen. The three thumb rings have the same shape, and they are all cylindrical. However, they differ in decorative patterns and the poems written by Emperor Qianlong. The outer wall of the thumb ring with a painting of hunting has a person riding on horseback to shoot a deer carved in low relief. Also carved in relief is a poem with seven characters per line written by Emperor Qianlong in clerical script, ending with a signature that reads, "inscribed on a day in spring in the *bingxu* year of the Qianlong period." It also has two pastime seals, one round and the other square, with the words "*qian*" and "*long*" respectively. The outer wall of the thumb ring with towers and pavillions is carved with decorations of figures, towers, pavilions, and trees. It has another poem of seven characters per line written by Emperor Qianlong in regular script and carved in intaglio, ending with a signature, which reads, "inscribed by Emperor Qianlong" and a round pastime seal. The outer wall of the thumb ring with figures has figures as decorations, such as figures, trees, hanging rocks, and waterfalls, carved on the surface of the jade. It also includes a poem of five characters per line by Emperor Qianlong in intaglio and regular script that ends with an inscription that reads, "inscribed by the Emperor in the spring of the year *renwu*," along with two pastime seals, one round and the other square. The year of *bingxu* is the 31st year of the reign of Qianlong (1766 A.D.), and *renwu* is the 27th year of the reign of Qianlong (1762 A.D.).

Thumb rings were originally for protecting the hands of the person when pulling a bow in shooting. They were popular in the Qing Dynasty, and gradually became jade ornaments. These three thumb rings are a set with exquisite decorative patterns and craftsmanship. They stand out from similar objects of the Qing Dynasty.

263

229

Jade Snuff Bottle with Two *Chi*-dragons Embracing the Bottle

Qianlong period

Full Height 4.7 cm
Largest Width of Mouth
1.2 cm
Qing court collection

This object is made of jade. It is in the shape of a flat bottle. It is oval and has a ring foot. Both sides of its neck are carved in openwork with two *chi*-dragons as handles. The two sides of the belly of the bottle have two *chi*-dragons carved in relief, with their bodies bent in the posture of embracing the bottle. One dragon has its body climbing upward, with its four feet holding firmly the body of the bottle. The other dragon has its body moving downward, and its head turns back at the belly of the bottle, as if watching. The base is carved in intaglio with a four-character mark of Qianlong (Qianlongnian *zhi*) in seal script. It has a ruby lid, which is linked to an ivory spoon below.

Snuff bottles are vessels for storing snuff. They began to become popular from the Qing Dynasty. They entered the court during the reign of Emperor Kangxi, and they were mostly small and exquisite. Snuff bottles made of jade or other similar materials were truly developed during the time of Emperor Qianlong.

230

Melon-shaped Jade Snuff Bottle

Qianlong period

Full Height 6.4 cm
Diameter of Mouth 0.8 cm
Qing court collection

This object, made of white jade, has some faults and spots on some parts. It is shaped like a long round melon. The entire body is carved with melon ridges. It also keeps the colour of the jade to carve out in openwork the stems, leaves, and intertwining vines. The base of the bottle is carved in intaglio with a four-character mark of Qianlong (Qianlongnian *zhi*) in seal script. The lid resembles a small melon, and is linked to a bronze-plated gold spoon below.

In ancient times, large melons were known as *gua*, while the small ones, as *die*. This vessel, with the kind of shape that groups together large and small melons, as well as their stems and leaves, is known as "a multitude of melons and little melons" (guadiemianmian), implying a large family with continuing generations.

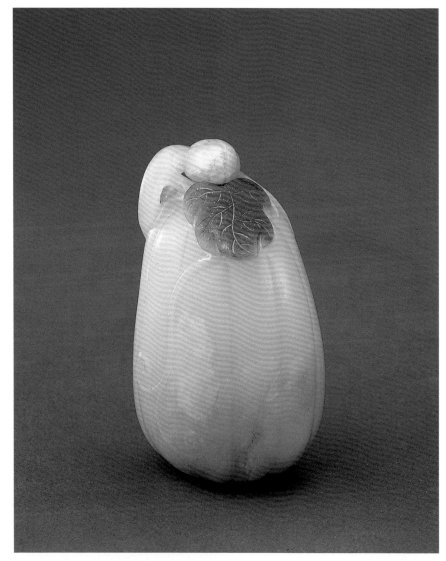

231

Magnolia-shaped Jade Snuff Bottle

Qianlong period

Full Height 6.2 cm
Diameter of Mouth 0.8 cm
Qing court collection

This object is made of white jade. It has no faults or spots. The bottle is shaped like a magnolia. The petals of the magnolia droop, as if about to blossom. The outside of the mouth includes a four-character mark of Qianlong (Qianlongnian *zhi*) in a single line and in seal script. The flower stalks serve as the lid, linked to a bronze-plated gold spoon.

232

Willow-pattern Jade Snuff Bottle

Full Height 5.7 cm
Diameter of Mouth 1.7 cm
Qing court collection

This object, made of white jade, has a round shape, a contracted mouth, and an oval contracted foot. The entire body is carved with fine willow patterns, shaped like a genuine fish junket. Carved in intaglio under the rim of the mouth and the rim of the foot is a round of cord patterns. Its lid has amethyst inlaid with bronze-plated gold, and it is linked to an ivory spoon below.

233

Jade Table Screen with Pines, Pavilions, and Figures

Length 24.7 cm Width 15.1 cm
Thickness 1.1 cm
Qing court collection

This object is made of green jade with tender and moist lustre. It is rectangular. One side of it has an elderly person carved in relief, who is sitting alone under the shade of a pine tree, watching a child in front of him watering chrysanthemums. There are mountain rocks, trees, pavilions, and terraces in the background. The upper right corner is carved with a poem of five characters per line traced in gold. The author of this poem is uncertain. The contents clearly refer to the allusion of Tao Yuanming's love for chrysanthemums. Carved on the other side are one hundred characters of "*fu*" (luck) and "*shou*" (longevity) in seal script.

234

Jade Incense Container (A Pair)

Full Height 128 cm Height of Tube 77.5 cm
Diameter of Mouth 12.7 cm
Qing court collection

This incense container consists of three parts: the top, pillar, and base. The middle part of the container pillar is made of green jade. It is hollow, and the wall of the pillar has openwork patterns of clouds and dragons. The upper part is the top with a multiple-eaved hexagonal pyramidal roof. The end of the ridge is decorated with the head of a dragon, with its mouth holding a wind bell. The lower part has a contracted-waist Sumeru base with bronze-plated gold, decorated with patterns of lotus petals and auspicious clouds.

An incense container is a display item in a palace that stores incense materials inside, and fragrant smoke flows out from holes in the wall of the container to clean the air.

235

Mythical Beast (*Luduan*) Jade Censer (A Pair)

Full Height 33.8 cm Length 21.5 cm
Width 18.6 cm
Qing court collection

This object is made of green jade. This censer has a mythical beast *luduan* carved in round, which is formed by joining the two parts of the head and body as a set. It can be placed with incense materials. The beast opens its mouth and spits out its tongue, and stands with its head raised. The lower part is supported by a gilded bronze base.

Luduan is an auspicious beast with a single horn in the mythical ancient legend. It can travel eighteen thousand miles a day and knows all the languages of the four directions. If the world has a sage king, it would appear, and serve the king by his side. During the late Ming, the *luduan*-style jade incense utensils began to appear inside the houses, and they were still popular in the Qing Dynasty. Jade beast censers in the Qing Dynasty can be divided into two categories: big and small. The big ones were placed at the two sides of the imperial throne, as ceremonial display objects. On the other hand, the small ones are placed in the sleeping chambers, as ordinary utensils for daily use.

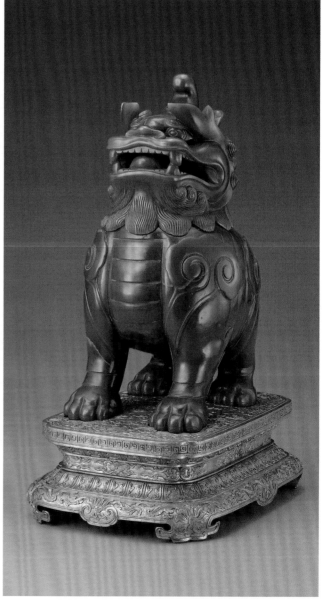

236

Jade Eight Auspicious Symbols

Full Height 32.5 cm Width 8 cm
Qing court collection

This object is made of green jade. It represents, in openwork, the eight vessels of Buddhism, including the Wheel of the Dharma, conch shell, victory banner, parasol, lotus flower, treasure vase, fish pair, and the endless knot. The above are known as the "eight auspicious symbols" or "*bajixiang*", and are decorated with the techniques of tracing and filling with gold, and inlaying with stones. The lower part is matched with the rosewood base inlaid with silver wires. The upper part has wavy lotus petals, and its middle part has flanges inlaid and carved with gray jade chips. The lower part, on the other hand, has an octagonal terrace with a white jade balustrade and eight bronze-plated gold pillars.

237

Jade Flower Goblet with Lotus Flowers

Height 21.5 cm
Diameter of Mouth 13.4 cm
Diameter of Leg 7.7 cm
Qing court collection

This object is made of green jade, which is glossy, moist, and slightly translucent. This object has the shape of a six-petal trumpet flower. It has a flared mouth, a long neck, a bulging belly, and a high ring foot contracted outward. The outer wall is decorated with symmetrical lotus flowers and lotus leaves.

A goblet is a wine vessel of the ancient time. Goblet-shaped vessels of different qualities in the Ming and Qing periods were used for holding flowers, display, or as ceremonial vessels. In Buddhist art, lotus flowers are the main decorative patterns, representing "pureland", symbolizing "purity", and implying "luck".

238

Jade Perfumer with Peonies Carved in Openwork

Full Height 10.2 cm
Diameter of Mouth 14 cm
Diameter of Leg 9.5 cm
Qing court collection

This object is made of green jade, and has some faulty spots. The perfumer is formed by locking up the lid and the vessel. The lid has a knob in the shape of a round cake. The vessel has a round mouth, a bulging belly, and a ring foot. Both the lid and the vessel are carved in openwork with peonies throughout. Flowers and leaves of a peony carved in openwork from the two handles.

239

Jade Perfumer with Eight Auspicious Symbols Carved in Openwork

Full Height 12.8 cm
Diameter of Mouth 11.8 cm
Diameter of Leg 5.8 cm
Qing court collection

This object, made of green jade, is formed by locking up the lid and the vessel. The lid has a top knob with the buds, branches, and leaves of a chrysanthemum. The vessel, on the other hand, has a round mouth, a bulging belly, and a ring foot. Its entire body is carved in openwork with the eight auspicious symbols, including the wheel of the Dharma, conch shell, victory banner, parasol, lotus flower, treasure vase, fish pair, and the endless knot. It also includes patterns of intertwining branches, supplemented by patterns of bats, drooping clouds, and lotus flowers. The buds, branches, and leaves of a chrysanthemum form a handle in each side.

240

Horn-shaped Jade Wine Vessel with an Elephant Head

Full Height 21 cm
Diameter of Mouth 9.8 x 6.9 cm
Qing court collection

This object, made of quality white jade, has lustre. The entire vessel is shaped as a flat tube and divided into the lid and the body. The lid is a curved mouth knob. The body of the vessel, in turn, has three parts. The upper and middle parts are carved with transformed beast masks. The lower part, shaped as an inverted elephant head, forms the foot of the vessel. On one side of the body is carved in openwork a *chi*-dragon as the handle.

Horn-shaped wine vessels were bronze ceremonial vessels of the ancient period. The jade horn-shaped wine vessels of the Qing Dynasty imitated their decorative patterns, but had changes in their shape. This jade wine vessel absorbs the contents of traditional art in the ancient period and embellishes the expression of form of jade ware. It must have been a display object in the imperial court.

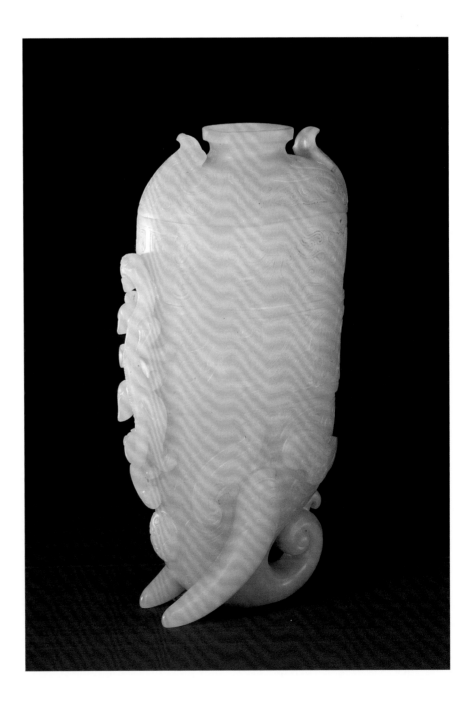

241

Jade Feather Tube with the Character "*Xi*" (Happiness)

Length 7.5 cm
Diameter of Hole 1.5 cm

This object is made of white jade. The tube is in the shape of a hollow cylinder. On one end is a tenon, with a hole on it. The wall of the tube is carved in relief and features two plucked branches of a peach, and the character "*xi*" (happiness). The top is carved with a bat and a *ruyi* sceptre.

Feather tubes were used for putting in decorative peacock-tail feathers on the official caps for officials of the Qing Dynasty. Peacock-tail feathers were made of feathers of a peacock. They were inserted into feather tubes to decorate the caps and to show the status of the official. Feather tubes could be made of white jade, emerald, enamel, or tourmaline. Among these, the jade and emerald tubes were considered the best.

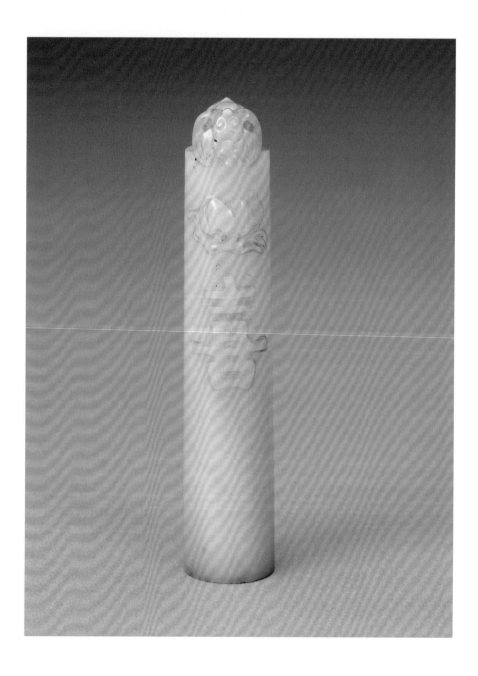

242

Jade Flower Holder with a Lotus Flower

Height 12.6 cm Length 22.5 cm
Diameter of Mouth 12.1 x 7 cm
Qing court collection

This object, made of white jade, has yellowing spots on some parts. It is formed by carving in round a lake rock, a lotus fruit, a lotus flower, and a lotus leaf. There is a lake stone, which is slender and has many holes, carved on one side. The lotus fruit sticks close to the lake rock and is carved with seven lotus seeds. The lotus flower spreads its petals, which are about to blossom. The lotus leaf, which is hollow, can be used to hold things. The side edges are slightly contracted. The outer part is carved with veins. Water flows under the leaf, the lotus stalk is submerged in water, and a swallow stands on the bud of the lotus flower, turning back its head.

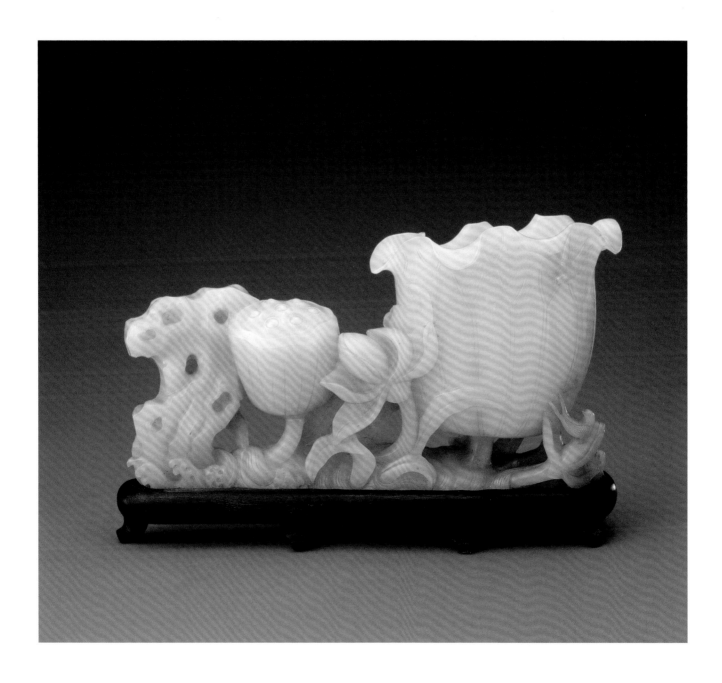

243

Jade Flower Holder with Pine, Bamboo, and Plum

Height 17.7 cm
Length 13.4 cm Width 4.7 cm
Qing court collection

This object is made of dark green jade. The main body is carved with a tall tree stump and a flower goblet standing side by side. The stump is hollow. A twig of a plum flower circles the stump, blossoming. There is a crane perching on a pine tree, beside the stump. On the other side is a carved bamboo. The pole of the bamboo is slender and small, and its leaves are few and scattered. The flower holders have mouths in the shape of a Chinese flowering crab-apple. They also have bulging bellies, carved with beast masks. The mouth of the goblet has a crouching *panchi*-dragon. On the side of the goblet is a phoenix, standing on a glossy ganoderma. In addition, there is a carved plum tree in the background.

This vessel has a pine, a crane, and a glossy ganoderma to form auspicious patterns of "living as long as the pine and crane" and "the glossy ganoderma, narcissus, and bamboo for birthday" to offer the wishes of longevity. It also has the pine, bamboo, and plum to form the "three companions in winter", namely the noble conduct of a gentleman. This type of work, which has many motifs and implications, is commonly seen in the jade ware of the Qing Dynasty.

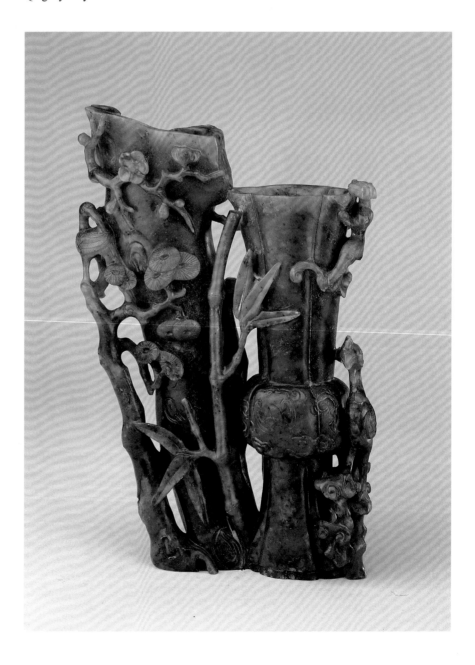

244

Jade Food Debris Pot with Dragon Patterns

Height 9.1 cm
Diameter of Mouth 8.1 cm
Diameter of Leg 4.7 cm
Qing court collection

This object is made of white jade and has no faults. It has an open mouth, a contracted neck, and a ring foot. The body of the object has decorative patterns in intaglio. The outside edge of the mouth is decorated with a band of hanging cloud patterns. The neck is decorated with banana leaves, and the belly, with three groups of dragons. The heads of the dragons are thin and long, and their manes stand upright. The bodies of the dragons are carved with lattice-style scales and flames. They have four toes in each claw and their tail is ruined. The foot is decorated with a band of raised drooping clouds.

In the early Qing Dynasty, a dragon head was usually shaped as a thin and long horse head. Since the time of Qianlong, they passed to be short, broad, and thick. According to the dragon shape, it can be deduced that this vessel was made in early Qing. A spit pot is a practical utensil to place food debris. The food debris pots used in the Qing court were made of materials such as ceramics, glass, lacquer, and jade, with the jade pots the most frequent.

245

Jade Inlaid
Ruyi sceptre

Length 44 cm
Qing court collection

This object, made of green jade, is inlaid with white jade. The green jade has dark green black spots, whereas the white jade has slight faulty spots on some parts. The head of the *ruyi* sceptre is inlaid with a piece of white jade, decorated with a plum blossom, a tagete flower, and a glossy ganoderma. The handle of the *ruyi* sceptre is made of green jade, inlaid with white jade and carved in openwork with the words "*jixiangruyi*" (as lucky as one wishes). The end of the handle is inlaid with white jade in the form of *ruyi* sceptre clouds.

This object has distinctive colours, a well-thought conception, and exquisite craftsmanship. Of all the jade *ruyi* sceptres in the collection of the Palace Museum, this kind of piece is rarely seen.

246

Jade Candle Holders with Bamboo Joints (A Pair)

Full Height 26.5 cm
Distance of Leg 12 cm
Qing court collection

These two objects are made of green jade. They have bamboo joints and identical shapes. The small trays at the ends of the tops are made of blue jade, in the shape of a five-petal plum blossom. The upper part has a candle rod. The large tray also resembles a plum blossom. The pillars of the candle holders are formed by joining two pieces of jade. They are decorated and carved with bamboo poles and leaves. The four feet have the form of bamboo roots, and the places where they join with the pillar of the holder are decorated with round-shaped chrysanthemum buds.

The decorative patterns of this pair of candle holders are novel, and the shapes are unique. They are not only ordinary daily utensils but can also be used as sacrificial tools.

247
Sunflower-shaped Jade Incense Holder

Height 3.3 cm
Diameter of Mouth 13.1 x 7.6 cm
Diameter of Base 6.7 x 4.6 cm
Qing court collection

This object, made of blue jade, has black spots and artificial colouring. This incense holder is in the shape of a sunflower with five petals. It has an oval mouth, a flat base, and a flower-shaped foot. The pistil of the sunflower is carved in relief and features round holes for holding incense. The outer wall has branches and leaves carved in openwork as handles. The flowers and leaves are turn and fold in an orderly way, being extremely real and vivid.

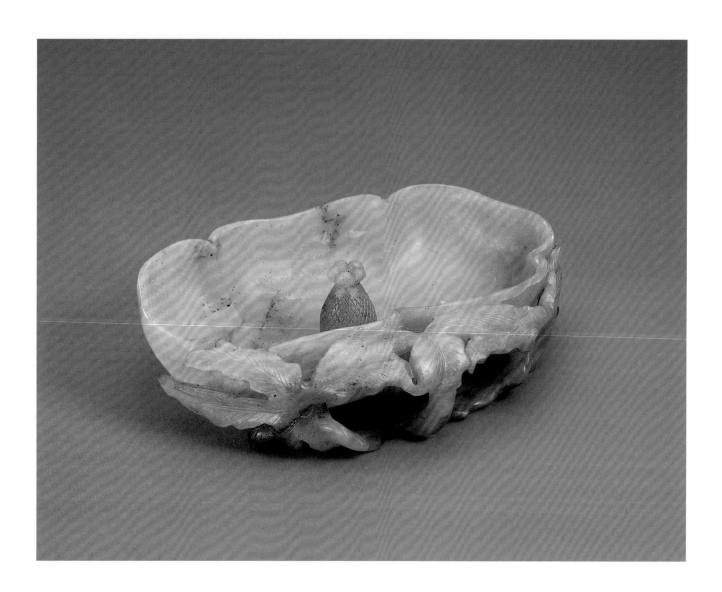

248

Jade Washer with Five Sons Passing the Imperial Examinations

Height 6 cm Diameter of Mouth 7.5 cm
Diameter of Base 3.6 cm
Qing court collection

This object is made of blue jade. The washer has a round mouth and a flat base. The inside is glossy and plain. In the outer wall, there are five children in openwork encircling the washer. The children are holding the branches of the flowers and present different postures, implying "five sons passing the imperial examinations".

The "five sons passing the imperial examinations" comes from an allusion of the Five Dynasties period. In the period of Later Zhou of the Five Dynasties, there was a person called Dou Yujun of Yanshan Prefecture. His five sons were all excellent in conduct and studies, and passed the imperial examinations successfully. This story is known as the "five sons passing the imperial examinations". The "five sons passing the imperial examinations" later became a good luck pattern, placing the good wish of candidates to pass the imperial examination.

249

Melon-shaped Jade Washer

Height 4.1 cm
Diameter of Mouth 9.3 x 7.7 cm
Qing court collection

This object is made of bluish-white jade. It has a lustrous surface and slightly yellowish soaking-induced spots on some parts. The washer resembles a cut-open melon. The outer and inner walls are decorated with patterns of melon ridges. On one side is a creeping vine as a handle. On the vine are melon leaves and a small melon (die). The base of the object has a complete melon and leaves carved as its foot.

The modelling of this washer is exquisite, its conception is delicate, and it comes from the good luck drawing of "a multitude of melons and little melons" (guadiemianmian), implying a large family and prosperity with continuing generations.

250

Jade Water Dropper with Three Goats and Two Pools

Height 4.8 cm
Diameter of Mouth 6.6 x 3.5 cm / 5.9 x 2.6 cm
Length of Base 19.4 cm
Qing court collection

This object is made of blue jade. The two pools are connected. They have oval mouths and flat feet. The shoulder of the pool is carved with grain patterns. Both ends have three crouching goats carved in relief. They are prostrated on the sides of the pools, looking forward and backward, and they act in coordination with each other, making an interesting scene.

A water dropper is a stationery tool. This object consists of three goats (*san yang*), which is homophonic with "*sanyangkaitai*" (an auspicious beginning of a new year). In the *Book of Changes* (Zhouyi), the *tai* trigram under the three long lines of *yangyao* represents the first month. The winter goes and the spring comes. The *yin* decreases and the *yang* increases, which is a sign of good luck. Most people, therefore, take this pattern as a symbol of good luck.

251

Jade Brush Rest in the Shape of a Bridge Carved in Openwork

Height 7.3 cm Length 22 cm
Width 5.6 cm
Qing court collection

This object is made of blue jade and has some slight faults and spots. It is carved in round with a ladder-shaped wooden bridge. Both ends of the bridge are sloped, and its surface is flat and straight. On the bridge, pedestrians are walking to and fro. Some are riding on donkeys, and others carrying a load. There is a shepherd boy riding on the back of a cow, passing the bridge leisurely. There are several carved bushes on one side of the bridge. Under the bridge, a small boat is passing through. There are two fishermen on the boat, one casting the net, and the other sculling. Another small boat anchors at the bridge pier, taking a short rest. It displays a water village scenery full of beauty and harmony.

This object uses the ladder-shaped wooden bridge as a leverage, together with figures and animals carved in round, to form a protruding tenon to rest a writing brush. It is said to be a skillful design and is unique in its own way.

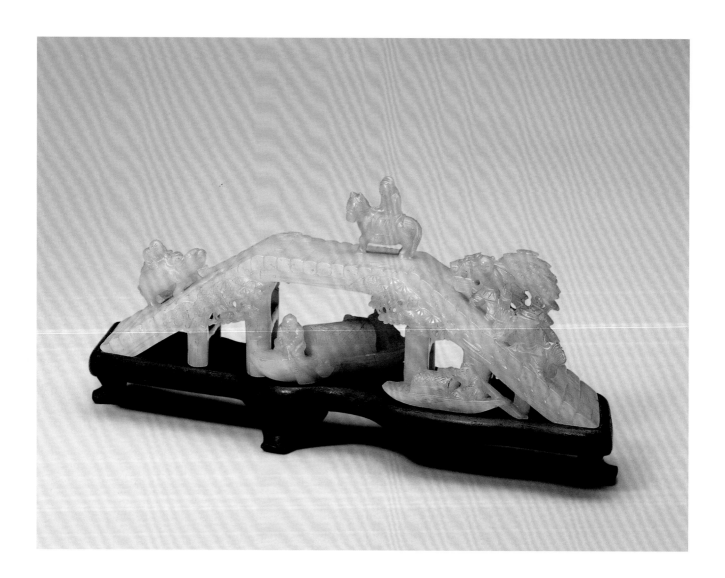

252

Jade Brush Rest with Three Peaks

Height 6.1 cm Width 9.8 cm
Thickness 4 cm
Qing court collection

This object, made of white jade, is tender and moist. It has three mountain peaks carved in round. In the peaks are eight animals, including a monkey, a bear, a tiger, a monster, and so on. Some of them are climbing, others are sitting quietly, and still others are playing. The carving is smooth and delicate, lively and vivid.

Mountain peaks are commonly used in brush rests. This object has many animals carved in the peaks, adding some liveliness and fun to it.

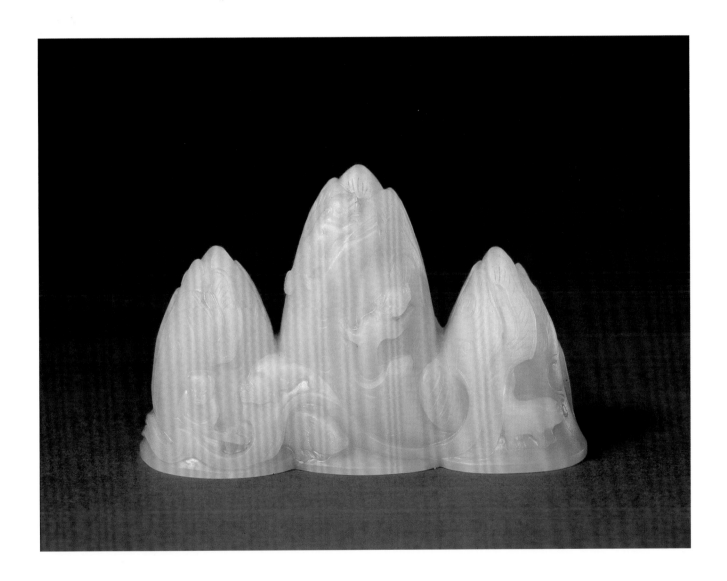

253

Rectangular Jade Paper Weight with a Horned Dragon and Two *Chi*-dragons

Length 27.8 cm Width 3.2 cm
Qing court collection

This paper weight, made of white jade, is rectangular. The front side is carved with a horned dragon and two *chi*-dragons. The former is prostrated on one end of the paper weight, turning back its head to look. Two small *chi*-dragons follow one after the other, like children who have just learnt to walk, making it a lovely scene. This painting carries the meaning of "a dragon teaching its son", with the implication of "hoping that one's children will have a bright future".

254

Jade Brush Holder with a Painting of Enjoying the Cool

Height 13 cm Diameter of Mouth 11.9 cm
Distance of Leg 11.8 cm
Qing court collection

This object, made of bluish-white jade, is pure and lustrous. This brush holder has a round mouth, a vertical wall, and a deep belly, and it is supported by five hanging cloud feet below. The surface of the holder is carved with three sections of a painting separated by mountain rocks, showing contents such as people enjoying the cool, walking with a cane, and children at play. The main theme is to show people enjoying the cool weather. It is carved with a pavilion in the middle of the water. In the pavilion is an old man leaning on a balcony and looking into the distance. In the water is a pair of mandarin ducks, and on the side of the bank is a child playing and feeding the fish. The background is decorated with trees, bridges, and houses, and the scenery is one of seclusion and quietness.

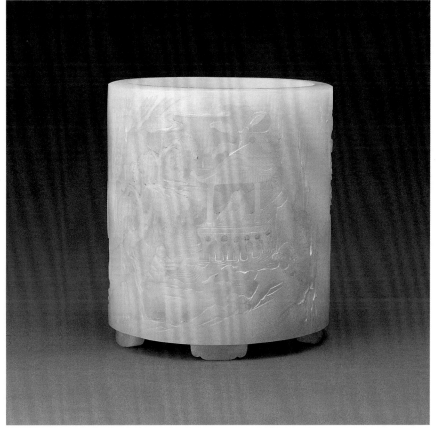

255

Jade Pendant Set with Climate and Phenology

Round Pendant:
Diameter 11.3 cm
Thickness 0.9 cm
Petal-shaped Pendant:
Length 6.4 cm
Width 5.5 cm
Thickness 0.7 cm
Qing court collection

This object, made of white jade, has thirteen pieces of jade to form the shape of a flower, with the jade in the middle resembling a pistil. The centre of the circle is carved with a movable centre with six rings. On one side of the round edge is carved with narcissus, flowering apple, Rohdea, and glossy ganoderma. On the other side, the twelve bamboo tuning pitch-pipes are carved in relief in seal script, including the *huangzhong*, *dalü*, *taicu*, *jiazhong*, *guxi*, *zhonglü*, *ruibin*, *linzhong*, *yize*, *nanlü*, *wuyi*, and *yingzhong*. The perimeter has twelve protruding tenons, which can tenon with petal-shaped pendants.

There are twelve pieces of petal-shaped pendants, with their upper parts having holes for threading and wearing. Carved on the pendants are flowers and leaves of narcissus, pomegranate, osmanthus, chrysanthemum, lotus, plum branches, apricot, gumbo, Chinese herbaceous peony, peach, hibiscus, and peony.

The ancient people believed that the twelve lunar and phenology in a lunar month corresponded to twelve different flower gods. By the same token, the twelve tunes also corresponded to different climates, phenology, and seasons. The pendant set was designed according to these relationships.

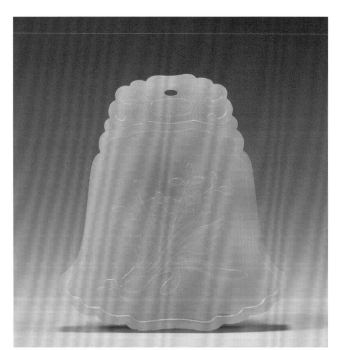 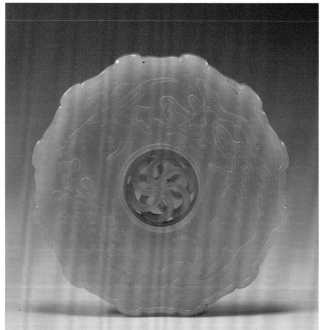

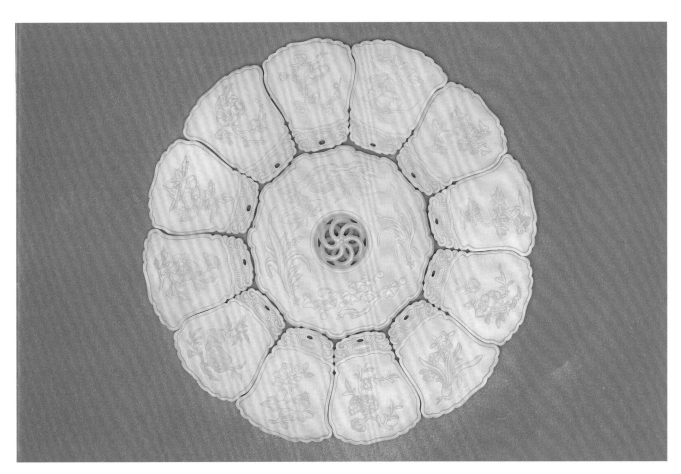

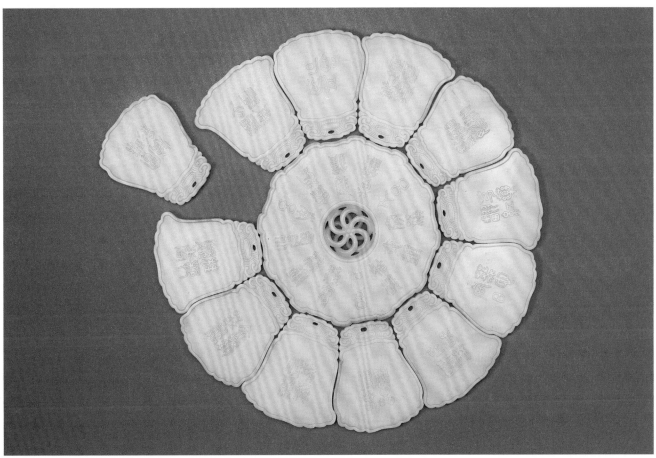

256

Jade Twelve Symbolic Animals

Height 3.1 – 3.4 cm
Qing court collection

This object, made of blue jade, represents sitting symbolic animals of the twelve branches with beast heads and human bodies carved in round. Each statue holds a different type of object, carrying different symbolic meanings.

The twelve symbolic animals, also known as *shuxiang*, are respectively the rat, ox (yellow cattle), tiger, hare, dragon, snake, horse, goat, monkey, rooster, dog, and boar, matching with the twelve *dizhi*. All of them have a transmigration cycle of twelve years. The birth year of a person can be matched with a corresponding animal, which is a traditional custom in China. The concept of the twelve symbolic animals began in the Eastern Han Dynasty, and figurines of the twelve symbolic animals, which appeared in the Sui Dynasty and became popular in the Tang Dynasty, were found in the ensuing dynasties.

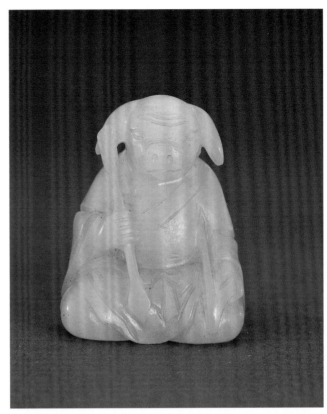

257

Double-ringed Jade with *Chiyou* Motifs

Diameter 8 cm
Thickness 2.2 cm
Qing court collection

This object, made of green jade, has faults and spots inside. The object consists of two rings combined into one. When the rings are combined, they become a single ring. When they are separated, they are still linked. They can thus be separated or combined. The outer wall of the ring is carved in low relief with the shapes of four *chiyou* heads. They have large round eyes with multiple rings, flange noses, and big mouths.

Chiyou was a tribal chief of the Jiuli ethnic group in ancient times. According to legend, he had a yellow cattle head and two wings on his back, and he was courageous and good at warfare. *Chiyou* rings were a jade object unearthed from Liangzhu Culture of the Neolithic Age. Zhu Derun of the Yuan Dynasty fixed the name of *chiyou* rings in his book *Guyu Tu*. This object is an antique imitation of the Qing court.

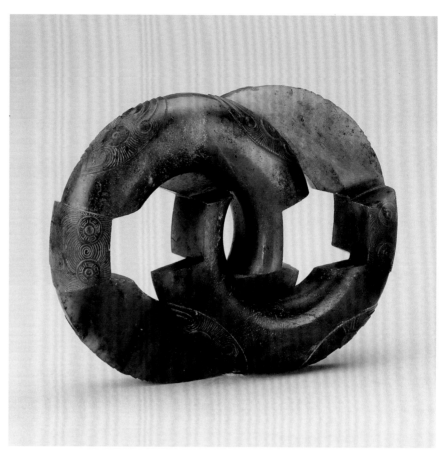

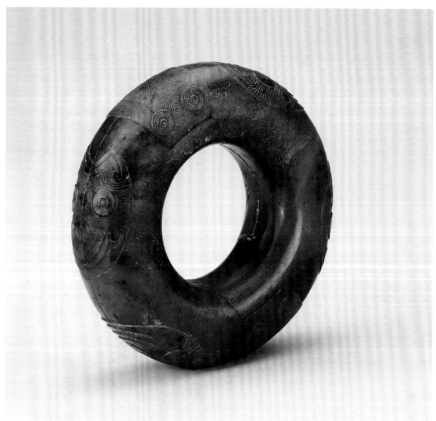

258

Linked Jade Disks

Single Diameter 17.5 cm
Diameter of Hole 3.5 cm
Thickness 1.1 cm
Qing court collection

This object, made of blue jade, is lustrous and moist and has no faults. It has two disks linked by a loose ring. The front sides of the disks are decorated, respectively, with patterns of clouds and dragons and patterns of clouds and phoenixes, implying "the dragon and the phoenix bring forth prosperity". The back sides are carved with patterns of silkworms. The two holes have loose cores. The middle part of the two disks has a loose flat ring, decorated with beast masks and grains. Inside the ring are the handles of both disks, so that they can be opened or linked.

This disk is cut and made with an entire block of blue jade. Its design is skillful, and its craftsmanship, elaborate. This is a new species in the Qing Dynasty and a valuable display object in the court.

259

Jade Tablet-disk with Twelve Imperial Emblems

Height 17.8 cm Width 12.3 cm
Thickness 1.5 cm

This object is made of white jade. It is a combination of a tablet and a disk. The entire body is decorated with patterns carved in low relief and in openwork. The front side of the tablet is decorated with the pattern of twelve imperial emblems. On the walls of both sides of the body are carved dragons. On each of the edges of the upper and lower rims of the walls are two *panchi*-dragons carved in openwork. On the centre of the back of the disk is a carved dragon, and its perimeter is decorated with grain ears. The upper part of the back of the tablet has three stars placed side by side. The lower part has water patterns.

A jade tablet-disk was a jade object held by kings and feudal lords in the ancient period when having official intercourses or offering sacrifices to gods or ancestors. The twelve imperial emblems were embroidered on the sacrificial robes in the ancient period, and they were given virtues, such as openheartedness, resolution, loyal and filial piety, and a clear distinction between right and wrong. The kings wore ceremonial robes decorated with the twelve imperial emblems on the most solemn occasions.

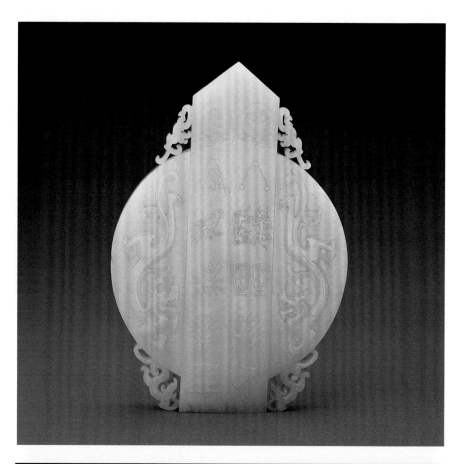

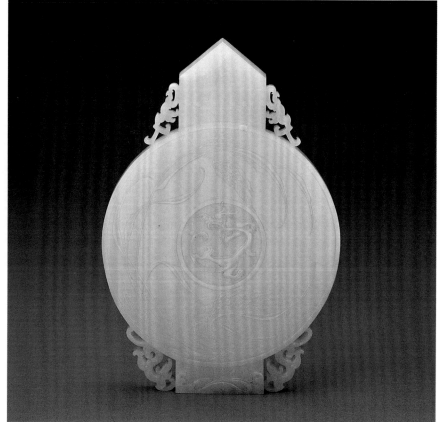

260

Jade Ewer with a Phoenix Handle and Flowers

Height 22.1 cm
Diameter of Mouth 5.8 x 4.8 cm
Diameter of Leg 5.4 x 4.5 cm
Qing court collection

This ewer, made of bluish white jade, has an oval mouth, a short neck, a flat round belly, and an oval ring foot. It is appended to a lid, the top of which has a *ruyi*-sceptre-shaped knob carved in openwork, as well as two loose rings. The surface of the lid is decorated with a band of lotus petals. The neck is decorated with passionflowers. The belly is polished, and inside it, there are peonies, mountain rocks, and glossy ganoderma carved in relief. The body of the ewer has a symmetrical handle and spout. The handle is carved with a phoenix turning back its head. The tail has a loose ring. It has a beast-swallowing spout. The space between the spout and the neck is decorated with a diagram of the universe (*taiji*). The lower part is supported by auspicious clouds.

This ewer has a beautiful design and is exquisite in cutting and making. It is a representative piece of the jade ware of the Qing Dynasty.

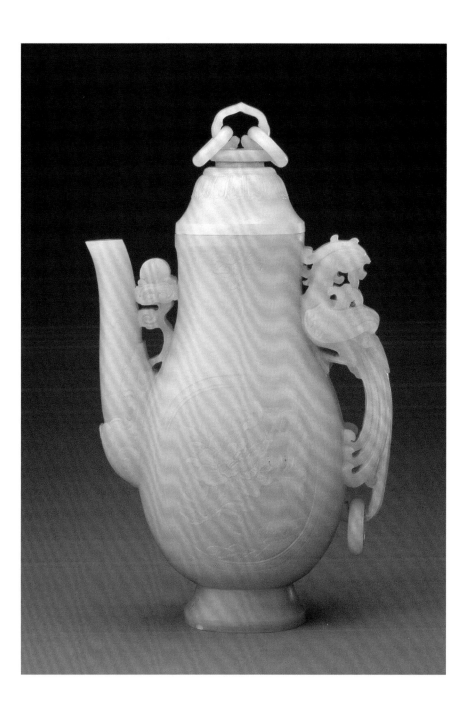

Index of Jade Ware and Corresponding Chinese Characters/Pinyin

JADE WARE	CHINESE CHARACTERS/ PINYIN	ITEM NUMBERS
Bodkin	觿 Xi	38/87
Bottle	樽 Zun	98
Breast Ring	乳環 Ruhuan	223
Chime	編磬 Bianqing	204
Chime Bells	編鐘 Bianzhong	204
Disk	璧 Bi	8/32/33/59/81/82/83/84/196/258/259
Disk	拱璧 Gongbi	99/100
Food-container	簋 Gui	176
Food Debris Pot	夯斗 Zhadou	244
Goblet	觚 Gu	185/186/209/237/243
Guard	格 Ge	110/111
Hairpin	簪 Zan	131/168
Head	首 Shou	110
Horn-shaped Wine Vessel	觥 Gong	240
Inkstone Water-dripping Pot	硯滴 Yandi	106/190
Mark Stamp	押 Ya	166
Miniature Landscape	山子 Shanzi	155/192/213/214
Mouthpiece	琀 Han	102
Nose	璲 Zhi	108/110
Penannular Jade Ring	玦 Jue	2/37
Pendant	佩 Pei	17/19/46/51/57/60/61/62/63/64/80/81/114/115/ 116/143/144/145/146/152/177/178/227/255
Pillar-shaped Vessel	勒 Le	39/40/41/42
Plate	牌 Pai	179
Ring with Hoisting Tackle/ Hoisting Tackle Rings	轆轤 Lulu	201
Semi-annular Jade Pendant	璜 Huang	9/13/35/36/65/68/74 75/76/77/78/90/119
Sheath Ornament	珌 Bi	109/110
Tablet	圭 Gui	24/30/197/259
Tablet	璋 Zhang	23/25
Tablet-disk	圭璧 Guibi	259
Teeth Tablet	牙璋 Yazhang	25
Thumb Ring	扳指 Banzhi	34/228
Thumb Ring	韘 She	34/90/115/116/177
Top Gem	珩 Heng	122
Tube	琮 Cong	6/7/8/22
Vat	甕 Weng	205
Washbasin	匜 Yi	174
Water Dropper	水丞 Shuicheng	250
Weight	鎮 Zhen	120/121
Weight	墜 Zhui	39/147
Wine Cup	爵 Jue	218
Wine Cup	觴 Shang	123
Wine Vessel	彝 Yi	210

Dynastic Chronology of Chinese History

Xia Dynasty	Around 2070 B.C.—1600 B.C.
Shang Dynasty	1600 B.C.—1046 B.C.
Zhou Dynasty	
Western Zhou Dynasty	1046 B.C.—771 B.C.
Eastern Zhou Dynasty	770 B.C.—256 B.C.
Spring and Autumn Period	770—476 B.C.
Warring States Period	475 B.C.—221 B.C.
Qin Dynasty	221 B.C.—206 B.C.
Han Dynasty	
Western Han Dynasty	206 B.C.—23A.D.
Eastern Han Dynasty	25—220
Three Kingdoms	
Kingdom of Wei	220—265
Kingdom of Shu	221—263
Kingdom of Wu	222—280
Western Jin Dynasty	265—316
Eastern Jin Dynasty Sixteen States	
Eastern Jin Dynasty	317—420
Sixteen States Periods	304—439
Southern and Northern Dynasties	
Southern Dynasties	
Song Dynasty	420—479
Qi Dynasty	479—502
Liang Dynasty	502—557
Chen Dynasty	557—589
Northern Dynasties	
Northern Wei Dynasty	386—534
Eastern Wei Dynasty	534—550
Northern Qi Dynasty	550—577
Western Wei Dynasty	535—556
Northern Zhou Dynasty	557—581
Sui Dynasty	581—618
Tang Dynasty	618—907
Five Dynasties Ten States Periods	
Later Liang Dynasty	907—923
Later Tang Dynasty	923—936
Later Jin Dynasty	936—947
Later Han Dynasty	947—950
Later Zhou Dynasty	951—960
Ten States Periods	902—979
Song Dynasty	
Northern Song Dynasty	960—1127
Southern Song Dynasty	1127—1279
Liao Dynasty	907—1125
Western Xia Dynasty	1038—1227
Jin Dynasty	1115—1234
Yuan Dynasty	1206—1368
Ming Dynasty	1368—1644
Qing Dynasty	1616—1911
Republic of China	1912—1949
Founding of the People's Republic of China on October 1, 1949	